BEAUTY & IMITATION

BEAUTY & IMITATION

A PHILOSOPHICAL REFLECTION ON THE ARTS

DANIEL McINERNY

Published by Word on Fire Academic, an imprint of
Word on Fire, Elk Grove Village, IL 60007
© 2024 by Word on Fire Catholic Ministries
Printed in the United States of America
All rights reserved

Design and layout by Rozann Lee, Cassie Bielak, and Clark Kenyon.

Except Psalm 19, all Scripture excerpts are from the *Revised Standard Version of the Bible*, Second Catholic Edition (San Francisco: Ignatius Press, 2006), © 2006 National Council of the Churches of Christ in the United States of America. Used by permission. All rights reserved worldwide. Psalm 19 is from *The Psalms: A New Translation* (Chicago: GIA Publications, Inc., 1963), © 1963 Ladies of the Grail. All rights reserved.

All efforts have been made to supply complete and correct credits and locate copyright holders; if there are errors or omissions, please contact Word on Fire Academic so that corrections can be addressed in any subsequent edition.

For more information, contact
Word on Fire Catholic Ministries
PO Box 97330, Washington, DC 20090-7330
or email contact@wordonfire.org.

ISBN: 978-1-68578-985-5

Library of Congress Control Number: 2022943567

This book is dedicated to my students,
past, present, and future,
at Christendom College.

And this our life, exempt from public haunt,
Finds tongues in trees, books in the running brooks,
Sermons in stones, and good in everything.
Shakespeare, *As You Like It*

Table of Contents

Acknowledgments

It is an honor for me to publish this book with the academic imprint of a ministry I have come to admire so much. To Jason Paone, the editor of Word on Fire Academic, I owe my first and special thanks for his immediate enthusiasm for the project. It also must be noted that no one at Word on Fire did more work helping improve the manuscript than David Augustine, who has been an unflagging source of support, encouragement, and expert editorial advice. I am also grateful to James O'Neil, who put in a yeoman's stint helping edit the manuscript, and to Matthew Becklo, publishing director at Word on Fire, and Brandon Vogt, senior publishing director, for their assistance in shepherding the book to its completion.

To the two anonymous peer reviewers of the manuscript, I owe a debt of gratitude for the criticisms that helped me to sharpen my arguments.

My wife, Amy, deserves a special word of thanks. In the summer of 2022, when I was bearing down on the draft of the manuscript, she created space for me to think and write even as we were moving houses—indeed, even as she was organizing the move of *two* houses, both ours and her father's house. This was a prodigious act of patient generosity for which I will always be grateful. Thank you, Miss Amy, for once again and always being my sturdy shelter, and for being such a precious way of beauty.

And to the students at Christendom College, to whom this book is dedicated, I thank you for our years of conversation and friendship and for helping me feel so much at home in our extraordinary community. Thank you especially for being so open to my courses. Many of the ideas in this book, and even drafts of chapters, were first developed and studied in my Philosophy of Art & Beauty course and in my course on Ethics & Imagination. I hope this book will enable us to continue our conversation about art in even more fruitful ways.

Daniel McInerny
Hume, Virginia
Feast of St. Pius of Pietrelcina

Introduction

The human person is an agent of truth, and one of the most important ways in which the human person seeks truth is through the arts. The enjoyment we experience both in making and in appreciating arts such as music, painting, literature, and the like is not merely emotional. The enjoyment certainly involves the emotions, but it is above all a joy in the mind's coming better to understand, at least in some small part, the nature of the human predicament. The arts, I want to suggest, are forms of inquiry, of investigation, as the beauty that we find in them illuminates the truth about ourselves. My philosophical inquiry in this book thus affirms "the way of beauty" insofar as it affirms how beautiful works of art help us realize our agency as truth-seekers.[1]

1. I take the striking definition of the human person as an "agent of truth" from Robert Sokolowski, who develops it in his *Phenomenology of the Human Person* (Cambridge: Cambridge University Press, 2008). The modern revival of the theme of beauty as a "way" of truth and moral and spiritual transformation is often credited to Dostoevsky, whose character Prince Mishkin, in chapter 5 of *The Idiot*, is quoted as saying, "Beauty will save the world." *The Idiot*, trans. Constance Garnett (New York: Dover, 2003), 334. Solzhenitsyn famously meditates upon Prince Mishkin's remark in his acceptance speech for the 1970 Nobel Prize in Literature: "Nobel Lecture," trans. Alexis Klimoff, in *The Solzhenitsyn Reader: New and Essential Writings 1947–2005*, eds. Edward E. Ericson Jr. and Daniel J. Mahoney (Wilmington, DE: ISI Books, 2006), 512–26. On the theme of the way of beauty, see also Josef Pieper, *The Philosophical Act*, in *Leisure: The Basis of Culture and The Philosophical Act*, trans. Alexander Dru (San Francisco: Ignatius, 2009); Pope John Paul II, "Letter to Artists," especially §16, where he also meditates on Prince Mishkin's remark; and Pope Benedict XVI, "Meeting with Artists, Address of His Holiness Benedict XVI." Pope Francis, in *Evangelii Gaudium*, explicitly speaks of the *via pulchritudinis*, the "way of beauty," which he sees as a means of "touching the human heart and enabling the truth and goodness of the Risen Christ to radiate within it. If, as Saint Augustine says, we love only that which is beautiful, the incarnate Son, as the revelation of infinite beauty,

I just called my inquiry a philosophical one. What does it mean to think about art philosophically?

Consider an ordinary experience of enjoying a work of art: sitting with family or friends watching a movie. Notice that as we watch the movie, we are not calling the movie into question; we are simply taking it in. When we philosophize about art, however, we step back from this ordinary experience. Or, to adjust the image, we swing away, in our thinking, from our seat in front of the flatscreen to a position that is figuratively "above" or "at a right angle" to the flatscreen. That is, we *reflect* upon our watching of the movie. We ask what it means for human beings to make movies (and how they are different, for example, from paintings); we ask what it means to watch movies (as opposed to watching human beings doing things in real life); we ask whether art is primarily "imitative" or "expressive"; we ask about the nature of beauty and about how beauty can function as a "way" to the intelligibility of human action, and perhaps even a way to realities that transcend the physical world. These are all philosophical questions, questions about the very nature of art. They are not questions that the art historian or art critic takes up, except when the historian or critic becomes philosophical.[2]

In pursuing my inquiry, I will be developing a philosophy of art inspired by the thought of Aristotle and St. Thomas Aquinas. Even taken together, these two giant intellects wrote relatively little about art, but what little they wrote provides the principles of a coherent, highly stimulating, and sometimes surprising understanding of what human beings do when they make pictures of themselves and their reality in the form of poems, novels, paintings, films, music, and the like.

That is the idea at the center of the Aristotelian-Thomistic

is supremely lovable and draws us to himself with bonds of love" (§167). Francis directs us to St. Augustine's *De Musica* 6.13.38 and *Confessions* 4.13.20.

2. For a lucid statement on the difference between the natural attitude and the philosophical, or phenomenological, attitude, see Robert Sokolowski, *Introduction to Phenomenology* (Cambridge: Cambridge University Press, 2000), chap. 4.

approach to art: that art is a picturing or *mimēsis* of reality. The Greek term *mimēsis* is typically translated as 'imitation' or 'representation' or simply left untranslated in the English word mimesis. In his treatise on the art of poetry, the *Poetics*, a slim, fragmented, massively influential treatise composed sometime in the middle of the fourth century BC, Aristotle speaks of mimesis as natural to human beings. We learn our first lessons, and no doubt many subsequent ones, through imitation of various models.[3] Mimesis is thus linked to understanding. We see this natural inclination to imitate in a little boy doing exactly what his father does as his father performs chores around the house, just as we see it in Michelangelo's painted imitation of his heavenly Father's creative act on the ceiling of the Sistine Chapel. Mimesis is one of the ways in which we human beings naturally try to make sense of our world, and I agree with Stephen Halliwell, who claims that "mimesis, in all its variations, has quite simply proved to be the most long-lasting, widely held and intellectually accommodating of all theories of art in the West."[4] Indeed, I think it is plausible to consider mimetic art as the default understanding of art and all other understandings as declensions from this primary one. Throughout my inquiry, unless otherwise qualified, I will use the term "art" in the sense of "mimetic art." I will not use the phrase "fine art" or only in special, qualified ways use the term "aesthetics," as such terminology derives from a modern tradition of the arts that is, in important ways, antithetical to the Aristotelian-Thomistic one.[5]

3. Aristotle, *Poetics* 4 (1448b4–19).

4. Stephen Halliwell, *The Aesthetics of Mimesis: Ancient Texts and Modern Problems* (Princeton, NJ: Princeton University Press, 2002), 5–6. This work by Halliwell is a key resource throughout my inquiry.

5. Though Halliwell, in *Aesthetics of Mimesis*, especially in the introduction and chapter 12, argues that the break with mimesis in the eighteenth century and beyond is not as sharp as many have taken it to be, I nonetheless maintain that the break is sufficiently sharp to warrant a rejection of the eighteenth-century terminology. M.H. Abrams's *The Mirror and the Lamp* (Oxford: Oxford University Press, 1971) remains a classic account of the "changing metaphors of mind" that characterize the shift, during the Romantic period, from a mimetic to an expressive model of art. See also C.M. Bowra, *The Romantic Imagination* (Oxford: Oxford University Press, 1969), and Charles Taylor, *Sources of the Self* (Cambridge, MA: Harvard University Press, 1989).

In the first seven chapters of my argument, as well as in the interlude that follows them, I present the main outlines of the Aristotelian-Thomistic understanding of mimetic art. I explain the nature of mimetic art according to Aristotle's own theory of the four causes or sources of explanation. Chapters 1–4 take up the formal and material causes of mimetic art in setting forth what is involved in picturing the formal realities of human existence in the media of mimetic art. Chapter 5 takes up the efficient cause of mimetic art, the artist-agent who brings the work into being, by considering the artist's creative process, or "sub-creative" process as Tolkien would have it, as a kind of inquiry seeking insight. Chapters 6 and 7 consider the final cause, the end or goal, of mimetic art, a goal that is at once cognitive (i.e., involving some knowledge of reality) and appetitive (i.e., involving a response by the passions or emotions and by the will).

More specifically, the structure of my argument is as follows. In chapter 1, I undertake to explain further the notion of imitation in art. Imitation is a potentially misleading translation of *mimēsis* because it tempts us to think of mimesis as mere copying. But mimesis is a far richer notion than that. It involves the re-presentation of an object in the alien matter of a particular artistic medium for the sake of making that object delightfully intelligible to an audience. The painted portrait of Churchill does not merely present a sensible likeness of the UK prime minister. It goes beyond resemblance to manifest the intelligibility of the man himself, his essence: *what it was to be Churchill* at the time he sat for the portrait.[6] We need to dismiss from the outset the idea that mimesis is primarily about achieving verisimilitude (though I will take up the "copying" objection again in chapter 1).

6. I depend here upon Robert Sokolowski's distinction between a likeness and a portrait: "A likeness is a mere copy of a person; it shows what he looks like. It gives you enough to be able to identify a person. A portrait is more than this; it is a depiction of an essay at beatitude. It presents, poetically, someone's shot at happiness and self-identity." Sokolowski, "Visual Intelligence in Painting," *The Review of Metaphysics* 59 (December 2005): 333–54, at 344. Along with Sokolowski's *Phenomenology of the Human Person*, this essay will play a key role throughout my argument.

Next, in chapter 2, I explore more deeply what is depicted in art. Aristotle says that the object of mimetic art is "human beings in action," and we know that according to Aristotelian ethics, action is always undertaken for the sake of *eudaimonia*, or ultimate fulfillment.[7] Mimetic art, therefore, depicts the human agent as wayfarer, as someone in quest of that ultimate fulfillment we commonly call happiness. To portray Churchill is, in a way, to sum up his pursuit of the good life. As Robert Sokolowski has written, a portrait is "a presentation of a whole life in its significant, articulated parts." A portrait "enfolds what the life unfolds."[8] This function of art is especially evident in narrative art or story. A novel, for example, offers images of a human protagonist seeking to achieve some important good taken to be necessary to, or constitutive of, the protagonist's happiness. By the end of the story, the protagonist either succeeds or fails or at least achieves some ironic mixture of failure and success. But the very attempt is what Sokolowski calls an "essay at beatitude."[9] Even an art such as painting, which we don't typically think of as a storytelling art, shows us some aspect of the human quest for happiness.

The story of a protagonist's quest for happiness is not simply the account of a delightful adventure. It is also, as I develop in chapter 3, a moral argument. A story, as we often remark, is supposed to "say" something. It has a "point" or "moral," though we would be gravely mistaken if we reduced a story to a bald statement of its moral. A story shows us a protagonist endeavoring to work out his or her happiness, but in so doing, a story attempts to prove something about the nature of happiness in the choices the protagonist makes. One of my chief claims in this book is that all the mimetic arts, in their different media, not only have a narrative dimension but also, in their narratives, present moral

7. *Poetics* 2 (1448a1).
8. Sokolowski, "Visual Intelligence in Painting," 347.
9. Sokolowski, 344.

arguments. In part 3, I will make good on this claim when I examine an array of specific mimetic arts.

The ultimate good for human beings, on the Aristotelian-Thomistic understanding, is not just one kind of good. It is multiform and hierarchical. It consists in an ordered set of virtuous activities (activities of temperance, courage, justice, and prudence, among other virtues) culminating in the activity of the highest virtue, wisdom, which is ordered to the contemplation of the divine. As the Aristotelian ethical picture is taken up into Christian theology by Aquinas, the contemplation of the divine available to us in this life itself becomes subordinated to the contemplation of God's very essence available to the blessed in heaven. A complete picture of the Aristotelian-Thomistic approach to mimetic art, therefore, requires a theological horizon. This theological horizon serves as a backdrop for the specifically Catholic imagination, the fulfillment of art's mimesis of the human quest. But what exactly does this phrase "Catholic imagination" mean? I understand the phrase to mean the way in which a Catholic believer—or someone who, like the author Willa Cather, has deep sympathy with Catholic belief—takes in the world through images formed by that belief. This "taking in" is a form of "seeing," of intellectual insight, that grasps reality by images enriched by the narrative that is salvation history and the traditions of art it has inspired. When this way of seeing, this "imagination," combines with excellence in artistic craft, there results a work that realizes the best possibilities of mimesis. A discussion of the Catholic imagination will be my focus in chapter 4.

I round out this first part of the book by turning, in chapter 5, to the situation of the artist. The way of beauty is, for the artist, no solitary way. When, for example, in the Renaissance, a master painter took on an apprentice, he introduced him to an entire way of life within the practice of painting. Drawing upon the work of Alasdair MacIntyre, I situate art within the social contexts of practices and tradition. Once we situate art within these

contexts, we are in a better position to see the life of the artist as a participation in an inquiry pursued by a community of artists over time. This communal inquiry prizes the mimesis of models but also, as we shall see, allows for new insights and approaches. A discussion of the role of insight, or intelligence, in artistic creativity will round out this chapter.

In part 2 of the book, comprising chapters 6 and 7, I examine the question of art's impact upon its audience. I argue that the function of art is to move its audience by beauty's peculiarly cognitive or intelligible delight and, in so doing, incline the sensible and rational appetites of its audience to moral transformation. But, by this, I do not mean the simplistic claim that any given individual, after enjoying a work of art, is necessarily a better person. My point, rather, is that in the contemplative space in which we enjoy beautiful works of art, our soul's powers enjoy a simulation of moral choice that can incline or attract us to future virtuous action. Chapter 6 takes up the cognitive or intellectual aspect of this experience, while chapter 7 addresses the effect of beautiful art upon our sensible and rational appetites.

Between parts 2 and 3 is an interlude in the form of a dialogue between two imaginary characters on the question of art's transcendence. On one side of the argument is the claim that because art has the power to make human life delightfully intelligible, we can speak of it as having a transcendent purpose—understanding "transcendence" in a sharply defined way. Even as it enthralls our sensations and emotions, a great work of art transports us beyond what Jacques Maritain calls our sense needs and sentimental selves and into the realm of the intelligible.[10] This is why art is so immensely attractive to us: it invites us to see the intelligible *in* the sensible and, therefore, without ever leaving the sensible behind, to achieve insight or intelligence into what something is.

10. Maritain uses the phrase I mention in his discussion of beauty in *Art and Scholasticism*, trans. J.F. Scanlan (Providence, RI: Cluny, 2016), 34.

But on the other side of the argument is the claim that art has, for its proper end, "Beauty" considered as a transcendental property of being, a property found wherever being is found. On this understanding of art's transcendence, art would be an arm of metaphysics. Its aim would be not only to make human life intelligible but also to map the very fabric of reality itself.[11]

The dialogue ends by rejecting the latter view in favor of a much humbler, though still endlessly fascinating, view of art. Aquinas describes poetry as the *infima doctrina*, "the least of doctrines."[12] He speaks of it as having a *defectus veritatis*, a "defect of truth,"[13] because the intelligibility it manifests in human action is only probable, not necessary. I am moved by Hamlet's meditation "To be, or not to be," not in the way my mind assents necessarily to the proposition twice two makes four, but in the way Aquinas calls an *existimatio*, a kind of conjecture or estimation, a tenuous assent of the intelligence—intelligence as carried away by the passions and the senses—to the truth portrayed by the artistic image.[14] The assent is tenuous because it is not based on insight into *necessary* truth of the kind that drives mathematics but on the insight that a character in Prince Hamlet's predicament would, in such highly constrained circumstances, very likely, though not necessarily, contemplate taking his life. What Aquinas says about poetry applies to all art: it deals with the probable in human action, the probable communicated not through demonstrative or rhetorical arguments but through pleasing images. Mimetic art, again, pictures the humble stuff of human agents endeavoring,

11. Maritain has propounded this view in both *Art and Scholasticism* and *Creative Intuition in Art and Poetry* (New York: Meridian, 1957). A major source not only for my understanding of the deficiencies in Maritain's account of art, but also for my positive understanding of the Aristotelian-Thomistic account, is Thomas Dominic Rover's *The Poetics of Maritain: A Thomistic Critique* (Washington, DC: Thomist, 1965).

12. Thomas Aquinas, *Summa theologiae* 1.1.9 obj. 1.

13. Thomas Aquinas, *Scriptum super libros Sententiarum* 1.1.5 ad 3.

14. Thomas Aquinas, *In Posteriorum Analyticorum* 1, prologue, no. 6. Rover translates *existimatio* as "conjecture" (*Poetics of Maritain*, 93). Deferrari suggests *existimatio* could also be translated as "estimation," "valuation," "notion," or "idea." See *A Latin-English Dictionary of St. Thomas Aquinas* (Boston: St. Paul Editions, 1986), 373. Aquinas in fact calls it a *sola existimatio*, which Jason Paone has suggested to me might best be rendered "a conjecture and nothing more."

sometimes quite hopelessly, to work out their happiness. It is not metaphysics, but it is no less crucial to our lives for that.[15]

Parts 1 and 2 and the interlude make up the main philosophical work of my inquiry. By the end of the interlude, we will be poised to move into more focused investigations of particular arts. Part 3, therefore, comprising chapters 8–14, considers music, poetry, painting, cinema, drama (with an emphasis upon the art of acting), and the novel. In chapter 14, I discuss the nature and political importance of the more popular forms of these arts in what we typically call "entertainment." The point of these chapters is not to answer every substantive philosophical question concerning these arts but to show, in light of a particular work or set of works, how each of these mimetic arts instantiates the Aristotelian-Thomistic understanding of art and its central idea of mimesis.

It should be abundantly clear that this book is not a survey of various approaches to the philosophy of art but rather an inquiry into the principles and resources of one definite tradition. Neither is my argument intended to be a dialectic between the Aristotelian-Thomistic tradition of mimetic art and rival traditions. Though, from time to time, I touch upon a distinction between the mimetic approach of the Aristotelian-Thomistic tradition and other traditions of art, I do so mainly to clarify what the Aristotelian-Thomistic approach is all about, not to pretend that what I say is a complete argument against those rival traditions. When it comes to the Aristotelian-Thomistic understanding of mimetic art, it is my view that it remains most inadequately understood and so deserves an independent and comprehensive exposition. A dialectic with rival traditions of art is of crucial importance, but it is pointless to take it up before the voice of the Aristotelian-Thomistic tradition has been registered clearly

15. My understanding of the probable character of mimetic arguments is deeply indebted to Rover, *Poetics of Maritain*.

in contemporary conversation.[16] So, with those caveats in place, let us turn now to a discussion of what it means for an artist to imitate reality.

16. I make a contribution to the dialectic I speak of in my unpublished essay "Literature as Tradition-Constituted Inquiry."

Part I
The Nature of the
Mimetic Arts

1

The Way of Beauty Is the Way of Imitation

The celebrity comes on the late-night program. He is known for his skill at doing voice impressions of other celebrities, and the host asks him to show his stuff. The celebrity obliges, and soon we are delighted to hear the voices of other celebrities coming out of this celebrity's mouth.

Impressions of the late British actor Alan Rickman and the American actor Christopher Walken are favorites of impersonators, as their voices were and are so quirky and distinctive. Voice impressions never fail to give delight, and it is interesting to think about why. Why is it so entertaining to listen to one person mimicking the voice of another person we know well? Why is it even more entertaining than listening to Rickman's or Walken's voice coming out of Rickman's or Walken's own mouth? Doubtless, it is enjoyable to listen to Rickman and Walken speak. In and of themselves, their voices are absorbing—Rickman's nasal baritone, Walken's weirdly syncopated New Yorkese. Yet we seem to find it even more entertaining to listen to someone else "doing" Rickman's or Walken's voice. Rickman's or Walken's voice *coming out of someone else's mouth*: *that* is what we enjoy. What we find so entertaining, in other words, is the imitation of a form. When it comes to impressions, the form in question is chiefly the distinctiveness of someone's voice, its unique timbre and delivery. St. Thomas Aquinas calls this kind of form a "sensible form," which

simply means a quality discernible by the senses. When the sensible form or quality of someone's voice comes out of the mouth of someone else—when the sensible form, that is, shows up in another medium—we take delight.

Doing voice impressions is just one of the ways we human beings engage in that strange yet captivating activity Aristotle calls *mimēsis*, a word from which we derive our English words "mimicry" and "imitation." In his *Poetics*, Aristotle says that imitation is a natural activity of human beings.[1] And this cannot be denied. We see the imitative impulse bursting forth in childhood play-acting and dramatic games—play that Aristotle suggests has a natural connection to the making of mimetic art. In *The Brothers Karamazov*, Alyosha Karamazov has a conversation with Kolya, a thirteen-year-old boy who is embarrassed to have been caught playing "robbers" with some younger kids. To convince Kolya that he has no need to feel embarrassed, Alyosha provides a defense of mimetic play:

> And a game of war among youngsters during a period of recreation, or a game of robbers—that, too, is a sort of nascent art, an emerging need for art in a young soul, and these games are sometimes even better conceived than theater performances, with the only difference that people go to the theater to look at the actors, and here young people are themselves the actors. But it's only natural.[2]

Aristotle calls human beings the most imitative of animals and observes that we learn our first lessons by imitation. When it comes to learning a new language, a new sport, or a new artistic skill, we begin by imitating what we see the teacher, the coach, or the master artist doing. When we look at how artists develop,

1. See the opening lines of *Poetics* 4 (1448b4ff).

2. Fyodor Dostoevsky, *The Brothers Karamazov*, trans. Richard Pevear and Larissa Volokhonsky (New York: Farrar, Straus and Giroux, 1990), bk. 10, chap. 4, 538. This text was brought to my attention by Halliwell, *Aesthetics of Mimesis*, 178–79n5.

furthermore, we see that imitation characterizes not only their apprentice work but also their masterwork. Shakespeare's imitation of his sources, even in his most mature writing, is legendary.[3] And it was Voltaire who said, "Originality is nothing but judicious imitation," even as Virginia Woolf observed: "We are a world of imitations." Eleanor Catton, Booker Prize–winning author of *The Luminaries*, captures the importance of imitation for her writing in the following way:

> I believe really strongly in imitation, actually: I think it's the first place you need to go to if you're going to be able to understand how something works. True mimicry is actually quite difficult. . . . You want to enlarge your toolbox, and enlarge what is available to you as a writer."[4]

As the mimetic arts are understood in the Aristotelian-Thomistic tradition, they are all different kinds of imitation. Whether we are talking about imitation that makes use of visual images in drawing, painting, photography, and sculpture, or imitation that involves impersonation or enactment of human behavior such as we find in stage plays, opera, ballet, cinema, television, as well as in many video games, or whether we are talking about imitation by way of language alone, as in works of fiction, or language joined with rhythm, as in poetry, we are talking about an activity in which some feature of the world is made present in another medium. In this chapter I would like to explore more deeply what it means for an artist to imitate the world.

3. For an engaging discussion of Shakespeare's imitation of his sources and the power of imitation in general, see the chapter "Of Imitation" in Scott Newstok's *How to Think Like Shakespeare* (Princeton, NJ: Princeton University Press, 2020).

4. The quotations from Voltaire, Woolf, and Catton are from Newstok's discussion in *How to Think Like Shakespeare*.

IMITATION AS A KIND OF PICTURING

I start by suggesting that mimetic art is a kind of *picturing*. There are pictures that have nothing to do with human making—reflections in water, echoes, idle daydreaming—but in this discussion I am going to focus on the picturing that occurs when human beings make art.[5] It might seem strange at first to think of arts such as music or poetry as picturing, but I invite you to expand your sense of this word and to think of picturing as a useful way of understanding all the arts. Of course, it is natural and best to think first of literal pictures—drawings, paintings, photographs—before you begin to extend the concept of picturing to other arts.

Robert Sokolowski distinguishes four elements that belong to any kind of picture. First, of course, there is the picture itself, the constructed thing, and second, that feature of the world that is pictured by the picture. But a third element, one that Sokolowski warns is often overlooked, is the audience that takes the picture *as a picture*:

> We do not think of what makes the invisible difference between this colored paper and this colored paper as a picture. We take it for granted that this is a picture and think only about what it depicts, its composition, the fidelity of its depiction, or its condition as a product; we do not ask what grants it its being as a picture. To ask what lets it be a picture at all, and what it is for it to be a picture, is to raise a philosophical question.[6]

Raising that philosophical question is what we are doing now, asking what it is that lets a picture be a picture at all, and realizing that identifying the audience that takes a picture as a picture is essential

5. For this understanding of mimetic art as a kind of picturing, I rely upon Sokolowski's essay "Picturing," from his book *Pictures, Quotations, and Distinctions: Fourteen Essays in Phenomenology* (Notre Dame, IN: University of Notre Dame, 1992). For a discussion of the distinctions between the various kinds of picturing, see "Picturing," esp. 6–7.

6. Sokolowski, "Picturing," 8.

to what picturing is. The fourth element of picturing is the activity of the maker of the picture: for example, Kolya and the kids playing "robbers," the teenager snapping a photo on her cell phone, or the songwriter composing a new song.

In all kinds of picturing, the relationship between the picture and that which is pictured is the most important relationship. When it comes to the mimetic arts, the relationship between the picture and that which is pictured involves invention and construction. But however much inventiveness occurs, there remains a fundamental correspondence between the picture and the pictured, between the work of mimetic art and that feature of the world being pictured. If this correspondence failed to exist, the audience would not achieve the sense of recognition, the sense of the picture as a picture, that is essential to picturing.

Let us apply all this to voice impressions, which are minor works of mimetic art.[7] We said that when we hear a good voice impression, we take delight in it; we are entertained by it. Experiencing the sensible form of someone's voice in another medium makes us smile and laugh. Aristotle contends that human beings delight in imitations, even of things that are in themselves distressing, "because what happens is that, as they contemplate them, they learn and reason out what each thing is, for example that 'this image is of so-and-so.'"[8] His point seems to be that when we, the audience, hear someone doing an impression of Walken, our delight is based on the fact that our minds are able to recognize the correspondence between the voice coming out of the celebrity's mouth (a kind of picturing) and the voice that comes out of Walken's mouth (the pictured). In enjoying the Walken impersonator,

7. Aristotle refers generally to vocal imitation in *Poetics* 1 (1447a20).

8. *Poetics* 4 (1448b15–17). Aristotle makes the same point in nearly the exact words at *Rhetoric* 1371b4–10. Translations from the *Poetics* are by Halliwell, as found in *The Poetics of Aristotle: Translation and Commentary* (Chapel Hill, NC: University of North Carolina Press, 1987), though in certain instances I make emendations of my own using Kassel's Oxford text, found in D.W. Lucas, *Aristotle: Poetics* (Oxford: Clarendon, 1986). In making emendations I have consulted, especially, Lucas's commentary and the translation by Seth Benardete and Michael Davis in *Aristotle: On Poetics* (South Bend, IN: St. Augustine's, 2002).

7

the mind does what the mind so often enjoys doing: identifying or recognizing a sameness within a difference, a presence within an absence.

The interplay between presence and absence is very important for an understanding of mimetic art. Sokolowski observes that "things are identities in their presence and absence."[9] One and the same thing can manifest itself in different ways or according to different "intentionalities." Most basically, a thing can manifest itself as present (Christopher Walken actually present as a guest on the late-night show), and a thing can manifest itself as absent (another celebrity doing an impression of Walken). In the latter case, Walken is not on the show; he may not even be in New York; he may be shooting a film on the other side of the world. And yet, while physically absent in the entirety of his being, one particular aspect of his being—the formal quality of his voice—*is*, in a sense, present on the show when the other celebrity does his Walken impression. When the other celebrity does his Walken impression, Walken is present-in-his-absence. It is the *same* Walken, present-in-his-absence, who might, in other circumstances, have been wholly and completely present as a guest on the show.

I have said that, when it comes to picturing, the relationship between the picture and that which is pictured is the most important relationship. Yet a proper understanding of this relationship is a challenging one to get right. We need two more distinctions to help better clarify this relationship: first, that between a picture, or mimetic image, and an ordinary case of resemblance; and second, that between a mimetic image and an instrumental sign.

MIMETIC ART AS IMAGE AND SIGN

The actor doing the Walken impersonation makes us smile because he is able to make the sound of his voice so much *like* that of Christopher Walken. In light of this, we might be inclined to

9. Sokolowski, *Phenomenology of the Human Person*, 139.

define imitation as the making of a kind of picture that is like, or that resembles, that which it pictures. Before we do so, however, we first need to recognize that not every likeness is an image. My wife and I both drive red Honda CR-Vs. The two cars *resemble* one another quite closely, but neither is an *image* of the other. Nor are the eggs in the egg carton images of one another, though the eggs look very much alike. However, though not every likeness is an image, it is the nature of an image to show a likeness. Aquinas says that "similitude," likeness or resemblance, belongs to the very idea of image.[10] Then how is an image different from the likeness that we find between two red Honda CR-Vs or the dozen eggs in the egg carton? Because, as distinct from these more ordinary resemblances, the likeness of an image involves the idea of something being taken as *origin and exemplar*—that is, as *source* of the likeness. One egg is not the exemplar or source of another. Nor is my red Honda CR-V the exemplar or source of my wife's red Honda CR-V. The Honda manufacturer might take a certain set of plans as an exemplar for all the Hondas that are made; nonetheless, no single Honda is an exemplar or source of another. An image comes about when something is taken as the source of the likeness found in the image—as when my face is taken as the source of the image in the mirror, or the line of trees is taken as the source of the image of the trees in the glassy surface of a lake.

So an image involves both the idea of likeness or similitude as well as the idea of having an exemplar or source. Let's go a bit further, now, and consider what it means for a mimetic image, in particular, to be "like" what it images. Aquinas says, speaking generally about all images, that an image is like the form or essence of something, or at least the "sign of some form."[11] I am translating as "form" or "essence" Aquinas's Latin term *species*. A form, or that which is essential to a thing, is that which is necessary for the thing

10. *Summa theologiae* 1.35.1: *de ratione imaginis est similitudo.* For bringing this text to my attention, and for insight into the distinctions that follow in the rest of this section, I am indebted to Rover, *Poetics of Maritain*, chap. 6, sec. C, entitled "Imitation *in significando.*"

11. *Summa theologiae* 1.35.1.

to be what it is. The idea of form seems to take us "deeper" than the mere appearance of a thing, "down" to what is most enduring about it, to what persists through change. Yet it is interesting, given our discussion of the mimetic image, that *species* also has the sense of "semblance" or "appearance" and even of "splendor" and "beautiful appearance." An image, accordingly, can be "like" its source either in regard to the essence of its source or in regard to the source's appearance. A son is the image of his father because the son is like the father in sharing the father's essence, both in terms of the father's essence as a human being and in terms of the father's particular genetic endowment. A work of art, a painting for example, can also image a father, though not because the painting shares the essence of a father but because the painting images, in Aquinas's words, the "sign of some form"—that is, a father's appearance. The most evident sign of the form of a material thing is found, Aquinas adds, in the "figure" (*figura*) or shape of that thing. The painting of a father images the father in showing the father's figure, not only in terms of the outline of the father's body, but also in terms of the figure or shape of the father's particular features (nose, eyes, mouth, ears, eyebrows, wrinkles, hairline, etc.).

Mimetic art makes its source or exemplar present-in-its-absence through the manifestation of form. A voice impersonation of Alan Rickman images the sensible form of his voice and no doubt something of Rickman's character as well.[12] Even more evidently, *The Brothers Karamazov* images sensible forms but also suggests deeper truths about the best form of human life.

We need now further to clarify the relationship between a

12. A good voice impression is akin to a portrait of someone, and as such, it is, as Sokolowski says about all portraits, "an essay at beatitude":

> [A portrait] presents, poetically, someone's shot at happiness and self-identity. It presents what Aristotle would call a 'first substance,' an individual entity, an instance of the species man, but it does not present that substance as a mere compound; it presents that entity as an essence, with a necessity and a definition. This definition is individualized (it is a *first* substance), but it is also able to be universal, that is, it can flow back on life, and more specifically, it can become identifiable with the persons who view it, the other individuals who are also an issue for themselves, who are also engaged in beatitude. ("Visual Intelligence in Painting," 344)

picture, or mimetic image, and what is pictured or imaged, by distinguishing the mimetic image from an instrumental sign. A stop sign at the corner, a mileage sign on the highway, smoke as a sign of fire—these are all instrumental signs. They are mere vehicles, the first two conventional, the third natural, for leading the mind to some other reality beyond the sign. About instrumental signs and pictures, or what he calls "pictorial intentions," Sokolowski says:

> There are differences between signitive and pictorial intentions. In signification the "arrow" of intentionality goes through the word [or artifact] to an absent object. It is outward bound. It goes away from me and my situation here to something somewhere else. In picturing, however, the direction of the arrow is reversed. The object intended is brought toward me, into my own proximity; the presence of the object is embodied before me on a panel of wood or a piece of paper. Signitive intentions point away to the thing, pictorial intentions draw the thing near.[13]

Making the same point in another context, Sokolowski writes:

> The general's flag on his limousine indicates that the general is in the car; but the general is in no way in his flag. We move away from the flag when we think of the general. But in picturing we do not move away from the image; what is depicted is presented, as an individual, in the picture itself. The peculiarity of pictorial presencing and representation is that pictures do not merely refer to something, but make that something present. I see Janet in her picture, I do not, in the picture, see a sign of Janet.[14]

13. Sokolowski, *Introduction to Phenomenology*, 82.
14. Sokolowski, "Picturing," 21.

As signs, the mileage sign on the highway and the flag on the general's limousine are solely intended to lead us away from themselves to some other reality. By contrast, the portrait of Janet is not meant to lead us *away* from the painting to knowledge of Janet. The portrait of Janet, rather, invites us to contemplate Janet *re-presented in the painting.* The brush strokes of Janet's portrait do not point us away from the canvas in the way that the sign saying "Los Angeles 250 Miles" points us away toward the city of Los Angeles. No, the brush strokes constitute a new way of seeing Janet.

An instrumental sign, to put the distinction another way, is only meant to be a vehicle for factual information.[15] It is not meant to manifest the form of what it signifies. The mileage sign "Los Angeles 250 Miles" gives us a fact about the distance to Los Angeles, but it does not tell us anything about what is essential to the city of Los Angeles or what the city might mean for us. The portrait of Janet, however, illuminates her sensible forms, such as the particular auburn of her hair, as well as the deeper intelligibility of what it means to be Janet, at this age, having this experience, with this amount of the weight of the world on her shoulders.[16]

I take Sokolowski in the passages just quoted to be concerned with the distinction between pictures and instrumental signs. Yet Aquinas calls images "signs" of their sources. Are Aquinas and Sokolowski in contradiction? We need not think so if we take Aquinas to be using the term sign in this context, not in the sense of an instrumental sign, but in the sense of a *formal sign*, the kind of sign that makes a form present. This kind of formal "signing"

15. Granted, over the course of time, a given instrumental sign, like a flag, might be hung in a museum for its historical significance, and even for its beauty. But when it is "in service" as an instrumental sign, the flag's function is to announce a piece of factual information.

16. Mortimer Adler frames the distinction between instrumental signs and artistic images in this way: "The work of art is an object of knowledge and not a medium of knowledge; it is something to be known and not that whereby something is known, although in knowing it as an imitation, the spectator knows not only it but its relation of similitude to the already known object of imitation." Adler, *Art and Prudence: A Study in Practical Philosophy* (New York: Longmans, Green, 1937), 598n19.

is just what picturing is.[17] Mimetic art, we can thus say, is a fabricated formal sign or picture.

Let me sum up our discussion so far, then, with this definition of mimetic art:

Art is imitation, the making of a picture of some feature of the world; art thus images, or re-presents, for our delighted contemplation, one or more formal aspects of its source or origin.

Notice the centrality of *re*-presentation to this definition. Again, mimetic art, as a kind of picturing, makes some formal aspect of its source present-in-its-absence. And the more vividly an art can make something present, the more mimetic it will be. This is no doubt why Aristotle favors what Stephen Halliwell calls a "dramatic" or "enactive" sense of imitation, a preference Aristotle makes evident in the praise of Homer he makes in the following passage from the *Poetics*:

> Among Homer's many other laudable attributes is his grasp—unique among epic poets—of what a poet ought to make. For the poet himself should speak as little as possible in his own voice, since when he does so he is not engaging in mimesis. Now, other epic poets "compete" throughout the whole, and engage in mimesis only little and seldom. But Homer, after a short preamble, at once 'brings onto stage' a man, woman,

17. See Rover's discussion of mimetic art as sign in *Poetics of Maritain*, 105–9. Though I disagree with Rover that mimetic art is "clearly an *instrumental* sign," I acknowledge the qualification of the claim he immediately makes: "[Mimetic art also] has in its instrumentality something of the immediacy of the *formal* sign. It attains the signified not as something distinct from the sign but as conjoined to the sign and contained in it" (108, emphasis in original). This sense of mimetic art as formal sign seems to be what Adler is after in the passage quoted in note 16, as well as what Halliwell is after when talking about mimetic art as an "iconic" sign. See *Aesthetics of Mimesis*, chap. 5.

or some other figure (and his agents are always fully characterized).[18]

Other epic poets "compete" by interjecting their own narrative voices. But Homer, for the most part, simply brings his characters "onto stage" and allows them to act. Such dramatization is what mimesis is, Aristotle insists in this passage. Which is why a mimesis that is even more vividly dramatic than an epic poem, such as a tragedy or comedy enacted on a stage, is an even more perfect sample. Now, as Halliwell points out, this passage from the *Poetics* jars against an earlier passage, where Aristotle has no problem calling mimetic a straightforward narration of a story, one without any dramatic characterization or performance.[19] The best way to deal with this apparent discrepancy, it would seem, is to recognize a hierarchy of vividity in mimetic art, with purely dramatic or enactive mimesis occupying the highest spot, and arts that are less vividly dramatic, like painting, occupying the lower places. But the point of even thinking about a ranking of the various mimetic arts according to their dramatic ability is to emphasize, once again, the power of mimetic art to bring the formal aspects of what it pictures "into the presence" of its audience. This power affords us human beings tremendous pleasure, a pleasure that Aristotle, in the passage from the *Poetics* earlier touched upon, relates to contemplation, learning, and understanding.[20] But be-

18. *Poetics* 24 (1460a5–11). Halliwell discusses Aristotle's privileging of enactive mimesis both in *Aristotle's Poetics* (Chapel Hill, NC: University of North Carolina Press), chap. 4, and *Aesthetics of Mimesis*, chap. 5.

19. *Poetics* 3 (1448a19–24), where Aristotle, beyond calling purely enactive poetry mimetic, also calls mimetic *both* an epic poetry that alternates between narrative and dramatic impersonation (as an example of which he also cites Homer) *and* a poetry that relies wholly upon narration. About the text at *Poetics* 24, Lucas writes: "This is a restricted sense of *mimēsis* (at 1460a8) as in Plato, *Republic* 392dff. According to Aristotle's normal usage the epic poet is a *mimētēs spoudaiōn* [an imitator of the serious or weighty character] regardless of whether he uses direct speech" (*Aristotle: Poetics*, 226).

20. Aristotle's account of the vividity of metaphors is also pertinent here, not least in the way he links it to the same process of learning and understanding that he speaks of at *Poetics* 4 in connection with mimesis. For a discussion of this account, see Halliwell, *Aesthetics of Mimesis*, 189–91.

fore we can pursue those relationships further, we need first to consider the most common and pressing objection to the whole idea of art as imitation.

IS IMITATION COPYING?

Giorgio Vasari, that great chronicler of the lives of Renaissance painters, remarked of the *Mona Lisa*'s smile that what made it "divine" was that it was "an exact copy of nature."[21] Leonardo da Vinci, who painted that smile, himself remarked that "the mind of the painter should be like a mirror which always takes the color of the thing that it reflects and which is filled by as many images as there are things placed before it."[22] Vasari and da Vinci understood painting as a mimetic art whose task was to represent nature as faithfully as possible.

In talking about the natural pleasure human beings take in imitation, Aristotle himself says that people take pleasure in looking at pictures or images

> because what happens is that, as they contemplate them, they learn and reason out what each thing is, for example that "this image is of so-and-so." Since, if by chance one has not seen the subject-matter of the imitation before, the image will not produce pleasure *as imitation* but on account of the workmanship or the color or on account of some other cause such as these.[23]

Aristotle here clearly identifies imitation as a symmetrical relationship, an "isomorphism," between a formal feature of something in

21. Giorgio Vasari, *Lives of the Artists* 2.164, as quoted in Étienne Gilson, *Painting and Reality* (New York: Pantheon: 1957), 248. Gilson's book is based upon his Mellon Lectures in the Fine Arts delivered in 1955 at the National Gallery of Art in Washington, DC.

22. Leonardo da Vinci, *Notebooks* 2.254, as quoted in Gilson, *Painting and Reality*, 248. The comparison of mimetic art to mirroring is also deployed by Hamlet in his famous advice to the players, where he advises the players to "hold as 'twere the mirror up to Nature." See *Hamlet* 3.2.1–43.

23. *Poetics* 4 (1448b14–19), emphasis added.

the world and some picture made by an artist.[24] This means that when we look at the painted portrait of Harry and recognize that it is a picture of Harry, we experience the delight proper to imitation. If we have never seen Harry, Aristotle says, we may admire the artist's use of color, but that is another thing, *not* the properly mimetic delight.

Later painters resisted this understanding of painting as an essentially mimetic art. The French Romanticist Delacroix threw down the gauntlet with these words: "The impression caused by the fine arts has no relation whatever with the pleasure that is caused by any kind of imitation."[25] Delacroix also speaks of what he takes to be the not-uncommon experience of entering a room and being seized by a painting, even when one is still a considerable distance from it. What is the cause of such an emotional response? Surely not what the painting imitates or represents because we're too far away from the painting to *know* what it represents. For Delacroix, what seizes us from that distance is the "music" of the painting, a kind of "magical accord." Paul Gauguin liked this passage from Delacroix so much he transcribed it into one of his own notebooks. Gauguin—who abjured the painting of shadows because a shadow was the *trompe-l'oeil* of the sun.

Modern painting—that is, the tradition of painting that began to emerge in Europe in the early nineteenth century—gradually emancipated itself from what it saw as the strictures of imitation. The philosopher Étienne Gilson describes the revolution this way:

> Even in imitational art, the poetic element had consisted in discovering, selecting, stressing, and integrating with a structured whole the elements of reality that effectively please the eye. In doing so, painters had to take along with plastic elements

24. I borrow the application of the term "isomorphism" to mimetic art from Halliwell, *Aesthetics of Mimesis*, 163. Given that mimetic art pictures the forms, sensible and intelligible, of the objects it pictures, describing mimesis as isomorphism is particularly apt.

25. Eugène Delacroix, *Oevres littéraires* 1.66, as quoted in Gilson, *Painting and Reality*, 252n18a.

a large number of merely representational elements without any aesthetic significance. Obviously, the intensity of the effect produced by a painting should increase in proportion to the plastic purity of its structure. Why not, then, eliminate all that, being merely representational, has no plastic value, and constitute a new type of painting containing nothing else than pure plastic elements?[26]

What Gilson calls "plastic elements" are simply the compositional elements of a painting: its use of line, shape, volume, color, shading, and light—the very things that Aristotle takes to be secondary. But these "plastic elements" are what make up what Delacroix calls the "music" of painting, and these, and not the object being imitated, are what, for many modern painters, make up whatever "intensity of effect" a painting is able to conjure. In his still lifes, Cézanne self-consciously abandons traditional rules of perspective that would allow his paintings to closely mimic the three-dimensionality of nature. In his *Nature Morte au Crâne*, the piece of fruit seems to hover over, rather than sit on, the plate in the middle of the canvas, and the white tablecloth does not drape over the edge of the table but seems to float toward the observer. Henri Matisse similarly toys with traditional perspective, as well as with the naturalistic use of color, in his painting *The Music Lesson*, as does Marc Chagall in *Abraham and the Three Angels*. Mark Rothko goes even further. His purely abstract paintings present sheer gradations and juxtapositions of tone without any apparent concern for correspondence with some feature of the world.

To speak of art as imitation, then, beginning with examples from the art of voice impersonation, as I have done in this chapter, will strike many as an offense against art's proper grandeur. "*Art,*" it will be objected, "*cannot be imitation. At least not art in the highest and best sense. For imitation is mere copying. No doubt, it requires a great deal of skill to produce a faithful copy of something.*

26. Gilson, *Painting and Reality*, 252.

The great masters of mimicry and trompe d-l'oeil *have skill worthy of praise. But we shouldn't mistake what they do for art. The ability to paint a window that fools people into thinking it is a real window in no way rivals the ability of a Delacroix or Cézanne or Chagall. True art is concerned only with the compositional, the purely 'aesthetic' elements, of a work."*

Versions of this objection have raged through the history of modern art, and not only in regard to painting. A response to it calls for two distinctions that will help better define the nature of art as imitation.

The first distinction is one we discussed earlier: that between an instrumental sign, like a stop sign, and the kind of picturing we find in mimetic art. When a work of art is taken as a picture, we do not regard it as we do the stop sign, as a mere vehicle for information, something our minds "pass through" in order to gain knowledge of something else, but rather as a re-presentation of what is being pictured. This distinction is important because it keeps us from thinking of the artistic image as a mere means for knowing what the image signifies. If the artistic image were no more than a means for knowing the signified, if it were no more than a mirror of the real, then we wouldn't be inclined to attend to its beauty as an image. When it comes to painting, for example, we wouldn't be inclined to attend to what Gilson calls the "plastic" or compositional elements of the painting—any more than we would be inclined to attend to the compositional elements of a stop sign. But I can and should attend to the way in which Cézanne uses color and design in his still lifes, quite apart from what his still lifes tell me about the human habitat. It is interesting to note in this context that Aristotle mentions harmony and rhythm, two of the foremost compositional elements of poetry, as things for which we have a natural inclination. But because we have a natural inclination for them, it only makes sense that we would want to appreciate them in a work of poetry for their own

sake, as distinct from the subject matter of the poem.[27] Art as imitation, in sum, appreciates the artistic image on its own terms, as distinct from appreciation of what the image signifies.[28]

But Vasari praises the *Mona Lisa* as an "exact copy of nature." And da Vinci uses the metaphor of mirroring in order to describe artistic imitation. So the question might still be pressed: Doesn't a mimetic approach to art encourage re-presentation that is as exact as possible—in short, "copying"—so that what is pictured can best be identified and known?

It does not. It is perhaps unfortunate that Vasari chose to describe the Mona Lisa as an "exact copy of nature," but imitation has nothing essentially to do with copying or naturalistic depiction. But, it will be objected, Aristotle says that if we are not able to discern in an artistic image that "this image is of so-and-so"—that is, if we are not able to identify in the picture what is being pictured—then we will not experience the properly mimetic delight. That is true. But here I come to the second key distinction in my response to the challenge of those who take mimesis for copying: the ability both to identify and to understand the exemplar or source of an imitation does not require anything like an exact likeness.

Recall our distinction between an image and a likeness or resemblance. A picture might resemble what is pictured, sometimes with great accuracy, yet a picture is always something more than mere resemblance. "Being a picture," Sokolowski argues, "is not just being like something else, it is being the presentation of what is depicted. If I see a picture of Harry Truman, I see Truman depicted, in his individuality; I do not just see something that looks like him."[29] Admittedly, some artists seek to make images that

27. See *Poetics* 4 (1448b20–24). I owe to Rover the connection of this passage to Aristotle's appreciation of the compositional elements of a work of art for their own sake (*Poetics of Maritain*, 152–54).

28. The way in which Aristotle departs from Plato's own use of mirror imagery to describe mimesis is discussed by Halliwell in *Aesthetics of Mimesis*, chap. 5, pt. 3.

29. Sokolowski, *Introduction to Phenomenology*, 84.

bear a remarkably close resemblance to what is being imitated. Exact likeness is a big part of the effect they are trying to produce. But exact likeness is not necessary to the special mode of re-presentation that is imitation. Sometimes, in fact, a picture that closely resembles its object leaves us cold, as it lacks the vivid "re-presencing" we expect from art. A less naturalistic picture, such as a cartoon caricature, can often make its object come alive in an unexpectedly exciting way.[30] When we realize that imitation is not foremost about resemblance but about re-presentation of form, we can welcome artistic experiments that sacrifice close resemblance for the sake of alerting us to the formal qualities of something that we might otherwise have been insensitive to. We don't dismiss Cézanne's still life because his fruit hovers over rather than sits on the plate. Rather, we ask him what he is trying to say about the arrangement of the items in the still life that he does not think can be said by the conventional rules of perspective.[31]

Aristotle's general description of mimetic art, found in the passage from the *Poetics* quoted above, emphasizes the connection between imitation and learning. His example of how learning occurs through imitation—by our recognizing that "this image is of so-and-so"—is admittedly a simple one, though surely not intended to cover the full complexity of our experience of mimetic art. Most art does not involve such a simple act of identification. When I watch a performance of *Hamlet*, it is not that I am trying to identify a real medieval Danish prince or even

30. "There are pictures that barely resemble what they picture: some sketches or statues, for example, may be so contrived that we would never say that this object resembles the thing it represents unless we knew that the object is to be taken as a picture. Its being taken as a picture allows us to find a similarity that we would not otherwise have seen" (Sokolowski, "Picturing," 5).

31. In chapter 8 of *Painting and Reality*, "Imitation and Creation," Gilson considers imitation only in the sense of close resemblance. He unfortunately fails to illuminate any of the nuances of the Aristotelian understanding. Maritain, also, undermines the power of mimetic picturing when he declares: "Art, as such, consists not in imitating but in making, in composing or constructing . . . and to allot to it for essential end the representation of the real is to destroy it" (*Art and Scholasticism*, 56). An excellent discussion of the nuances of the Aristotelian understanding of mimesis is in Halliwell, *Aristotle's Poetics* (Chapel Hill, NC: University of North Carolina Press, 1986), chap. 4, and *Aesthetics of Mimesis*, chap. 5.

the mythological figure from Saxo Grammaticus's Scandinavian legend or Belleforest's French version of the same tale. The identification Shakespeare invites me to make is rather that between his character Hamlet and the human condition, a condition in which circumstance often presses upon our weakness in ways that lead to disastrous consequences. The play *Hamlet* "re-presences" the human condition not by copying nature but by putting on display a picture that aspires to manifest something of the form or intelligibility of that condition.

The deeper point in Aristotle's "this image is of so-and-so" remark is that art affords the pleasure of learning about and contemplating a world that we need to see afresh by a new form of presentation. A closer look at Aristotle's discussions of mimesis, moreover, clearly shows that he understands imitation in a flexible way. He names the art of the flute and that of the cithara, as well as the art of dance, as mimetic arts. What are the objects of their imitations? Aristotle says "characters, passions, and actions."[32] But do the flute, the cithara, and the dance imitate "characters, passions, and actions" with anything like close similarity? Does the sound that comes out of the flute resemble the emotion I feel? Not evidently.[33] And this is not even to mention Aristotle's central concern with tragic drama as an imitation. The tragic actors somewhat resemble human beings doing things and talking to one another. But tragedy also depicts human action in neat, two-hour packages that only suggest the flow of real human life. Resemblance is always approximation. A certain level of "abstraction" from close resemblance does not undermine the work of imitation. Indeed, the poet and painter David Jones argues in his essay "Art and Sacrament" that *all* art is abstract and that

32. *Poetics* 1 (1447a23–28).

33. At *Politics* 8.5 (1340a-b19), Aristotle also speaks of music as imitative of qualities of moral character. About this text Halliwell observes: "But it is important to notice that Aristotle does not restrict [mimetic] likeness to a sensory or perceptual match. If he did, he could not regard musical sounds and rhythms as standing in mimetic relationship to qualities of ethical 'character' (which are themselves patently not audible phenomena)" (*Aesthetics of Mimesis*, 156).

all art re-presents. For all art re-presents a given reality in matter *other* than that in which it is naturally at home, and this is a kind of abstraction.[34]

Still, some experience of likeness, and thus of recognition, is bound up with the notion of art as imitation. This is the case even when the object imitated doesn't exist in real life, like Hamlet or Tolkien's elves, orcs, and dwarves.[35] Observes Sokolowski: "I have a painting of a copper kettle, and it remains a picture of a copper kettle even though there may never have been a real kettle of which this is the copy. I can still refer to 'the' kettle depicted in my painting, and when I do so I need not refer to a kettle in some storage cabinet; I mean the one in the painting."[36] This is true, but if the painting were not in some sense representing a reality with which I am familiar—the world of copper kettles or kitchen utensils in general—then I would not be able to enjoy a properly mimetic response. I would not be able to refer to "the" copper kettle in any sense. To change the example, Tolkien's elves, orcs, and dwarves help me contemplate not elves, orcs, and dwarves in the real world but *human* realities with which I already had some familiarity before I read Tolkien.[37]

I conclude my response to the objection that imitation

34. David Jones, "Art and Sacrament," in *Epoch and Artist: Selected Writings by David Jones* (London: Faber & Faber, 2008), 143–85, see esp. 173.

35. "The cognitive pleasure afforded by the contemplation of mimetic works is accordingly a pleasure in the recognition and understanding of likenesses. But a likeness need not be of an individual or specifiable model. Most mimetic works are not. . . . Yet all mimetic works are likenesses, and they are so by virtue of having been made to represent imaginable realities in the perceptual and semantic properties of their particular media. . . . It is accordingly possible to discern in them features of the kind possessed by, or predicable of, things in the world" (Halliwell, *Aesthetics of Mimesis*, 188).

36. Sokolowski, "Picturing," 21.

37. In the context of his interpretation of Aristotle's *Poetics*, Halliwell also concludes that mimetic art depends upon a background sense of familiarity with the world that makes possible a certain sense of "recognition": "Mimetic art may extend and reshape understanding, but it starts from and depends on already given possibilities and forms of meaning in its audiences' familiarity with the human world" (*Aesthetics of Mimesis*, 174). Halliwell's remark assumes an answer to the question of whether mimetic art really leads to new knowledge, whether it is a real *inquiry*. Halliwell believes that Aristotle's understanding of art, at least, extends and reshapes understanding. The present chapter provides some hints of my view that mimetic art in general is a real inquiry leading to new knowledge, but I will take up the question more fully later, in chapter 5.

is copying by reiterating two important characteristics of the Aristotelian-Thomistic tradition of art as imitation: first, that it appreciates, along with devotees of modern abstract modes of art, the compositional elements of a work of art for their own sake; and second, that it recognizes that the mimetic image, in re-presenting the formal qualities of its source, need not be limited to exact likeness. But how far can abstraction go before it ceases to be mimetic? Many modern works of abstract art, visual and otherwise, might be said to be mimetic in the minimal sense that they endeavor to capture some feature of the world, if only the psychological state of the artist. Yet there is a point where even this minimal sense of imitation yields to a mindset that is decidedly anti-mimetic, a mindset we see, for example, in the movement in modern painting to treat the painted canvas as a mere object, one that might provoke a response in the viewer, but which is not intended to be a picture of anything. But for its part, the Aristotelian-Thomistic tradition of art is committed to more than a minimal mimeticism. It aspires not only to picture but to picture forms that manifest the truth of human existence. Let us now begin to see how this is so.

ART AS CONTEMPLATIVE "WAY" STATION

The delightful congruence between a picture and what is pictured makes space for learning and contemplation. A vocal impersonation of Christopher Walken gives us, the audience, the opportunity to marvel at what is distinctive, say, about Walken's voice. What the impersonator of Walken does is, in a sense, "frame" Walken's voice for us; or, to switch the metaphor, the impersonator puts Walken's voice on a "slide" that we can then examine under the "microscope" of our contemplation. The impersonator allows us to focus on the idiosyncratic syncopation of Walken's voice in a way that is harder to do when we engage with Walken's voice directly, without the benefit of

imitation. Mimesis can often afford us a *better* insight into the formal quality of something than does the direct experience of the thing.[38] Before we hear them imitated, we will typically experience the oddities of Walken's speech patterns as an undifferentiated, albeit compelling, whole. What the imitation of Walken's voice enables us to do is make distinctions regarding that undifferentiated whole: to understand, for instance, that the ungrammatical pauses Walken inserts into his speech, along with the unexpected emphases he places on certain words, are key elements of his distinctive way of speaking—and even hint at the quality of his character and his pursuit of ultimate fulfillment. No one is claiming that this is contemplation of the highest order, but it is contemplation, nonetheless. It is a delightful turning over in the mind of one fascinating display of human reality. Thus, mimetic picturing brings to light what Sokolowski calls "a deeper intelligibility," the intelligibility of what a thing essentially is.[39]

But here is where things get somewhat complicated. We human beings make and enjoy works of mimetic art because we love to think about and delight in the world—*this* world of sensible particulars right outside our window. Paradoxically, it is because we want to understand and take pleasure in our actual physical world that we make up tales about imaginary worlds.

Yet the sensible world only becomes intelligible when the intellect gets involved. The sensible world is sensible, memorable, and able to be imagined by our external and internal senses. But a sensible thing only becomes intelligible, an object of contemplation, when our intellect grasps its formal reality, what it means to be the kind of thing it is.

Again, when our mind grasps the formal reality of some-

38. "Some of the essentials of a tree might show up more vividly in a picture or a painting than in the tree itself as it is perceived" (Sokolowski, *Phenomenology of the Human Person*, 138).

39. Sokolowski, *Phenomenology of the Human Person*, 137. In chapter 9 of this work, Sokolowski returns to the question of how we know things in their absence through pictures, imagination, and words.

thing, we grasp what *must* belong to a thing for a thing to be what it is. If it is a certain tone of red in a painting or a certain vocal quality like Rickman's nasal baritone, we reflect on what it means to be that tone of red or to have that vocal quality. If it is *King Lear*, we reflect, for example, on what it means for the play to be a tragedy. To grasp what must belong to a thing is to grasp what is *essential* to all instances of that thing. It is to grasp a kind of *universal*.

The grasp of the essential is the product of an act of abstraction on the part of the intellect.[40] Aquinas calls this abstracting power of the intellect the *agent intellect*. It is from the *phantasm*, the complex sensory image of a thing, that the intellect "abstracts" or distinguishes what is essential from what is merely accidental to that thing.[41] From the phantasm I have of my house, along with the phantasms I have of many other houses, I can distinguish what is essential to all houses, what must be present for a house to be what it is. But doesn't this abstractive activity of the intellect take me far away from the sensible particular (Christopher Walken's voice) that I want to contemplate? I don't want to contemplate a universal; I want to contemplate a sensible particular. But the contemplation of the sensible particular, like a work of mimetic art, is possible because the intellect is able to take the essential knowledge of a thing and *apply it back* to the sensible particular.[42] In my life, for example, I have heard syncopated rhythm many times (including by watching Christopher Walken's performances), and from this sense experience, I have formed a phantasm, a complex sense image of syncopated rhythm, and from that phantasm, my intellect has distinguished what is essential to syncopated rhythm. Due to this experience, I can apply my understanding of the essential nature of syncopation back to Walken's voice.

40. See *Summa theologiae* 1.79.3.
41. *Summa theologiae* 1.84.7 and 1.85.1.
42. *Summa theologiae* 1.84.7.

In this roundabout way, I make Walken's voice intelligible and available for contemplation. And what is most fascinating for our purposes, and the reason why we have gone into these details regarding the Aristotelian-Thomistic theory of knowledge, is that mimetic art facilitates this roundabout way of knowing the sensible world.

Now, some mimetic art imitates real particulars and is only interested in leading an audience to a delightful contemplation of the sensible forms of those particulars.[43]

But most mimetic art—including, I would say, a good voice impression—is more ambitious than this. Such art invites us to contemplate something more than the sensible features of an individual substance. It invites us to contemplate formal realities embodied, say, by a real or imaginary person, but which also transcend him. Alexander Gardner's 1865 photographic portrait of Abraham Lincoln affords us a unique focus on Lincoln as he was in 1865, at about the age of fifty-six. In contemplating the photograph, we can enjoy viewing the sensible features of Lincoln. We can delight in seeing what he *really* looked like. But we can also contemplate formal realities that he embodies but which also transcend him, realities such as "nobility" or "courage" or even just "immense fatigue." The portrait might even be read as an icon of political leadership, one that invites us to reflect upon the virtues it demands and the tremendous physical, emotional, and spiritual toll it takes.

At these various levels of formal reality, mimetic art enables us to understand and contemplate the world of sense particulars. Art imitates those particulars in a way that lifts us above the merely particular and makes possible the grasp of a kind of universal, an essential knowledge that can be applied back to

43. The text we considered from *Poetics* 4 (1448b15–17) indicates that Aristotle recognizes the mimesis of particulars. See also *Poetics* 9 (1451b14–15), which mentions the poetry that lampoons individuals. I am grateful to Halliwell, *Aristotle's Poetics*, 133n38 and 55n15, for drawing my attention to these passages.

the work itself and what it pictures.[44] The reason why we love mimetic art so much is that it suits us so perfectly as embodied spirits: it combines both the sensible delight we take in sense particulars and the rational delight we take in grasping the intelligibility of things.[45]

In light of this, consider what Flannery O'Connor says about the art of fiction. "Fiction operates through the senses," she observes in one of her essays,

> and I think one reason that people find it so difficult to write stories is that they forget how much time and patience is required to convince through the senses. No reader who doesn't actually experience, who isn't made to feel, the story is going to believe anything the fiction writer merely tells him. The first and most obvious characteristic of fiction is that it deals with reality through what can be seen, heard, smelt, tasted, and touched.[46]

44. But it is worth noting again that we also bring previously acquired universal knowledge to our appreciation of a work of art. As Halliwell argues:

> According to Aristotle, we make sense of poetic fictions by interpreting them in the light of the general or universal concepts derived from our cumulative experience and understanding of human life. Because this experience rests ultimately on actual particulars in the world, Aristotle would not deny that we frequently employ universals (or, at least probability) in our cognitive response to real events. But what he does deny, in *Poetics* 8 and 9, is that raw life can often produce whole structures of action capable of satisfying probability in an entirely unified fashion. So in contemplating poetry (or other works of mimetic art) we draw on our real experience of the world, but we do so in order to understand events which possess a special degree of coherence and, therefore, significance."(*Poetics of Aristotle*, 107)

45. "The mind takes a distinctive pleasure in this constructed probable because such a way of knowing uniquely combines the perfection of sensible knowledge and of intellective knowledge. The object of this unique knowledge and knowledge-making is neither the singular as singular; rather, it is, as we have seen, the typical or the poetic probable, i.e. the singular as it is brought to a state of imperfect knowability by the selective or inventive activity of the artist. Sense is pleased by the proportion to the singular, intellect by the quasi-abstraction, both by the image-idea, the universal-singular, the common concrete. In this way does the imitative artifact satisfy the mind's desire to know things as they are, the nature in the individual, the essence in the existent" (Rover, *Poetics of Maritain*, 199).

46. Flannery O'Connor, "Writing Short Stories," in *Mystery and Manners: Occasional Prose*, ed. Sally and Robert Fitzgerald (New York: Farrar, Straus and Giroux, 1997), 91.

This comment firmly grounds the art of fiction in the five senses. The writer's first task, as Joseph Conrad famously put it, is to make the audience "see" the world in a more perceptive way. All great writers possess what Nabokov credited to Tolstoy: a "fundamental accuracy of perception." In the essay of O'Connor's just quoted, she discusses how she came to write her short story "Good Country People," a story in which, in O'Connor's own paraphrase, "a lady Ph.D. has her wooden leg stolen by a Bible salesman whom she has tried to seduce."[47] "When I started writing that story," O'Connor recalls, "I didn't know there was going to be a Ph.D. with a wooden leg in it. I merely found myself one morning writing a description of two women that I knew something about, and before I realized it, I had equipped one of them with a daughter with a wooden leg."[48] This peek behind the curtain of O'Connor's writing process is illuminating. The two women O'Connor began writing about that morning eventually turned out to be Mrs. Hopewell, the lady PhD's mother, and her friend Mrs. Freeman, the wife of a farmer Mrs. Hopewell employs to work her land. In the first two-and-a-half pages of the finished story, O'Connor gives us vivid portraits of these two women: the nosy, conceited, resentful Mrs. Freeman and the sly, long-suffering, sentimental Mrs. Hopewell.[49] O'Connor does not present us with broad "types." She gives us individuals clearly rooted in a particular time and place, with a particular and most distinctive way of speaking, with settled patterns of thinking and acting. In these paragraphs, we learn their morning routines, that Mrs. Hopewell keeps the gas off at night, and that Mrs. Freeman enjoys delivering a daily report on how many times her

47. O'Connor, 98.

48. O'Connor, 100.

49. As printed in Flannery O'Connor, *The Complete Stories* (New York: Farrar, Straus and Giroux, 1997), 271–73.

fifteen-year-old, married, pregnant daughter has vomited in the past twenty-four hours.

And yet—Mrs. Hopewell and Mrs. Freeman are also, in a sense, types. Not to the point that they are purely allegorical. But to the point that we recognize them, or certain aspects of them, as among the kinds of things we've noticed before in the people we have met. We have met the passive, vapid, and eminently malleable; and we have met, if only in the mirror, the conceited person with too many strong opinions. What O'Connor has done in imagining these two women is this: she has embedded "universal" or "general" characteristics of human beings into imagined sensible particularities. Mrs. Hopewell and Mrs. Freeman are each a "universalized singular" or "singular universal."[50] Each is a hybrid of a universal characteristic, such as "slyness" or "conceitedness," and a collection of imitated or pictured singulars. We can learn a lot about reality by looking at so much of it summed up in one place: the singular, imaginative, mimetic universal.[51]

Interestingly, both philosophy and mimetic art have contemplation as their aim, but they achieve contemplation in different ways. Philosophy proceeds in a purely abstractive way. By "abstractive way," I mean that philosophy involves thinking about things essentially, in abstraction from things in their sensible concreteness. The philosopher thinks about "human nature" and "justice" and "mimetic art," not this or that instance of human nature or justice or mimetic art. The philosopher is forever in quest of a *definition* of whatever he or she is thinking about. At the beginning of Plato's dialogue *Euthyphro*, his protagonist

50. I borrow these terms from Rover, *Poetics of Maritain*, 51. This part of my argument leans heavily on Rover's excellent discussion of the definition of mimetic art in chapter 3 of his work.

51. In a discussion of poetry, Rover also calls the mimetic universal a "quasi-universal": "The universals of poetry, then, are not equivalent to the universals of science. Rather, they are the quasi-universals that we call 'possibles' or 'probables.' The poet is concerned with events that 'conform to the laws of the probable and the possible.' These probables, moreover, are not the real probables of science nor the constructed probables of scientific hypothesis; they are *the contrived or constructed probables of poetry* which depend as much on invention and creative intelligence as on conformity to objective truth" (*Poetics of Maritain*, 52; emphasis in original).

Socrates asks the self-proclaimed expert in religious matters, Euthyphro, what the definition of piety is. Euthyphro's first response is to point to the specific action he is involved in when he encounters Socrates. Surprisingly, he is on his way to court to prosecute his own father for the murder of a household slave. But Socrates tells Euthyphro that he didn't ask him to provide an instance or an example of a pious action; Socrates wants to know what piety is "in itself," in abstraction from all particular acts of piety. What Socrates tries to get Euthyphro to see is that the philosophical quest for definition is always a quest for what is essential to a thing.

But open the pages of Dostoevsky's *Crime and Punishment*, and immediately one discovers something very different from a philosophical dialogue, even one, like the *Euthyphro*, with characters involved in an intellectual drama. The reader of *Crime and Punishment* is plunged deeply into a world of imagined concrete singularity: it is the world of the impoverished ex–law student Raskolnikov, who is considering getting his hands on some money by murdering an elderly pawnbroker. As he walks the streets mulling over the possibility of committing this terrible crime, the reader follows Raskolnikov from a third-person point of view, but one that hugs closely to the contours of his perspective. Throughout the novel, Dostoevsky never adopts the pure stance of the philosopher; his task is not to seek a definition of justice. Granted, as the reader experiences Raskolnikov's thoughts and his conversations with others, the reader witnesses much philosophizing. Dostoevsky was, in a very real sense, the most philosophical of novelists. But whatever explicitly philosophical thoughts occur in *Crime and Punishment*, they are situated in the minds and conversations *of his characters or of his narrator*. They are not presented as definitions and propositions and arguments offered by Fyodor Dostoevsky himself. The enjoyment of mimetic art, with its full immersion in sensible

particularity, would seem to be the very opposite of the philosopher's quest for definition.

But this is not the whole story concerning mimetic art, for we can also say about all the examples just noted that they inspire big ideas in their audiences. The glory of *Crime and Punishment* is that it helps us think deeply about whether justice is a mere convention of human beings or whether it is woven into the natural fabric of the human good.

So again, there is a strangely hybrid character to the work of mimetic art. It invites us into the experience of sensible particularity even while it invites us to contemplate ideas and meanings. It can do this because its object is not the sensible particular *as such* but, as we recognized in discussing the O'Connor story, the "singular universal" or what has alternatively been called the "poetic universal" or "probable universal."[52] Because the mimetic arts embody a universal, or at least something very general, I will refer to this universal as the *mimetic universal*. This notion of the mimetic universal is drawn from this famous passage in Aristotle's *Poetics*:

> It is clear from what has been said that to speak of that which has come to be is not the function of the poet, but rather such as *could* come to be, i.e., the possible according to the likely or necessary. For the historian and the poet do not differ by speaking in meter or without meter (since it would be possible to place the writings of [the historian] Herodotus into meter and they would not be inferior history with meter than without meter). But history and poetry differ in this: the one speaks of that which has come to be, while the other speaks of the sort of thing that could come to be. On which account poetry is more

52. The two latter terms are also borrowed from Rover, *Poetics of Maritain*, 51–52. Rover again nicely describes the hybrid character of much mimetic art: "The knowledge aimed at in the imitative arts, the knowledge embodied in the imitative artifact itself, is a knowledge which shares in universality and individuality alike. It partakes in some way of the universality of abstractive knowledge without losing its share in the perfection of sense knowledge. *This* man is known insofar as he is *this kind* of man" (*Poetics of Maritain*, 51).

philosophical and weightier than history: for poetry speaks of
the universal while history speaks of the particular.[53]

At this point in his argument Aristotle is not talking about mi-
metic art as a whole but about *poiēsis*, a word that can be con-
strued sensibly enough as "poetry" as long as we don't limit the
meaning of the word to what we tend to think of in our day
when we hear the word "poetry"—namely, lyric poetry. By *poiēsis*
Aristotle doesn't exclude lyric poetry, but he is thinking above
all of what were in the ancient Greek world the major genres of
the poetic art: epic and tragedy. But what Aristotle says about
poetry in this passage is a truth, I contend, that can be extended
to the other mimetic arts. What is that truth? That poetry is more
philosophical and intellectually weightier than history because it
speaks of the universal or the essential understood as the mimetic
universal. History deals with "that which has come to be"—that
is, with *facts*—while poetry deals with "the sort of thing that
could come to be." *Given* such a character placed in such a situ-
ation, the storyteller promises to us, this is the *kind of thing* the
character would say or do. A kind of universal, a kind of truth, is
thus offered to our contemplation.[54]

* * *

In discussing mimetic picturing in this chapter, we have been
considering how mimetic art makes the world intelligible for
contemplation. But we might still ask: What is it exactly that
mimetic art pictures and makes intelligible? I have answered this
question, so far, only very generally. I have talked about art as

53. *Poetics* 9 (1451a36–b7).
54. As Rover puts the thought: "The Philosopher [Aristotle] goes on to explain what the
poetic universal is—not that nature or essence which is the result of a perfect abstraction from
the material singular but, rather, the probable or typical or inevitable in singular character and
in singular events" (*Poetics of Maritain*, 51–52). Rover then refers to Aristotle's explanation at
Poetics 9 (1451b8–10).

picturing "the human condition" and the "mimetic universal as manifest in the sensible particular." I want to suggest, now, that all these descriptions of the object of mimetic art presuppose a notion of human beings caught up in the story of their lives. Hamlet advises the players "to hold as 'twere the mirror up to Nature"—why? "To show Virtue her feature, Scorn her own image, and the very age and body of the time his form and pressure."[55] Hamlet advises the players, that is, to imitate the story of the human quest for happiness, a quest that, according to the Aristotelian-Thomistic tradition that Hamlet is drawing upon, succeeds when one lives out the virtues and fails when one succumbs to vice. The mimetic universal that characterizes the greatest art, such as we see in the conceitedness of O'Connor's Mrs. Freeman, aspires to reveal something true about how well such a character is living out the quest for happiness. But do *all* the mimetic arts picture the human story? How can that be? How can music tell a story? How can a statue, an inert piece of stone, tell a story? How can the movement and gesture of dance, where no words are spoken, where no background narrative is present, tell a story? These are all important questions. Yet, in the face of them, I submit that the mimetic arts are all, in analogous ways, storytelling arts.[56] The defense of this claim will require the rest of my argument to develop. But the first and most necessary step in that task is to show how the arts that are most explicitly narrative—fiction, epic poetry, drama on both stage and screen—picture the essentially narrative structure of human life itself. And to this task I now turn.

55. *Hamlet* 3.2.22–24. I use the text of the play edited by Ann Thompson and Neil Taylor (London: Arden Shakespeare, 2006).

56. By way of preview, it is worth noting that Aristotle at *Poetics* 2 (1448a1) doesn't say that only "poets" imitate human beings in action. He speaks generally of "imitators" [*hoi mimoumenoi*], and given that when he makes this remark he has just finished, in *Poetics* 1, a brief survey of the various media of the mimetic arts, and names specifically among these arts painting, music, and dance, it is reasonable to conclude that he thinks *all* mimetic art imitates human beings in action—and thus, as I will discuss in chapter 2, the human story.

2

Mimetic Art Is the Way of Story

"Who's there?"

With this simple yet gripping opening line begins the most famous drama in the English language: Shakespeare's *Hamlet*, first performed at the Globe Theatre in London by Shakespeare's company, the Lord Chamberlain's Men, sometime in the winter of 1600–1601. I am not interested here in addressing any of the weightier themes of this complex and endlessly discussed drama. I only want to draw attention to what we, in search of the depth of meaning in *Hamlet*, might be apt to ignore in this opening line. The line is spoken by a sentinel, Barnardo, who has come to relieve another sentinel, Francisco, of his watch. Strangely, it is Barnardo, just reporting for duty, who asks, "Who's there?" It is as though he has heard Francisco moving about in the dark but has not yet seen him. His nerves are obviously a little on edge. Francisco, for his part, being the sentry on duty, doesn't much care to be asked to identify himself. He replies by calling back to the approaching figure, "Nay, answer me. Stand and unfold yourself." Barnardo then gives the password, "Long live the King," and the two men relax, now having identified one another.

This exchange between Barnardo and Francisco is, of course, preliminary to the central plot of *Hamlet*, and even the excerpt I have given of it does not provide the part that touches upon the central plot (Barnardo and Francisco are both rattled because, on

previous watches, they have seen the ghost of old King Hamlet). What I would like to draw attention to is the patent but wondrous fact that Barnardo's opening line indicates a man in motion, and this in two senses. First, Barnardo is physically on the move. He is coming presumably from inside the castle of Elsinore to wherever the watch is posted. Shakespeare does not explicitly indicate where Francisco is waiting for him. Maybe it is a parapet of the castle or outside the main gate. In any event, Barnardo is just arriving on the spot. But his physical motion is consequent upon a more significant motion: his *decision* to fulfill his duty to relieve Francisco of the watch at the appointed time. Without that decision, Barnardo would not have left his comfortable bed in the castle. Something similar can be said about Francisco. He is physically moving along the parapet—or wherever he is stationed—because he has *committed himself* to fulfilling his duty to keep the watch.[1]

Why belabor these glaringly obvious points?

To highlight the fact that a stage drama is, as Aristotle tells us, a mimesis, a picturing of human beings in action. That it pictures human beings in action is true not only of stage drama but also of any kind of story—though when I use the words "story" or "storytelling" in this chapter, I will be speaking about fictional storytelling, the kind that we find in novels and short stories, stage plays and movies, and the like.

I could have made the point that stories imitate human beings in action by focusing on Hamlet himself rather than on Barnardo and Francisco. After all, the first time we see Hamlet, he is attending his uncle, Claudius, the new king, and his mother,

1. In his essay "Poetry and Drama," T.S. Eliot, speaking as a playwright, remarks that this first scene of *Hamlet* is "as well-constructed as that of any play ever written." He describes the opening twenty-two lines as "built of the simplest words in the most homely idiom. Shakespeare had worked for a long time in the theater, and written a good many plays, before reaching the point where he could write these twenty-two lines. . . . No poet has begun to master dramatic verse until he can write lines which, like these in *Hamlet*, are *transparent*." Quoted in Frank Kermode, *Shakespeare's Language* (New York: Penguin, 2000), 97.

35

Gertrude, Claudius's new queen.[2] Hamlet is there because he has made a decision to be present when the king and queen hold court. But focusing on Hamlet and the other central figures might distract us from something so obvious it is liable to be missed: that *whenever* a dramatist presents a character, major or minor, the dramatist imitates human beings on the move. Aristotle says in his Greek that imitators imitate *prattontas*, a plural participle that literally means "the ones acting."[3] Less literally, the word can be rendered as "human beings in action."

Let us return to an example I used in the introduction. It is Saturday night, and you are hunkered down with family or friends to watch a movie. Now imagine yourself floating slightly above the scene, watching yourself and others watching the movie. What an odd way to spend the evening! Sitting in the dark, facing a large flat screen, watching flickering images of—what? Well, human beings doing things. What kinds of things? All kinds of things. Falling in love, flying into space, trying to catch a murderer, trying to save the world. What you are watching on the screen are human beings "in action," and to be "in action" is to be in pursuit of some good (if only the good of avoiding an evil). Every human action, Aristotle tells us at the very beginning of his *Nicomachean Ethics*, aims at some good, something perceived to be perfective of the person. To win the heart of the beloved is a good; to boldly go where no man has gone before is a good; to catch a murderer is a good; to save the world is a good. In everything we do—from flossing our teeth to reading philosophy—we human beings are on the hunt for something that we at least perceive to be good, as perfective of our natures. Therefore, the first, rough-and-ready definition of the good, Aristotle

2. *Hamlet* 1.2.

3. Aristotle, *Poetics* 2 (1448a1). Plato says the same thing in *Republic* 10 (603c): "We say that imitative poetry imitates human beings acting voluntarily or under compulsion, who believe that, as a result of these actions, they are doing either well or badly and who experience pleasure or pain in all this." This translation is found in Plato, *Republic*, trans. G.M.A. Grube, rev. C.D.C. Reeve (Indianapolis, IN: Hackett, 1992). This passage in the *Republic* is pointed out by D.W. Lucas in his commentary on *Poetics* 2 (14481a1).

submits, is *that at which all of our actions aim*. From which we can posit a first, rough-and-ready definition of story:

A story pictures the human pursuit of some good.

THE LONG WAIT FOR THE BUS

Let us now consider a very simple story to see how it pictures the human pursuit of some good. Playwright-screenwriter-director David Mamet offers the following homey example:

> "I waited *half an hour* for a bus today" is a dramatic statement. It means: "I waited that amount of time sufficient for me to be sure you will understand it was 'too long.'"
>
> (And this is a fine distinction, for the utterer cannot pick a time too short to be certain that understanding is communicated, or too long for the hearer to accept it as appropriate—at which point it becomes not *drama* but *farce*. So the *ur*-dramatist picks unconsciously, and perfectly, as it is our nature to do, the amount of time it takes for the hearer to *suspend his or her disbelief*—to *accept* that the half-hour wait is not outside the realm of probability, yet *is* within the parameters of the unusual. The hearer then accepts the assertion for the enjoyment it affords, and a small but perfectly recognizable play has been staged and appreciated.)[4]

"I waited *half an hour* for a bus today." An entire story is contained in those nine words. We can imagine a wife saying this to her husband as she enters the house at the end of a long day. We can hear the emphasis in her voice on the phrase *half an hour*. A certain storyteller might even make it more of a performance by drooping her shoulders, say, or by making a wildly uncomprehending,

4. David Mamet, *Three Uses of the Knife: On the Nature and Purpose of Drama* (New York: Vintage Books, 2000), 4.

exhausted expression, mimicking her reaction while standing on the corner and looking down the street for the bus.

And here, there would be a "small but perfectly recognizable play." We could give it a title, as we sometimes do when we tell stories about our day. We could call it "The Long Wait for the Bus." The play features a *protagonist*—that is, someone engaged in a fight ("protagonist," from the Greek *proto* + *agonistes*, means "first competitor"). A fight of some kind is all that story essentially is. Our protagonist, the bus-riding wife, went to the corner this morning in pursuit of a good: getting to work on time. But then she had an unexpected fight with the city bus system, and perhaps too with the city's congested morning traffic, which delayed her bus. To have been in this fight means that our protagonist was embroiled in *conflict* on the way toward her goal.

The most important thing to notice about this story is that the wife who tells her husband, "I waited *half an hour* for a bus today," is not *imposing* story-structure onto her morning commute. Life is not some amorphous mess that storytellers "clean up" with their neat narrative structures. Life itself takes the form of a story. The "fight" about which the wife tells her husband was *there* in her long wait for the bus.

Stories, of course, typically employ a large degree of artifice. A story usually involves a certain packaging of life's events so that they become maximally intelligible and enjoyable to an audience. We have all heard people try to tell a good story about something that happened in their day and fail to deliver its impact because they put in too many extraneous elements. Their packaging of the story was inartful. Still, stories are not all packaging. They are a way of contemplating the narrative structures that are inherent to human life.

Crucial to the wife's telling of an artful story is, as Mamet says, inducing her husband to suspend his disbelief, "to *accept* that the half-hour wait is not outside the realm of probability, yet *is* within the parameters of the unusual." If the wife told her

husband that she had to wait *three hours* for a bus, her tale would strain credulity. It would tempt the husband to ask his wife why she bothered standing on the corner so long, why she didn't hail a cab or simply hoof it, questions that would undercut the drama of the wife's *having to wait*. Similarly, the wife's telling her husband that she had to wait *five extra minutes* for her bus makes for much less of a story. There's not much of a "fight" in a five-minute delay. The wife's story demands a waiting time that is not too long or too short, that is within the realm of probability yet still within the parameters of the unusual.

Fortunately for the wife's story, life itself delivered the perfect waiting time. A half-hour delay is what really happened. Thirty minutes is a long time to wait for a bus, but not so long as to strain credulity or to raise questions about the wife's good sense in waiting. The wife's story presents a fact transformed into a probability. Her actual thirty-minute wait is the kind of thing that, given the circumstances, is not unlikely to happen. Probability is linked with understanding. To invite suspension of disbelief means that a storyteller is offering something comprehensible. The wife telling the story of "The Long Wait for the Bus" is not simply offering to her husband part of the itinerary of her day. She is offering something meaningful to him, something that will increase understanding. Understanding of what? Understanding of what it means to live in a city with an incompetent or under-funded or understaffed (or all of the above) public transit system. Or what it means to live in a city with too much traffic. Or what it means to live in a universe where one can be the victim of fate. Or what it means to be under God's providential care, where even late buses have a benign significance. It depends on what moral the wife wants to draw from her story. Aristotle, as we saw in chapter 1, famously says that "poetry," fictional storytelling, is more philosophical than history.[5] He means that fictional

5. *Poetics* 9 (1451b5–6).

storytelling, analogously to philosophy, seeks understanding of what essentially is the case.[6]

But to invite suspension of disbelief can also mean that a storyteller is offering something marvelous (what Mamet calls "the unusual"). The marvelous is the out-of-the-ordinary, that which provokes our wonder, our curiosity, our indignation, our joy—but which is still, in the circumstances of the story, probable, inevitable, accountable by the actions taken by the protagonist. Aristotle tells a blackly comic story to illustrate the marvelous. One day, the statue of a man named Mitys happened to tumble over and fall, killing a man who was looking at it—who also happened to be the murderer of Mitys![7] Too ironic, we say. Too full of purpose. As if it was *meant* to happen. And that is exactly Aristotle's point. He is talking about how even an event that comes about randomly—like Mitys's statue falling on his murderer—is marvelous because it *seems* to have been done on purpose. Good stories manifest this intoxicating mixture of the unexpected coming about in a way not wholly unexpected.[8]

The probable and the marvelous characterize the resolution of a protagonist's adventure. The wife's story of her long wait for the bus is probable and marvelous in the way in which her conflict, her long wait, resolved itself after thirty long minutes when her bus finally arrived. A protagonist's encounter with conflict in pursuit of a goal or good always points to a resolution of the conflict, a resolution that can be either happy or unhappy or some

6. Historians, of course, will quarrel with the claim that historical storytelling does not manifest a universal and so is not "philosophical" in its own way. Thucydides's *History of the Peloponnesian Wars* would be a key witness in history's defense of this claim. But much history, at least, is only interested in the intelligibility of a certain chain of events (say, the causes of World War I), and does not inquire into what these events manifest about human nature as such.

7. *Poetics* 9 (1452a3–11).

8. Stephen Halliwell's translation of *Poetics* 9 (1452a1–7), where Aristotle speaks about the marvelous in the context of tragic drama, brings out this connection between the marvelous and the probable especially well: "Since tragic mimesis portrays not just a whole action, but events which are fearful and pitiful, this can best be achieved *when things occur contrary to expectation but still on account of one another*" (*Poetics of Aristotle*, 42).

ironic mixture of the two but one that is, in any event, both probable and marvelous.

The resolution of a story, moreover, typically manifests a reversal in the protagonist's fortunes. The wife who left the house in the morning, eagerly anticipating her day, had her fortunes reversed, slightly, when her bus arrived thirty minutes late. Hamlet's fortunes are reversed tragically. Elizabeth Bennet in Jane Austen's *Pride and Prejudice* enjoys, at the climax of the novel, a comic reversal of her fortunes.

My use of the term "fortunes" here might be misleading. It might tempt one to think that a story is what merely happens to a protagonist on account of fortune or chance. The story of "The Long Wait for the Bus" appears to lend credence to such an understanding, for the story seems to be about what simply happens to the wife, her bad luck. But while we human beings sometimes tell stories simply to relate a stroke of good or bad fortune, when we take time to really craft a story, we are usually after something more. To paraphrase Hemingway, in stories, we most of all look for whether a protagonist will act with grace, with virtue, under the pressure of circumstances. We want to see what *choices* the protagonist will make *in the face of good or bad fortune*—and especially the choice that will *ultimately* resolve the conflict keeping the protagonist from his goal. Without her choice to remain on the corner and wait for the bus, the wife would not have been able to tell her husband her story of "The Long Wait for the Bus." Without the choices he made, Sophocles' Oedipus would never have been vulnerable to the undeserved bad fortune that made a calamity of his life.

We are now in a position to sharpen our definition of story:

A story pictures the human pursuit of some goal or good.

In this pursuit, the protagonist encounters conflict keeping him from the goal, conflict that the protagonist resolves or fails to resolve by his own choices, not by chance.

These choices ultimately reverse the protagonist's fortunes in a way that is both probable and marvelous and so offer the reader or audience an understanding of the meaning of the protagonist's adventure.

The last part of this definition has been touched upon, yet it merits further scrutiny. *Stories trade in meaning.* The wife's story of "The Long Wait for the Bus" offers her husband a certain understanding of how things are in the world where buses run late. Shakespeare's *Hamlet* offers to its audiences a certain understanding (I propose) of what it is to mourn and to doubt and to fail to do one's duty. But how exactly does a story reveal the meaning in human action? To answer this question, we need an important distinction—that between a *purpose* and an *end*.[9]

STORY IS THE INTERPLAY OF PURPOSE AND END

In the opening scene of *Hamlet*, Barnardo and Francisco each have a purpose. What this means is that each is literally in motion because each has an intention, a goal, that he wants to achieve. A purpose is a mental act. Specifically, it is an act of the will that occurs when we deliberately intend to pursue some target of desire. In other words, a purpose is the result of a decision or choice on the part of a protagonist. Purposes don't exist until there is a human agent who has fixed on a goal to pursue. When Jay Gatsby, in F. Scott Fitzgerald's novel, throws wildly sumptuous

9. For this distinction between purpose and end and its connection to story, I am drawing upon Francis Slade's perceptive essay "On the Ontological Priority of Ends and Its Relevance to the Narrative Arts," in *Beauty, Art, and the Polis*, ed. Alice Ramos (American Maritain Association, distributed by The Catholic University of America Press, 2000), 58–69.

parties at his mansion in order to attract the attention of Daisy Buchanan, who lives across the bay, he is acting *with purpose*. He has a goal (making Daisy see how wealthy he has become), which he is striving to achieve by definite means (throwing outrageous parties that he hopes Daisy will hear about and seek to attend).

Purposes must be distinguished from *ends*. An end, what Aristotle calls a *telos*, is not something chosen by a human agent. The terminology is tricky here because "end" can also be a synonym for the good that is the object of a purpose. Our purposes aim at ends or goods. But I am using "end" in a different sense here, as something having to do with the *being* or *nature* of a thing. More precisely, an end is the fullness of a thing's being. A fully mature and healthy oak tree, for example, capable of doing excellently everything that oak trees are by nature capable of doing, has achieved its end in the sense of completion, wholeness, perfection, fulfillment. Unlike a purpose, an end is not the product of the consciousness of a human agent. An end is the condition of perfection for the sake of which the being exists. Of course, when it comes to artifacts, the end is, in a sense, chosen by an agent insofar as the being of the artifact requires an artist or designer to bring it into being. But once the artifact has been brought into being, its end is a function of its nature, not a matter for human agents to decide upon.

"Narrative," writes Francis Slade, "presenting the interplay between purpose and end, is the classic form that allows us to contemplate human life in its completeness and incompleteness."[10] Narrative allows for the contemplation of human life because it pictures a human agent, by his purposes, either achieving or failing to achieve the end in which human nature is completed and fulfilled. Slade elaborates: "The story imitating an action complete in itself manifests an *end-telos* against which are

10. Slade, "On the Ontological Priority of Ends," 66.

profiled those images or representations of ends that are human purposes."[11]

Human action—human life—is for the sake of its end: its completion, wholeness, perfection, fulfillment. Because an end is that for the sake of which we do everything that we do, ends have what Slade calls an "ontological priority" over purposes. Ends, in other words, have more reality than purposes. After all, purposes are only acts of a human mind deciding to pursue something in the here and now, whereas ends determine human nature and the human good by necessity. Ends have more reality because they are the point of our constructing purposes in the first place. We apply for a job or start a new project because, ultimately, we are seeking wholeness and fullness as human beings.

Stories picture this pursuit of wholeness and the ontological priority of wholeness to whatever purposes a protagonist fixes upon. As Slade elegantly puts the point:

> The narrative arts presuppose the ontological priority of ends to purposes because, without that priority, there is nothing to be revealed about the adequacy or inadequacy of human purposes to the completeness of human life, for in action, a human being 'purposes' the realization of his life as a whole, complete in itself.[12]

Stories, in other words, show us a protagonist (or protagonists) constructing purposes and taking actions that lead to a climactic action, reversal, and resolution that reveal how well the character's purposes "measure up" to the human end. The wife tells her husband the story of "The Long Wait for the Bus" because the lateness of her bus undermined her purpose, getting to work on time, a purpose that is linked to her pursuit of her end as a human being. The narrative interplay of ends and purposes is most

11. Slade, 67.
12. Slade, 67.

44

evident, however, when a protagonist chooses a purpose that is not congruent with the human end, such as when Macbeth and his wife conspire to murder Duncan. In such a choice, end and purpose split apart, and the trajectory of the story moves toward a tragic ending. About the character Macbeth, Slade observes:

> Macbeth inhabits a world in which he acknowledges only human purposes, a world in which he must ceaselessly strive to become the master of consequences. When the achievements of great ambition fall apart, his life seems to him, as all lives seem to him, 'a tale told by an idiot, full of sound and fury, signifying nothing.' Macbeth cannot tell the story of his own life. But Shakespeare could, and we understand Macbeth's life because we see it within the context of the whole which human life is as apprehended by Shakespeare.[13]

In light of this distinction between ends and purposes, we can now say that stories reveal meaning by showing us the purposes of a protagonist as being either adequate or inadequate to the human end. This adequacy or inadequacy is the "point" or "moral" or "meaning" that a story aims to picture. It is not simply, however, that we know the human end first and then go to a story to see if the protagonist's purposes measure up to it. To some degree, this is true. I knew that murder was wrong before I ever saw a performance of *Macbeth*; I walked into the theater with my moral measuring rule (as it were) in hand. But the greatest stories, in showing us the adequacy or inadequacy of purposes to the human end, also more clearly and persuasively manifest to us the human end itself: by revealing nuances of it we had never noticed before, by showing us how it ought to be realized in given circumstances, by distinguishing it from that which it is not, and—as in *Macbeth*—by showing us the consequences of mistaking or rejecting it.

13. Slade, 68. The quotation of *Macbeth* is from 5.5.26–28.

We can sum up this section by making further refinements to our definition of story:

A story pictures the human pursuit of some goal or good.

In this pursuit, the protagonist encounters conflict keeping him from the goal, conflict that the protagonist resolves or fails to resolve by his own choices, not by chance.

These choices ultimately reverse the protagonist's fortunes in a way that is both probable and marvelous and that offer the reader or audience an understanding of the meaning of the protagonist's adventure—

—an understanding that manifests the adequacy or inadequacy of the protagonist's purposes to the human end.

BEGINNING, "MUDDLE," AND END

Now I would like to consider story as *an ordered sequence of events*, as opposed to being a hodgepodge of *episodes*. In modern parlance, especially when we think of streaming television, an "episode" is simply the next chapter in a long story. But in the sense of the term I want to use here, a tale is told episodically when its actions are strung together without clear causal connection, without order, and therefore without intelligibility. But a story is a picturing of human action that is intelligible, meaningful.

What brings order and intelligibility to a story is a picturing of *wholeness*. The human actions depicted are complete and unified. What makes for wholeness? Aristotle says that in storytelling, what has a beginning, middle, and end is a whole.[14] He is referring to the three main parts of a story and how they are causally connected, thus making up a single, albeit complex, action.

14. *Poetics* 7 (1450b26–27).

As Aristotle explains, the beginning of a story is not of necessity after something else but rather that after which other actions necessarily follow. By this, he doesn't mean that nothing was happening in the life of the protagonist before the "beginning" of the story. What he means is that a story's beginning is some event in the life of the protagonist *without which* there would be no story, no *significant action* to draw our attention. This event—what contemporary screenwriters like to call the *inciting incident*—upends the protagonist's life in some substantial way. Before the "beginning" or inciting incident, the protagonist's life was going relatively smoothly, or at least, the course of his or her life was running in a predictable pattern. But with the inciting incident comes surprise and the possibility of a new direction, wanted or unwanted. The protagonist will have to react to the inciting incident in some way. A new *purpose* will be decided upon. Michael Tierno refers to the inciting incident as "a virtual 'big bang' that sets the entire plot in motion."[15]

The "beginning" is that after which other actions necessarily follow with a special sort of causality that Aristotle calls "the probable or the necessary" (*kata to eikos hē to anagkaion*).[16] This odd phrase is one that Aristotle made up, as there was no existing one in Greek that captured the way in which a character's actions in a story proceed out of that character's mental and moral habits, experiences, and proclivities with a sort of inevitability or strong probability. Aristotle did not want to say that action proceeded with unqualified necessity, as that would preclude choice, and without a character's choices, there is no story. At the same time, Aristotle wanted to suggest more than the merely "likely," as this word apparently did not do enough in his mind to convey that character implies a kind of destiny, a kind of "necessity." So Aristotle made up a phrase, "the probable or the necessary," to help articulate the special sort of "causal sauce" that is employed

15. Michael Tierno, *Aristotle's Poetics for Screenwriters* (New York: Hyperion, 2002), 8.
16. Discussed by Aristotle in *Poetics* 7–9.

in the imitation of human character and action. Without a character's thoughts and actions being according to "the probable or the necessary"—that is, without those thoughts and actions being strongly probable given the kind of character in question—a reader loses interest in the story because the story has failed to be convincing.

We saw this kind of causality in play in the wife's story of "The Long Wait for the Bus," and we can see it also in Shakespeare's *Hamlet*. Given the inciting incident of encountering the ghost of his father—a "big bang" in someone's life if ever there was one—it is plausible and persuasive, given Hamlet's character and circumstances, that he will swear to avenge his father's murder.

There is an important connection between this causality of "the probable or the necessary" and the mimetic or probable universal we talked about in the last chapter. When a character is recognized to act with a high degree of probability, there is a recognition of something at least approaching universality. While reading about or watching a character, we implicitly say to ourselves: *This kind of character would probably, perhaps always, act like this in these circumstances because this kind of character has a certain "necessity," a certain form or nature to it.* This connection between "the probable or the necessary" in the plot and characters of a story and the mimetic universal is the point of the text from Aristotle's *Poetics* that we have considered where Aristotle says that "poetry is more philosophical and weightier than history: for poetry speaks of the universal while history speaks of the particular."[17] In the following passage, Stephen Halliwell elaborates upon this connection:

> The universals . . . are built into the plot structure of a dramatic poem, into the causal network of actions and events that it comprises. As such, they also necessarily concern the agents, and chapter 9 [of the *Poetics*] makes this explicit: "'universal'

17. *Poetics* 9 (1451a36–b7).

means the sorts of things that it fits a certain sort of person to say or do according to probability or necessity" [1451b8–9].[18]

A story, therefore, is a packaging of events held together by the special causal sauce of "the probable or the necessary," a packaging that makes it easier for us, the audience, to identify and contemplate the quasi-universal characteristics of human character and events.

What follows the inciting incident is a choice by the protagonist that catapults him or her into what Aristotle calls the "middle" of the story. The "middle" comprises the actions that follow the "beginning" according to "the probable or the necessary."

The "middle," however, should not be equated with the second act of a story. Contemporary screenwriters, of Hollywood feature films in particular, usually structure their stories in three acts, a structure that often is said to be derived from the passages in Aristotle's *Poetics* that we are considering. But Aristotle says nothing about three acts in the *Poetics*. Acts are subunits of narrative that occur between reversals or turning points. A turning point is where the expected trajectory of the narrative is upset or "reversed"—that is, sent in a new and surprising direction. A story can have many acts and turning points, though most stories will have at least one turning point at the climax.[19] Shakespeare's plays, for example, are structured around five acts. Nonetheless, Shakespeare's plays manifest a single beginning, middle, and end. The beginning, middle, and end are structural elements more fundamental than act-structure. The "middle" is not the same as the second act of a story, and the "beginning" is not the same as the first act. A good story will have just one beginning, middle, and end, no matter how many acts it has.

18. Halliwell, *Aesthetics of Mimesis*, 195.
19. Stories with at least one reversal have what Aristotle at *Poetics* 10 calls a complex, as distinct from a simple, action.

The "middle" of a story is where the protagonist finds him- or herself in a real "muddle." It is where things get really challenging for the protagonist in the quest for the goal. There are serious complications, and no sooner does the protagonist handle one when an even more serious complication comes along. The "middle" of a story consists of a series of progressive complications. If the complications cease to be progressive, if one complication is actually less serious than the one that precedes it, the story loses steam, and the audience grows restless.

But what about the "end" of a story? Aristotle says that the "end" of a story is that which has the nature to follow the "beginning" and the "middle" according to the story's logic, but after which nothing else follows. The "end," in the most obvious sense, is the terminus of the story, the last action performed in a sequence of events. In *Hamlet*, the "end" is when Fortinbras, the Norwegian prince who has just captured the Danish monarch's castle, gives a command to his soldiers to pay tribute to the dead Hamlet with a military salute: "Go, bid the soldiers shoot." That is the last line and so the "end" of the play. After that action, nothing else follows. For reasons that would take us too far into the political themes of *Hamlet*, Shakespeare thought it important not to end the play with the lines Hamlet speaks as he expires or the sorrow his friend Horatio expresses directly after Hamlet's death. Shakespeare thought it important to make one last move: to end with Fortinbras entering the castle as the conqueror of Denmark, prepared to treat his vanquished enemies with honor. But what happens to Fortinbras afterward, whether he is a successful ruler of Denmark and how long he rules, is matter for another story. It is not part of the story of Prince Hamlet.

Is this sense of the word "end," as the last action of a story, the same sense of "end" we were using when talking about "end" as distinct from "purpose"? Following Slade, we can say this: the "end" of a story—that is to say, the realized wholeness of

an ordered sequence of actions with a beginning, middle, and end—is a picture, an imitation, of the "end" or wholeness of human nature against which human purposes are profiled. The "end" of a story, in one sense, is its terminus, but it should not be thought of as an isolated event. For it is the "end" of an ordered *sequence* of events, and "end" makes no sense apart from that sequence. Fortinbras's last command, "Go, bid the soldiers shoot," finally and fully realizes the wholeness that has been coming into being from the moment Barnardo first asked, "Who's there?" And this wholeness pictures the wholeness that all human beings seek as they undertake their various purposes.

Does this mean that Fortinbras's conquering of Denmark is Shakespeare's picturing of human fulfillment in *Hamlet*? Not quite. Again, the "end" of a story only makes sense in light of the ordered sequence of which it is the terminus. The intelligibility of the last action depends upon seeing the last action as the realization of the events of the story's beginning and middle. From this perspective, Fortinbras's conquering of Denmark only makes sense in light of the sequence of Hamlet's decisions from the point of his encounter with his father's ghost. And that sequence of actions shows us Hamlet's *purposes*—pretending to be mad, organizing the play-within-a-play, returning to England after he is banished, engaging in the rapier duel with Laertes—failing to achieve the end or wholeness to which, in these circumstances, his human nature is ordered. I say Hamlet's purposes *fail*, if only because Shakespeare calls his play a tragedy. But what is this "end" that measures Hamlet's purposes and deems them a failure? Here, we find ourselves on the edge of a critical battlefield. For to ask about the "end" that measures Hamlet's purposes is to ask about the meaning of the play, and that is what critics disagree about. For the sake of our discussion, I will simply assert my own view: Prince Hamlet's purposes fail as measured against his duty, as the rightful heir to the throne of Denmark, to take just revenge on a usurper of

the crown (even if such a usurper is his own uncle). That duty is Hamlet's "end" in the sense of the wholeness that his nature requires *in the circumstances in which he finds himself*. It is the measure against which we say his purposes fail to achieve that wholeness.[20]

Again, Slade writes that "the story imitating an action complete in itself manifests an *end-telos* against which are profiled those images or representations of ends that are human purposes." Ends have an "ontological priority" because there is *more being, more reality* to an end than to any purpose a human agent may happen to pursue. Ends have priority because they are *that-for-the-sake-of-which* we undertake purposes in the first place. We purpose things because we seek the end, the wholeness, that our nature demands. An implication of this is that human purposes, whether real or pictured in stories, take their ultimate meaning from being measured against the end of human existence.

In light of this discussion, let us make a final precision to our definition of story:

20. I rely here on Sister Miriam Joseph, "*Hamlet*, A Christian Tragedy," *Studies in Philology* 59, no. 2 (April 1962): 119–40; John Alvis, "Shakespeare's *Hamlet* and Machiavelli: How Not to Kill a Despot," in *Shakespeare as Political Thinker*, ed. John Alvis and Thomas G. West (Wilmington, DE: ISI Books, 2000), 289–313; and David N. Beauregard, *Virtue's Own Feature: Shakespeare and the Virtue Ethics Tradition* (Newark, DE: University of Delaware Press, 1995), chap. 4; and chap. 5 of his *Catholic Theology in Shakespeare's Plays* (Newark, DE: University of Delaware Press, 2007). Sister Miriam Joseph sums up her thesis this way:

> If we agree with Aristotle that a tragedy is the imitation of a serious action in dramatic form having as its specific function to arouse pity and fear in the audience through its incidents and thereby to purify their emotions, then a Christian tragedy must accomplish this purification through incidents that have Christian significance. And if a tragic hero must be a man, not perfect, but on the whole good and likable, who brings upon himself through a flaw in his character or an error of judgment the misfortune he suffers (and the audience with him), then a Christian tragic hero must bring upon himself misfortune and suffering through a flaw in his character as a Christian.
>
> I hope to demonstrate that the play *Hamlet* is in the strict sense a Christian tragedy and that Hamlet is a Christian hero whose tragic flaw is his failure at the moment of crisis to measure up to the heroic Christian virtue demanded of him by the moral situation and by the ghost. I believe that the centuries-old Christian doctrine of the discernment of spirits is a key to the understanding of the ghost.

A story is an ordered sequence of events with a beginning, middle, and end that pictures the human pursuit of some goal or good.

In this pursuit, the protagonist encounters conflict keeping him from the goal, conflict that the protagonist resolves or fails to resolve by his own choices, not by chance.

These choices ultimately reverse the protagonist's fortunes in a way that is both probable and marvelous and so offer the reader or audience an understanding of the meaning of the protagonist's adventure—

—an understanding that manifests the adequacy or inadequacy of the protagonist's purposes to the human end.

WE TELL STORIES BECAUSE HUMAN LIFE ITSELF TAKES THE FORM OF A STORY

A story, then, presents us with a kind of *whole.* The whole it presents us with is, as Flannery O'Connor puts it, the picture of a "complete dramatic action":

> A story is a complete dramatic action—and in good stories, the characters are shown through the action, and the action is controlled through the characters, and the result of this is meaning that derives from the whole presented experience.[21]

Slade puts the same thought this way: "Stories imitate actions by being themselves wholes that represent the manifestations of ends in action."[22] The wholeness of a story—the "complete dramatic

21. O'Connor, "Writing Short Stories," 90.

22. Slade, "On the Ontological Priority of Ends," 67. Aristotle says, in *Poetics* 8 (1451a30–32), that "just as in the other mimetic arts the mimesis is of one thing, so also the plot, since it is the mimesis of action, is of one action, and whole."

action" with a beginning, middle, and end—pictures human purposes as being adequate, or inadequate, to the end of human nature. But this means, as I touched on earlier in this chapter, that human life itself takes the form of a story. Let me explain more fully why this is so.

The most fundamental characteristic of human existence is that we seek the fulfillment, the end or *telos*, of our nature. Any nature has potentialities or powers that demand to be actualized, and when those potentialities are actualized with excellence when they are brought to perfection, we say that the nature in question flourishes as it was meant to flourish. The purple lilies blooming beautifully in my yard as I write these lines are even now fully actualizing their potential as lilies—a process that requires no consciousness or deliberation on the lilies' part. By contrast, my grandson, just about to celebrate his first birthday, is still in the very early stages of perfecting his powers as a human being; but as he grows, the process of actualizing his powers will become an ever more conscious and deliberate one. What my grandson will become increasingly conscious of and deliberative about is what we who have reached maturity are most conscious of and deliberative about: the desire to be fulfilled and to flourish, to achieve excellence and perfection. In a word, my grandson will, in time, become reflective as we are reflective about his natural desire for what Aristotle calls *eudaimonia*. Aristotle's Greek word is often translated as "happiness," but this is a translation that holds traps for the unwary. The word "happiness" in twenty-first-century English typically refers to an emotional state. To be happy means to feel positive feelings. But by *eudaimonia*, Aristotle means not a feeling so much as an *activity*—an activity in which we, analogously to my blooming lilies, manifest the excellence that is the full perfection of our powers. In this kind of activity, we human beings flourish. Our natures come to a kind of completion, or, we might say, a kind of wholeness.

The wholeness that we achieve when we flourish as human

beings is not the same thing as the wholeness of a good story, but the two senses of wholeness are connected. The wholeness of a story is that of a well-constructed artifact, an artifact that shows whether or not a protagonist's purposes are adequate to his end. The wholeness of a human life is that of a nature having achieved its fulfillment, a fulfillment in which the human agent's purposes fully actualize his natural potentialities. The story's wholeness pictures human life's wholeness—or the failure to achieve it.

Our lives take the form of a story because we, like any protagonist in a story, are striving for goods and for the ultimate good that is wholeness or flourishing. Our quest for wholeness by achieving the end of our nature serves as the "plot" of our lives. Does the story of our life have an author? Certainly. God is the author. But only with the benefit of Christian revelation do we understand God's authorship as having a personal dimension. Philosophically speaking, God's authorship is realized in the nature we have been given and in its potential being ordered to a certain actualization.

What is that actualization? What does our wholeness consist in? The specific character of the human end, as Aristotle teaches us and as Hamlet reminds us in his advice to the players, is living the virtues, those excellences of mind and character that realize our potential as rational animals. Acting virtuously—e.g., prudently, justly, courageously, temperately—is the essence of the good life for human beings and thus constitutes what it means for us to achieve wholeness or happiness. Even though we may live happily ever after for many more years, when we act habitually according to virtue, our story achieves its end in the sense of fulfillment.

So, human life takes the form of a story or drama (I use these terms synonymously), and we can consider ourselves the protagonist and, to some extent, the author of our life's story. I emphasize "to *some* extent." Because, of course, we cannot, like a novelist or playwright, have total control over every aspect of our drama. We do not choose the circumstances into which we are born or many other circumstances of our lives. Chance—and providence, from

the point of view of faith—plays a significant role in our stories. Alasdair MacIntyre meditates upon this theme:

> We are never more (and sometimes less) than the co-authors of our own narratives. Only in fantasy do we live what story we please. . . . We enter upon a stage which we did not design and we find ourselves part of an action that was not of our making. Each of us being a main character in his own drama plays subordinate parts in the drama of others, and each drama constrains the others. In my drama, perhaps, I am Hamlet or Iago or at least the swineherd who may yet become a prince, but to you, I am only A Gentleman or at best Second Murderer, while you are my Polonius or my Gravedigger, but your own hero. Each of our dramas exerts constraints on each other's, making the whole different from the parts, but still dramatic.[23]

To what genre does the story of a human life belong? The answer to that question depends on the choices made by the protagonist of that life. Our nature is ordered to a certain fulfillment in a virtuous action, and it is always possible, even in the direst circumstances, to live the virtues. To successfully achieve one's natural end, even after many struggles, is to live a comedy. Comedy is not essentially about laughter; it is about personal transformation in light of what is truly good for human beings. But just as characters in stories can make bad decisions, so can we. Our lives, like that of Hamlet, can always make a tragic reversal as our purposes become inadequate to the demands of virtue. Comedy and tragedy are the master genres both of storytelling and of human life, as they mark the extremities of what is possible in human action.

Much of the time, however, our lives may feel like the hodgepodge of episodes that is the antithesis of story, whether comic or tragic. The distinction between ends and purposes, the distinction

23. Alasdair MacIntyre, *After Virtue*, 3rd ed. (Notre Dame, IN: University of Notre Dame Press, 2007), 213–14.

that allows us to see our lives as a whole, is not one that we make on a daily basis. We are too busy waiting for the bus. But there are times, prompted perhaps by some great decision, or by some setback, or simply by the occasion of leisure, that we reflect on the meaning of our lives as a whole and whether the purposes we have chosen, or might choose, are adequate or inadequate to our end. But stories, works of narrative art in which the ontological priority of ends to purposes is shown, are one of the best and most enjoyable ways of taking stock of our lives. And the more we understand what stories are doing when they picture human action, the more we can contemplate their significance for the story we are living.[24]

This theme of contemplation, which we first encountered in chapter 1, is of special importance to our discussion of the human end because, for both Aristotle and Aquinas, contemplation is the highest and best of virtuous activities. Contemplation actualizes our potential as human beings, our specifically rational potential, more than any other activity. As Aristotle says, contemplation is that activity by which we most closely imitate God, for God's own activity is contemplation. And when we contemplate God himself, our imitation of God is as complete as it can be. What exactly is contemplation? It is intellectual insight or "seeing" into the forms or essentials of things, a seeing that occurs within an ambience of delight.

Stories are a way of contemplatively seeing what it means to quest for wholeness. Imitation in general is natural to human beings from childhood, as Aristotle tells us, because imitation is a mode of learning, our definitive activity as rational beings. We take pleasure in imitating even unpleasurable things because such imitation is a contemplative way station. Like any form of

24. For more on how we become aware of the narrative structure of our lives, including a response to Galen Strawson's arguments against the idea of life as story, see Alasdair MacIntyre, *Ethics in the Conflicts of Modernity* (Cambridge: Cambridge University Press, 2017), 238–42. Strawson's essay "Against Narrativity" is found in *The Self?* ed. Galen Strawson (Oxford: Blackwell, 2005), 63–86.

mimesis, stories imitate human beings doing things so that we might be delighted by the understanding of their doings. And crucial to that delighted understanding is that human life itself is story.

HOW STORIES MANIFEST THE END OF HUMAN NATURE

Yet it may still be unclear just *how* stories manifest the end of human nature and so illuminate our own story.

It seems clear enough how the *purposes* of the protagonist and other characters are manifest. When we see or hear the story, we see human purposes in action: for example, Hamlet swearing to avenge his father's murder. But where is the end of human nature in Hamlet's decision? Is his purpose congruent with his end—as was the wife's in her desire to use the bus to get to work, as I posited earlier? If so, then how do we *know* it is congruent? And if Hamlet's decision is not congruent with his end, then how in the play is his end illuminated?

Here, it is helpful to draw a distinction between nature and convention. Convention (sometimes called "custom") refers to any habit, practice, or institution that is a product of human purposes coming together in agreement, whether tacit or explicit. For example, that men wear neckties is a convention of business or formal dress in many cultures today. The convention came about because of human purposes, though not because some explicit agreement was made (the Committee for the Advancement of Neckties never met). The agreement was made tacitly through the influence of various purposes at work in society and in the fashion industry. Other conventions do come about by way of explicit agreement, such as the traffic law that asks us to stop our cars at red lights rather than at red puffs of smoke. A legislature had to convene and make a formal decision that cars must stop at red lights.

We have spoken of ends as being ontologically prior to human

purposes. Because an end is the condition of fulfillment of a nature, we can likewise say that human nature is ontologically prior to the human purposes that are conventions.

Nature and convention, however, do not manifest themselves to us separately. We do not pursue our purposes and conventions in one area of our lives and, in a separate area, live out the ends of our human nature. In human affairs, nature and convention are bound up with one another. In fact, before we become sufficiently reflective, we tend to regard human nature and its ends as the *same* as our conventions. We assume that the way *we* do things is identical with how things *must be* done according to nature.

Into this confused mixture of nature and convention, we must go seeking after nature and its ends. Robert Sokolowski argues that "nature is displayed to us only as refracted through custom, and custom always mixes with the natural."[25] So it is only in customary practices like the wearing of neckties that the natural dimension of human clothing and fashion comes to light. But *how* does it come to light? Through the making of good distinctions. Sokolowski explains that the distinction between nature and convention "occurs primarily in an immediate, particular criticism of the customary behavior in which one lives."[26] Such criticism might arise in a number of ways. My customary patterns of behavior might be put into question by someone, perhaps from a different culture, with a much different experience. Or, an unexpected consequence of one of my conventional practices—maybe an unforeseen conflict with another of my conventional practices—might lead to an interrogation of the fittingness of the original practice. Or it could be that more philosophical minds within a culture, in the manner of Socrates, will simply begin asking whether the culture's customs are identical to the way human

25. Robert Sokolowski, "Knowing Essentials," *The Review of Metaphysics* 47, no. 4 (June 1994): 691–709, at 697.

26. Robert Sokolowski, "Knowing Natural Law," in *Pictures, Quotations, and Distinctions: Fourteen Essays in Phenomenology* (Notre Dame, IN: University of Notre Dame Press, 1992), 279.

beings ought to live. But one of the chief ways in which a culture puts its customs in question is through storytelling.

Stories are important ways in which cultures inquire into the natures of things and their ends. Think about what we have already said about the nature of story: that it always involves a beginning, a middle, and an end. Before the beginning of a story, the life of the protagonist is running in a predictable pattern. The protagonist's life, in other words, is characterized by convention. Often enough, the purposes and conventions of the protagonist simply mirror the purposes and conventions of his wider culture. At other times, the protagonist's purposes will be idiosyncratic to him or her and run counter to how things are usually done in the surrounding culture. In any event, at the inciting incident, the protagonist's life is upended. When we first encounter Bilbo Baggins, for example, the protagonist of J.R.R. Tolkien's *The Hobbit*, he rests complacently in a veritable hammock of convention. He eats several meals a day, smokes his pipe, visits with his neighbors, and sleeps late—a customary way of living that more or less tracks the practices of the wider hobbit community. But then the wizard Gandalf, for inscrutable reasons of his own, puts in motion a plan that assigns Bilbo the role of "burglar" in a scheme to assist a pack of dwarves planning to steal back their ancient ancestral gold from a dragon. Bilbo's life is quite definitively upended. He resists the change at first. He even refuses to go on the adventure. But then he changes his mind and runs after the dwarves, having recognized that his comfortable life is missing something important. *Bilbo's adventure, from beginning to middle to end, is a kind of critique or inquiry into his conventional life*. By the end of the story, Bilbo has learned that goods such as fellowship, courage, and sacrifice are far more important, far more *necessary* to hobbit fulfillment and wholeness, than his creature comforts. This note

of necessity signals that Bilbo has discovered the end that his hobbit nature is made for.[27]

This is how stories manifest the end of human nature: by picturing a kind of critique or inquiry into convention that gives us insight into the distinction between the necessities of the human end and the merely conventional purposes of human agents.

The human end is complex. "Living the virtues" is not just one sort of activity but a collection of many kinds of virtuous activities. It would take quite a story to reveal the entire complexity of the human end to us. Dante's *Commedia* comes as close as any story has ever come to doing so. What Dante's poem shows us, in fact, is that the human end is both complex and ordered hierarchically, a hierarchy that culminates in the highest form of virtuous activity: the contemplation of God as the Love toward which all our earthly loves find their ultimate point and fulfillment.

Shakespeare's *Hamlet* does not attempt to reveal the entire complexity of the human end. Its primary focus is on the virtue of justice, and by the end of the play, we are able to distinguish what justice requires of a prince. The play shows us—*all* of us, princes and paupers alike—that there is such a thing as just vengeance and that we are all called to exercise it when required.

But I keep speaking of stories as "showing," "revealing," or "manifesting" the human end. Am I saying that stories merely show us what their authors *think* or *believe* about the human end, or am I saying that stories show us what is *true* about the human end?

Many would deny that stories have anything to do with

27. For further philosophical discussion of the relationship between stories and the narrative of human life, see MacIntyre, *After Virtue*, especially chap. 15–16, and *Ethics in the Conflicts of Modernity*, especially sec. 4.12, as well as my *The Difficult Good* (New York: Fordham University Press, 2006), especially chap. 4 and 8. The present chapter, as well as the next, makes clear my position that stories should be read for their ethical relevance. I thus am in sympathy, broadly speaking, with the approaches to the ethical reading of fiction taken by Wayne C. Booth in *The Company We Keep* (Berkeley: University of California Press, 1988) and Martha Nussbaum in *Love's Knowledge* (New York: Oxford University Press, 1992), though regrettably neither of these authors adopts the teleological understanding of the human good that undergirds the Aristotelian-Thomistic approach to both ethics and storytelling.

truth. After all, stories are *fiction*. They are about enjoyment, not truth. Think of all the lovers of Dante who in no way subscribe to his Catholic vision of reality. Truth plays no part in their enjoyment. Truth, many will say, is the concern of science. It is about *facts*, not *fiction*.

One of Aristotle's great principles is that we cannot expect the same degree of certitude or exactness from every inquiry.[28] The hard sciences pursue a degree of certitude to which it would be inappropriate for other inquiries, such as ethics, to aspire. Storytelling, too, is a kind of inquiry. But, as Aquinas says, it is the *infima doctrina*, the "least of doctrines," because it produces the least degree of certitude in its audience.[29] So, in one sense, the objection is correct: stories do not manifest truth in the sense of absolutely certain and evident truth.[30]

But this does not mean that the enjoyment we take in stories has nothing to do with truth. Storytelling aspires to show us what is true about the human end, but its mode of persuasion, its way of arguing, does not demand, logically, that we agree with what it shows us. This claim raises more than one issue. In what sense is story a form of argument? And how does its particular form of argument work? These questions will be our concern in the next chapter.

28. Aristotle sets down this principle and explains its application to inquiries involving moral and political matters in *Nicomachean Ethics* 1.3.

29. *Summa theologiae* 1.1.9 ad 1.

30. Halliwell's interpretation of the *Poetics* articulates well the connection between the lack of certitude in poetry and the fact that stories are inquiries of particular cultures:

> A variant on the idealizing reading is to equate the universals of *Poetics* 9 with possibilities that are 'universal' in the sense of common to all human experience across time and space, transhistorically and transculturally capturing an "immutable human condition." Aristotle never thinks or speaks in such terms, and it is unjustified to assume that he would have wanted to do so. . . . He recognized clearly the degree to which canons of "probability" and plausibility, which are central to this definition of universals in *Poetics* 9 (1451b9) are dependent on—and must therefore vary according to—the social, political, cultural, and personal background of individual audiences. (*Aesthetics of Mimesis*, 196–97)

3

Story as Moral Argument

Practically every day, at a small desk with a typewriter set up in her bedroom on the ground floor of the house near Milledgeville, Georgia, that she shared with her mother, Flannery O'Connor sat down to write fiction. Her writing stints, always in the morning, would last about two hours. The time limit was determined, at least in part, by the lupus from which O'Connor suffered for most of her adult life, but which she doggedly refused to let undermine her vocation as a writer. "I write only about two hours every day because that's all the energy I have, but I don't let anything interfere with those two hours, at the same time and the same place."[1]

From time to time at this desk, O'Connor also wrote non-fiction—book reviews, talks, and essays—tasks she took on more often for financial than for literary reasons. Many of these non-fiction pieces have been collected and edited by O'Connor's dear friends Sally and Robert Fitzgerald (the translator of Homer) in a book entitled *Mystery and Manners*. One of the most interesting pieces in this volume is the essay "Writing Short Stories," which the Fitzgeralds, in their notes, tell us was originally a talk given at a Southern Writers' Conference. In the essay, we can hear O'Connor addressing the seven participants of this conference who were given the opportunity to have O'Connor read their work. What O'Connor has to say to these apprentice writers—and to us—turns out to be a master class in the art of the short story. What she

1. Flannery O'Connor to Cecil Dawkins, September 22, 1957, in *The Habit of Being: Letters of Flannery O'Connor*, ed. Sally Fitzgerald (New York: Farrar, Straus and Giroux, 1988), 242.

has to say also makes for an excellent beginning to the next phase of our inquiry, which has to do with the way in which stories work as arguments yielding experiential ethical knowledge.

MISS O'CONNOR'S MASTER CLASS

In "Writing Short Stories," O'Connor's most illuminating remarks concern the relationship between story and meaning. These remarks were certainly inspired by the fact that the home O'Connor shared with her mother was a working farm:

> I prefer to talk about the meaning in a story rather than the theme of a story. People talk about the theme of a story as if the theme were like the string that a sack of chicken feed is tied with. They think that if you can pick out the theme, the way you pick the right thread in the chicken-feed sack, you can rip the story open and feed the chickens. But this is not the way meaning works in fiction.[2]

What O'Connor is leery of is the misguided understanding that the meaning of a story is something separable from the story itself. We may remember from our school days identifying the "theme" or "meaning" of a story or poem as if it were an isolated statement that could be neatly detached from the work of literature and memorized for a test. O'Connor invites us to correct this misguided understanding. Tearing back the right thread allows the chicken feed to be dispensed. But the meaning of a story is not some magic thread; it is, as it were, the chicken feed itself:

> When you can state the theme of a story, when you can separate it from the story itself, then you can be sure the story is not a very good one. The meaning of a story has to be embodied in it, has to be made concrete in it. A story is a way

2. O'Connor, *Mystery and Manners*, 96.

of saying something that can't be said in any other way, and it takes every word in the story to say what the meaning is. You tell a story because a statement would be inadequate. When anybody asks what a story is about, the only proper thing is to tell him to read the story.[3]

This text is a powerful reflection on the way stories work. In order to understand what O'Connor is saying here, it is helpful to keep in mind three ways in which we can know something.

The first is by way of theoretical statements. We can learn a lot by listening to a lecture. In this mode of knowing, we endeavor to abstract from the particulars of the case and grasp what is essential to it. Although the lecturer might use examples or illustrations to aid comprehension, the primary mode of delivery is by way of statements and arguments made up out of abstract notions.

Another way we can know something is by what we might call the way of doing. There's real know-how that comes from doing something, especially when we do something so much that our experience of it becomes rich and varied. For example, our sweet, humble Aunt Emily knows a lot about the virtue of humility by having lived humility over many years. Her theoretical knowledge of humility—her knowledge of humility by way of universal statements and arguments—may be nil. She may have never studied moral theology. If asked to give a definition of humility, she would probably be at a loss. And yet, it's undeniable that Aunt Emily has a real understanding of what it means to be humble, an experiential knowledge embodied in her habitually humble acts. And by imitating Aunt Emily's humility, we can proceed along this way of doing as well.

The third way of knowing is by what we might call the way of showing. By "showing," I mean the activities of the artistic imagination. A movie is a kind of showing, as is a play. But there

3. O'Connor, 96.

are other kinds of showing that do not involve performance either live or recorded. A novel is a kind of showing, as is a poem, as is a short story. These latter arts are showings in the sense that they, just like a movie or play, offer us images of human beings doing things. And whether a showing is performance-based or text-based, it attempts—as we so often say about a work of art—to "say" something. It offers us the experience of something meaningful.

Again, in talking about the theme of a story, O'Connor says, "When you can state the theme of a story, when you can separate it from the story itself, then you can be sure the story is not a very good one." O'Connor is clearly dissuading us from thinking that the meaning of a short story can be communicated by way of theoretical statements. Sure, we can try to formulate a theoretical statement *describing* the story. O'Connor's own short story "Good Country People" is a darkly comic tale of Hulga, a nihilistic PhD who gets her wooden leg stolen when she attempts to seduce a young man who, unknown to Hulga, is only pretending to be an innocent Bible salesman. We might describe this story with the following statement: *"O'Connor's 'Good Country People' is about the hubris that eventually must undermine the attempt to live as a nihilist."* We can easily imagine someone writing an entire essay full of theoretical statements and arguments that attempt to articulate the meaning of "Good Country People." Yet we should never treat theoretical statements about a story as capable of delivering the full meaning of a story. This would be to treat the meaning or theme of a story like the string on a sack of chicken feed, as something that can be picked out and abstracted from the story itself.

But it is worth pressing the question: Why can't the meaning of a story be captured in a theoretical statement like the sentence above regarding "Good Country People," or at least in an entire essay arguing for a certain interpretation of the story's meaning? The reason is this: it is the nature of stories, and works of art

generally, to communicate their meaning through images. Stories are showings, and any attempt to reduce them to theoretical statements and arguments is to leave behind the imagery that makes them what they are. "A story," O'Connor insists, "is a way of saying something that can't be said in any other way, and it takes every word in the story to say what the meaning is. You tell a story because a statement would be inadequate." So it is not just that a single statement or critical essay on "Good Country People" is not as exciting as reading the story itself. It's more that the story *can't* be communicated, at least not fully, by way of statements. No such translation is possible. "When anybody asks what a story is about," O'Connor says, "the only proper thing is to tell him to read the story."

O'Connor's next move in the essay "Writing Short Stories" is to make a distinction that will be hugely important for our inquiry. She writes, "The meaning of fiction is not abstract meaning but experienced meaning, and the purpose of making statements about the meaning of a story is only to help you to experience that meaning more fully."[4] First of all, note the last sentence in this passage, where O'Connor talks about the purpose of making theoretical statements about the meaning of a story. O'Connor is clearly *not* saying that we shouldn't attempt to make theoretical statements about stories. There is a purpose to theorizing about works of fiction, and that purpose is to help us understand them more fully. The art concerned with this more theoretical approach to literature is the art of literary criticism. But O'Connor's point in this passage is that literary criticism is an activity ancillary to, supportive of, the original experience of reading the story. Whatever theoretical understanding literary criticism affords us must be absorbed back into the experience of delighting in the story.

"The meaning of fiction," O'Connor contends, "is not abstract meaning but experienced meaning." What is this distinction between *experienced meaning* and *abstract meaning*? It seems

4. O'Connor, 96.

fair to connect abstract meaning with the way of theoretical statements and arguments. But what about experienced meaning? This kind of meaning seems to connect to the two other ways of knowing we distinguished: the way of doing and the way of showing. In both of these latter types of knowing, meaning is experienced rather than formulated theoretically. Aunt Emily has experience of humility but no way of putting that experience in the abstract terms of the theologian. And our experience of the kind of showing that is a short story does not give us conceptual knowledge but a kind of "lived" know-how. The short story, in other words, offers us a simulation of reality that we can "step inside"—as we might do by putting on a virtual-reality headset— and experience with and through the characters.[5]

What O'Connor says about the short story in "Writing Short Stories" applies, of course, to stories of all kinds. All stories aim at delivering meaning—which is to say, *truth*—but they deliver it in the form of the kind of virtual-reality experience we have been talking about. Now I would like to explore more deeply just how stories deliver this experiential truth. They do so by constructing an argument or proof, but one of a very special kind.

THE POETIC SYLLOGISM

Who can come away from a performance of Shakespeare's *Macbeth* and not feel that the "argument" of the play is that ruthless ambition can only lead to a person's destruction? Is not the vanity of such ambition what Macbeth realizes in his final soliloquy?

> Out, out brief candle,
> Life's but a walking shadow, a poor player,
> That struts and frets his hour upon the stage,
> And then is heard no more. It is a tale

5. Walter Ong pursues thoughts along these same lines in his essay "Imitation and the Object of Art," *The Modern Schoolman* 17, no. 4 (May 1940): 66–69.

Told by an idiot, full of sound and fury
Signifying nothing.[6]

Who can come away from a reading of Dostoevsky's *The Brothers Karamazov* and not feel that the loving unity experienced by Alyosha and the boys who were friends of the kind and brave little Ilyusha—kindness and bravery manifested most of all in Ilyusha's untimely death—embodies the most important "point" that Dostoevsky wants to get across to us in this novel? This loving unity, grounded in Christian charity, is what Alyosha exhorts Ilyusha's young friends to in his final speech to them at the stone:

> And so, first of all, let us remember him, gentlemen, all our lives. And even though we may be involved with the most important affairs, achieve distinction or fall into some great misfortune— all the same, let us never forget how good we once felt here, all together, united by such good and kind feelings as made us, too, for the time that we loved the poor boy, perhaps better than we actually are. . . .
>
> No matter how wicked we may be—and God preserve us from it—as soon as we remember how we buried Ilyusha, how we loved him in his last days, and how we've been talking just now, so much as friends, so together, by this stone, the most cruel and jeering man among us, if we should become so, will still not dare laugh within himself at how kind and good he was at this present moment! Moreover, perhaps just this memory alone will keep him from great evil, and he will think better of it and say: "Yes, I was kind, brave, and honest then."[7]

6. William Shakespeare, *Macbeth* 5.5.22–27, ed. Sandra Clark and Pamela Mason for Arden Shakespeare series (New York: Bloomsbury, 2020).

7. Fyodor Dostoevsky, *The Brothers Karamazov*, trans. Richard Pevear and Larissa Volokhonsky (New York: Farrar, Straus and Giroux, 2002), epilogue, chap. 3, 774–75. Joseph Frank, the great biographer of Dostoevsky, notes about this last chapter of the novel describing Ilyusha's funeral: "Twelve of Ilyusha's schoolmates, gathered round his bier, were soon joined by Alyosha; and this symbolic number provides a Christological aura to the pathos of the scene." *Dostoevsky: The Mantle of the Prophet, 1871–1881* (Princeton, NJ: Princeton University Press, 2002), 701.

And who can come away from watching *Star Wars: Episode IV—A New Hope* and not feel that the "moral" of the story is that the pluckiness, bravery, and "faith" of a small group of loyal friends can overcome the most menacing evil?

Stories make arguments. They put forward reasons in an effort to persuade us of the truth of a certain proposition. This is what we are recognizing when we talk about the "argument" of a play, the "point" of a novel, and the "moral" of a story.

The very phrase "the moral of the story" indicates that the kinds of arguments stories make are moral ones, understanding the word "moral" not as a list of rules or of right and wrong actions but as a way of describing the rich adventure of the human quest for happiness. To use the terminology established in the previous chapter, story-arguments dramatize the measuring or critiquing of human purposes against the backdrop of the human end.

In the Aristotelian tradition as it developed in the Middle Ages, "poetry"—a term we will continue to extend to include all storytelling—was classified by certain thinkers as a branch of logic. This no doubt strikes us as very strange—especially when we keep in mind all that we were discussing in the last section about story meaning as not being reducible to theoretical statements and arguments. How can we talk about stories as "moral arguments" if stories are not theoretical structures but patterns of imagery that we experience? Are not attempts to construe *Macbeth*, *The Brothers Karamazov*, and *Star Wars: Episode IV* as logical argument just the sort of mistake O'Connor warns us against?

We would indeed be making a mistake if we, again, aspired to

And about the final scene depicting Alyosha's speech to the boys at the stone, Frank writes, summing up the novel in a way with which I wholeheartedly agree:

> The book ends on this boyish note of innocence and optimism, providing a welcome relief, similar to the epilogues of eighteenth-century plays or operas, to all the tragic tensions that have gone before. And just as those earlier examples pointed to the moral of the story, so Dostoevsky reaffirms, in a naïvely acceptable and touching form, the basic beliefs and moral-religious convictions he has sought to champion so peerlessly all through his greatest novel. (*Dostoevsky: The Mantle of the Prophet*, 703)

reduce a story to theoretical statements and arguments. But that is not what we are doing when we situate storytelling within the divisions of logic. While respecting that a story is a pattern of imagery yielding experiential, not theoretical, knowledge, we can still affirm that theoretical knowledge can supplement the experience of delighting in a story. This, as I noted earlier, is the function of literary and other forms of narrative criticism. Criticism can help us reflect, for example, upon a story's symbolism, its characters, its relationship to other stories, as well as its theme. And what philosophy can add to this critical reflection is an understanding of the way storytelling itself is a form of moral argument. Compare critical reflection upon a story to the full-color sketches that an architect makes for a new church and compare the philosophical reflection upon story as moral argument to the blueprint for the church. The story itself is the finished church that you worship in and love for its updated Romanesque style, its stained glass, its statuary, and its magnificent altarpiece. Now, the architect's sketches and blueprint can never substitute for the experience of worshipping in and delighting in the church. But they can aid the appreciation of these experiences—for example, by helping us distinguish more easily the essential features of the Romanesque. Likewise, narrative criticism and philosophical reflection can supplement our enjoyment of stories. When such theorizing is absorbed back into the fundamental experience of enjoying a story, it can enrich the experience considerably.

With these distinctions in mind, let us look at the most basic "blueprint" of any story: its logical structure as moral argument. Begin by considering the following:

All men are mortal.
Socrates is a man.
Therefore, Socrates is mortal.

No doubt your mind drew the conclusion of this argument even before you read the conclusion in the text. This is what is known as a *demonstrative argument*. It demonstrates its conclusion with logical certitude or necessity. As long as you understand the meaning of the two premises, you *must* assent to the conclusion—on pain of being illogical. This is for two reasons. First, because the argument is *formally valid*—if all A are B, and C is an A, then C is also B—but second, because the *content* of the premises is true. Poetic arguments, by contrast, are *not* demonstrative. They do not produce anything close to logical certitude. Their structure might be formally valid, but their content is not as necessarily true as the propositions "All men are mortal" and "Socrates is a man." To see how this is so, we need to look more closely at the structure of poetic argument, or what I will now call the *poetic syllogism*.

The word "syllogism" comes from the Greek and literally means reasoning from one thing to another.[8] In the example above, we reason from the fact that "All men are mortal" and from the fact that "Socrates is a man" to the conclusion that "Socrates is mortal." Stories are also a kind of reasoning from one thing to another and can even be put in the form of a syllogism. Here is my attempt to put Shakespeare's *Macbeth* into a poetic syllogism:

Willingness to do anything to get what one wants leads not only to others' but to one's own destruction.

Ruthless ambition is defined as willingness to do anything to get what one wants.

Therefore, ruthless ambition leads not only to other's but to one's own destruction.

8. In a text we have considered from *Poetics* 4, Aristotle uses a form of the Greek word for "syllogism" when he describes how we learn and reason things out (*sullogizesthai*) when we contemplate a work of mimetic art (1448b16).

You probably wouldn't pay money to sit in a theater and listen to me recite that syllogism to you. Even if I were wearing a doublet, hose, and a fake beard. There is, to put it mildly, much that is lost in compressing Shakespeare's five-act masterpiece into this tiny, unexciting, poetic syllogism. Still, the exercise is instructive—as any blueprint is instructive—for it shows us the fundamental structure of the thing. My poetic syllogism of *Macbeth* does *not* give us the full meaning of *Macbeth*. As O'Connor stresses, only the experience of the play itself can do that. But my syllogism does give us, as it were, a schematic for the "bones" of the story, which allows us to see how the story works as moral argument.

Earlier, I said that stories put forward reasons in an effort to persuade us of the truth of a certain proposition or conclusion. In what sense do stories put forward "reasons"? Another way of putting the question is, what are the "premises" of a story-argument? The "reasons" or "premises" are not theoretical statements but the pictures or images that the story shows us. Stories are composed of images, and it is their images that beguile us and persuade us of the truth of which the story wants to convince us. The power of a story's picturing is what distinguishes it from its poor redaction in a poetic syllogism.

But in what sense are images "reasons"? Images are reasons insofar as they can be understood by us and articulated by us in speech. Even when an image in a story is simply a picture with no narration or dialogue, we are still able to understand and articulate what is happening in the picture. We are still able to see the "point" that the picture is making. For example, the very image of the Death Star in *Star Wars: Episode IV* is enough to give us the idea that *here is something menacing*. Just by seeing it, we have "reason" to expect something evil to come from that enormous and ominous piece of technology. And when narration or dialogue is added to imagery, then it is even more evident that an image can provide "reasons" or "premises" in an argument. In the passage quoted above from *The Brothers Karamazov*, the image of

Alyosha giving a farewell speech to his young friends has a verbal argument embedded in it:

> A beautiful, sacred memory preserved from childhood is the best education.
>
> The memory of little Ilyusha is a beautiful, sacred memory from childhood.
>
> Therefore, preserving the memory of little Ilyusha is the best education.[9]

It would take a rather hard-boiled reader of *The Brothers Karamazov* not to assent to the conclusion of Alyosha's syllogism in this speech: namely, that preserving the memory of little Ilyusha—or some beautiful, sacred memory from the reader's own childhood—is the best education. Nonetheless, a reader would not be illogical if he wasn't moved to assent to Alyosha's conclusion. And why not? Because poetic arguments do not compel assent like demonstrative arguments do. There is nothing in Alyosha's argument that binds the intellect with absolute necessity. While Alyosha's argument, in the syllogistic form in which I've put it, is formally valid, the content of its premises—which in reading Dostoevsky's novel, we encounter not as mere abstract statements but as statements bound up with the character and actions of Alyosha as well those of little Ilyusha and all the others—does not compel us to assent to it. A reader might read Alyosha's argument and say to him- or herself, "You know, I disagree; I actually think hard lessons from *adulthood* provide the best education," and there would be nothing illogical in thinking this. It is just as plausibly true as Alyosha's argument. So, what makes Alyosha's argument so compelling to the reader of *The Brothers Karamazov*? We are moved to agree with Alyosha

9. Dostoevsky, *Brothers Karamazov*, epilogue, chap. 3, 774. The first premise of this argument is very nearly a direct quotation of what Alyosha says on p. 774.

74

because of all the kind and brave images of Ilyusha, especially the images of his death, that Dostoevsky has composed for us. Poetic argumentation is the *infima doctrina*, the "least of doctrines," because its arguments are based on the power of images, images that can either attract or repel but that can never command logical assent.

In the introduction I mentioned a text from Aquinas that underscores how poetic arguments provoke assent through images. It is one of the key texts of the medieval period where we find poetry classified as a branch of logic. There are three modes of reasoning, Aquinas says in this text, that fall short of the full certitude we expect from science, and they are called dialectic, rhetoric, and poetics. Poetry is the mode of reasoning at the furthest remove from the certitude of science, for in poetry, we "incline to one side of a contradiction," in Aquinas's language; that is, we assent to the conclusion of a poetic argument because of the power of its images. Here is the text:

> At other times a conjecture only [or "mere fancy": *sola existimatio*] inclines one to one side of a contradiction because of some representation, as when a certain food is made disgusting to a man if it is represented to him in the likeness of something disgusting. And to this is ordained the *Poetics*. For the poet's task is to lead us to something virtuous by some becoming representation.[10]

10. "Quandoque vero sola existimatio declinat in aliquam partem contradictionis propter aliquam repraesentationem, ad modum quo fit homini abominatio alicuius cibi, si repraesentetur ei sub similitudine alicuius abominabilis. Et ad hoc ordinatur poetica; nam poetae est inducere ad aliquod virtuosum per aliquam decentem repraesentationem" (Aquinas, *Expositio libri Posteriorum Analyticorum*, liber 1, lectio 1, from the Leonine text available at *Corpus Thomisticum*, accessed May 30, 2023, https://www.corpusthomisticum.org/cpa1.html; translation my own). The translation of *sola existimatio* as "mere fancy" is that of Fabian Larcher found at *Aquinas: Commentary on the Posterior Analytics of Aristotle*, trans. F.R. Larcher, preface by James A. Weisheipl (Albany, NY: Magi Books, 1970), available online at http://www.logicmuseum.com/authors/aquinas/posterioranalytics/aquinasPA.htm.

The comparison Aquinas makes here between poetic argument and the way in which we turn away in disgust from a certain food if it is represented to us in a disgusting way illuminates the way in which images have the power to attract or repel. For me, at any rate, advertisements for fast-food restaurants, with their intense close-ups of cheeseburgers and pizza, sometimes have the opposite of their intended effect: they in fact make me turn away in disgust from the food on offer. Likewise, Aquinas says, poetic images cause us to have an emotional reaction: either to incline toward the virtuous action being pictured—or, presumably, recoil from the pictures of vice.

Later, in chapter 7, we will delve into the implications of the final line in this text, in which Aquinas declares that the function of poetry is to induce us to virtue. For now, let me once more point out what is potentially misleading in thinking about "poetry," or storytelling, in terms of an argument or syllogism. Precisely because they take the form of statements, poetic syllogisms can mislead us into thinking that statements alone are what provide the "reasons" for a story's conclusion, when it is really the story's images that provide the "reasons," even when those images contain characters or narrators who make statements and verbal arguments.

The certitude of the demonstrative syllogism, found in the syllogism regarding Socrates's mortality, sets a very high bar for certitude. On this scale, the degree of certitude produced by a story is weak indeed. But when you think of the experiences you have had being moved by a favorite story, you realize that storytelling's weak degree of certitude still packs a powerful punch. Central to what is so powerful is the moral truth put on display by the story, that aspect of the end of human beings, in Slade's terms, against which the purposes of the protagonist are found either adequate or inadequate. Consider each of the three stories I alluded to at the beginning of this section, and you will find a moral truth being argued for: ruthless ambition leads

to personal destruction (*Macbeth*); the memory of kindness and bravery can educate one in virtue (*The Brothers Karamazov*); evil is a force that can be overcome by courage and loyalty (*Star Wars: Episode IV—A New Hope*). Stories make moral arguments. I would even say that they are a kind of moral philosophy, though a philosophy that works by imagery and dramatization. Let us look now at a more extensive example of a story so as to see better how story structure functions as dramatized argument.

STORY AS THE LIVING PROOF OF A CONTROLLING IDEA

In Sam Mendes' World War I drama *1917* (Universal Pictures, 2019), the protagonist, Lance Corporal Will Schofield, is sent with one of his comrades on a dangerous mission. Schofield and his comrade are tasked to deliver a message that, if delivered in time (the next morning), will prevent 1,600 men from falling into a trap set by the Germans. At its core, *1917* is an elegantly simple adventure story. However momentous its import, the protagonist, Schofield, has a simple goal or purpose: *deliver the message on time*. Of course, achievement of the goal is not easy. Schofield and his comrade are pressed to overcome a series of progressive complications, beginning with the crossing of No-Man's-Land and including an encounter with a downed German pilot and another with a German sniper.

The film is about rescuing 1,600 men, and so its principal theme is the beauty and nobility of courage: the sacrificing of great things—including one's life—for the sake of others in a just cause. If pressed to put the argument of *1917* into strict syllogistic form, I would put it in the following way:

The sacrifice of great goods in the courageous service of others reveals all that is beautiful and noble in human beings.

Rescuing 1,600 of one's comrades demands the sacrifice of great goods in the courageous service of others.

Therefore, rescuing 1,600 of one's comrades reveals all that is beautiful and noble in human beings.

As we watch *1917* in the movie theater or at home, this argument is not, of course, presented to us in the form of statements. It is presented to us in the form of pictures, of imitated actions on screen, dramatized acts of courageous sacrifice that "argue," so to speak, for their beauty and nobility. Either we are impressed by the images of courageous sacrifice Sam Mendes offers us, or we are not. We are not logically compelled either way.

Putting a film in the strict form of a poetic syllogism is, again, an exercise meant to help us learn how to think about films, and all stories, as arguments. The premises of the poetic syllogism have a lot of dramatic action packed into them. Let us continue to think about stories as arguments by unpacking the dramatic action of *1917* to see how it works in defense of the film's conclusion. For this, I will enlist the aid of Robert McKee. McKee is one of Hollywood's most revered screenwriting teachers and has coached many Oscar-winning writers, directors, actors, and producers. His celebrated book *Story* is the best treatment of story structure I know, in large part because McKee takes a perceptively philosophical approach to story.

For McKee, a film (or any kind of story) is about proving a Controlling Idea. He defines the Controlling Idea as a single sentence "describing how and why life [for the story's protagonist] undergoes change from one condition of existence at the

beginning [of the story] to another at the end."[11] He analyzes the Controlling Idea into two components:

Value + Cause

The value in a Controlling Idea refers to the good or evil or ironic mixture of good and evil of whatever emerges as victorious through the climactic action of the story. The cause is the main agency that brings this value or mixture of values about. By thus combining a film's dominant value and its cause, the Controlling Idea of a film "expresses the core meaning of the story."[12]

Take a simple example: Aesop's fable "The Tortoise and the Hare." What is the moral of this story? *Slow and steady wins the race.* This sentence expresses the story's Controlling Idea. It contains a value, in this case, a positive value, *winning the race*, and a cause or agency that brings this value about: *being slow and steady*, in other words, the virtue of *perseverance*. The actions of the story are images Aesop puts forward to prove this Controlling Idea to us. By engaging with images of the hare's hubris and the tortoise's dogged persistence, we are encouraged, though not compelled, to agree that *Slow and steady wins the race.*

Does McKee's focus on the proof of a Controlling Idea contradict what O'Connor says about story as experienced meaning? McKee seems to place the meaning of a story in a theoretical statement of its Controlling Idea, while O'Connor denies that the meaning of a story can be adequately captured by such a statement.

There is no conflict between McKee and O'Connor here. McKee is not suggesting that a story's Controlling Idea can *replace* the story. He knows that even the best Controlling Idea is a poor substitute for the experienced meaning gained by actually

11. Robert McKee, *Story: Substance, Structure, Style, and the Principles of Screenwriting* (New York: ReganBooks, 1997), 115.

12. McKee, 115.

engaging with the story. He acknowledges that an audience can only be convinced of a Controlling Idea by seeing or reading and feeling the events of the story. O'Connor rightly advocates that "fiction writing is very seldom a matter of saying things; it is a matter of showing things."[13] And McKee, in fact, trenchantly remarks upon the priority of dramatized action over any bare statements of ideas on the part of an author:

> Master storytellers never explain. They do the hard, painfully creative thing—they dramatize. Audiences are rarely interested, and certainly never convinced, when forced to listen to the discussion of ideas. Dialogue, the natural talk of characters pursuing desire, is not a platform for the filmmaker's philosophy. Explanations of authorial ideas, whether in dialogue or narration, seriously diminish a film's quality. A great story authenticates its ideas solely within the dynamics of its events; failure to express a view of life through the pure, honest consequences of human choice and action is a creative defeat no amount of clever language can salvage."[14]

It is worth noting, too, that O'Connor herself in "Writing Short Stories" states, or at least begins to state, the Controlling Idea of her own short story "Good Country People": "[Hulga] believes in nothing but her own belief in nothing, and we perceive that there is a wooden part of her soul that corresponds to her wooden leg."[15] Hulga's "belief in nothing," O'Connor intimates here, is the cause of the story's ironic ending (+Value mixed with -Value). What is that ironic mixture of values? Hulga's having been duped and her wooden leg stolen (-Value), an occurrence, however, that shocks her into opening her eyes to the poverty of her nihilistic outlook on life (+Value).

13. O'Connor, "Writing Short Stories," 93.
14. McKee, *Story*, 114.
15. O'Connor, "Writing Short Stories," 99.

But how do we square McKee's notion of the Controlling Idea with our analysis of the poetic syllogism? Are they the same thing? Or do these ideas refer to different things?

McKee's notion of the Controlling Idea includes *both* the conclusion of the film's poetic syllogism *and* the syllogism's middle term. McKee is interested in the value that emerges in the conclusion of a film, be it positive, negative, or a mixture of both. The film *1917* ends (spoiler warning) on a positive value: the rescue of 1,600 comrades from an ambush as revelatory of what is beautiful and noble in human beings. But McKee is also interested in the cause or reason why this positive value "wins" the film's argument. Which is to say, McKee is interested in the middle term of the film's poetic syllogism—the term, present in each one of the two premises, which brings the subject and the predicate of the conclusion together. For this reason, McKee includes the cause or middle term in the statement of the Controlling Idea. Accordingly, because the Controlling Idea of a story includes both the conclusion and middle term of a story's poetic syllogism, we can say that the Controlling Idea is a synopsis of a story's poetic syllogism.

At least in stories that end on a positive value, some aspect of the genuine end of human beings, some aspect of the life of virtue, will be manifest in a story's Controlling Idea, typically in the causal term. In "The Tortoise and the Hare," it is being slow and steady that reveals an aspect of the end, not of tortoises, but of the human beings they allegorize. For it is part of the human end to exercise perseverance in the face of prolonged difficulties. Likewise, it is part of the human end to exercise courage in beautiful and noble acts of sacrifice, and this is the end made manifest by *1917*.[16] In stories that end on a negative or on an ironic

16. In taking courageous action as the middle term of *1917*'s poetic syllogism, I am understanding courage as an efficient or moving cause. But in another sense, courageous action *just is* part of the human end, whether that action successfully achieves its purpose (saving 1,600 men) or not. In this latter sense, courageous action is understood either as a formal or a final cause.

mixture of values, the causal term will indicate a human defect. Hamlet's indecisiveness is the cause of both his and his nation's downfall. Hulga's "belief in nothing" is the cause of the negative value of her being duped, which has the positive effect of making room for self-knowledge.

In his book McKee offers the following definition of story:

> Storytelling is the creative demonstration of truth. A story is the living proof of an idea, the conversion of idea to action. A story's event structure is the means by which you first express, then prove your idea . . . without explanation.[17]

That first sentence makes a powerful claim: *Storytelling is the creative demonstration of truth.* This links story with argument, with syllogizing, with the amassing of evidence in support of a conclusion. *It links storytelling with the quest for truth.* A story, however, is "the living proof" of an idea, which means that it is not a series of theoretical statements and arguments but a mimetic picturing. By the closing phrase "without explanation," McKee refers to the way in which stories prove their Controlling Ideas without theoretical statements of explanation.[18]

The "premises" of *1917*'s argument are thus to be found in its "event structure" or plot. The "living proof" of the film's conclusion is *experienced* by the audience through the actions Schofield takes to achieve his goal. When, for example, Schofield, in the scene immediately preceding the climax, sprints across a battlefield where British forces are charging out of their trenches

17. McKee, *Story*, 113.

18. McKee's idea that a story should prove its Controlling Idea "without explanation" harmonizes well with David Mamet's insistence that a film tell its story in cuts that are "basically uninflected." See Mamet's *On Directing Film* (New York, Penguin, 1992), chap. 1, p. 2. Both statements encourage the storyteller to let images do the work of persuasion—in other words, to dispense with narration or dialogue that holds the audience's hand in order to convince them of the value of the Controlling Idea. Excellence in such "enactive mimesis," recall, is what Aristotle, at *Poetics* 24, praises Homer for. The portrayal of enactive mimesis is a far more satisfying experience for the audience than explanation. As the director Billy Wilder once remarked: "Let the audience add up two plus two. They'll love you forever."

toward the enemy, German bombs exploding all around him and his goal so close yet in greatest jeopardy, the audience experiences the truth beautifully embodied in the Controlling Idea. We *see and feel and are persuaded by* the power of the value at stake in this action, and we *see and feel and are persuaded by* the power of the causal agency that brings about this value: Schofield's indefatigable courage.

We have been endeavoring to understand how stories work as arguments, first by considering how stories can be compressed into poetic syllogisms, then by considering how a story functions as proof for a Controlling Idea. But you might be wondering about how another idea we've talked about, one that I first introduced back in chapter 1, relates to this discussion: the idea of the mimetic universal. Allow me to say a word about this connection.

Recall, first, that the mimetic universal, just like any universal notion, is something that is grasped by the mind. When we watch *1917*, we immerse ourselves in the mimetic action unfolding on screen. Our senses of sight and hearing are fully engaged, as are our imagination and appetites, but our mind, too, is at work, beginning to articulate for itself what the mimetic action is all about. We may not have it all worked out during the screening of the film; it may take continued reflection after the film is over, perhaps in conversation with friends. But hopefully, at some point, we will successfully articulate the "blueprint" for the meaning of the film; we will grasp the film's mimetic universal. The mimetic universal seems equivalent to what is known as the major premise of the poetic syllogism, the premise that includes both the middle term of the syllogism—the causal term of McKee's Controlling Idea—and the predicate of its conclusion. In *1917*, the mimetic universal is captured in the major premise, "The sacrifice of great goods in the courageous service of others reveals all that is beautiful and noble in human beings." What our mind grasps in a story's mimetic universal is the substantial

form of the artwork, that which shapes the matter of the work and accounts for the work's being what it is.

STORY AS DRAMATIZED DIALECTICAL DEBATE

Every story manifests a movement from appearance to reality. Sherlock Holmes must investigate various suspects, each of whom appears to be the murderer, on his way to identifying the real murderer in the case. Hulga is attracted to the prospect of seducing a Bible salesman, who appears to be a naïve Christian believer, only to be shocked by the reality of the salesman's deviousness. And Lance Corporal Schofield is asked to take up a mission that appears to be doomed to failure, only to see his bravery make possible a very different reality.

In its movement from appearance to reality, a story works *dialectically*. What does this mean? It means, first, that a story does not make a beeline from appearance to reality. Holmes does not arrive on the scene, assemble a group of suspects, and immediately identify the murderer. That wouldn't make for much of a story. Anyway, the appearances are too complicated for such an easy procedure. What happens is that Holmes arrives on the scene and slowly discovers that several people appear to have had motive and opportunity to commit the murder. The appearances *conflict*; they generate puzzles and ambiguities; and Holmes's task is to carefully examine each one of the conflicts, puzzles, and ambiguities in order to resolve and clarify them. This work of sifting through appearances is a dialectical procedure, where one idea or possibility is pitted against a counter-idea or counter-possibility. Only when this sifting work is done will the ground have been sufficiently cleared for Holmes to have the insight that will solve the crime.[19]

19. Throughout this discussion of dialectic, I rely especially on Kurt Pritzl, "Ways of Truth and Ways of Opinion in Aristotle," *Proceedings of the American Catholic Philosophical Association* 67 (1993): 241–52; and Richard Kraut, "How to Justify Ethical Propositions: Aristotle's

Similarly, what makes Lance Corporal Schofield so compelling a character is the way in which he overcomes so many obstacles, so many *apparent* defeats, that test the mettle, the *reality*, of his courage. If Schofield were able to just pick up a field telephone and deliver his message without difficulty, we would have no reason to be especially impressed by the value of the lives of the 1,600 men saved by his phone call or by whatever courage Schofield possesses. The power of *1917*'s Controlling Idea would not be argued for. In fact, there would not even be a Controlling Idea because, without conflict, there would be no story. Stories are images of a protagonist in the constant conflict that sifts appearances.[20] *But the necessity of conflict means that the value depicted in a film's Controlling Idea must be challenged dialectically by at least one other conflicting value, or counter-value.* The simple structure of *1917* helps us readily to identify the film's dialectic: on the one hand, there is the positive value of Schofield's indefatigable courage; on the other hand, there is the opposing negative value of the German army and its goal of gaining an advantage in the war by luring 1,600 British soldiers into a trap.[21] More precisely, the conflicting counter-value is Schofield's *fear* of the German threat. Throughout the film, Schofield's courage and the fear of defeat engage dialectically and "argue" back and forth. McKee describes the dialectics of a film's plot-structure this way:

> These events echo the contradictory voices of one theme. Sequence by sequence, often scene by scene, the positive Idea and its negative Counter-Idea argue, so to speak, back and forth, creating a dramatized dialectical debate. At climax

Method," in *The Blackwell Guide to Aristotle's Nicomachean Ethics*, ed. Richard Kraut (New York: Blackwell, 2006), 76–95.

20. Again, Billy Wilder on the three-act structure of a conventional Hollywood film: 1. You get your hero up a tree. 2. You throw rocks at him. 3. You get him down from the tree.

21. In a broader sense, all German forces of antagonism in the film, to include the downed pilot and the sniper, stand in for this counter-value.

one of these two voices wins and becomes the story's Controlling Idea.[22]

What is the one theme of *1917*? *How to deal with the dangers involved in delivering the message.* Does one attack the dangers with courage, or does one flee them out of fear? That question poses the dialectic of the film. What is the one theme of "Good Country People"? *Who is the real nihilist?* Is it Hulga, the duped seducer, or is it the devious Bible salesman?

The kind of dialectical debate that we find in stories is a dramatized version of the theoretical dialectical debate that philosophers engage in when they proceed in their inquiries from appearance to reality. Take, for example, Aristotle's dialectical inquiry that begins his *Nicomachean Ethics*.

What is the one theme that Aristotle is curious about as he launches the study of ethics? The nature of the ultimate end of human action: *happiness.* But his situation is analogous to that of Sherlock Holmes and Lance Corporal Schofield. He cannot simply slap down a definition of happiness and then get on with other matters. He is faced with too many conflicting appearances, too many puzzles and ambiguities, too many things that *look like* they might be happiness. So, like a fictional protagonist, Aristotle sifts through these appearances and pits one against another in the hope of resolving the puzzles and clarifying the ambiguities.

The appearances that Aristotle collects and sifts through in the first book of his *Nicomachean Ethics* are of a special kind. They are reputable opinions about happiness. Whose opinions are these? Reputable opinions are those opinions that are of some "repute," that we have reason to give some credit to. Reputable opinions are not held by just anyone but, as Aristotle says, by many people (which alone gives credit to the opinion), by the wise, or by both the many and the wise. It may seem strange

22. McKee, *Story*, 119.

to us that Aristotle even bothers with reputable opinion. Why doesn't he just offer us his own thoughts about happiness? The answer to this question is twofold. First, Aristotle has great confidence in reason's ability, once it becomes familiar with an area of inquiry, to hit upon something of the truth. Truth, for Aristotle, is like the proverbial barn door: it is virtually impossible to miss it entirely. For this reason, Aristotle eagerly collects reputable opinions (in Greek, *endoxa*) about whatever topic into which he is inquiring because he knows these opinions are bearers of reality, of truth. It is just because his dialectical procedure shows great confidence in the human ability to grasp reality that it also shows great humility in submitting to the opinions of others. The second reason why Aristotle does not go straight to his own thoughts about happiness is because the puzzles and ambiguities generated by the reputable opinions about happiness are his puzzles and ambiguities. He does not know, or cannot give final credit to, his own reputable opinions until he resolves the puzzles and clarifies the ambiguities in the reputable opinions of others.

The following is one example of how Aristotle sifts through reputable opinions about happiness:

There is a reputable opinion, one very much alive in our own day, that says happiness consists in sense pleasure. The opinion is reputable not only because so many people believe it, but also, for Aristotle, because the Assyrian king Sardanapallus (669–626 BC)—one of the wise?—lived in legendary luxury.[23] Yet Aristotle challenges this reputable opinion with another: the life of sense pleasure cannot be the ultimate end we human beings desire, for that is the same end as that of grazing animals.

Dialectical arguments, like poetic ones, can be put into the form of syllogisms. Here are the two dialectical arguments facing off at this point in Aristotle's inquiry into happiness:

23. Aristotle, *Nicomachean Ethics* 1.5 (1095b17–22). For the information on Sardanapallus, I am grateful to Terence Irwin's notes to his translation of the *Nicomachean Ethics*, 2nd ed. (Indianapolis, IN: Hackett, 1999), 177.

The Argument for Sense Pleasure as Happiness	The Argument against Sense Pleasure as Happiness
The thing people like more than anything else is sense pleasure. Happiness is the thing people like more than anything else. Therefore, happiness consists in sense pleasure.	The life characteristic of lower animals is one of sense pleasure. Human happiness cannot consist in a life characteristic of lower animals. Therefore, happiness cannot consist in sense pleasure.

Let us now go back to the world of story and see how such dialectical conflict in the theoretical or philosophical mode is particularized and dramatized in a narrative conflict. In Evelyn Waugh's comic novel *Vile Bodies*, a group of wealthy and privileged "bright young things" are depicted living the life of Sardanapallus. They go from party to party, drunken rout to drunken rout, little thinking of the vacuity of their lives or the consequences of their actions. The protagonist of the novel, Adam Fenwick-Symes, and the young woman he wants to marry, Nina Blount, are part of this circle of partygoers. At one point, Adam, prompted by one more party invitation, peers suddenly into the vacuum of his existence:

> "Oh, Nina, what a lot of parties."
> (. . . Masked parties, Savage parties, Victorian parties, Greek parties, Wild West parties, Russian parties, Circus parties, parties where one had to dress as somebody else, almost naked parties in St. John's Wood, parties in flats and studios and houses and ships and hotels and night clubs, in windmills and swimming baths, tea parties at school where one ate muffins and meringues and tinned crab, parties at Oxford where one drank brown sherry and smoked Turkish cigarettes, dull dances in London and comic dances in Scotland and

disgusting dances in Paris—all that succession and repetition of massed humanity. . . . Those vile bodies . . .)

He lent his forehead, to cool it, on Nina's arm and kissed her in the hollow of her forearm.

"I know, darling," she said and put her hand on his hair.[24]

The phrase "vile bodies," whether Adam knows it or not (and probably not), is from Philippians 3:21 (King James Version): "Who shall change our vile body, that it may be fashioned like unto his glorious body, according to the working whereby he is able even to subdue all things unto himself." The reference helps us, if not Adam and Nina, see the purposes of their vile bodies profiled, most inadequately, against the supernatural end of human life, where our bodies, like Christ's body, will be glorified. But even if Adam and Nina do not have this much insight, they have enough at least to be exhausted and bored by the endless cycle of partygoing. They do not explicitly articulate the dialectical argument against sense pleasure set forth in the syllogism above, but they articulate enough ("Oh, Nina, *what a lot of parties*") to indicate that they have some vague sense they are not happy, that they are living less than human lives.

We have been looking at two dialectical arguments in conflict, in both philosophical and literary modes. How do we know which one wins the debate? In other words, how do we know when we have moved from appearances to reality? In Aristotle's dialectical treatment of sense pleasure, it seems that his judgment that those who hold that happiness consists in sense pleasure "appear completely slavish, since the life they decide on is a life for grazing animals"[25] is the judgment that wins the day. Yet it is at this point that he adds the allusion to Sardanapallus in defense of those who believe happiness is found in sense pleasure: "Still, they

24. Evelyn Waugh, *Vile Bodies* (New York: Little, Brown, 1999), 170–71.
25. *Nicomachean Ethics* 1.5 (1095b19–21). Translations from the *Nicomachean Ethics* are by Terence Irwin in the Hackett edition.

have some argument in their defense, since many in positions of power feel as Sardanapallus felt, [and also choose this life]."[26] So why should the judgment regarding the slavish nature of sense pleasure win the day?

Keep in mind, first, that a dialectical argument is an argument based on opinion, albeit reputable ones. All the premises in the syllogisms above are based on what people say about happiness. At the same time, however, as we have noted, what people with reputable opinions say about happiness contains a certain amount of reality or truth. We must realize, then, that in examining reputable opinions, we are *already* dealing with reality. We are not simply stuck in the minds and thoughts of those who hold the reputable opinions. Their opinions reflect reality, to one extent or another. In fact, in his *Republic*, Plato defines opinion as a mixture of reality and unreality, of the true and the false. The philosopher's job, the fictional protagonist's job, is to distinguish between what is real and what is unreal in the reputable opinions he and others hold. Aristotle thinks he has made an important distinction that disqualifies the opinion that happiness consists in sense pleasure: the happiness he is looking for *has to be* the happiness commensurate with the powers distinctive of human beings—which is to say, our rational powers. Human happiness by definition *must be* an achievement befitting a rational animal. Mark well the imperatives in these last two sentences. Aristotle believes he has hit upon a necessity, a requirement of the human essence, and this note of necessity means that, to his way of thinking, he has hit upon something that cannot be denied, on pain of being illogical. He has hit upon *reality* pure and simple.

In order to move from the opinions of dialectical argument to a grasp of the real without puzzles and ambiguities, intellectual *insight* must occur, insight into some necessary characteristic of whatever topic is under discussion—in our case, happiness. Aristotle's procedure, to put it in the briefest terms, is to collect

26. *Nicomachean Ethics* 1.5 (1095b21–22).

these insights and use them to fashion a theory about the true nature of happiness. His theory is that happiness is the activity of exercising our rational powers along lines of excellence. And one reason Aristotle has confidence in his theory is not only that it contains the thought that human happiness must be defined by the exercise of our rational powers but also because it "saves" the partial and obscure reality contained in the reputable opinions he eliminated as candidates for happiness. To exercise reason along lines of excellence—that is, to live the virtues—involves, as Aristotle's argument will take pains to make clear, the enjoyment of sense pleasure. Sense pleasure is not the essence of the happy life, but it must be a part of any happy life as long as it is regulated by the virtue of temperance.

A fictional protagonist must also garner insights from the conflicts, puzzles, and ambiguities he or she encounters and use those insights to move more fully and clearly into the light of truth. There will always be a moment in a Sherlock Holmes story when Holmes simply *sees* what must be the case. At the climactic moment of *1917*, Lance Corporal Schofield simply *sees* that if he doesn't test his courage to the limit by running across an open battlefield so that he can deliver his message on time, then the beauty and nobility of his humanity will be lost. And at a key moment in Jane Austen's *Pride and Prejudice*, Elizabeth Bennet simply *sees* how she has been seduced by appearances, how her own pride and prejudice have blinded her to the reality of Mr. Wickham's and Mr. Darcy's characters: "Till this moment, I never knew myself."[27]

But poor Adam Fenwick-Symes. He fails to nurture his moment of insight. The last we see of him, he has lost Nina forever, as a war, not a party, circles him like a typhoon. There is never a guarantee that we will successfully journey from appearance to reality.

27. Jane Austen, *Pride and Prejudice* (New York: Penguin, 2014), vol. 2, chap. 13, 202.

STORY AS MORAL ARGUMENT

In this chapter, we have been thinking about how stories function as arguments, and specifically as moral arguments that give us experiential ethical knowledge about the end of human life. To picture human beings in stories is to show them either achieving or destroying their happiness. As we read a story or watch a film or drama, the narrative holds us in suspense as we wait to see if the protagonist's choices will secure the happiness he or she explicitly or implicitly desires.

Stories show us their moral truths by way of dramatization. They dramatize a debate between the habits and attitudes of the protagonist and the counter-habits and counter-attitudes or even just counter-energies of whatever forces of antagonism the protagonist faces.[28] Schofield's courage is at cross-purposes with his fear of his German enemies; Jo March's desire in *Little Women* to become independent as a writer is at cross-purposes with Laurie's feelings for her and her own desires for marriage and family. Happiness as conventionally conceived by the protagonist at the beginning of his quest is thus challenged by rival forces or rival conceptions of happiness. Often enough, the protagonist's conception of happiness, while challenged, will not change from the beginning to the end of the story, though it may well *deepen* on account of having been put in so much jeopardy. In other kinds of stories, however, the protagonist's conception of happiness will *transform* under the pressure of the conflicts the protagonist endures. This is a trope of romantic comedies, such as we find paradigmatically in Austen's *Pride and Prejudice.* The person thought by Elizabeth Bennet to be a source of romantic fulfillment (Mr. Wickham) is discovered not to be so; and in fact, it is the person originally found to be offensive (Mr. Darcy) who turns out to be the real source of happiness. But whether the conception of

28. I add "counter-energies" because the force of antagonism in a story may be a purely natural force, like a storm at sea or a tornado.

happiness remains the same, deepens, or transforms altogether, when some aspect of happiness, or unhappiness, shows itself to be the victorious value in the film's Controlling Idea, it shows itself as part of the *true* conception of happiness or the reverse. In the dialectical engagement of the story, various reputable opinions about happiness have been, as it were, canvassed, with the result that what is necessary for human happiness—necessary according to the film's poetic persuasion—emerges as the standard of truth.

A story immerses us in its argument, in its dramatized debate, in the hope of persuading us of the truth of its Controlling Idea.[29] We are not logically compelled to assent to the Controlling Idea, but powerful imagery can so delight us that we assent to a story's argument even against our better judgment. This possibility underscores the importance of stories that help us think and feel more deeply about the good moral life that we, the audience, are already living. We do not engage with stories as neutral observers. We come to a story with settled habits and attitudes that will either be broadly in sync with or in conflict with the argument of the story. It is, of course, important to engage with stories outside one's own cultural commitments. But stories that actively undermine good moral formation are dangerous and should be entertained only by those with sufficient maturity and sufficient critical awareness and purpose.

But insofar as the Controlling Idea of a story manifests something true about human happiness, the story helps us transcend our egos and acts as a powerful intrusion upon misguided self-understanding. The truth manifested is not demonstrative. It cannot compel intellectual assent. But by appealing to our senses, our intellect, and our will with delightful picturing, a story can move us to an intellectual-appetitive assent that is more

29. Stories also make use of rhetoric in the dialogue and speeches uttered by the characters, as well as in effects, in film for example, such as a musical soundtrack and surround sound. Such rhetorical effects help the dialectic of the plot summon the emotions that persuade the audience of the truth of the film's Controlling Idea.

immediately attractive than purely theoretical argument and more connatural to our lives as embodied spirits.

In the past two chapters, we have been considering the way in which mimetic art, and in particular narrative art or storytelling, pictures the human quest for happiness. We have seen that stories are arguments that try to convince us, through pleasing imagery, of how we ought to understand that quest. "Art is entangled with life with the aim of untangling life by making it clear to itself."[30] Yet happiness, as understood in the Aristotelian-Thomistic tradition, is incomplete in this life. The human destiny ultimately lies in a transcendent realm, where we hope to lovingly contemplate the beatific vision, he who is beatitude, for all eternity. No discussion of mimetic art in the Aristotelian-Thomistic tradition, then, can be complete without an account of art that imagines the human quest from the point of view of our ultimate destiny. What is needed is a discussion of the specifically Catholic imagination. By the term Catholic imagination, I do not refer simply to the psychological power of the imagination, a power that every human being possesses. I mean a way of seeing reality through images, a seeing that is informed by Catholic belief, practice, and culture. As I hope to show as my argument unfolds, this way of seeing involves human rationality and human appetitive life (both the will and the sense appetites) just as much as the psychological power of imagination. But because it expresses itself in artistic images, we call this way of seeing the Catholic imagination. As we pursue now an understanding of this imagination, our discussion will necessarily turn theological, but it will involve definitions and distinctions, like those having to do with the narrative structure of human life, that depend upon a properly philosophical inquiry.

30. This statement by Francis Slade is quoted by Sokolowski in "Visual Intelligence in Painting," 346.

4

The Catholic Imagination

A live man enters the realm of the dead. A "high concept" story pitch if ever there was one.

When we first meet this man, he is lost, wandering in a dark wood. How did he get there? What was he up to? We are not told. He attempts to find a way out. He sees a mountain in the distance and makes for it. But he is prevented from climbing it by three ravenous beasts, who force him back toward the wood. He is now more lost than ever.

But then the man encounters someone. Not another live man but, incredibly, a denizen of the inferno, the dreadful pit for souls cut off from the mercy of God. The two men did not know one another in life. But the live man, a poet, always took the dead man, a very famous poet, as his hero. The dead man is there to help him, but not in the way the live man wants. If he is to return home again, the live man will need to go on a most unexpected journey. He will need to descend into the pit of the inferno, to discover the true horror of sin; then ascend the mountain of purgatory, that he might learn what it means to cleanse oneself of the effects of sin; finally, he will need to ascend into paradise, so that he can realize the nature of his true home. It is apparent, now, that the man's wandering in the wood is not simply due to a wrong turn in the literal sense, but that he has made a wrong turn in a deeper, moral, indeed spiritual, sense.

IMAGINING THE THEO-DRAMA

You did not choose me, but I chose you.
John 15:16

Will it sell to Netflix or Amazon? Perhaps not. Nonetheless, Dante's *Commedia*, later nicknamed by Boccaccio *The Divine Comedy*, endures as one of the greatest works of literature ever written. It also marks a groundbreaking new literary genre[1] and stands quite arguably as the most glorious monument of Catholic artistic culture. Dante's *Commedia* just *is* the Catholic imagination in its highest and best form. With a vivid diversity of character and conflict and a richness of language rivaled only by Shakespeare, Dante's *Commedia* shows us, not just tells us, what it means and how it feels to be a human actor in what theologian Hans Urs von Balthasar calls the "theo-drama."

By "theo-drama," Balthasar means *God's drama*, the story of creation, our fall, and our salvation.[2] The theo-drama is the story of human life as seen not from the perspective we have been taking since chapter 2—that is, from the human perspective prescinding from faith—but from God's perspective as he mercifully endeavors to help us attain unity with him. The theo-drama, again, is the story of human life raised to the supernatural plane, with the Triune God as its author. It is the story of God's love affair with humanity. Let us not miss this most important and profound point. At the end of the last chapter, I defined the Catholic imagination as a way of seeing reality through images, a

1. For an interpretation of the *Commedia* as an epic poem that also, via the influence of St. Augustine's spiritual autobiography in the *Confessions*, anticipates the modern novel's concern with the inner life of the individual, see John Freccero, "Shipwreck in the Prologue," in *In Dante's Wake: Reading from Medieval to Modern in the Augustinian Tradition*, ed. Danielle Callegari and Melissa Swain (New York: Fordham University Press, 2015).

2. "In theo-drama it is God's stage; the decisive content of the actions is what he does: God and man will never appear as equal partners. It is God who acts, on man, for man and then together with man; the involvement of man in the divine action is part of God's *action*, not a precondition of it." Balthasar, *Theo-Drama*, vol. 1, *Prolegomena*, trans. Graham Harrison (San Francisco: Ignatius, 1983), 18.

seeing that is informed by Catholic belief, practice, and culture. When we see in this way, what we see is our lives as story, as drama, a drama in which the protagonist, the main character, is God himself. Accordingly, the story of the man wandering in the dark wood that we read in Dante's *Commedia* is not principally Dante's story. It is God's story. God is the one who, out of sheer love, made a creature named Dante Alighieri with a heart that could only find ultimate fulfillment by entering into the communion of persons that is God's very life. God is the one who gave Dante the freedom to choose that communion or not choose it. God is the one who took the risk that Dante might not return love for love and that Dante might lose his way definitively.

Which is why when he sees Dante lost, God acts. He will risk losing Dante's love forever, but he will also do everything he can to avoid it. He acts, as is his wont, by generously delegating his power. As Virgil, the Roman poet, explains when he arrives to rescue Dante, he has been sent by a triumvirate of ladies.[3] Our Lord's Blessed Mother is the first to discover Dante's plight, about which she alerts St. Lucy, to whom Dante has a special devotion, who in turn alerts Beatrice, the woman, now in paradise, whom Dante has loved from childhood. It is Beatrice who comes down to limbo, the antechamber of hell reserved for virtuous souls like Virgil who lived and died before the Christian dispensation. Beatrice comes to ask Virgil, Dante's hero and paragon of poetic and philosophic wisdom, to be Dante's guide through hell and purgatory.

Now, I have to amend a point I made back in chapter 2 when I first spoke about human life as story. There I said that every human being is the protagonist of his or her own story. And that is true enough, speaking philosophically. But when we speak theologically, as we are doing now, we have to expand

3. *Inferno*, canto 2. Subsequent references to the *Commedia* will be abbreviated by canto and line number.

our horizon and say that because God is the chief protagonist in any human life, the human agent him- or herself is a secondary protagonist, a supporting actor. Which means that we, just like Dante, are secondary protagonists in the drama of our own salvation, and as we read the *Commedia*, we empathize with Dante's plight because we see it as a paradigm of our own deep alienation from ourselves, from one another, and from God. We empathize, too, with Dante's desire to overcome his alienation and achieve reintegration and wholeness. This is fundamentally what it means to appreciate a work of the Catholic imagination: to connect empathetically with the human protagonist depicted in it because we understand that we are, in an analogous way, living the same adventure.

The empathy we feel in enjoying a work of art like Dante's *Commedia* is not some amorphous emotional experience. It is a targeted mode of understanding, emotional apprehension, and interior transformation. It is an understanding, apprehension, and transformation by way of identifying with the image constructed by the artist. Human beings are strange animals. As the philosopher Iris Murdoch intriguingly puts it, "Man is the animal who makes pictures of himself, and then comes to resemble the picture."[4] That is, we human beings make pictures or images of our experience, whether it is a simple bedtime story or something as grand as Dante's *Commedia*, and then, in delighting in and thinking about the picture, we are changed by our empathetic connection to it into something closer to the picture.[5]

The mimetic arts as pursued according to the Catholic imagination are imitations of the art God makes in creating his theo-drama. Following the natural inclination of which Aristotle speaks in the *Poetics*, the Catholic imagination imitates the

4. Iris Murdoch, "Metaphysics and Ethics," in *Existentialists and Mystics: Writings on Philosophy and Literature*, ed. Peter Conradi (New York: Penguin, 1998), 75.

5. Murdoch in fact applies the quoted apothegm to the workings of moral philosophy, but it seems clear that she would accept a wide application of the insight, including to the workings of art.

theo-drama as a way of searching for and contemplating who we are truly meant to be as children of God. The Catholic imagination, therefore, is what Charles Williams calls a Way of Affirmation, an approach to God through images.[6]

In this chapter, I want to explore the nature of the Catholic imagination. As I proceed, in support of the theme that the Catholic imagination, like all mimetic art in the Aristotelian-Thomistic tradition, is a way of story, I will continue to take examples almost exclusively from the narrative arts. Again, in the second half of my argument, we will take up other mimetic arts. For now, however, let us consider Dante's Catholic imagination in action in one of the most compelling episodes from the *Inferno*.

ULYSSES'S LAST VOYAGE

Down in one of the deepest parts of the pit of hell, in the ditch reserved for evil counselors, Virgil shows Dante the damned soul of Ulysses, imprisoned with his comrade Diomedes within a tongue of fire.[7] Ulysses is a colorful Greek warlord who first appears by the name Odysseus in Homer's epic poems, the *Iliad* and *Odyssey*, and who also makes an appearance in Virgil's own great epic, the *Aeneid*. Ulysses and Diomedes are being punished, in particular, for two egregious acts of evil trickery: the Trojan horse scheme, by which the Greeks smuggled themselves into Troy, and, in the ensuing ambush, the theft of the Palladium, the tutelary statue of the goddess Pallas Athena.[8] Most strange about Dante's meeting

6. Charles Williams, *The Figure of Beatrice: A Study in Dante* (New York: Octagon Books, 1983), 9. Williams contrasts the Way of Affirmation with the Way of Rejection, the approach to God "in the renunciation of all images except the final one of God himself" (8). These two ways, Williams stresses, are not mutually exclusive ways to God, but companion ways. Nonetheless, "after the affirmations we may have to discover the rejections, but we must still believe that after the rejections the greater affirmations are to return" (10–11). For Williams, in "the literature of Europe the greatest record of the Way of Affirmation of Images is contained in the work of Dante Alighieri" (11).

7. *Inferno* 26.

8. Both acts are recounted by Virgil in *Aeneid*, bk. 2.

with Ulysses in hell is that Ulysses is a mythical figure. What is an imaginary character doing in hell? It is as if Dante had come upon the soul of Loki or Shakespeare's Iago.

Dante-the-poet has a good reason for wanting Dante-the-protagonist to meet Ulysses. According to John Freccero's analysis, Ulysses is a figure of the "proud philosopher" with "overweening confidence" in reason unaided by grace—a pitfall that Dante, according to the imagery of canto 1 of the *Inferno*, takes himself to have fallen into.[9] We could say that Dante's aim in this episode is to resituate Ulysses, and Dante's own misguided philosophical quest, within the theo-drama, to show what his life really looks like against the backdrop of the divine comedy. In order to understand how Dante does this, it is necessary first to know the story Ulysses tells Dante from his flame. It is one of the most gripping passages in the *Inferno*, an attempt at a total reboot of the Ulysses franchise. I will only paraphrase it here.

As we find him in Homer's *Odyssey*, Ulysses is the war-weary husband and father who, more than anything else, just wants to get home to his wife, Penelope, and his son, Telemachus. The *Odyssey* is the story of his ten-year quest to achieve that goal. Dante's Ulysses tells the sequel to this story. After a time back at home with Penelope and Telemachus, Dante's Ulysses relates, he gets the itch to go to sea again:

> Neither the sweet affection for my son,
>> nor piety due my father, nor the love
>> I owed Penelope to being her joy

9. Freccero, "Shipwreck in the Prologue." Freccero argues that Dante takes this theme from St. Augustine, and then concludes:

> The extraordinary parallelism between [St. Augustine's] spiritual experience and Dante's, at roughly the same age, even with comparable erotic distractions, would be exact, if it had been Neoplatonists rather than Aristotelians who led Dante to the overweening confidence in philosophy he seemed to share with Guido Cavalcanti, his 'first friend.' But by far the most striking similarity in the spiritual adventures of Augustine and Dante is that both chose to describe the crisis of the proud philosopher in terms of the Homeric allegory of Ulysses, although, as even the most casual reader of the poem knows, Dante's Ulysses dies in a shipwreck. (14–15)

Could drive from me the burning to go forth
 to gain experience of the world, and learn
 of every human vice, and human worth.[10]

Ulysses's desire is to sail after knowledge, an apparently noble mo-
tivation. He musters a small band of loyal troops, and off they go
across the Mediterranean toward the Atlantic Ocean. Ulysses and
his mates must have been back at home a good while, it seems, as
Ulysses describes them as "stiff-limbed and old" by the time they
reach the Strait of Gibraltar (lines 106–08). At this point they
might wisely have stopped and turned back, for, as they well knew,
the god Hercules had set the Strait as a limit beyond which mor-
tal men were not to venture. As Anthony Esolen notes, the Strait
serve as a "symbol of the bounds beyond which human reason
and achievement, unaided by grace, cannot go."[11] But Ulysses will
have none of it. He exhorts his men:

"O brothers, who have borne innumerable
 dangers to reach the setting of the sun,
 from these few hours remaining to our watch,
From time so short in which to live and feel,
 do not refuse experience of the lands
 beyond the sun, the world where no one dwells.
Think well upon your nation and your seed!
 For you were never made to live like brutes,
 but to pursue the good in mind and deed."
I made my comrades' appetites so keen
 to take the journey, by this little speech,
 I hardly could have held them after that.[12]

10. *Inferno* 26.94–99. All quotations from the *Inferno* are taken from the Anthony Esolen
translation (New York: Random House, 2005).

11. See *Inferno*, note on 271.

12. *Inferno* 26.112–23.

This "little speech." You can hear Ulysses's whole character in that humblebrag. He knows his rhetoric has "killed it," that it has stoked the flames of his comrades' desire to be men of great deeds, so much so that he cannot hold them back. So they set off beyond the Strait on what even Ulysses calls a *folle volo*, a "mad flight."[13] They sail until they reach the Southern Hemisphere, where in the distance they see a mountain shore (which we will later learn is Mount Purgatory). The mountain represents the goal of their desires, the peak of their ambition. They have done it! They have boldly gone where no man has gone before. But in the very moment of their triumph, everything comes crashing down:

> We cheered, but soon that cheering turned to woe,
>> for then a whirlwind born from the strange land
>> battered our little vessel on the prow.
> Three times the boat and all the sea were whirled,
>> and at the fourth, to please Another's will,
>> the aft tipped in the air, the prow went down,
> Until the ocean closed above our bones.[14]

ULYSSES IN DEPTH; OR, THE ESSENTIAL ELEMENTS OF THE CATHOLIC IMAGINATION

Of all the episodes from Dante's *Commedia*, why choose this one to illustrate the Catholic imagination? For one thing, it is a great story, "perhaps the most beautiful thing in the whole *Inferno*," as Dorothy Sayers, the translator of the *Commedia*, attests.[15] Besides this fact, however, the story of Ulysses's last voyage, being a tragedy,

13. *Inferno* 26.125.
14. *Inferno* 26.136–42.
15. See Dorothy L. Sayers, *The Comedy of Dante Alighieri: Hell* (New York: Penguin, 1949), commentary on canto 26, esp. p. 238. Sayers remarks that Dante derives this story of Ulysses's last voyage from no classical source, and so it appears to be his own invention. And as Esolen remarks in his own commentary on *Inferno* 26, the "astonishing invention" of the story is even more astonishing given the fact that Dante knew Homer's *Odyssey* only secondhand (see p. 493).

illuminates the inadequacy of Ulysses's purposes to the divine end. Ulysses's "burning to go forth" is contrasted, now even in his own mind, with "Another's will," and so the distinction between human purposes and God's providence is thrown into stark relief.

I see the story of Ulysses's last voyage as a kind of foreshadowing of a story by a modern Catholic author, one that depicts an individual attempting to live only by his wits and by his will. To borrow a phrase from Walker Percy, Dante, in the story of Ulysses's last voyage, "names death-in-life," so that later Life itself might more effectively be proclaimed.[16] If we do not contemplate the condition of godforsakenness imaged by Ulysses and his companions, we cannot comprehend fully the meaning of the theo-drama as the central plot-structure of the Catholic imagination. So let us reflect further on this episode from the *Inferno*, as well as upon other narratives, in order to discern the Catholic imagination's essential elements.

The Catholic Imagination as the Concrete Expression of Mystery

I will open my mouth in parables,
I will utter what has been hidden
since the foundation of the world.
 Matthew 13:35

Now that he is in the ditch reserved for evil counselors, Ulysses understands that, while living, he mistook the adventure of his life. He thought he was living one sort of story, a crusade of courageous self-affirmation, while in fact he was playing a tragic role in the theo-drama. Even for those who enjoy the grace of Christian faith,

16. "But the novelist . . . must by virtue of his very calling be on the side of life. Otherwise, he would not go to the trouble of writing and put up with all the miseries and loneliness. But, before life can be affirmed for the novelist or his readers, death-in-life must be named. Naming death-in-life as Faulkner did with his character Quentin [i.e., Quentin Compson, in *The Sound and the Fury*] is a thousand times more life-affirming than all the life-affirming self-help books about me being okay and you being okay and everybody being okay when in fact everybody is not okay, but more than likely in deep trouble." Walker Percy, "Novel-Writing in an Apocalyptic Time," in *Signposts in a Strange Land*, ed. Patrick Samway (New York: Farrar, Straus and Giroux, 1991), 164.

much of the plot of the story unfolding day by day in and around our lives remains hidden. God's actions as author-protagonist of the theo-drama remain a mystery. Nevertheless, the Catholic imagination boldly endeavors to picture the mysterious workings of God's actions in the concrete particulars of the lives of human beings. As Flannery O'Connor once wrote to a friend:

> Fiction is the concrete expression of mystery—mystery that is lived. Catholics believe that all creation is good and that evil is the wrong use of good and that without Grace we use it wrong most of the time. It's almost impossible to write about supernatural Grace in fiction. We almost have to approach it negatively.[17]

And in one of his own letters, Evelyn Waugh articulates well the charge of the Catholic imagination to give, in O'Connor's phrase, "the concrete expression of mystery." Speaking of the poor reception that his novel *Brideshead Revisited* received from the American critic Edmund Wilson, Waugh wrote:

> He was outraged (quite legitimately by his standards) at finding God introduced into my story. I believe that you can only leave God out by making your characters pure abstractions. Countless admirable writers, perhaps some of the best in the world, succeed in this. . . . They try to represent the whole human mind and soul and yet omit its determining character—that of being God's creature with a defined purpose.
>
> So in my future books there will be two things to make them unpopular: a preoccupation with style and the attempt to represent man more fully, which, to me, means only one thing, man in his relation to God.[18]

17. Flannery O'Connor to Eileen Hall, March 10, 1956, in *Habit of Being*, 144.

18. Evelyn Waugh, "Fan-Fare," in *A Little Order: A Selection from His Journalism*, ed. Donat Gallagher (Boston: Little, Brown and Company, 1977), 31–32. Both this text from Waugh and the excerpt just above from Flannery O'Connor's letter are deployed by Thomas Prufer

For the first British edition of *Brideshead*, by way of acknowledging to his readers that this most unabashedly religious novel was a departure from his previous work, Waugh wrote a "Warning" for the dust-jacket in which he described *Brideshead* as "ambitious, perhaps intolerably presumptuous; nothing less than an attempt to trace the workings of divine purpose in a pagan world, in the lives of an English Catholic family, half-paganized themselves, in the world of 1923–39."[19]

Man in his relation to God, the workings of divine purpose—these mysteries, which no human being can entirely see or know, are what the Catholic imagination attempts to picture. And part of what it pictures, indeed the most important part, is the sense of mystery still left over when all that can be shown is shown: like the hidden seed of grace that breaks open in both the Grandmother's heart, and perhaps, too, the Misfit's heart, at the terrible climax of O'Connor's short story "A Good Man Is Hard to Find," or the hidden grace at work in Lord Marchmain's heart that moves him to his fateful decision on his deathbed.[20]

The task of the Catholic imagination would thus seem to be twofold: (1) to depict how the supernatural end of human beings, through the gift of grace delivered through Catholic sacramental life and Catholic culture more generally, helps to distinguish ends (supernatural and natural) from purposes; and (2) to show (likely enough in the same mimetic move) how the natural end is insufficient without the supernatural end—that is, how grace perfects nature.

But how to accomplish the "almost impossible" task of

in his marvelously perceptive essay "The Death of Charm and the Advent of Grace: Waugh's *Brideshead Revisited*," in *Recapitulations: Essays in Philosophy* (Washington, DC: The Catholic University of America Press, 1993).

19. Quoted by Douglas Lane Patey in *The Life of Evelyn Waugh* (Cambridge, MA: Blackwell, 1998), 224.

20. About "A Good Man is Hard to Find," O'Connor once wrote: "I don't want to equate the Misfit with the devil. I prefer to think that, however unlikely this may seem, the old lady's gesture, like the mustard-seed, will grow to be a great crow-filled tree in the Misfit's heart, and will be enough of a pain to him there to turn him into the prophet he was meant to become. But that's another story" ("On Her Own Work," in *Mystery and Manners*, 112–13).

depicting the action of grace in a story? O'Connor says, "We almost have to approach it negatively," by which presumably she means, as one necessary ingredient, the point I made above regarding Dante's story of Ulysses's last voyage: that the Catholic imagination must first present characters that have rejected or are at least fighting with grace:

> In my stories a reader will find that the devil accomplishes a good deal of groundwork that seems to be necessary before grace is effective. . . .
>
> To insure our sense of mystery, we need a sense of evil which sees the devil as a real spirit who must be made to name himself, and not simply to name himself as vague evil, but to name himself with his specific personality for every occasion. Literature, like virtue, does not thrive in an atmosphere where the devil is not recognized as existing both in himself and as a dramatic necessity for the writer.[21]

To insure our sense of mystery, O'Connor asserts, we need a sense of evil, too, that is concrete. But, of course, the vivid portrayal of evil is never, for the Catholic imagination, the end of the story. To show the hidden workings of grace, the Catholic imagination further depends upon a second essential element: action, and action of a most special sort.

Action as the Soul of the Catholic Imagination

Be doers of the word, and not hearers only.
James 1:22

Dante's dramatic depiction of Ulysses's last voyage shows us that the Catholic imagination is just that, a *dramatic* imagination. Its focus is on imitating or representing both God and human beings doing things and the conflicts that arise in the course of those

21. O'Connor, "On Her Own Work," 117.

doings. The poet, critic, and Catholic convert Allen Tate, in an important essay on Dante, also emphasizes the centrality of dramatic action to the imagination, of which Dante is the foremost representative:

> To bring together various meanings at a single moment of action is to exercise what I shall speak of here as the symbolic imagination; but the line of *action* must be unmistakable, we must never be in doubt about what is happening; for at a given stage of his progress the hero does one simple thing, and one only.[22]

Tate emphasizes the point: "It is the business of the symbolic poet to return to the order of temporal sequence—to *action*. His purpose is to show men experiencing whatever they may be capable of, with as much meaning as he may be able to see in it; but the action comes first. Shall we call this the Poetic Way?"[23] The Poetic Way is not a bad term for what Tate is describing, though he settles on the term Symbolic Imagination. By either of these terms, however, Tate is talking about the way in which an imaged line of action—like Ulysses's decision to get the band back together and sail after knowledge—radiates a multiplicity of meanings. In other words, the depth of meaning we find in a work of mimetic art is always a function of a hero taking action, whether that hero be God himself, the protagonist of salvation history, or human beings as secondary protagonists working out their salvation. William Lynch, confirming the argument of Tate's essay, writes: "I should like to take the position that *action* is the soul of the literary imagination in all its scope and forms."[24] Tate and Lynch are only echoing Aristotle, who, while speaking specifically about

22. Allen Tate, "The Symbolic Imagination," in *Essays of Four Decades* (Wilmington, DE: ISI Books, 1999), 427.

23. Tate, 428.

24. William Lynch, *Christ and Apollo: The Dimensions of the Literary Imagination* (Wilmington, DE: ISI Books, 2004), 206.

tragic drama, says something applicable in analogous ways to all mimetic art; namely, that *plot* (i.e., the line of dramatic action taken by the hero of a story) is the "soul" of drama.[25]

I am going to stand pat and continue calling the imagination that Tate and Lynch, and even Aristotle to a certain extent, are talking about, and that Dante best exemplifies, the "Catholic imagination." In this imagination, the action of God is paramount, as I have stressed, but God's action is also, in a way, dependent upon a human protagonist's action. Grace is made operative, hiddenly, in the gesture of a human being at the height of crisis. Another passage from O'Connor's prose writings underscores this point most brilliantly:

> I often ask myself what makes a story work, and what makes it hold up as a story, and I have decided that it is probably some action, some gesture of a character that is unlike any other in the story, one which indicates where the real heart of the story lies. This would have to be an action or a gesture which was both totally right and totally unexpected; it would have to be one that was both in character and beyond character; it would have to suggest both the world and eternity. . . . It would be a gesture which somehow made contact with mystery.[26]

The Definite and Small: Where the Catholic Imagination Operates

My soul magnifies the Lord,
And my spirit rejoices in God my Savior,
For he has regarded the low estate of his handmaiden.
 Luke 1:46–48

The fact is that the materials of the fiction writer are the humblest. Fiction is about everything human and we are made out of dust, and if you scorn getting yourself dusty, then you shouldn't try to write fiction.
 Flannery O'Connor, "The Nature and Aim of Fiction"

25. See Aristotle, *Poetics* 6 (1450a38–39).
26. O'Connor, "On Her Own Work," 111.

The third essential element of the Catholic imagination, one crucially implied by the centrality of action to it, is a privileged focus on the limited, the definite, the humble, and the *small*. To imitate human beings doing things involves taking an absorbing interest in a *creature* and, therefore, in something that is limited in every way: metaphysically, morally, spiritually, and physically. Even the great warrior-king Ulysses is small when it comes to the power of the sea and the strictures placed by the gods against human endeavor. Lynch, whose book *Christ and Apollo* is entirely dedicated to exploring and championing the theme of the definite in literature, introduces it in the following way:

> Human life, as our own intuitions and our greatest writers have always told us, is simple and limited. It is a process in which one simple moment follows another, in which we take one limited step after another, draw one small breath after another. We can do but one thing at a time. Even our loves are limited; they leave us or die. We are born in helplessness and end in it. The human race is not a great complex entity called man, but many individual men, each leading his own separate, concrete life, each life having its own limited, separate identity.[27]

This observation by Lynch clearly shows that to imagine human action is to imagine a limited, separate entity attempting to achieve something—like Ulysses desiring new experience—one step at a time, one small breath after another.

The importance of the limited and finite to the Catholic imagination can be brought out further by considering it from the point of view of the working artist. Flannery O'Connor's essay "Writing Short Stories" is an extended meditation on the importance of the definite and concrete for the writing of successful fiction:

27. Lynch, *Christ and Apollo*, 11.

> I have found that the stories of beginning writers usually bristle with emotion, but *whose* emotion is often very hard to determine. Dialogue frequently proceeds without the assistance of any characters that you can actually see, and uncontained thought leaks out of every corner of the story. The reason is usually that the student is wholly interested in his thoughts and his emotions and not in his dramatic action, and that he is too lazy or highfalutin to descend to the concrete where fiction operates. He thinks that judgment exists in one place and sense-impression in another. But for the fiction writer, judgment begins in the details he sees and how he sees them.[28]

The concrete, the definite, the limited, is where fiction operates, maintains O'Connor, and the principle holds for all genres of mimetic art. To make the concrete vivid, the artist must create a world that appeals to the senses. Failure to do this in fiction is what O'Connor calls, borrowing a term from Henry James, "weak specification."[29] The reason why sense impressions must be the starting point of all art comes down to the way in which human cognition, human knowing, works.

All knowledge, on the Aristotelian understanding, begins with the senses. To know something is to grasp its essential characteristics—in exactly the way that we are now working to grasp the essential characteristics of the Catholic imagination. But the human intellect is not made to go straight to essences. Because we are essentially bodily, every one of our activities, including the activity of knowing, is a bodily activity. This is not to say that knowing is exclusively a bodily activity. Rather, it is to say that our minds come to know things *through* our bodily way of being in the world. We could look at this as another way in which we are finite, limited, and small. But we could also look at it as part

28. Flannery O'Connor, "Writing Short Stories," in *Mystery and Manners*, 92.

29. O'Connor, 92. O'Connor adds in this same paragraph: "Ford Madox Ford taught that you couldn't have a man appear long enough to sell a newspaper in a story unless you put him there with enough detail to make the reader see him."

of the glory of being a human animal. For our bodily being allows us to sing, with Gerard Manley Hopkins, "Glory be to God for dappled things," precisely because we are able to see the concrete dappled things of this world.[30]

The job of our senses is to register and gather impressions from the physical world. These impressions allow the spiritual (i.e., nonmaterial) power of the mind to distinguish what is essential to something from that which is merely accidental to it. We have five external senses, of course, but we also have several internal senses, senses that do not work with particular sense organs but that function as various ways of storing and compiling the data we receive from the external senses. The imagination, considered simply as a psychological power, is one of these internal sense powers. Its job is both to store sense impressions and to structure them into that sensible whole or complex image of the object Aristotle and St. Thomas Aquinas call the phantasm. The phantasm is what my mind is directed toward as I ponder the form or nature of something, and it would be impossible for me to ponder that thing if I did not have a phantasm of it as the concrete focus of my thinking.[31]

So, when Flannery O'Connor exhorts beginning writers to build their fictional worlds and characters from closely observed sense impressions, she is not giving advice merely out of her "personal aesthetic." She is stating a principle: *the concrete—that is, the definite, the limited, the small—is where fiction operates.* This principle is grounded in the natural operations of human knowledge, the neglect of which can only be detrimental to art's attempt to imitate reality.

30. Hopkins's sonnet "Pied Beauty" beautifully expresses the Catholic imagination's joy in the concrete:
> Glory be to God for dappled things –
>> For skies of couple-colour as a brinded cow;
>>> For rose-moles all in stipple upon trout that swim . . .

31. Yet the phantasm should not be understood along the lines of a picture like a photograph or painting. It is more dramatic than that, more of a simulation of lived reality. On this theme, see Sokolowski, "Picturing," 17ff. and *Phenomenology of the Human Person*, 140–47.

We can see the Catholic imagination's preference for the concrete, the definite, and the small in play in all the classic protagonists of the tradition, from the humility of Our Lady to Our Lord's incarnation as a child, and from the widow's mite to Tolkien's hobbits. In Waugh's *Brideshead Revisited*, Father Mackay argues to the family for the anointing of the dying Lord Marchmain by saying, "It is something so small, no show about it." And when Charles Ryder kneels at Lord Marchmain's bedside and prays that the dying man will give to Father Mackay some sign of contrition for his sins, Ryder reflects: "It seemed so small a thing that was asked, the bare acknowledgement of a present, a nod in the crowd."[32] For the Catholic imagination, grace works through such small things, yet in ways that totally reverse the trajectory of the protagonist's life.

The Catholic Imagination Involves Levels of Meaning

I have said this to you in figures.
 John 16:25

The subject of the whole work, then, taken in the literal sense only, is "the state of souls after death," without qualification, for the whole progress of the work hinges on it and about it. Whereas if the work be taken allegorically the subject is "man, as by good or ill deserts, in the exercise of the freedom of his choice, he becomes liable to rewarding or punishing justice."
 Dante, "Letter to Cangrande della Scala," regarding the *Commedia*

In his famous letter to his patron, the formidably named Cangrande della Scala, Dante explains how meaning works in the *Commedia*. Following a long tradition of scriptural exegesis, Dante tells his patron that the *Commedia* can be read, as Scripture is, on four different levels: the *literal*, the *moral*, the *allegorical*, and the *anagogical* (the last three comprising the "allegorical" or "symbolic" meaning of the work in a more general sense). These

32. I am indebted to Thomas Prufer for pointing out these texts and their contribution to the theme in *Brideshead* of what Prufer calls the "thinness of the signs of grace" ("Death of Charm," 97).

four levels of meaning make up the fourth essential element of the Catholic imagination.

Before we examine these four levels of meaning further, let us note the distinction between how they function in theological discourse and how they function in art. Aquinas takes up this distinction when exploring the question of whether theology should make use of figures and metaphors.[33] His answer is that both poetry and theology have reason to make use of metaphor due to a disproportion in each discipline between the knower and the thing known. As Thomas Dominic Rover explains:

> The disproportion in sacred science [theology] stems from an excess of intelligibility on the part of the object, in poetry from a defect of intelligibility. In divine science the metaphor or symbol or parable is used in order to reduce the disproportion, as the sacred writer instructs the minds of the faithful through a sensible similitude of supra-sensible or even supra-rational truth. In the poetic art, on the other hand, the symbol or metaphor is constructed not to reduce the object to knowable proportions but to raise it to a higher degree of knowability.[34]

So Christ spoke in parables and other figures because the truths about the kingdom of God that he wanted to impart exceeded the natural ability of his audience to grasp. But the poet uses metaphor and other figures because of the *defectus veritatis*, the "defect of truth" in the subject-matter of his art: that is, the world of sensible particulars that, in one respect, being only sensible, is "below" reason's grasp. The poet constructs a metaphor and, indeed, an entire plot, or what I have called a contemplative way station, so that the world of sensible particulars is made intelligible.

33. The question is explored by Aquinas both at *Scriptum super libros Sententiarum* 1.1.5 ad 3 and *Summa theologiae* 1.1.9. See also *Summa theologiae* 1-2.101.2 ad 2.

34. Rover, *The Poetics of Maritain*, 61.

And indeed, all the mimetic arts, as employed by the Catholic imagination, use their respective media, their various symbolic languages, to picture the way in which the world of sensible particulars radiates both natural and supernatural meaning.

Though we have not identified it yet by name, we have been talking all along about the literal level. This level has to do with the action of a limited human protagonist encountering obstacles and conflict in the pursuit of some goal. To make action vivid to the senses and thus readily intelligible to the mind was Dante's first task as a storyteller, and he succeeds brilliantly in telling the story-within-a-story of Ulysses's final voyage. Whatever else Ulysses's final voyage might mean, on the literal level, it is a ripping good yarn. An audience's failure to understand and enjoy *literally* what is going on in a work of mimetic art is the most fundamental kind of failure.

Sometimes a person will fail to understand a work of art, or an artist fail to produce a successful one, due to moving too fast through the literal level. But as Lynch contends, "There are no shortcuts to beauty or to insight. We must go *through* the finite, the limited, the definite, omitting none of it lest we omit some of the potencies of being-in-the-flesh."[35] This truth has significant ramifications for our discussion of mimetic art as a way of beauty. The way of beauty is not a way that uses the world of sensible, limited particulars as a mere launch pad for a brilliant voyage to the transcendental reality of beauty nor one that simply ignores or rejects the value of the sensible dimension of reality. The way of beauty, as Lynch rightly says, is a way that goes *through* the finite. Any attempted end run around the finite is impossible, in

35. Lynch, *Christ and Apollo*, 16. In the ensuing discussion, pp. 16–21, Lynch provides a digest of different ways in which writers of fiction and drama diminish the importance and integrity of the literal level of meaning. In "The Symbolic Imagination," written in 1951, Allen Tate admonishes Catholic poets for failing to appreciate the literal meaning of what is sensible and definite: "Catholic poets have lost, along with their heretical friends, the power to start with the 'common thing': they have lost the gift for concrete experience. The abstraction of the modern mind has obscured their way into the natural order. Nature offers to the symbolic poet clearly denotable objects in depth and in the round, which yield the analogies to the higher syntheses" (430).

the first place, and, moreover, contrary to what it means to make and appreciate a work of art.

Three other levels of meaning in art, as I've mentioned, radiate from the literal level of meaning. These three other levels together make up the *symbolic* level of meaning in the work. "Now the word *symbol* scares a good many people off," O'Connor wryly observes in one of her essays, "just as the word *art* does. They seem to feel that a symbol is some mysterious thing put in arbitrarily by the writer to frighten the common reader—sort of a literary Masonic grip that is only for the initiated."[36] But the symbolic meaning of a work of art is nothing so occult. It is simply the meaning, or levels of meaning, that can be distinguished, but not separated, from the literal meaning. Symbols, as O'Connor defines them, "are details that, while having their essential place in the literal level of the story, operate in-depth as well as on the surface, increasing the story in every direction."[37] Her explanation of this definition, centered on the novelistic symbol but not limited to it, makes plain the way in which symbolic meaning grows naturally out of the literal meaning:

> I think the way to read a book is always to see what happens, but in a good novel, more always happens than we are able to take in at once, more happens than meets the eye. The mind is led on by what it sees into the greater depths that the book's symbols naturally suggest. . . . The truer the symbol, the deeper it leads you, the more meaning it opens up.[38]

Again, the three levels of symbolic meaning, distinguishable from the literal meaning, are the *moral*, the *allegorical*, and the

36. O'Connor, "The Nature and Aim of Fiction," in *Mystery and Manners*, 71.

37. I am grateful to Glenn C. Arbery's introduction to Lynch's *Christ and Apollo*, in particular p. xxiv, for the reference to O'Connor's definition of symbol in "Nature and Aim of Fiction," 71, which led me to discover the broader significance of O'Connor's essay for my argument. She discusses the fourfold levels of meaning in a literary work at 72–73.

38. O'Connor, "Nature and Aim of Fiction," 71–72.

anagogical. The moral sense has to do with how an artistic image, beyond what it literally pictures, shows us something true about the human quest for wholeness. A novel, for example, illuminates the reader's own life story, and the human story in general, because it has this moral or ethical meaning. The allegorical meaning has to do with types or forerunners of Christ's salvific action. Its use in art developed from ancient and medieval scriptural exegesis, in which people and events from the Old Testament were read as types or forerunners of people and events in the New Testament. But even when the Catholic imagination depicts something outside the Old Testament, allegorical meaning can still come into play insofar as a certain kind of image can be read as a type or forerunner of the saving action of Christ—as in *Brideshead Revisited,* where the charm of the Marchmain family serves as a type or forerunner of the action of grace in the life of Charles Ryder.[39] Finally, the anagogical meaning has to do with the ultimate comic resolution of human life: the soul's enjoyment of the beatific vision. In the *Paradiso,* Dante offers images that literally depict the Church Triumphant but that still have anagogical meaning insofar as they explore the theological depths of souls enjoying the vision of God.

In the passage from Flannery O'Connor that we considered earlier regarding the "totally right and totally unexpected action" through which grace is delivered, she also makes reference to the various levels of symbolic meaning:

> The action or gesture I'm talking about would have to be on the anagogical level, that is, the level which has to do with the Divine life and our participation in it. It would be a gesture that transcended any neat allegory that might have been intended or any pat moral categories a reader could

39. One of the central points made by Prufer in "Death of Charm."

make. It would be a gesture which somehow made contact with mystery.[40]

In another essay, O'Connor herself provides an example of the workings of the three levels of symbolic meaning from one of her own comic novels, *Wise Blood*. The hero of the tale, Hazel Motes, a prophet of the Church Without Christ, owns a rat-colored automobile. On the literal level, the car serves as Motes's pulpit as well as a means of escape. On the symbolic level, she tells us, the car signifies a kind of death-in-life.[41]

What specific level of meaning is in play when we see Motes's car as a death-in-life symbol? Most immediately, the *moral* level, the level that has to do with human action and its natural ordering to the good. O'Connor wants us to see that the sense of power and authority that Motes gets from the car is not life-giving, as he thinks, but in fact is helping lead him away from the fulfillment he naturally desires. Because O'Connor writes with a Catholic imagination, we can also discern an *anagogical* meaning in the image of Hazel Motes's car, that meaning having to do with our participation in God's very being in the next life. Motes militantly preaches against the entire idea of salvation in Christ, and so the car can also be seen as having anagogical meaning in that it is being used to subvert the life in God for which Motes was made. The third symbolic level of meaning in a work is the *allegorical* level, which has to do with the way in which images can be seen as forerunners or *types* of other things. It does not appear that Motes's automobile can be easily read on this allegorical level (there is no requirement that every image has to radiate every level of symbolic meaning). But if we turn back to Ulysses's final voyage, we can see the car as an allegorical type of all human efforts to spurn Christ's saving friendship in favor of mastering and controlling the natural world.

40. O'Connor, "On Her Own Work," 111.
41. O'Connor, "Nature and Aim of Fiction," 72.

The Catholic Imagination Offers the Master-Story of Human Existence

The heavens proclaim the glory of God,
and the firmament shows forth the works of his hands.
Day unto day takes up the story,
and night unto night makes known the message.
 Psalm 19:1–2

I would like now to return to a point I alluded to earlier, that in bringing Ulysses into his poem, Dante aims to resituate Ulysses within the theo-drama. Again, as Anthony Esolen observes, Ulysses is, for Dante, an image of human endeavor, unaided by grace, driving a person on to master and control. By picturing Ulysses searching for experience of the world to the point of disaster, what Dante does is enfold the figure of Ulysses within a wider Christian narrative, a fundamentally comic narrative, in order to make a critique of epic categories. In doing so, Dante demonstrates the fifth and final essential element of the Catholic imagination: that it functions as the master-story of all other stories, whether mythical or real.

From the point of view of the Catholic imagination, every story we come across, in any genre of art or in life, is a story that can only be understood fully within the wider context of the story God is writing through his creation. As Alasdair MacIntyre puts the point, Dante offers "a single history of the world within which all other stories find their place and from which the significance of each subordinate story derives"—which, MacIntyre adds, issues a challenge to future readers: "Tell me your story and I will show you that it only becomes intelligible within the framework provided by the *Commedia*, or rather within some framework provided by the scriptural vision which the *Commedia* allegorizes."[42]

42. Alasdair MacIntyre, *Three Rival Versions of Moral Enquiry* (Notre Dame, IN: University of Notre Dame Press, 1990), 144–45. I would quibble with MacIntyre's contention and say that other stories only become *fully* intelligible within the framework provided by the *Commedia*.

I have said that the Catholic master-story is fundamentally a comic one. Even when tragedy is depicted by a Catholic imagination, as by Dante in the Ulysses episode or by Waugh in his novel *A Handful of Dust*, the tragic events of the story are seen as just that: *tragically inadequate* to the genuine, comedic end of human nature. Tragedy, as Lynch describes it, takes a protagonist "all the way up to the hilt of helplessness, all the way into the abyss of non-being that lies underneath the masks of finitude."[43] The term "comedy," according to the Catholic imagination, is a narrative genre in which the major conflict is resolved in such a way as to bring the protagonist's purposes back in line with the human end naturally or supernaturally understood. The happy resolution occurs because the protagonist has, in some way, come to terms with the littleness in himself and in his purposes. He has realized his inadequacy and successfully repaired it. That reparation, however, must come at some cost to the protagonist or else the limitations of this concrete and very broken world will not be respected. This is, presumably, what Tolkien means by speaking of the best fairy stories as evincing "eucatastrophe." Such stories are comic in their resolution, and so are "good" or "happy," but only at the price of catastrophe. Without taking a protagonist to the very "abyss of non-being," a fairy story or any other kind of comic story cannot reflect the story of what Tolkien calls the "Great Catastrophe."[44]

THE CATHOLIC IMAGINATION: FOUR PRECISIONS

I would now like to offer four precisions to my discussion of the essential elements of the Catholic imagination.

First, none of the above is meant to suggest that art made by

43. Lynch, *Christ and Apollo*, 128. Lynch's book is a treasure-trove of insights on the distinction between tragedy and comedy.

44. J.R.R. Tolkien, "On Fairy-Stories," in *The Monsters and the Critics and Other Essays* (New York: HarperCollins, 2006), 156. Tolkien's epilogue to this essay is a moving meditation on the notion of eucatastrophe.

non-Catholic believers or even by nonbelievers, art perhaps having nothing to do or any contact with the Catholic tradition, may not feature one or more of the essential elements of the Catholic imagination. The basic Catholic principle already alluded to— that grace does not destroy but rather perfects nature—is enough to explain how it can be that artists working in radically different cultures and with radically different beliefs can still make art that reflects something of the Catholic way of imagining reality. Yet certain works made by non-Catholics will share more with the Catholic imagination than will others. The novels of Jane Austen, for example, with their fundamentally Aristotelian way of picturing the centrality of the virtues, are just one case in point.

Nor, second, does an artist have to profess Catholic belief to compose a work that belongs specifically to the Catholic imagination. Willa Cather's so-called "Catholic novels," *Death Comes for the Archbishop* and *Shadows on the Rock*, are both remarkable instances of a non-Catholic artist's ability to inhabit the Catholic way of seeing reality well beyond the capabilities of even most Catholic authors. And even when a non-Catholic artist, a non-Catholic Christian, for example, does not choose to depict a specifically Catholic culture, as Cather's two "Catholic" novels do, but whose work nonetheless embodies all the essential elements discussed above, that work can still legitimately be called a work of the Catholic imagination.

Third, implicit throughout my discussion is the view that a work doesn't need to be a work of sacred art in order to be a work of the Catholic imagination. Works of sacred art, like Michelangelo's ceiling in the Sistine Chapel or Palestrina's *Missa Papae Marcelli*, very explicitly picture God's theo-drama as an aid to prayer and worship in sacred space. But the Catholic novels and short stories I have mentioned throughout this chapter are not works of sacred art in this narrow sense. Still, they all picture a human protagonist working out his or her quest for completion and communion against the larger backdrop of the theo-drama.

It can be added to this that, even in an explicitly Catholic work of art, a depiction of Catholic sacramental life is not necessary, although it often enough is depicted or at least alluded to. All that is necessary is that the essential elements of the Catholic imagination are accounted for.

Finally, it should be said that the emphasis of the Catholic imagination upon action, including above all God's action, does not forget the way in which God is often depicted without human beings present, as in icons. But even in iconic depictions, the story of man's salvation is always assumed as a backdrop. Someone contemplating an icon of the Triune God might focus on God's radical self-sufficiency, his having no need to create. But such a focus cannot and should not utterly leave aside the fact that God, in his mercy, *did* create, and created human beings, especially, to share in his divine life.

MODERN IMAGINATIONS: ANGELIC AND HOMELESS

But what happens when the human end, understood in both its supernatural and natural dimensions as Catholics understand it, is reduced to purpose? What does it mean to have "a world without ends"? This is one way of describing what has largely happened in the Western world in the last four-hundred-plus years. With the rise of "modernity," at least in the dominant sectors of mainstream culture, ends both natural and supernatural have been jettisoned in favor of the choices of individual human beings. How this happened is, of course, a long and many-stranded history, far too long a history to tell here.[45] What is of interest to us is the impact of a "world without ends" on human artistic activity. Different and conflicting imaginations, based upon different

45. The best places to begin unraveling this history are MacIntyre's *After Virtue*; *Whose Justice? Which Rationality?* (Notre Dame, IN: University of Notre Dame Press, 1988); and *Three Rival Versions of Moral Enquiry*; also, Charles Taylor's *Sources of the Self*; *The Ethics of Authenticity* (Cambridge, MA: Harvard University Press, 1992); and *A Secular Age* (Cambridge, MA: Belknap, 2007).

understandings of the human person and his or her destiny, have asserted themselves both against the Catholic imagination and against one another. I would like to close this chapter by looking briefly at two of these modern imaginations. Considering these will help sharpen our sense of the Catholic imagination itself, as well as provide a basic framework for making sense out of the chaotic panoply of art with which we are confronted in our time.

The first modern imagination I would like to consider is one that Allen Tate calls the *angelic imagination*. As we touched upon earlier, in the Aristotelian-Thomistic tradition, our embodied human knowledge must begin with sense impressions that are eventually built up into a phantasm from which the intellect can abstract what is essential. But an angel, on the Christian understanding, is a disembodied rational spirit. Not having a body, the angel does not know in the way that human beings know. An angel's disembodied intellect, having no need of sense powers, can go straight to the essences of things, whether of material things or of supernatural things. According to Tate, some poets have attempted to emulate the angel's special way of knowing by reconceiving the imagination as a direct access to the essences of things, including supernatural realities. "I call that imagination angelic," argues Tate, "which tries to disintegrate or to circumvent the image in the illusory pursuit of essence."[46] It is as though the angelic imagination wants to capture the anagogical meaning of reality—understood, if not in the Christian sense as the beatific vision, as the ultimate point and synthesis of meanings—without having to bother with the literal, moral, and allegorical meanings of existence.[47]

Tate attributes the rise of the angelic imagination to a new

46. Tate, "Symbolic Imagination," 429. In Tate's companion essay, "The Angelic Imagination," also in *Essays of Four Decades*, Edgar Allan Poe represents the angelic imagination.

47. Tate, "Symbolic Imagination," 430n5: "Another way of putting this is to say that the modern poet, like Valéry or Crane, tries to seize directly the anagogical meaning, without going through the three preparatory stages of letter, allegory, and trope." An older name for the moral sense is the tropological sense.

mentality that arose in the West at the end of the sixteenth cen-
tury, "a mentality which denied man's commitment to the physi-
cal world, and set itself up in quasi-divine independence."[48]

What Tate refers to here is the modern break with the Aris-
totelian understanding of reality, a break that began with certain
fissures in the late medieval period, but that cracked wide open,
as Tate rightly says, in the twilight of the sixteenth century and in
the first half of the seventeenth century. This was the beginning of
the end of Aristotelian teleology—the understanding of nature,
including human nature, as governed by ends—as a dominant
idea of Western culture. The physical world was understood now
as no more than matter-in-motion, governed by inflexible laws
but in no way ordered to ends.[49] Consequently, the powers of
human beings were no longer seen as capabilities that must be
tutored by culture in light of the human end. Rather, these untu-
tored powers, as they were once conceived, were now *themselves*
regarded as the benevolent sources of intellectual, moral, and ar-
tistic excellence.[50]

Sentiments, or feelings, thus took on enormous importance
for many thinkers and artists of the modern period. They became
the chief sources, in fact, of moral and artistic value. Feeling was
important in the Aristotelian scheme, too, but again, as a capabil-
ity that had to be tutored or formed by culture if excellence was
to be achieved. In the new scheme, the sentiments did not require
tutoring by culture. In fact, for a thinker like Rousseau, culture
was an absolute detriment to the natural, uninhibited expression
of feeling.[51]

For the artists, literary and musical, that we associate with

48. Tate, 429.
49. For a good discussion of this shift, see Robert Sokolowski, "Formal and Material
Causality in Science," *Proceedings of the American Catholic Philosophical Association* 69 (1995):
57–67.
50. I am summarizing Alasdair MacIntyre's assessment of why the Enlightenment project
of justifying morality had to fail, from *After Virtue*, chap. 5.
51. For a good recent treatment of this theme in Rousseau, see Carl Trueman, *The Rise and
Triumph of the Modern Self* (Wheaton, IL: Crossway, 2020), chap. 3.

the Romantic period in the first several decades of the nineteenth century, everything came down to the expression of feeling. They ardently believed in the benevolence of nature, but they understood nature not as teleological order, not as order to an end, but as a mysterious, hidden, even divine source that could be made manifest by the creative power of the imagination.[52] The artist on the Romantic understanding, as Charles Taylor observes, "doesn't imitate nature so much as he imitates the author of nature. The artist creates not in imitation of anything phenomenally pre-existing. By analogy, the work of art now doesn't so much manifest something visible beyond itself as constitute itself as the locus of manifestation."[53] M.H. Abrams articulates the Romantic understanding of poetry, in particular, as "the impulse within the poet of feelings and desires seeking expression, or the compulsion of the 'creative' imagination, which, like God the creator, has an internal source of motion."[54] Taylor follows Abrams in recognizing the quasi-religious status that art takes on within the new expressivist culture:

> In our civilization, molded by expressivist conceptions, [art] has come to take a central place in our spiritual life, in some respects replacing religion. The awe we feel before artistic originality and creativity places art on the border of the numinous, and reflects the crucial place that creation/expression has in our understanding of human life.[55]

The image of art as a kind of secular sacramental system, and

52. This is the argument of chapter 21 of Charles Taylor's *Sources of the Self*, a chapter entitled "The Expressivist Turn."

53. Taylor, *Sources of the Self*, 377–78.

54. Abrams, *Mirror and the Lamp*, 22. Samuel Coleridge, in his definition of imagination in the *Biographia Literaria*, makes a literal connection between the poet's imagination and the creative action of God: "The primary IMAGINATION I hold to be the living Power and prime Agent of all human Perception, and as a repetition in the finite mind of the eternal act of creation in the infinite I AM" (quoted in Taylor, *Sources of the Self*, 379).

55. Taylor, *Sources of the Self*, 376.

of the artist as creative genius who can plumb the mysterious depths of human feeling and experience and express them in a work, is certainly one of the defining attitudes of contemporary Western life.[56] The creative genius is often understood along the lines of a priest, a person specially called to make manifest—*really present* in the wholly original poem or piece of music—the hidden spirit or élan that runs through the universe. The idea of originality is integral to this expressivist view of the artist, as the élan running through the universe must remain inarticulate until it is articulated by the unique expression of a particular artist.[57] This unique expression is of feelings understood to be the very core of the artist's self, which explains why the *life* of the contemporary creative genius is inseparable from the *work* that is made and, therefore, must be just as expressive as the work. To be Picasso or Bob Dylan or Kendrick Lamar *just is* to be the genius who can express what no other can express.

How easy it is, on this view of art, for the imagination to become the sole creator of value. Whatever objective, even Christian, understanding of value might have initially been in play with some of the Romantics, it did not take long for the emphasis upon original, individual expression to devolve into a raw subjectivism in which the artist creates a cosmos out of the hidden, mysterious resources of what Charles Taylor has called the "buffered self." For the buffered self, as Taylor explains, "the possibility exists of taking a distance from, disengaging from everything outside the mind. My ultimate purposes are those which arise within me, the crucial meanings of things are those defined in my responses to them."[58] Earl Wasserman astutely recognizes this subjectivism playing out in the context of modern poetry: "Within itself the modern poem must both formulate its own cosmic syntax and

56. The philosopher T.E. Hulme refers to Romanticism as "spilt religion." Hulme, "Romanticism and Classicism," in *Speculations: Essays on Humanism and the Philosophy of Art*, ed. Herbert Read (London: Routledge & Kegan Paul, 1949), 118.

57. Taylor, *Sources of the Self*, 374.

58. Taylor, *Secular Age*, 38.

shape the autonomous poetic reality that the cosmic syntax permits: 'nature,' which was once prior to the poem and available for imitation, now shares with the poem a common origin in the poet's creativity."[59]

Thus, it was in the Romantic period that the ideal of the artist's expressiveness began sharply to distinguish itself from the mimetic approach to art. And no twentieth-century poet exemplifies this tendency better than Wallace Stevens, who from his first and best-known poem, "Sunday Morning," was dedicated to creating a "cosmic syntax" forged out of his own subjectivity. In "Sunday Morning," Stevens declares:

> Death is the mother of beauty; hence from her,
> Alone, shall come fulfillment to our dreams
> And our desires.

For Stevens, a supernatural entity is not the mother of beauty; that honor belongs to death. The winking of divinity that we think we detect when we behold the beautiful is no more than a grinning skull with the mournful words engraved upon its brow: *Et in Arcadia Ego.*[60] This declaration might seem like an embrace of the finite, for to be finite is to be marked by death. The beautiful April's green, the wakened birds, and the June evening mentioned in "Sunday Morning" are, after all, experiences in time that come to be and pass away, and they are poignant for us, the poem argues, precisely because they cannot last. But I would contend that, for Stevens, the beauty that death mothers is a beauty that exists not in passing things but solely within the cosmos of the poem. Death's ravages, unredeemable, make the creation of a

59. Earl Wasserman, *The Subtler Language* (Baltimore, MD: Johns Hopkins University Press, 1968), 10–11, quoted in Taylor, *Sources of the Self*, 381.

60. Such a skull is kept by Charles Ryder, the narrator of Evelyn Waugh's *Brideshead Revisited*, in his student rooms at Oxford. It is a *memento mori*, a reminder of death. The motto engraved on the skull's brow means "I, too, am in Arcadia." I, too—that is, death—am in Arcadia, a metonym (for Virgil and other Latin poets) for a rural paradise.

new poetic cosmos necessary. Stevens is thus among those artists who, on Lynch's description, "touch the finite as lightly as possible in order to rebound, not into a quick eternity of beauty, but back into the self. Their aim is to create states of affectivity, areas of paradise, orders of feeling within the self."[61]

Stevens's angelic imagination is of that sophisticated, not to say Nietzschean, sort that seeks to create new systems of value.[62] His imagination is an attempt to disintegrate or to circumvent the theo-drama and its hard images of limited human reality in the illusory pursuit of a new vision of reality, a reality created *ex nihilo* out of the resources of the buffered, expressive self. It is not surprising that Stevens found this creative burden too heavy to bear. On his deathbed, he abandoned the angelic imagination and accepted the theo-drama by converting to Catholicism.[63]

Interestingly, the angelic imagination is prefigured in Dante's Ulysses, *not* as Ulysses is resituated by Dante within the theo-drama, but as he exists in his own mind, venturing out bravely into the unknown to assert his intellectual power. Ulysses thinks he is living one story, though he is actually living another. Taken in this light, Ulysses and his comrades might be compared to the Rosencrantz and Guildenstern of Tom Stoppard's eponymous play, who enter the situation of Shakespeare's *Hamlet* without any idea of what story they are in.

61. Lynch, *Christ and Apollo*, 17. Steven's aspiration to create orders of feeling within the self is on full display in a later poem, "The Idea of Order at Key West." See Paul Mariani's discussion of this poem in chapter 11 of his book *The Whole Harmonium: The Life of Wallace Stevens* (New York: Simon & Schuster, 2016). "We speak of the world," Mariani writes of the mind of the poem, "but there is no world for us except the one we create in our imagination and which is constantly being created—and re-created—only as we sing or write, composing our world even as we attempt to compose ourselves" (187).

62. Accordingly, Philip Rieff identifies Stevens as one of the chief proponents of "deathworks," works that assault traditional Western religious culture. See Rieff's *My Life among the Deathworks* (Charlottesville, VA: University of Virginia Press, 2006). Yet the story of modern poetry and fiction is surely more complicated than what we find in Stevens's angelism. "But some of the very greatest of twentieth-century writers are not subjectivist in this sense," Charles Taylor argues. "Their agenda is not the self, but something beyond. Rilke, Eliot, Pound, Joyce, Mann, and others are among them" (Taylor, *Ethics of Authenticity*, 89). See also Taylor, *Sources of the Self*, chap. 24. To pursue this intriguing line of thinking, however, is beyond the scope of my present argument.

63. Mariani tells the story in the last chapter of *The Whole Harmonium*.

The image of a hapless and benighted Rosencrantz and Guildenstern makes for a nice connection to a second kind of modern imagination, one that I will just touch on and call the *homeless imagination*. It is a nice connection because Stoppard's play was very much inspired by another bleakly comic two-hander, Samuel Beckett's *Waiting for Godot*, which gives the homeless imagination its most definitive twentieth-century expression. The Vladimir and Estragon of Beckett's play also have no clue what story they are in. They have a certain notion of the theo-drama—

VLADIMIR. Did you ever read the Bible?

ESTRAGON. The Bible . . . (*He reflects.*) I must have taken a look at it.

VLADIMIR. Do you remember the Gospels?

ESTRAGON. I remember the maps of the Holy Land. Colored they were. Very pretty. The Dead Sea was pale blue. The very look of it made me thirsty. That's where we'll go, I used to say, that's where we'll go for our honeymoon. We'll swim. We'll be happy.[64]

—but there is no serious suggestion in the play that the message of the Bible has the power to make anyone happy. But it is not just that the theo-drama has been consigned to the dustbin of useless mythologies. There is no alternative drama, either. All horizons of significance have been discarded as worthless. Nihilism reigns. To recognize such is authenticity.

Waiting for Godot has been said to be the play where nothing happens, twice. It consists of two acts in which we see Vladimir and Estragon whiling away the time waiting for a man named Godot who (spoiler warning) never comes. We never find out who Godot is or why they are waiting for him. Not even Vladimir and Estragon seem to know. A few other characters drift in and

64. Samuel Beckett, *Waiting for Godot: A Tragicomedy in Two Acts*, translated from the original French by the author (New York: Grove, 1982), 5.

out of the scene of their waiting, one of whom, Pozzo, erupts
furiously at Vladimir toward the end of the play:

POZZO, *suddenly furious.* Have you not done tormenting me with your
accursed time! It's abominable! When! When! One day, is that not
enough for you, one day he went dumb, one day I went blind, one
day we'll go deaf, one day we were born, one day we shall die, the
same day, the same second, is that not enough for you? (*Calmer.*)
They give birth astride of a grave, the light gleams an instant, then
it's night once more.[65]

Pozzo longs to be released from accursed time, the field of limita-
tion and death. For time is no longer the way of the Incarnation,
or even of Ulyssean assertion. It is a meaningless track now, where
if a light gleams, it gleams only for an instant before the night of
meaninglessness descends once more. Human action, the soul of
the Catholic imagination, is reduced to a kind of suspended ani-
mation. And so the play ends:

VLADIMIR. Well? Shall we go?

ESTRAGON. Yes, let's go.

They do not move.

65. Beckett, 103. In his essay "On the Ontological Priority of Ends and Its Relevance to
the Narrative Arts," Slade discusses the fiction of Kafka as well as the films of Quentin Tarantino
in a way that connects them to what I call the homeless imagination, the imagination that has
given up all "angelic" pretension. About Tarantino, Slade writes:

A world of purposes only is a world of cross-purposes, the definition of fiasco. What
is intended in the portrayal of such a world is not, of course, a 'classic form,' the
manifestation of an order, 'things held together in a living way with the sense of life
going on,' but the manifestation of an author. Style, then, not order. Where there
are only the purposes of human beings, there are no actions to imitate; there are
events to be strung together, not stories to be told. ("On the Ontological Priority
of Ends," 68)

5

Imitation as Inquiry and Intelligence

In the late 1580s, a young William Shakespeare, then in his early twenties, left his wife and children in Stratford-upon-Avon to pursue a career as an actor. We do not know for certain the circumstances that took him there, but we do know that once he got there, he became what was known as a "hireling" in one of the playing troupes cropping up like mushrooms in Elizabethan London. In other words, he became an apprentice, perhaps not even taking the stage at first but helping the company with costumes, ticket sales, and the like. Eventually, he was given parts and, by at least one report, was taken to be a rather good actor. By and by, he learned his craft, and at one point, again for reasons we cannot be sure of, he tried his hand at writing plays. Research into this period of Shakespeare's life reveals his writing to have been influenced by a wide variety of sources, such as the intense education in classical rhetoric he most likely received at the King Edward VI grammar school in Stratford, which included both the study and imitation of pieces from ancient Roman drama, as well as by the plays of several of his contemporaries, in particular John Lyly, Thomas Kyd, and Christopher Marlowe. Shakespeare's work blossomed, to put it mildly, and before long, he became a part owner or "sharer" in his own troupe, the Lord Chamberlain's

Men, ownership that included the Globe Theatre on the south bank of the Thames.[1]

What Shakespeare's story tells us is that his journey toward becoming the greatest playwright in the English language was made possible by his participation in a practice—namely, the practice of stage drama. The notion of a *practice* is one developed by Alasdair MacIntyre in *After Virtue*.[2] A practice is, to use a theatrical metaphor, the social arena in which we live out the virtues. In a well-known passage, MacIntyre puts the definition this way:

> By a 'practice' I am going to mean any coherent and complex form of socially established cooperative human activity through which goods internal to that form of activity are realized in the course of trying to achieve those standards of excellence which are appropriate to, and partially definitive of, that form of activity, with the result that human powers to achieve excellence, and human conceptions of the ends and goods involved, are systematically extended.[3]

What sort of "socially established cooperative human activity" counts as a practice? Among the examples MacIntyre gives, such as chess and football, physics and biology, he also mentions painting and music, and, as his argument in *After Virtue* continues, the practice of portrait painting is discussed more extensively than any other example. In the Aristotelian-Thomistic tradition, the social backdrop for art, as with other kinds of virtue, is that of a practice, and practices, in turn, are supported by traditions. In the first four chapters of my argument, I have considered, very generally speaking, the picturing that is mimetic art and the object of that picturing. In this chapter, I turn to the artist and to

1. For the details of this biographical sketch, I draw mostly from Park Honan's *Shakespeare: A Life* (Oxford: Oxford University Press, 1999), chap. 7–8.

2. See, in particular, MacIntyre, *After Virtue*, chap. 14.

3. MacIntyre, 187.

the phenomenon we call "artistic creativity." This is a large, complex, and mysterious subject, one that naturally arouses much curiosity. In *Voyage*, the first in Tom Stoppard's trilogy of plays, *The Coast of Utopia*, the character Belinsky, a Russian literary critic, talks about his failure to be a writer:

> I am not an artist. My play was no good. I am not a poet. A poem can't be written by an act of will. When the rest of us are trying our hardest to be present, a real poet goes absent. We can watch him in the moment of creation, there he sits with the pen in his hand, not moving. When it moves we've missed it. Where did he go in that moment? The meaning of art lies in the answer to that question.[4]

Where does the artist go in that moment, the moment of inspiration? This question might be approached theologically, psychologically, or even neurobiologically. I would like to approach it philosophically, with a focus on what it means for artistic creativity to be a function of the artist's participation in the kind of inquiry that takes place within artistic practices, and that leads, in ways I cannot hope completely to explain, to the insight that happens when, as Belinsky says, the artist "goes absent."

ART, PRACTICES, AND INQUIRY

It may seem a strange suggestion to say that the practice of art is an inquiry. For what is an inquiry but an attempt to discover what-is-in-fact-the-case—that is, the *truth*? And why should art be understood in such a philosophical way?

What blocks such an understanding, MacIntyre argues in another context, is a peculiarly modern understanding of art's

4. Tom Stoppard, *The Coast of Utopia: Voyage, Shipwreck, Salvage* (New York: Grove, 2007), 44.

relationship to truth and falsity, a point he makes in a discussion of the art of poetry:

> Questions about the truth or falsity of poetry are not often posed nowadays. For in the compartmentalizations of modern culture, questions about truth and falsity, rational justification, and the like are allocated to philosophy and the sciences and more generally to theoretical inquiry, while poetry is conceived as an exercise of quite a different order. Theorizing about poetry is of course admissible; but that a poem qua poem might itself be a theory, let alone that a poem qua poem might provide for some particular subject matter the most adequate expression for some particular theoretical claim, these are thoughts excluded by our culture's dominant ethos.[5]

The point of this passage is not to collapse the distinction between philosophy and art but to underscore that each is a kind of inquiry into truth. Philosophy inquires into truth by means of abstract concepts, judgments, and arguments, while poetry and the other arts inquire into the truth primarily by way of images. MacIntyre stresses this point in regard to poetic images, but again, the point can be extended to include all the arts:

> Images are true or false, but not in the same way that statements are. Statements say or fail to say how things are; images show or fail to show how things are. Images are true insofar as they are revelatory, false insofar as they obscure, disguise, or distort. But the reality that an image represents more or less adequately is not one to which we have access independently of any exercise of imagination. Our perceptions are partly organized in and through images, and a more adequate imagination is one

5. Alasdair MacIntyre, "Poetry as Political Philosophy: Notes on Burke and Yeats," in *Ethics and Politics: Selected Essays*, vol. 2 (Cambridge: Cambridge University Press, 2006), 159–60.

that enables us to see or envisage what we could not otherwise see or envisage.[6]

To enter into an artistic practice, then, as Shakespeare did when he arrived in London in the late 1580s, is to enter into a form of inquiry, one that endeavors to show the truth of the human predicament through mimetic images. The way of beauty, the way toward the delightful intelligibility of things as displayed through the beauty of the artistic image, is thus the way of inquiry through practices.

Any apprentice to an artistic practice will be asked to learn and to live a key distinction: that between the feelings, experiences, and level of technique appropriate to a beginner, and the feelings, experiences, and level of technique appropriate to a proficient.[7] But necessary to the making of that distinction is the learning and living of another distinction: that between goods internal to the practice and goods external to it.[8] Consider the practice of filmmaking, which in fact is something of an umbrella practice involving numerous different practices: screenwriting, acting, directing, producing, cinematography, production design, digital effects, costuming, makeup, etc. The primary internal good of the practice of filmmaking is, of course, a finished film, one that hopefully meets the standards of excellence that have developed since filmmaking began in the 1890s. These standards of excellence are not *rules*; excellence in filmmaking is not achieved by following a recipe. Doubtless, there are certain rules in force in the practice of filmmaking: some absolute, such as the prohibition against exposing celluloid to sunlight; others

6. MacIntyre, "Poetry as Political Philosophy," 160.

7. In a hypothetical discussion of someone learning how to become an educated listener to classical music (pursued within a wider discussion of Oscar Wilde's expressivist view of art), MacIntyre makes a distinction between what he calls two kinds of aesthetic judgment: the judgments of those who listen to classical music only casually and occasionally, and those who listen to classical music with an educated ear. I adapt this distinction to the situation of the apprentice to an artistic practice. See MacIntyre, *Ethics in the Conflicts of Modernity*, 145–46.

8. MacIntyre, *After Virtue*, 188–89.

less so, like the "180-degree rule" that says the camera should not cross the imaginary axis between two characters in dialogue. But standards of excellence do not function as rules. They are, rather, *principles* and so admit of an infinite variety of different embodiments and can be pulled and stretched sometimes to the breaking point and beyond—as well as, by great artists, *added to* when their work establishes a new standard of excellence. So, for example, a screenwriter may learn the standards of storytelling excellence appropriate to a conventional Hollywood film, standards that involve, among other things, an unambiguous plot structure in which a protagonist pursues a goal against primarily external forces of antagonism through continuous time and, in the end, either succeeds or fails at attaining the goal. But, after mastering this approach to plot—the genealogy of which, as we have seen, goes back to Aristotle's *Poetics*—the screenwriter may want to play with this conventional standard, experimenting with more minimalist plotting, internal conflicts, and open, ambiguous endings. He may even go so far as to try to deconstruct the classical design, forsaking the minimalist plot for an anti-plot, as Jean-Luc Godard does in his 1967 film *Weekend*.[9] Whether a story stretches the principles of screenwriting and filmmaking practice beyond the breaking point is the kind of discussion typically undertaken with great relish by the members of these practices and those who enjoy and critique them.

If trespassing against the basic principles of a practice is one way in which the internal goods of a practice can be put in jeopardy, another way is when the internal goods of the practice are subordinated to goods external to the practice, such as profit, power, and glory. The identifying mark of external goods is that they can be achieved without any participation whatsoever in a practice. One does not need to achieve excellence in the craft of screenwriting or acting in order to make money or achieve power.

9. Robert McKee discusses these differences between classical story design, minimalism, and anti-structure in *Story*, 44–66.

Often enough, we see the participants of an artistic practice com-
promising their artistic integrity by, for instance, putting profit
before excellence in their craft. There is certainly nothing wrong,
of course, with a film company wanting to make a profit on its
work; for a professional company, such a concern is required. But
if concern for profit becomes the overriding consideration, as is
clearly the case in sectors of the mainstream film industry with all
the tired sequels and reboots they bring to market, the integrity
of the practice is seriously compromised.

But as long as an artist subordinates the desire for external
goods to his dedication to the internal goods and standards of
excellence of his practice, he positions himself to acquire the
virtues specific to his art. For an actor, these virtues would in-
clude excellence in diction, projection, and vocal resonance. For
a screenwriter, these would include excellence in the devising of
compelling story concepts, intriguing plots, and complex, believ-
able characters. The *virtues of art*, as we may call them, fulfill
the definition of virtue that MacIntyre correlates with his notion
of a practice: they are "acquired human qualities the possession
and exercise of which tends to enable [the artist] to achieve those
goods which are internal to practices and the lack of which effec-
tively prevents [him] from achieving any such goods."[10]

A picture has begun to emerge as to how successful inquiry
in an artistic practice proceeds. By learning to live the distinction
between goods internal and external to the practice, the artist
moves from the feelings, attitudes, and level of technical prowess
appropriate to the stage of apprenticeship toward the feelings,
attitudes, and level of technical prowess appropriate to the stage
of mastery. Mastery consists in the possession of the virtues of art,
which allow the artist, consistently and with excellence, to pro-
pose truths about the human quest for happiness using the kinds
of images definitive of the art in question. We might call this
picture a sketch for a "virtue poetics," understanding "poetics"

10. MacIntyre, *After Virtue*, 191.

broadly enough to cover the whole panoply of mimetic arts. But the sketch will remain only that, a sketch, until we fill in further details concerning what it means for an artist to live the virtues.

ARTISTIC INQUIRY, MORAL INTEGRITY, AND THE POLITICAL COMMON GOOD

Progress toward mastery in artistic inquiry also requires a set of virtues, or at least of incipient virtues, distinct from the virtues of art: namely, the intellectual virtue of prudence, on the one hand, and, on the other, the moral virtues, or virtues of character. Park Honan's account of Shakespeare's participation in the practice of drama is replete with descriptions of Shakespeare's moral as well as artistic progress, descriptions that show that artistic excellences can develop alongside qualities of character. Honan describes Shakespeare's survival in his first playing troupe as depending on "quick, instinctive co-operation," as well as adaptability, endurance, usefulness, and the discipline needed to find time in a busy schedule to write while also meeting the demands of being an actor.[11] "Our slim evidence," Honan writes, "suggests he avoided quarrels, then and later, and took pride in ordinary competence."[12] Similarly, in reading Kenneth Branagh's account in his autobiography, *Beginning*, of the making of his 1989 film adaptation of Shakespeare's *Henry V*, one cannot help but be impressed with the persistence with which he pursued, still in his twenties and with no track record as a film director, not only financing for the film, but also the participation of a collection of heavyweight actors such as Derek Jacobi, Paul Scofield, and Judi Dench.[13] A certain amount of prudence and moral virtue would seem to be indispensable for the exercise of artistic virtue.

Another way in which prudence and moral virtue complement

11. Honan, *Shakespeare: A Life*, 111 and 121.
12. Honan, 111.
13. Kenneth Branagh, *Beginning* (New York: St. Martin's, 1989).

artistic inquiry within a practice is by forming the intelligence and "loves" of the artist so that the artist is able to "see" intelligently and to love rightly. Prudence develops the artist's intelligence, while moral virtue develops the artist's "loves"—that is, the sense appetites, and primarily the emotions, in addition to the rational appetite, or will, through which the artist conforms to a beloved object of inspiration in the world. These developments together afford the artist the *emotional intelligence* that feelingly perceives the mimetic universals that manifest what is true about human existence. In the next section of this chapter, I will have more to say about the role of emotional intelligence within the inquiries of art.

For the present, however, I want to underscore the importance for artists of developing prudence and moral virtue beyond just what is necessary for the exercise of their art. On the Aristotelian-Thomistic view, every artist is called by the inclinations of human nature not only to achieve excellence as an artist, but also, and more importantly, to achieve excellence as *a human person*, which demands the acquisition of virtues across the spectrum of human capability, most importantly moral and intellectual virtue. If artists only develop intellectual and moral virtue to the extent demanded by their craft, their moral development will remain stunted and lacking in integrity. The persistence or endurance on display in their work might well coexist outside it with sexual intemperance or habitual acts of injustice. Moreover, the persistence or endurance itself would not necessarily be an aspect of the fully formed virtue of courage. Why not?

On an Aristotelian-Thomistic understanding of the virtues, no virtue acquires its full specification until it is situated within the hierarchy of goods and virtues that comprise human fulfillment. Courage, for example, is incompletely conceived until we coordinate it with the true conception of justice that it is the purpose of courage to defend. Similarly, the entire panoply of morally virtuous action is incomplete until it is pursued not only

for its own sake but also for the sake of speculative wisdom and contemplation. And it is not merely that an artist's courage would be incomplete if it consisted only in the persistence necessary to complete demanding projects. Without an understanding of how the goods of the artist's entire life and the virtues needed to attain them are ordered hierarchically, the artist's life, once he leaves his workshop, would be an incoherent set of compartmentalized commitments and activities, against one or another of which he would be constantly and unavoidably offending, as Gauguin did most egregiously in the betrayal of his family. Moral integrity, in sum, requires that one be devoted to a particular narrative of the human quest for happiness, a narrative correlated to a teleological order of human goods and virtues.

The artist is, in addition, a political animal, and so the familial and social relationships and practices in which he or she lives out prudence and the moral virtues are brought to maximum integrity within the widest and most important (human) community of all: the political community.[14] Politics, for Aristotle and Aquinas, is itself a craft, and not just any craft. It is the architectonic craft. As architectonic, the task of politics is to care for the political common good by providing direction to all the other arts and sciences with which members of the political community are involved. Thus, the inquiries of art cannot escape being a political concern. The craft of politics provides direction to those inquiries by dictating, first, what arts are allowed to contribute to the political common good, and second, how those arts, in fact, are to contribute.[15] In a pandemic, a political regime might close movie theaters and so restrict the practice of the art of screen projection, and, by extension, other filmmaking practices. In other circumstances, a political regime might dictate how a certain art

14. Understanding, of course, that there will likely be different levels of political community (e.g., the local, state, and federal levels in the United States).

15. On these distinctions, see Aquinas's commentary on Aristotle's *Nicomachean Ethics, In Sententia libri Ethicorum*, lectio 2, nos. 26–30, esp. 26.

is to be practiced, as when, during wartime, regimes enlist film artists to make training films for the military.

Artistic practices, however, do not only passively receive direction from those with authority over the political common good. They also actively contribute to the political common good by producing works that help the community contemplate and understand its way of life—so that artistic inquiry becomes the shared inquiry of the entire political community.

For many living in the liberal democratic nation-states of late modernity, an Aristotelian-Thomistic politics, with its underpinning in natural teleology and natural law, its robust understanding of the common good, and its equally robust reach into areas of life that we are accustomed to think of as private, will seem hopelessly archaic, if not downright tyrannical, to denizens of modern, secular, individualist regimes. Even those of us attracted to it will feel at a loss for ways of making it a lived reality. Is it possible for an Aristotelian-Thomistic politics to be relevant today?

In a limited though still practicable way, yes. Of course, this Aristotelian-Thomistic politics will not likely be a matter of the *regime*. Rather, and here again I depend upon MacIntyre, it will take the form of a re-creation or regeneration of Aristotelian-Thomistic political life within the structures of a liberal democratic regime, a re-creation that must always be precarious, always careful not to become co-opted by market and other liberal forces. MacIntyre understands practices, including artistic practices, as involving a re-created Aristotelian-Thomistic politics in two ways. First, in order to sustain themselves, practices very often take the form of cooperative organizations, organizations that draw upon wider communities for mutual assistance of various kinds, including material support. In this way, there emerges a network of new or revamped communal relationships. Second, those involved in practices are constantly faced with the question of what place the common goods of their practice are to enjoy in relation to their lives as a whole, as well as to the common goods

of their households and neighborhoods and other communities. And in asking such questions, members of practices aid in the creation of a new network of communities founded upon a hierarchy of common goods. So, MacIntyre concludes, "the recurrent regeneration of practices on occasion produces at least a movement towards a regeneration of local community and therefore towards a regeneration of the communal practices of ordering goods, that is, of communal politics."[16]

What such political regeneration requires from the arts is the kind of work that would enrich a contemplative, and ideally Catholic, imagination in the ways I have talked about in this and in earlier chapters. It would encourage artistic practices that respected the ways in which such an imagination is nurtured first within the bosom of family life, serving the individual person's and family's need for story, beauty, and self-understanding, even as it sought to bring that imagination to fulfillment in addressing the political community's need for story, beauty, and self-understanding. In reaping the benefits of this imagination, a regenerated Aristotelian-Thomistic political community would mimic those ancient Athenian audiences whose participation in tragic and comic drama helped them understand the promises and threats endemic to the pursuit of virtue in a democratic polity.[17] When it comes to those threats, a contemporary Aristotelian-Thomistic politics would need its art not merely to reflect, but rather to subvert, the *status quo*.

16. The analysis in this paragraph is indebted to Alasdair MacIntyre, "The Virtues of Practice against the Efficiency of Institutions," the third of his three Agnes Cuming Lectures at University College, Dublin, in 1994, unpublished manuscript, 56. Used with permission.

17. I have learned from Stephen G. Salkever's discussion of the Athenian situation in "Tragedy and the Education of the *Dēmos*: Aristotle's Response to Plato," in *Greek Tragedy and Political Theory*, ed. J. Peter Euben (Berkeley, CA: University of California Press, 1986), 274–303.

ARTISTIC TRADITIONS AND ARTISTIC INTELLIGENCE

The inquiry of an artistic practice is not merely the inquiry of those artists currently participating in the practice. It is also a conversation handed down from one generation to the next. It is, in other words, a *tradition*. To move forward in their inquiries and to meet the standards of excellence of their practice, artists must learn from the best works of their practice throughout the ages. This learning begins with imitation of the masterworks of their tradition and progresses by asking how this imitation might be developed so that the practice can reveal even more of the truth of the human situation, either by adopting new techniques or by using old techniques to address new questions and problems posed by the present age.

So much might be said about how inquiry progresses within artistic practices and traditions, but in the rest of this chapter, I would like to address more specifically the main driver of such progress: the artist's creative inspiration, intuition, insight, or what I prefer to call the artist's *intelligence*.[18] This is a theme we first encountered back in chapter 3 in discussing the dialectical nature of poetic, or narrative, argument as it culminates in insight. The relationship of intelligence, or insight, to dialectical inquiry—dialectic that occurs just as much in the artist's creative process, as alternative creative possibilities are evaluated, as it does in narrative itself—should be kept in mind as we now further explore the nature of intelligence.

Works of art are made not just by one act but by a constellation of such acts of intelligence. An artist lighting upon the idea that will become the germ of a work is just one example. Another is when an artist intuits that, to break through an impasse in composition, *this* revision must be made. Yet another is a writer's

18. Following Sokolowski's use of the term in "Visual Intelligence in Painting" and *Phenomenology of the Human Person.*

hitting upon the perfect metaphor.[19] Bit by bit, as the Sondheim song goes,[20] by one act of intelligence after another, the artist puts together the form in the matter that will deliver to an audience the experienced meaning of the mimetic universal.

But what exactly is artistic intelligence? First and most importantly, it is the intellectual act by which the artist "sees" something true about the object of the artist's imitation. Secondly, it is the intellectual act by which an artist "sees" how best to picture that truth. As an intellectual seeing, intelligence is distinct from the rational activity that must "work" to achieve the truth, as when the mind, for example, considers two or more premises in an argument and from them infers a conclusion. In intelligence, there is no such working by the mind; it simply "sees" what it knows.[21]

Other acts, both intellectual and sensible, prepare the way for artistic intelligence. Acts of the five external senses and the imagination's perception of the phantasm are necessary to prepare the mind for any act of intelligence. Memory also will play a role. And acts of the mind other than intelligence, such as research and study, have their preparatory function. But even in the act of intelligence itself, reason plays a role in articulating the experience, formulating the words, the gestures, the mimetic movements of whatever sort, that bring the object of inspiration to light. We should not think of intelligence as a nonverbal "flash" of illumination. As Sokolowski observes, we have intelligence of something, "not just in a single, isolated grasp, but within and

19. In *Poetics* 22, Aristotle speaks of the ability to hit upon the likeness that makes a metaphor as a natural ability and something one can never learn from another. He uses the verb *theōrein* at 1459a8 to name the act of the mind that perceives the likeness, the same word he uses in the *Nicomachean Ethics* for the act of intelligence that is contemplation.

20. I'm thinking of "Putting It Together," from Stephen Sondheim's musical *Sunday in the Park with George*.

21. For a fine analysis of the texts of Aristotle on the difference between intelligence and discursive reason, see Kurt Pritzl, "The Place of Intellect in Aristotle," *Proceedings of the American Catholic Philosophical Association* 80 (2007): 57–75. On the same distinction, see also Josef Pieper, *Leisure: The Basis of Culture and The Philosophical Act*, trans. Alexander Dru (San Francisco: Ignatius, 2009), chap. 2.

underneath the articulations of syntactic structure. . . . [Intelligence] occurs in the syntactic achievement that overlays the grasp of the intelligibility of the thing."[22]

In a related passage, Sokolowski expands on this important point. Intelligence, or what Sokolowski also calls a "categorial insight," is an occurrence

> in which someone installs syntax into a situation that had been obscure and muddled, and thereby identifies what a thing is or what is going on. The person in question suddenly succeeds in putting things into relief, with the parts assembling themselves into a coherent and consistent whole and the nature of the issue being brought to light. To use the classical vocabulary, this event shows that the agent intellect has done its job and something has become understood.[23]

It would be hard to find a better philosophical description than this of the intelligence that occurs in artistic inquiry, especially when we consider that "syntax" does not have to take the form of a literal language but can also be understood, analogously, as the arrangement of colors and lines in a painting, of tones in a piece of music, and of bodily movements in dance.

Often crucial to artistic inquiry, too, are acts of the internal sense that Aquinas calls the cogitative sense. The cogitative sense has for its object sense particulars perceived in light of one or another aspect (a ladder as stable, a tree as swaying), or as related to action (a tree as climbable, an apple as edible), or as beneficial or harmful to the agent perceiving (a snarling dog perceived as dangerous).[24] In human action, the cogitative sense helps connect the universal considerations of reason to the sensible particulars

22. Sokolowski, *Phenomenology of the Human Person*, 308–9.

23. Sokolowski, 305.

24. For these distinctions I am indebted to Daniel D. De Haan, "Perception and the *Vis Cogitativa*: A Thomistic Analysis of Aspectual, Actional, and Affectional Percepts," *American Catholic Philosophical Quarterly* 88, no. 3 (July 2014): 397–437.

in regard to which the agent acts. Because its operations come as close as those of any sense power to the operations of reason, Aquinas nicknames the cogitative sense "particular reason."[25] I want to suggest that in artistic inquiry, the cogitative sense helps the artist "see" connections between the parts of the image under construction—as when, for example, a painter "sees" the benefit of juxtaposing a certain color to another on the canvas. This cogitative "seeing" is an act of sensation, not of intelligence, but it prepares the intelligence for its own act of "seeing" the rightness, say, of the painter's juxtaposition of two colors. We will return to the importance of the cogitative sense when we talk in chapter 7 about the audience's appreciation of the formal structures of a work of art.

Now let us zoom in on artistic intelligence itself, especially in regard to its primary manifestation: when the artist "sees" something true about the object of inspiration. Recall, first, what we said earlier about the artist's emotional intelligence. We must acknowledge the role played by the emotions, not to mention the will, in this act of intellectual seeing.[26] Creative intelligence for the artist deeply involves his or her sensible and rational appetites. These appetites are all different kinds of "loving," different ways of being attached to a desirable object. But what is it, specifically, that the artist loves? Following Josef Pieper, I say that the artist's love is a "praise of Creation," an "affirmation of Creation" as something fundamentally good.[27] And as a lover, the artist seeks union with the beloved. The artist's inquiry is realized by becoming one with the object of love via the process of artistic mimesis.

The knowledge produced by the union of lover and beloved has a special name: knowledge through affective connaturality, or simply, connatural knowledge. It is the same kind of knowledge

25. *Summa theologiae* 1.78.4.

26. The will would be involved, I take it, insofar as the artist chooses to pursue contemplation of some marvel in the world.

27. Josef Pieper, *In Tune with the World: A Theory of Festivity* (South Bend, IN: St. Augustine's, 1999), chap. 6, esp. p. 54.

Flannery O'Connor has in mind when she speaks of "experienced meaning." An example often used in discussions of this kind of knowledge is taken from the opening scene in Charles Dickens's novel *Hard Times*.[28] The harsh Mr. Gradgrind gives the following advice to a schoolmaster:

> Now, what I want is, Facts. Teach these boys and girls nothing but Facts. Facts alone are wanted in life. Plant nothing else, and root out everything else. You can only form the minds of reasoning animals upon Facts: nothing else will ever be of any service to them. This is the principle on which I bring up my own children, and this is the principle on which I bring up these children. Stick to Facts, Sir![29]

Gradgrind then calls on a girl in the classroom, "girl number twenty," Sissy Jupe. When he learns that her father is a breaker of horses, Gradgrind waves off "the objectionable calling with his hand." Then he asks Sissy Jupe to define a horse. When she cannot, Gradgrind erupts: "Girl number twenty unable to define a horse! . . . Girl number twenty possessed of no facts, in reference to one of the commonest of animals! Some boy's definition of a horse. Bitzer, yours." Bitzer then defines a horse:

> "Quadruped. Gramnivorous. Forty teeth, namely, twenty-four grinders, four eye teeth, and twelve incisive. Sheds coat in the spring; in marshy countries, sheds hoofs too. Hoofs hard, but requiring to be shod with iron. Age known by marks in mouth." Thus (and much more) Bitzer.

28. See, for example, James S. Taylor's book on connatural knowledge, or what he, following Jacques Maritain, calls poetic knowledge: *Poetic Knowledge: The Recovery of Education* (Albany, NY: State University of New York Press, 1998), 6–7.

29. Quotations are taken from chapters 1 and 2 of *Hard Times* (New York: Alfred A. Knopf, 1992). In the copy of *Hard Times* I borrowed from my college library, someone had typed out and pasted onto the first inside page the following passage from Plato's *Phaedrus* (274–75): "By telling them of many things without teaching them you will make them seem to know much, while for the most part they know nothing, and as men filled, not with wisdom, but with the conceit of wisdom, they will be a burden to their fellows."

Gradgrind triumphs at Bitzer's performance and declares to Sissy Jupe that she now knows what a horse is. Poor Sissy is ashamed. And there's the irony: because of her father's work, she has been around horses her entire life. In one sense, she knows horses better than anyone in that classroom. Sissy has connatural knowledge of horses because she is united to horses through her affections and experience. What she doesn't have is Bitzer's *scientific* knowledge of horses. Yet scientific knowledge is the only kind of knowledge a cruel taskmaster like Mr. Gradgrind recognizes.

In his monumental work *Creative Intuition in Art and Poetry*, Jacques Maritain calls experiential or connatural knowledge "creative intuition," "poetic intuition," or "poetic knowledge." According to Maritain, poetic knowledge arises out of the preconscious, as opposed to the subconscious, life of the intellect. Specifically, it arises from the activity of what Aquinas calls the "agent intellect" and Maritain the "Illuminating Intellect," that power of our intellect that abstracts from phantasms and so conceptualizes the essentials of things. Our mental focus is typically outward, on the things we are thinking about. But we can, as we are doing now, with a reflexive turn, think about the process of thinking itself and *how* our agent intellect conceptualizes the essentials of things, a process that, argues Maritain, is unconscious: "And this primal source of light cannot be seen by us; it remains concealed in the unconscious of the spirit."[30] Out of this unconscious night of the agent intellect comes the inspiration, the act of creative intelligence, that Maritain calls poetic knowledge, a special knowledge through inclination or connaturality that ultimately tends to express itself in a work.[31] Poetic knowledge "proceeds from the intellect in its most genuine and essential capacity as intellect, though through the indispensable

30. Jacques Maritain, *Creative Intuition in Art and Poetry* (New York: Meridian, 1957), 73.

31. Maritain, 86.

instrumentality of feeling, feeling, feeling."[32] Apparently, then, Maritain would agree that Sissy Jupe's experiential knowledge of horses is connatural knowledge, though he probably would also say that Sissy Jupe's connatural knowledge of horses is not the same as a creative intuition, as it is insufficiently infused with wonder, as well as insufficiently conjoined with the artistic skills necessary, to inspire an artistic work.

Maritain further maintains that poetic knowledge has an important connection with the self of the artist, as it is an "intercommunication between the inner being of things and the inner being of the human Self which is a kind of divination."[33] What in poetic knowledge the artist intuits as true about some reality in the world both resonates with and reveals the artist's innermost being. I take Maritain to mean that affective union with an object always has a personal meaning for the artist. The deepest longings of the artist's soul are answered, in part, by that aspect of the world with which the artist communicates in poetic knowledge. On this understanding, a work of mimetic art can be considered both as a picturing of something and as an expression of the artist's thoughts, feelings, and experiences.[34]

But in what sense, for Maritain, is poetic knowledge *knowledge*? Maritain provocatively asserts that, although poetic knowledge involves the activity of the agent intellect, the conceptualizing power of reason, poetic knowledge is nonetheless *not* conceptual knowledge. It does not grasp, in the abstract, the essential reality of things. At the same time, however, Maritain insists that poetic knowledge is cognitive—which is to say, it is a grasp of the real, an "intercommunication," as he says, between the inner reality of

32. Maritain, 87.

33. Maritain, 3.

34. Maritain takes pains to distinguish the inner self that is engaged in poetic knowledge and the egoistic self. Poetic knowledge, he says, "engages the human Self in its deepest recesses, but in no way for the sake of the ego. The very engagement of the artist's Self in poetic activity [i.e., any artistic activity], and the very revelation of the artist's Self in his work, together with the revelation of some particular meaning he has obscurely grasped in things, are for the sake of the work" (Maritain, 107).

things and the inner reality of the artist's self.[35] But how can any form of intellectual knowledge, poetic or otherwise, grasp reality without grasping that reality's essence? Maritain's answer is the following:

> Poetic intuition is directed toward concrete existence as connatural to the soul pierced by a given emotion: that is to say, each time toward some singular existent, toward some complex of concrete and individual reality, seized in the violence of its sudden self-assertion and in the total unicity of its passage in time. This transient motion of a beloved hand—it exists an instant, and will disappear forever, and only in the memory of angels will it be preserved, above time. Poetic intuition catches it in passing, in a faint attempt to immortalize it in time.[36]

Poetic knowledge, in brief, is for Maritain a knowledge of *particulars*; it is the grasp of a *thing*, not a concept, a thing taken into the deep recesses of the artist's soul through the instrumentality of the emotions by which the artist is made connatural with the thing.

What service, then, does the agent intellect provide in poetic knowledge if it is not that of illuminating the essential nature of some object? In the following passage, Maritain offers a reply to this question by way of describing the dynamics of poetic knowledge within the artist's soul:

> Emotion, falling into the living springs, is received in the vitality of intelligence, I mean intelligence permeated by the diffuse light of the Illuminating Intellect and virtually turned toward all the harvests of experience and memory preserved in the soul, all the universe of fluid images, recollections,

35. About poetic knowledge, Maritain says, "First, I am speaking of a certain kind of knowledge, and emotion does not know: the intellect knows, in this kind of knowledge as in any other" (Maritain, 87).

36. Maritain, 91.

associations, feelings, and desires latent, under pressure, in the subjectivity, and now stirred.[37]

Here Maritain wonderfully evokes the rich and mysterious microcosmos that is the artist's soul in the grip of poetic experience, where the emotion suffered falls like a meteor through a solar system of experience and memory, of images, recollections, associations, other feelings, and latent desires. The first principle of this microcosmos is the agent intellect, what Maritain calls the Illuminating Intellect, whose "diffuse light" permeates the other acts of the artist's soul and especially the appetites as they embrace the inspiring object. Yet the emotion gripping the soul of the artist, "while remaining emotion," is also made

with respect to the aspects in things which are connatural to, or like, the soul it imbues—into an instrument of intelligence judging through connaturality, and plays, in the process of this knowledge through *likeness* between reality and subjectivity, the part of a nonconceptual intrinsic determination of intelligence and its preconscious activity. By this very fact it is transferred into the state of objective intentionality; it is spiritualized, it becomes intentional, that is to say, conveying, in a state of immateriality, things other than itself.[38]

Maritain says here that in poetic knowledge, the emotion through which the artist is made connatural to an object becomes "an instrument of intelligence," "a nonconceptual intrinsic determination of intelligence and its preconscious activity," able to convey, "in a state of immateriality, things other than itself." The emotion becomes the means "through which the things which have impressed this emotion on the soul, and the deeper, invisible things that are contained with them, and which have ineffable

37. Maritain, 88.
38. Maritain, 88–89.

correspondence or coaptation with the soul thus affected and which resound in it, are grasped and known obscurely."[39] This last comment is especially curious, for in it Maritain indicates that the "invisible things" contained within the object of the artist's object of inspiration, which can only mean the object's essential characteristics available to the mind and not to the senses, are "grasped and known obscurely." Grasped and known by the emotions, or by the mind? Maritain seems to want to say that in poetic knowledge, the emotional connection with the object of inspiration, in carrying the object into the artist's soul while in connatural unity with it, makes possible an obscure grasping of the "invisible things" contained within the object, without involving the abstractive workings of the agent intellect (but still in some way "illuminated" by it—?).[40]

I do not find Maritain's account of artistic intelligence or poetic knowledge entirely persuasive. Certainly, he is correct that artistic intelligence binds the artist emotionally and connaturally with the artist's object of inspiration. And certainly, he is correct that this connatural experience involves no discursive reasoning but rather receives its object in a single "look" or insight, one that, further, resonates with and reveals the artist's innermost self. But when it comes to the claim of artistic intelligence being nonconceptual, Maritain's account runs afoul of a basic truth of the Aristotelian-Thomistic theory of knowledge: that there is, for human beings, no such thing as intellectual knowledge without the grasp of a thing's essence. On this score, I follow the criticism of Thomas R. Heath, one of the earliest reviewers of Maritain's *Creative Intuition in Art and Poetry*:

If we are going to talk about poetic knowledge we must, it seems to me, admit that it is knowledge. It may be, and it is,

39. Maritain, 89.
40. In a related passage, Maritain says that creative intuition is *"above conceptual reason"* (*Creative Intuition*, 179; emphasis in original).

a special kind of knowledge, but if the Angelic Doctor teaches that the ordinary way of knowing extra-mental reality is the only way, so long as man is a union of soul and body, then poetic knowledge with all its special indults, must still conform in its essentials to this way. Asking whether the intellect can understand through its intelligible species [or concept] without a phantasm (*ST* 1.84.7) he quotes Aristotle with complete approval: "the soul understands nothing without a phantasm." This implies, of course, that the soul can understand nothing without an intelligible species, or without a concept.[41]

Extrapolating from Heath's analysis, we can say that artistic intelligence, or poetic knowledge, must involve the mind's abstraction of an essence—abstraction made possible and complemented by the artist's emotional, connatural experience of the inspiring object.

In his essay "Visual Intelligence in Painting," Robert Sokolowski describes how artistic intelligence functions in the viewing of a portrait:

The portrait calls for intelligence (*intellectus* or *nous*) and not reasoning (*ratiocinatio* or *syllogismos*). You might carry out inferences when you are studying the painting, when you are decoding the symbols, being informed about the iconography, and examining the patterns of line and color; but when you see the painting as a whole, you engage not in inference but in articulated identification, in categorial synthesis, in an act of intelligence, an act of understanding. . . . We are therefore moved, we rejoice or we are stunned, not because we have solved a puzzle but because we have understood something about the kind of actuality we call happiness.[42]

41. Thomas R. Heath, "*Creative Intuition in Art and Poetry* by Jacques Maritain (Review)," *The Thomist* 17, no. 4 (October 1954): 586.
42. Sokolowski, "Visual Intelligence in Painting," 348.

In a related passage from his book *Phenomenology of the Human Person*, Sokolowski talks about intelligence, or insight, in the context of the novels of Henry James. Sokolowski notices that James often uses the phrase "taking something in" as a synonym for intelligence:

> When we take something in, we identify a particular situation, event, or entity, but we do so by understanding what it is. We take it not only as an individual but also as a kind."[43]

The first text from Sokolowski itself "takes in" the notion of intelligence from the viewpoint of the viewer of a portrait, while the second text regards intelligence from the viewpoint of a character in a novel or any human agent arriving at an understanding of a situation, event, or person. We can adapt these discussions to the situation of artistic inspiration. For just as someone looking at a painting, or "sizing up" a situation, can understand, in a single intellectual "glance," what that something is, so too, an artist, struck by some marvel in the world, can understand the essence of that marvel. To use a different metaphor, the artist can "get it" or "see the point of it" in an act of artistic intelligence.

In the first passage, Sokolowski calls intelligence an act of "articulated identification." In the second text, he talks about intuition as "identifying" a particular situation, event, or entity. Intelligence, including the intelligence involved with artistic creativity, achieves an identity. It grasps oneness amidst multiplicity. The various aspects or profiles of a thing, which contribute to its

43. Sokolowski, *Phenomenology of the Human Person*, 308. What Sokolowski says in "Visual Intelligence in Painting" is also helpful:

> [A portrait] presents, poetically, someone's shot at happiness and self-identity. It presents what Aristotle would call a 'first substance,' an individual entity, an instance of the species man, but it does not present that substance as a mere compound; it presents that entity as an essence, with a necessity and a definition. This definition is individualized (it is a *first* substance), but it is also able to be universal, that is, it can flow back on life, and more specifically, it can become identifiable with the persons who view it, the other individuals who are also an issue for themselves, who are also engaged in beatitude. (344)

marvelousness, are identified as being just that: aspects or profiles *of a thing* and of a certain *kind* of thing. Sokolowski observes: "We take it [i.e., whatever the object of the artist's inspiration is] not only as an individual but also as a kind." He explains:

> The thing is recognized for what it is, and we understand, or at least we think we understand, what is going on, and we can distinguish it from other things and events: it is a betrayal, a deception, a lapse into weakness, an act of generosity; or a tree, a spider, a shelter, a tribal ceremony; or perhaps something that still needs a name and that will get one, very likely, with the help of qualification or metaphor added to a familiar name. We take in the essence of something.[44]

The acts of intelligence that characters display in stories imitate acts of intelligence on the part of their authors. When the ghost who seems to be his father reveals to Prince Hamlet the circumstances of his death—

> But know, thou noble youth,
> The serpent that did sting thy father's life
> Now wears his crown.

—Hamlet expresses an act of intelligence, an insight, when he exclaims:

> O my prophetic soul!
> My uncle![45]

He registers not merely his uncle, Claudius, but his Uncle Claudius as a *murderer* and *usurper*. He takes in Claudius for what

44. Sokolowski, *Phenomenology of the Human Person*, 308.

45. Shakespeare, *Hamlet* 1.5.37–41, ed. Ann Thompson and Neil Taylor (London: Arden Shakespeare, 2006). All quotations from *Hamlet* will be taken from this edition.

he is, both as an individual and a kind. Even before this encounter, Hamlet had been entertaining vague suspicions that there was something strange and untoward about his father's death. Three scenes earlier, when his friends first tell him they have seen his father's ghost appearing in a full suit of armor, Hamlet tells himself:

> My father's spirit—in arms! All is not well;
> I doubt some foul play.[46]

Even earlier than this, Hamlet has, in conversing with his friends, divulged his deep resentment of his uncle, his mother, and "the most wicked speed" with which they were married after his father's death.[47] Until he meets his father's ghost, Hamlet's heart is a storm of thoughts and emotions, with only the most diffuse light of suspicion breaking through. But when his father's ghost tells him that his uncle murdered him and took his crown, the storm is dispersed by the sun of intelligence: "O my prophetic soul!" Hamlet finally gets it. He understands now that his suspicion was not unfounded. Of course, as the play proceeds, other doubts creep into Hamlet's mind: that the ghost might not be trustworthy; indeed, that it might be a devil sent to trick him.[48] Hamlet's doubts serve as a good reminder that what we take to be understanding can be illusory. Artists in the throes of composition know this. What seems like a brilliant insight one day can be deleted from the laptop the next. Acts of intelligence can always be put into question by later acts of intelligence and further experience. Thus, Hamlet takes action to convince himself of the real identity of the ghost. Only at the end of the play-within-a-play is he convinced that the ghost is trustworthy, an act of intelligence

46. *Hamlet* 1.2.253–54. "Doubt" here, as the editors of Arden Shakespeare tell us, means suspect or fear.

47. *Hamlet* 1.2.156.

48. *Hamlet* 2.2.533–40.

he confirms by saying to his friend Horatio, "O good Horatio, I'll take the Ghost's word for a / thousand pound."[49]

Plainly, then, intelligence grasps the essential. But how does intelligence identify something as *individual*? The registration of an individual *as an individual* seems to be the work of sensation rather than intellect. But, in fact, it is a combination of both. Recall that after the agent intellect grasps the essence of something, it then relates its grasp of the essential back to the sensory knowledge that originally made the grasp of the essential possible. Specifically, it relates its essential knowledge back to the phantasm or complex sensory image of the individual thing. All of which occurs instantaneously so that it seems that we grasp both the individual and the kind of thing it is in one simultaneous "look."[50]

An interesting question is whether artistic intelligence merely perceives in a fresh—call it "aesthetic"—way what we already know, or whether artistic intelligence produces genuinely new insights. Montgomery Belgion denies that the poetic image, at least, offers to the reader anything that might be called a "revelation." He asks us to consider the following image from *Hamlet*, spoken by the dying prince:

> (as this fell sergeant Death
> Is strict in his arrest....)[51]

Belgion then goes on to argue:

> Now, when we first read this, we may well realize that we ourselves had never seen a similarity between an arrest and death, and yet that the assumption of similarity, which the maker

49. *Hamlet* 3.2.278–79.

50. See *Summa theologiae* 1.84.7: "And therefore, for the intellect to understand its proper act, it must turn to the phantasms so that it might understand [*speculetur*] the universal nature in the particular existing thing." Translation my own, in consultation with the Anton Pegis translation used in Thomas Aquinas, *On Human Nature*, ed. Thomas S. Hibbs (Indianapolis, IN: Hackett, 1999).

51. *Hamlet* 5.2.320–21.

of the image goes upon, is entirely legitimate. But we have learned nothing more about death, or about being arrested, than if Hamlet had been made to say merely: "The end is near." On the contrary, in order that the image should fulfil its purpose and that we should be moved, it is indispensable that we should already be familiar—by description, if not by acquaintance!—with the possible suddenness of arrests and the possible suddenness of an imminent death.[52]

Shakespeare's image, thus, according to Belgion, is capable of producing an "aesthetic emotion" in the reader or audience, but nothing in the way of discovery of anything new. My response to Belgion is first to recall a point made back in chapter 1: that as audience, we always bring to the enjoyment of mimetic art a general background knowledge of the world, a background filled in by culture, education, and personal experience. And, true enough, we draw upon this background knowledge, and in particular what we know about "death" and "arrests," in order to make sense of Shakespeare's image. But we must distinguish this background knowledge from the genuinely new knowledge, for both artist and audience, of which artistic intelligence is capable. Such new knowledge can be of two kinds. First, poetic knowledge—that is, knowledge through the affections—of something previously known but never experienced as "poetic." Shakespeare's image, especially in the context of the entire play of *Hamlet*, can give me an emotional experience of death's suddenness that I never "knew" before. Second, artistic intelligence embodied in a work of mimetic art can deliver new knowledge in the hard sense of *never before known*. For myself, I can say that I simply did not know the logic of eternal damnation, as the *reductio ad absurdum* of our wayward desires, until Dante showed it to me in the

52. Belgion makes this point in a review of Maritain's *Art and Scholasticism*, interesting apart from the point being discussed here: Montgomery Belgion, "Art and Mr. Maritain," in *The Human Parrot and Other Essays* (Freeport, NY: Books for Libraries, 1967). Belgion's book was first published by Oxford University Press in 1931.

Inferno. Of course, I had *some* knowledge of what eternal damnation meant before this. But seeing it as a condemnation in and by our own desires, as Dante taught me to see it, was indeed a revelation for me. And, I believe, examples of such new intelligence experienced in the enjoyment of mimetic art could be fairly easily multiplied. This seems to me one of the chief reasons why we value mimetic art: its ability to help us see in ways we have never experienced before.[53]

It is important to note, however, that an act of artistic intelligence need not be scientific. As Heath argues:

> It is by no means necessary to have a clearcut concept of man (i.e., man is a rational animal) in order to see him. Our concepts may be obscure from the standpoint of logic, lacking genus and species, but still brilliantly accurate in capturing some aspect of man.[54]

This observation articulates well what artistic inspiration is like, especially the original inspiration that spurs creation: the essence of something is grasped by the artist intuitively, but still vaguely and obscurely. Contra Maritain, a vague and obscure grasp of an inspiring object in emotional experience is perfectly compatible with the universalizing powers of the intellect. What the artist must do then is undertake an inquiry, in the form of composition, to clarify what has been grasped and to articulate it in a mimetic universal embedded in pleasing particulars.

Heath gives a fine example of someone's vague and obscure grasp of a concept, one that could easily be seen as an example of artistic inspiration:

> Someone in musing over the tortures inflicted on him by men

53. Halliwell interprets the *Poetics* as also upholding the view that poetry does not merely confirm previously existing experience of life. See *Aesthetics of Mimesis*, 198–201.
54. Heath, "*Creative Intuition in Art and Poetry* by Jacques Maritain (Review)," 587.

158

of an opposing army, said: "Man is a dirty animal." Logically, that is obscure. Descriptively, it is shattering clear. It is like a gunshot. It is, we submit, the beginning of poetry; a flash into the depths.[55]

That such an intuition, "Man is a dirty animal," is logically obscure should remind us how, for Aquinas, poetry is a branch of logic, albeit the lowest branch. Poetry's form of persuasion through images convinces us not by a scientific grasp of things but by intelligence animated by appetites seeking conformity to their object.[56] The insight that "man is a dirty animal" grips both the mind and the emotions. Again, Sokolowski observes that with the act of intelligence comes emotional reaction: "We are therefore moved, we rejoice or we are stunned, not because we have solved a puzzle but because we have understood something about the kind of actuality we call happiness." The last part of Sokolowski's observation further reminds us of the ordering of all the stages of mimetic art to the picturing of an "essay at beatitude." At the stage of artistic inspiration, our intuition or intelligence identifies something against the ultimate backdrop of what it means to live a happy life.

I close this chapter with another illuminating remark from Heath. Rather than calling artistic inspiration or poetic knowledge "nonconceptual," Heath prefers to call it "extremely conceptual." He begins with the following lines from Yeats—

The winds that awakened the stars
Are blowing through my blood

55. Heath, 587. For a fascinating discussion of the relationships between intuition, imagination, and truth from the perspective of contemporary neuroscience, see Iain McGilchrist, *The Matter with Things* (London: Perspectiva, 2023), chapters 17–19.

56. Both Aristotle and Aquinas argue that even images of things not pleasant in themselves can give us pleasure, because the images provide a kind of knowledge of how things are. Aquinas makes this point at *Summa theologiae* 1-2.32.8, and in doing so references *Poetics* 4.

—and then offers the following comment:

> I do not think [Yeats] is dealing with nonconceptual knowledge. He begins, I believe, with a keen feeling of his exultation, and here we do see the element of knowledge by inclination, or emotion, but he also has a clear awareness, and it seems to me a *conceptual* awareness of his exultation. He knows he has it and that it is unlike anything on earth. So he reaches into the heavens for his illuminating image.[57]

I agree with Heath that the "extremely conceptual" nature of artistic intelligence explains better than Maritain's account of nonconceptual poetic knowledge "where" the artist goes when, as Stoppard's Belinsky describes him, he suddenly becomes "absent."

57. Heath, "*Creative Intuition in Art and Poetry* by Jacques Maritain (Review)," 587–88. The Yeats poem is "Hanrahan Laments Because of His Wanderings."

Part II
The Mimetic Arts and Moral Transformation

6

Mimetic Art as Delight in Knowing

To those of us who love Jane Austen, she is like the brightness of burnished silver. Something lovely, with sparkle, that makes our world more beautiful. I adore her. I love the pleasure she gives with a well-turned line, the way she can make you actually laugh out loud, the bite of her sarcasm, how she lets you fall in love again and again.[1]

To lovers of the novels of Jane Austen, and of the film, stage, and audio adaptations of the same, the sentiments expressed above will elicit nods and smiles of heartfelt agreement. Few authors rival Jane Austen for the sheer delight she produces in her legions of devoted readers. The charming opening scenes of *Pride and Prejudice*, for example—Mr. and Mrs. Bennet's verbal sparring over Mr. Bingley's arrival, the introduction of the witty and winsome Elizabeth Bennet—fill us with eager expectation of delightful romantic complications. Is this delight not what we want most from a work of art? What else could the purpose of mimetic art be if not to *move* an audience, to produce that feeling of sheer delight?

What, then, about Shakespeare's *Macbeth*? The ominous opening scenes of that play—the three witches on the heath, the prophecies they speak to Macbeth and Banquo—fill us with horror and foreboding, not (it seems) with delight. And yet, we pay

1. The sentiments belong to Jane Adams, author of *Remarkably Jane: Notable Quotations on Jane Austen* (Kaysville, UT: Gibbs Smith, 2009).

money to feel that horror and foreboding. We watch those opening scenes of *Macbeth* with our attention riveted. Feelings of horror and foreboding in the theater are delightful to us not because they give us an easy, cozy experience, but because they give us an interesting, contemplative experience. And the same, for that matter, must be insisted regarding *Pride and Prejudice*. Though many are content to take it merely as an exercise in romantic wish-fulfillment, the deeper delights of *Pride and Prejudice* are to be found in contemplating the moral transformations of its heroine and hero and how those transformations make possible the happy ending in a marriage.

The delight we experience in works of mimetic art is what we might call *mimetic delight*. It is a peculiarly cognitive delight. A delight in *knowing*. We first encountered the notion of cognitive delight back in chapter 1 in talking about the connection between mimesis and our natural love of learning and contemplation, and it arose again in chapter 3 in our discussion of story as moral argument. More, however, needs to be said to make this experience plain. So, in this chapter and the next, I would like to break open, philosophically, this experience of cognitive delight in mimetic art. Although it is one complex experience, for the sake of my analysis, I am going to artificially treat it in two parts. First, here in chapter 6, I will delve into the cognitive side of the experience, and then, in chapter 7, take up the "delight" side. It will be impossible wholly to separate the two aspects of the experience, of course, but I will nonetheless attempt to emphasize one more than the other in their respective chapters.

WHAT WE KNOW WHEN WE COGNITIVELY DELIGHT
IN A WORK OF ART,
PART I: COMPOSITIONAL FORM

First, we need more clarity on what it is in the work of art that we respond to with cognitive delight. To what is our delight in knowing directed?

Given that mimetic art is a kind of picturing, there seem to be three dimensions of a work that can elicit our cognitive delight: the object, or subject matter, of the picture; the picture *as a picture* and therefore its quality *as imitation*; and finally, the formal compositional elements of the picture. More precisely, however, there are two dimensions of a work that can elicit our cognitive delight, as the focus on the picture as a picture and the focus on the object of the picture are simply different ways of considering the same thing: the re-presentation of a certain form in a pictorial medium.[2]

I want to consider the second dimension first: the formal compositional elements of a picture. What is it that we learn about and know when we focus on a work's formal structure?

When we focus on the compositional form of a work, we focus on the artistic technique exhibited in the work. In reading *Pride and Prejudice*, we might focus, for example, on the wonders of Austen's use of "free indirect style," the technique of capturing a character's voice in apparently detached narration. In the following passage, the Bennet sisters, in the company of their boorish cousin, Mr. Collins, arrive at their Aunt Philips's house in the nearby village of Meryton:

> Mrs. Philips was always glad to see her nieces, and the two eldest, from their recent absence, were particularly welcome, and she was eagerly expressing her surprise at their sudden return

2. A point made by Thomas Dominic Rover in *Poetics of Maritain*, 196. My entire discussion of cognitive delight in this chapter and the next is deeply indebted to Rover's analysis.

home, which, as their own carriage had not fetched them, she should have known nothing about, if she had not happened to see Mr. Jones's shop boy in the street, who had told her that they were not to send any more draughts to Netherfield because the Miss Bennets were come away, when her civility was claimed towards Mr. Collins by Jane's introduction of him.[3]

This is free indirect style. It is what Douglas Lane Patey calls a "stylistic impersonation" of a character's speech.[4] About this sentence, Patey observes: "The voice we hear does not sound like the narrator's. The style is not hers. In this long-winded, shapeless sentence we hear the voice of Mrs. Philips herself: this breathless run-on sentence is the outer form of her run-on, undiscriminating mind."[5]

It is in part for the pleasure of Austen's technical prowess with free indirect style and other stylistic devices that the reader returns, time and again, to *Pride and Prejudice*. It is in part for his pointillistic technique that lovers of painting return, time and again, to the work of Seurat. And it is in part for the unique timbre of his Irish brogue and his powerful phrasing that lovers of folk rock and jazz love listening to the voice of Van Morrison.

THE INTEGRITY, PROPORTION, AND RADIANCE OF COMPOSITIONAL FORM

Golden lads and girls all must,
As chimney sweepers, come to dust.
 Shakespeare, *Cymbeline*

3. Jane Austen, *Pride and Prejudice* (New York: Penguin Classics, 2014), bk. 1, chap. 15, 72.

4. Douglas Lane Patey, "The Voices of *Pride and Prejudice*," in the Ignatius Critical Edition of *Pride and Prejudice*, ed. Joseph Pearce (San Francisco: Ignatius, 2008), 407. For an extensive meditation on the nature and effects of free indirect style, see the opening sections of James Wood's *How Fiction Works* (New York: Farrar, Straus and Giroux, 2008).

5. Patey, "Voices of *Pride and Prejudice*," 407.

Let us turn to a different literary example of compositional form.

Consider the couplet that I've chosen as an epigraph for this section. It is taken from a song in Shakespeare's late romance *Cymbeline*, a song often known by its opening line, "Fear no more the heat o' the sun."[6] It is not important for what I want to say about this couplet to get the context of the song as a whole, much less the scene in which it occurs or the plot of *Cymbeline*. Let us simply take this couplet as a stand-alone item.

The first thing to notice is that these two lines of verse *can* be taken as a stand-alone item. They form that poetic construct already identified: the couplet. A couplet is a "coupling" of two lines of verse in which the last words in each line rhyme. Shakespeare often uses couplets in plays to signal the ending of a scene; the rhyme works as something of a little bell, alerting the audience that the scene is over. In his sonnets, Shakespeare likes to sum up his meditation with a couplet, and in this song from *Cymbeline*, Shakespeare likewise uses couplets at the end of each stanza to sum up the thought the stanza has meditated upon. So, what makes our two lines a "couple" is not simply the rhyme. They are united also and more importantly by the fact that they express an entire thought. If we abstract the first line and consider it singly—"Golden lads and girls all must"—we are left hanging. We need the second line of the couplet to complete the thought that golden lads and girls are no different than chimney sweepers. Like all human beings, they are made from dust and to dust they shall return.

A couplet is a *compositional whole*. It is a miniature work of art. As John Donne said about the human body, a couplet is "a little world made cunningly."[7]

6. The couplet is to be found at *Cymbeline* 4.2.262–63, in *Arden Shakespeare Complete Works*, ed. Richard Proudfoot, Ann Thompson, and David Scott Kastan (London: Thomson Learning, 2001).

7. Stanley Fish, in his delightful *How to Write a Sentence: And How to Read One* (New York: HarperCollins, 2012), p. 8, borrows Donne's poetic description of the human body as his definition of a sentence. I, in turn, borrow it for a definition of a couplet, which is simply a sentence in verse.

Compositional wholes come in many shapes and sizes. There is not just one kind of compositional whole. Each stanza of this song from *Cymbeline* is a compositional whole, as is the song in its entirety. The scene in which the song occurs is a larger compositional whole, and the act in which the scene occurs is an even larger one. The plot of *Cymbeline* is the largest, most all-encompassing compositional whole associated with the play.

For any poetic construct to be a compositional whole, its mimetic picturing must bring a line of action and thought to completion. It must have, in other words, a beginning, middle, and end. *Even something so small as a couplet?* Yes. The thought begins with golden lads and girls (the beginning) and goes on to complicate matters by making a comparison between them and chimney sweepers (the middle), a comparison that leads to the marvelous inevitability of the conclusion that golden lads and girls are just as mortal as chimney sweepers. The "thought" of the song is a mimetic picturing of the entire lives, which is to say, the "action," of two sorts of human beings—robust youth and humble chimney sweepers.

To say that our couplet has a plot is to use the word "plot" analogously. The plot of a story as a whole is the primary analogate, the controlling sense of plot. Interestingly, though, we do not need the wider context of the plot of *Cymbeline* to appreciate the plot of our couplet. We can understand its plot even when the couplet is abstracted from the song and from the play. That is because the couplet is a compositional whole: a mimesis of human action and thought complete unto itself. We can therefore speak of this couplet's Controlling Idea: Golden lads, girls, and chimney sweepers all must succumb to mortality simply because they are all, no matter their age and station in life, human beings.

Rhetorical devices are among the primary weapons in any writer's arsenal. Rhetorical devices enhance language. They help to make it more intelligible, more attractive, more persuasive. Rhetoric, in fact, is defined as the art of persuasive speech. Our

couplet from *Cymbeline* employs rhyme, one of the most peren-
nially attractive of rhetorical devices. Though the device is largely
out of favor in modern poetry, it continues to maintain a vigorous
existence in popular music. Our auditory power and imagination
cannot get enough of that repetition of sound. This is a sign that
we love harmony, order, proportion—the intelligible relationship
between parts. In a perfect rhyme, the proportion consists of rep-
etition of the exact same sound: must/dust. Aurally we discern in
the rhyme a sameness within difference: there are two entirely dif-
ferent words with entirely different meanings, which even begin
with entirely different letters, but they share the exact same core
sound. In weaker rhymes, the repetition is not quite so exact but
is still close enough for us to register sameness within difference.

Another rhetorical device employed by Shakespeare in our
couplet is alliteration, which again has to do with repetition, but
this time of consonant sounds. Alliteration, like rhyme, helps to
create order among disparate parts, an order that, also like rhyme,
is meant to be discerned aurally. There is alliteration of the letter
"g" in "golden" and "girls" and a subtler alliteration of the letter
"l" in "golden," "lads," "girls," and "all."

The verse itself—the rhythm of the words—also manifests
proportion. Shakespeare is famous for his use of the poetic foot
known as the iamb, a unit of verse consisting of two syllables
each, the first unstressed, the second stressed, as in the word "per-
haps" (per-HAPS). Shakespeare likes poetic lines consisting of
five iambs, the resultant verse form known as iambic pentameter.
But in this couplet, he stays away from the iamb. In the first
line, he seems to use two dactyls, a poetic foot consisting of three
syllables, the first stressed and the latter two unstressed, as in the
word "happenstance" (HAP-pen-stance). The first two words of
the first line, "Golden lads," which add up to three syllables, form
a dactyl, and the last three words of the line, "girls all must," seem
to do so as well. I say "seem to do so" because one can aurally
imagine a reading of the line in which the actor or speaker, to

wring out the meaning of the words—which have to do, as we
find out by the end of the second line, with the ineluctability of
mortality—lays stress on all three of them, "girls all must," or at
very least on the final word "must." But the more natural reading
of these final three words would seem to be as a dactyl. The word
"and" in the middle of the line is unstressed so as to set up the
stress on "girls."

There is a similar pattern in the second line of the couplet. "As"
is unstressed so as to set up the dactyl of "chimney sweep[ers],"
the "ers," a fourth syllable, not being part of the dactyl but func-
tioning like "and" in the first line. The last three words, "come to
dust," are most naturally read as a dactyl, with the dying fall of the
final two unstressed syllables nicely underscoring the literal dying
fall of golden lads, girls, and chimney sweepers. Shakespeare's use
of rhythm with this final dactyl is a fine illustration of the way
in which compositional form, in this case the pattern of stressed
and unstressed sound, can support the intelligible form of a work.
There is a harmony, order, or proportion between the pattern of
sound and the work's meaning.

We have been noticing two compositional features of Shake-
speare's couplet from *Cymbeline*: its wholeness and its various
uses of proportion. Now let us notice another poetic quality of
this couplet. Shakespeare uses a simile, another rhetorical de-
vice, to persuade us of his point regarding the mortality of all
human beings, young and old, born high or low. He compares
the golden lads and girls—"golden" because of their youth, in-
nocence, and vigor, or because of their being highborn, or all of
the above—to chimney sweepers. It seems an odd comparison
until we come to the final dactyl: they both *come to dust*. Here
Shakespeare plays upon two meanings of the phrase "come to
dust": the literal meaning that chimney sweepers get all dusty in
their work, and the less obviously literal but no less true fact that
chimney sweepers, along with the golden lads and girls to whom
they are being compared, will return to dust in their graves. This

play on the double meaning in "come to dust" is what makes the couplet "pop." Without it, there would be no clear reason for comparing golden lads and girls with chimney sweepers, and the couplet would fail to persuade us. Everything rides on the couplet's "climax" in these three final words and the way in which our mind playfully oscillates between the two senses of "come to dust." Once we recognize Shakespeare's play on these two senses, our will rejoices in the mind's grasp of the marvelous inevitability of the couplet's climax, even as we take pleasure in the sensible features of its execution: the imagery, the rhyme, the alliteration, the dactylic rhythm.

Further discriminations are available to the mind as it explores the terms of the couplet's simile. Here is the critic Hugh Kenner riffing on Shakespeare's pairing of the words "golden" and "dust":

> English lads, perhaps, with yellow hair; "golden," because once precious when they lived; "golden," touched with the nobility and permanence of gold (that royal metal, colored like a cold sun, in which wages are paid), as now, gone home, they receive the wages of immortality; "golden," in contrast to "dust": a contrast of color, a contrast of substantiality, a contrast of two immemorial symbols, at once Christian and pagan: the dust to which all sons of Adam return, the gold by which human vitality braves time; dust, moreover, the environment of chimney-sweepers, against whose lot is set the promise of shining youth, *la jeunesse dorée*, who may expect to make more of life than a chimney-sweeper does, but whom death at last claims equally. "Golden," magical word, irradiates the stanza so that we barely think to ask how Shakespeare may have found it.[8]

8. Hugh Kenner, *The Pound Era* (Los Angeles, CA: University of California Press, 1971), 121–22.

But Kenner himself thinks he knows how Shakespeare found it. His theory stems from the report of a twentieth-century man from Shakespeare's home county, Warwickshire, who was heard to say that in that region of England, dandelions are known as "golden boys" and that when they go to seed, they are known as "chimney sweepers" due to their resemblance to the chimney sweeper's broom.[9] This explanation adds a layer of local, naturalist charm to Shakespeare's simile. More recent scholarship, however, has challenged Kenner's theory, arguing that there is no evidence that in the late sixteenth to early seventeenth centuries, dandelions were known as "golden lads" (the word "dandelion" itself does not appear anywhere in Shakespeare's works) and that, moreover, chimney sweepers in Shakespeare's time did not use the kind of brooms required to make Kenner's theory work.[10] In any event, while we might not be able to add to our meditation on Shakespeare's simile local color from Warwickshire, Kenner's meditation quoted above is enough to prove that there exists already a radiance of "ordinary" meanings and connotations associated with the words "golden" and "dust," not to mention of the other qualities of the couplet already discussed.

All this is by way of elucidating the nature of beauty. In a famous passage, Aquinas tells us that beauty has three features or requirements: *integritas* (integrity or wholeness), *consonantia* (proportion or harmony), and *claritas* (clarity or radiance):

> For beauty three things are requisite. In the first place, integrity or perfection, for things that are diminished are by that fact ugly; and due proportion or consonance; and again clarity: whence brightly colored objects are said to be beautiful.[11]

9. Kenner, 122.

10. E. Charles Nelson, "Shakespeare Has Missed the Dandelion," *Shakespeare* 12, no. 2 (2016): 175–84. Kenner, in a way, anticipates the riposte to his theory, in that he goes on to observe that since 1611, when *Cymbeline* was first performed, few if any in its audiences knew of the dandelion connection.

11. *Summa theologiae* 1.39.8. The translation of the passage is my own. The context of the passage, in question 39, is a discussion of the relationships between the persons of the Trin-

Aquinas is here defining beauty in its most common and analo-
gous sense, a sense as applicable to the beauty of my grandson's
face or the beauty of the second person of the Trinity as it is to
the beauty of a work of mimetic art. I chose not to begin this
section with the quotation of this passage. I chose, in fact, up
to this point, not to mention Aquinas or beauty at all. To *begin*
with Aquinas's definition of beauty, especially if one is trying to
understand the beauty of the mimetic arts, is, to my mind, to
risk confusion. The passage from Aquinas speaks about beauty at
the most abstract level possible, whereas beauty in the mimetic
arts is a very concrete thing. Beauty in mimetic art is simply the
excellent construction of the work's compositional form, excel-
lence defined by the requirements of wholeness, proportion, and
radiance.[12] For this reason, I chose to ground our approach to
beauty in a particular work of art, and a miniature one at that.
Shakespeare's couplet from *Cymbeline* puts all three features of
beauty on display while also offering the benefit of displaying
them in two lines consisting of just twelve total words whose es-
sential meaning is readily intelligible.

To summarize:

The couplet manifests integrity or wholeness in being a com-
 positional whole; specifically, in having a plot with a be-
 ginning, middle, and end.

ity. The immediate context, in article 8, is whether beauty is appropriately associated with the
Son. Aquinas did not write a separate treatise on mimetic art or beauty, and so one must glean
his thoughts on these subjects from asides he makes in discussions of other things. Stephen
Dedalus quotes and explicates this passage in a well-known episode in Chapter V of James
Joyce's *A Portrait of the Artist as a Young Man* (New York: Penguin Classics, 1992). Umberto
Eco accuses Joyce, however, through the character of Stephen Dedalus, of interpreting the three
requirements of beauty "not as objective properties of things, but rather as stages in our aesthetic
encounter with them." Umberto Eco, *The Aesthetics of Thomas Aquinas*, trans. Hugh Bredin
(Cambridge, MA: Harvard University Press, 1988), 249n85. But Dedalus does say that "the
most satisfying relations of the sensible [by which he seems to mean the three requirements of
beauty] must therefore *correspond to* the necessary phases of artistic apprehension" (emphasis
added). This can be read as indicating that the objective characteristics of beauty track three
phases of their apprehension in the one contemplating.

12. I am following here Eco's analysis in *Aesthetics of Thomas Aquinas*, chap. 4.

It manifests proportion or harmony in the various ordered relationships between its parts, and principally the two senses of "come to dust" upon which springs the marvelous inevitability of the couplet's climax.

Finally, the couplet manifests radiance or clarity in the way in which its sensible forms (e.g., the rhyme of "must" with "dust") shine brightly to the senses and in the way in which its intelligible form (e.g., the double if not triple meaning of "comes to dust") shines forth brightly to the intellect.[13] In the *Poetics*, Aristotle says that among the techniques in the poet's arsenal, the ability to make what we might call "bright" metaphors is the most important. This tool alone, Aristotle contends, "cannot be learned from another and is a sign of natural talent."[14] Strictly speaking, of course, the simile in our couplet from *Cymbeline* is not a metaphor. But the same general gift for associative transference is on display in the couplet's simile. A bright association is enjoyed on the sensible level, as, for example, images of golden-haired kids are juxtaposed with the image of a hardworking chimney sweeper. And the association deepens on the intelligible level, particularly when our minds oscillate between the senses of "come to dust" and thus see the meaning in the couplet's marvelously inevitable climax.

This is where we find beauty in the mimetic arts: in the close, specific analysis of a particular work. There are deeper metaphysical and theological dimensions of beauty to be explored. But these explorations lead beyond the realm of the mimetic arts.

13. Eco argues that *claritas* is not so much another intrinsic characteristic of a work's compositional form but the integrity and proportion of the form itself—the artist's design as it structures a medium—shining forth upon the senses and the intellect of the one contemplating it. Eco, *Aesthetics of Thomas Aquinas*, 114–20.

14. *Poetics* 22 (1459a6–7). This is Halliwell's translation at *Aesthetics of Mimesis*, 190.

Someone trying to understand the beauty of a particular work of mimetic art would best concentrate on the compositional form of the piece. It is in our contemplation of that *concrete entity*—the artist's design structuring a material medium—that our senses and our intellect are irradiated by order and intelligibility.[15]

SO IS BEAUTY OBJECTIVE?

Of course. Beauty is not something we concoct for ourselves as a reader or viewer or member of an audience, any more than we concoct the beauty of an autumn sky or a baby's face. Artistic beauty is there in the formal qualities, sensible and intelligible, of the work. It is present in what Shakespeare has done with those twelve little words in our couplet from *Cymbeline*.

Yet, a few qualifications are in order that will keep us from thinking that beauty is merely a subjective experience.

First, the beauty of a work of art need not compel at first sight. Sometimes the perfection and harmony of a work do not make a good first impression—either due to the complexity of the work or because we are not yet in a position to appreciate them. Often, it is only after becoming better acquainted with a work that we understand what is happening in its compositional form. Just because someone dislikes a work after a first encounter does not mean that the work is not objectively beautiful.

Second, to appreciate the beauty of a work does not mean

15. It would take me too far afield to get into the debate between Jacques Maritain and Umberto Eco on what Maritain calls poetic knowledge, or what Eco calls the nature of the aesthetic *visio*. Both are interested in *how* the mind knows what it knows when it appreciates a work of mimetic art. Maritain argues for a kind of intuition of the intellect that precedes, or supersedes, abstraction. Eco argues that in the appreciation of mimetic art, the mind must not only abstract but also make judgments. I can only assert that I believe Eco's interpretation is closer to the text of Aquinas and truer philosophically. See Eco, *Aesthetics of Thomas Aquinas*, chap. 3, esp. 63, and chap. 7, esp. 192ff. "But genuine, complete aesthetic pleasure occurs when we grasp the reasons for the harmony, the various ways in which it is realized, and all of its most intricate inner workings. This type of understanding comes about gradually; it relates to its object in such a way that a state of judgment, of one kind or another, precedes the flowering of aesthetic pleasure" (Eco, 198). Étienne Gilson criticizes the idea of creative intuition in *The Arts of the Beautiful* (Dallas, TX: Dalkey Archive, 2000), 59–60.

that one sees all the beauty that there is in the work. Just because one person grasps a sensible or intelligible feature of a work that another does not grasp does not mean that beauty is only a subjective experience. It simply means that the compositional form of the work is complex.

Third, someone contemplating a beautiful work of mimetic art might find certain intelligibilities in it that the artist did not specifically have in mind when making it. Again, this does not mean that beauty is only a subjective experience. That object of mimetic picturing, human thought, feeling, and action, contains untold depths of intelligibility, more than any one person can wholly grasp, including the artist who made it.

Finally, to say that beauty is objective also does not mean that *preferences* cannot be legitimate. Anyone who denies Shakespeare's greatness is in need of either literary education or a swift kick in the shin. But this does not mean that someone who prefers Shakespeare's late romances to his tragedies is culturally backward—as long as such a person does not disparage the beauty of the tragedies. For any number of personal reasons, a lover of Shakespeare might prefer the late romances. And we can also imagine someone preferring the tragedies over the late romances. At a certain personal level of artistic enjoyment, *de gustibus non est disputandum*. Personal taste ought not to be disputed.

WHAT WE KNOW WHEN WE COGNITIVELY DELIGHT IN A WORK OF ART, PART 2: ITS QUALITY AS IMITATION AND THE OBJECT OF IMITATION

Insights, I suggest, are what the novelist has in mind, insights into the way things are. But what things? And where? Certainly we are talking about a pathology. Something has happened, all right, something has gone wrong, but what? Is it a psychic disorder which can be diagnosed from a scientific, therapeutic stance? Or is it something else? Is it the final passing of the age of faith? Are we talking a post-Christian malaise, the sense of disorientation which

presumably always comes whenever the symbols and beliefs of one age are no longer taken seriously by people in a new age?
 Walker Percy, "The State of the Novel: Dying Art or New Science?"

In part 3 of this book, we will continue to look at beauty in the compositional form of artworks in various genres. For the present, let us consider briefly a second focus of our cognitive delight in mimetic art: the picture *as a picture* and, therefore, its quality *as imitation.*

Here our focus turns to the relationship between the picture and what is being pictured. Aristotle has just this focus in mind when he observes in the *Poetics*, "For we take pleasure in contemplating the most precise images of things whose sight in itself causes us pain—such as the appearance of the basest animals, or of corpses."[16] The reason why we take delight in pictures of distressing things, Aristotle goes on, is because the delight is a contemplative delight: "Because what happens is that, as they contemplate them, there occurs learning and reasoning out what each thing is, for example that 'this image is of so-and-so.'"[17] So in thinking about a picture *as a picture*, as an imitation, we ask ourselves, "Is this picture a faithful imitation of what it pictures? Are the choices the artist made in constructing its compositional form well suited to helping us contemplate the intelligibility of what is being pictured? Or does the work's compositional form obscure the reality it is trying to picture?"

With such questions in mind, someone might try to mount a criticism of *Pride and Prejudice*, arguing that Austen's Cinderella story in no way reflects the real romantic entanglements of men and women, that it is pure fantasy. Someone else might counterargue, without denying the story's "dream denouement,"[18] that

16. *Poetics* 4 (1448b10–12). Aristotle, as Halliwell points out in *Aesthetics of Mimesis*, 179, makes the same point at *Rhetoric* 1371a31–b12.

17. *Poetics* 4 (1448b15–17).

18. The phrase is from Claire Tomalin's discussion of *Pride and Prejudice* in *Jane Austen: A Life* (New York: Alfred A. Knopf, 1997), 159.

Austen's novel gives us an excellent picture of how virtue is lived within a romantic relationship between a man and a woman. The philosopher Alasdair MacIntyre has famously said that Jane Austen is "the last great effective imaginative voice of the tradition of thought about, and practice of, the virtues I have tried to identify" (i.e., the Aristotelian tradition).[19] A claim such as this reflects someone thinking about the relationship of certain pictures (Austen's novels) to the reality they are trying to depict (an Aristotelian conception of virtue). And in such thinking, the lover of art can find another source of mimetic delight.

Notice how when we reflect on Jane Austen's work as a picturing of the Aristotelian tradition of the virtues, our mind oscillates between literary or technical issues, on the one hand, and philosophical delight, on the other. We have one eye on Austen's picturing, her compositional form, and one eye on the object of her picturing, a particular understanding of the virtuous life. This comparison of picture and the object of the picture would seem to be the defining cognitive delight of mimetic art. But there is an intellectual delight even more important than this, and that is the contemplative delight in the object of the picturing itself. When it comes to storytelling, we know that the main object of the picturing is the mimetic universal or Controlling Idea, that probable truth about human action embedded in the events of the story. This is the knowable in which the reader primarily takes delight.[20]

19. MacIntyre, *After Virtue*, 240. MacIntyre's point in fuller context:

It is her uniting of Christian and Aristotelian themes in a determinate social context that makes Jane Austen the last great effective imaginative voice of the tradition of thought about, and practice of, the virtues which I have tried to identify. She thus turns away from the competing catalogues of the virtues of the eighteenth century and restores a teleological perspective. Her heroines seek the good through seeking their own good in marriage. The restricted households of Highbury and Mansfield Park have to serve as surrogates for the Greek city-state and the medieval kingdom. (240)

20. "There are times when pictures are merely objects of idle curiosity for us, and times when they are taken as aesthetic objects, in which our interest in the compositional relations of shape and color predominates in importance over the interest we have in what is depicted; but it is more normal for pictures to provoke the affective and personal response that we make to the bodily presence of what is depicted" (Sokolowski, "Picturing," 15).

In the moment that we are reading *Pride and Prejudice*, when we are absorbed, for example, in Mr. Darcy's first, failed proposal of marriage to Elizabeth Bennet, we feel toward this event much of what we would feel if we were actually sitting in the room at Huntsford and Darcy's proposal were being made right in front of us. Given that Elizabeth Bennet is the story's protagonist, we feel most of all her surprise, her consternation, her offended dignity at Darcy's self-serving proposal, but we also feel Darcy's passion, impulsiveness, and defensiveness regarding his own sense of pride as he makes it. We feel toward the object of the picturing what we would feel toward the object in real life—with one key difference. We are always aware as readers of *Pride and Prejudice* that we are engaged with a picture. Our intentionality, in fact, is not *quite* that of someone sitting in a room observing a failed proposal of marriage. The wonder of mimetic art is that it can make us feel so like how we feel in real life, but with feelings that remain circumscribed within a fundamentally contemplative attitude. Picturing allows for a powerful affective response to occur within a wider space of tranquility and reflection.[21]

This delight in knowing the object of the work of mimetic art is the primary cognitive delight because the whole tendency of the experience of art is toward a kind of knowledge, and knowledge terminates in the object known, not in the medium of that knowledge.[22] But keep in mind, too, a point made back in chapter 1. To contemplate the object of a picture is not to "move away" from the picture. I contemplate the Aristotelian tradition of the virtues in the compositional form of *Pride and Prejudice* itself. The form of that tradition is re-presented there in the events

21. "The depiction [of an angry man] allows us to be involved with the angry man, but with him as represented, and this insertion of the difference between the picture and the depicted permits us to experience the angry man in the special kind of tranquility that Gertrude Stein calls *relief* and Aristotle calls *catharsis*" (Sokolowski, "Picturing," 14). Sokolowski has been meditating upon Stein's distinction, in her *Lectures in America*, between the sense of *completion* we feel when an exciting situation reaches its climax in real life, and the *relief* we feel when an exciting situation being depicted or pictured reaches its climax. We will consider further this relief or *catharsis* later in this chapter.

22. A point emphasized by Rover, *Poetics of Maritain*, 102, and reiterated on 196.

of the novel. To be sure, I can put the book down and go read Alasdair MacIntyre on the Aristotelian tradition of the virtues and take my contemplation of the object of Austen's picturing to the next level. This kind of study can further enhance one's contemplation of *Pride and Prejudice*. I know it has enhanced mine. But notice: reading MacIntyre only enhances my reading of *Pride and Prejudice* if and when I realize that what he is saying about the virtues is already there present in the work itself.

The two main foci of our minds when we appreciate a work of mimetic art, that on the compositional form and that on the picturing, distinguish the Aristotelian-Thomistic tradition of mimetic art from two other major philosophies of art that arose in the modern period: formalism and expressivism. The formalist— whom we first encountered in chapter 1 through the "copying" objection to mimesis—grounds mimetic delight in "significant form"—that is, "forms arranged and combined according to certain unknown and mysterious laws."[23] The formalist delights, in other words, in the artist's arrangement of the parts of his chosen medium, like the reader's delight in Jane Austen's use of free indirect style. The expressivist, by contrast, is more interested in the feelings that the artist wants to clarify and communicate through the chosen medium. "Until a man has expressed his emotion, he does not yet know what emotion it is. The act of expressing it is therefore an exploration of his own emotions. He is trying to find out what these emotions are."[24]

Both theories capture something true about our experience of mimetic art but wrench it out of its proper context. A proponent of Aristotelian-Thomistic mimesis would agree with the formalist that an appreciation of compositional form is integral

23. Clive Bell, *Art* (London: Dodo, 2007), 4, 6. Bell's book was a prominent defense of formalism originally published in 1913.

24. R.G. Collingwood, *Principles of Art* (New York: Oxford University Press, 1958), 111. Noël Carroll pithily describes the expressivist approach to art as follows: "For the artist, her emotional state is like the sitter who poses for a portrait." Noël Carroll, *Philosophy of Art: A Contemporary Introduction* (New York: Routledge, 2007), 63.

to the experience of mimetic art, yet underscore that compositional form is only one focus of our cognitive delight. The picture as a picture and, most importantly, the object being pictured, are also integral to the experience. Formalism, in sum, leaves out the whole notion of art as picturing. Similarly, a proponent of mimesis would agree with the expression theory that the clarification and communication of the artist's feeling and experience is integral to the making of mimetic art. I explored this theme in chapter 5 in terms of the artist's inquiry and intelligence. Nonetheless, the proponent of mimesis would emphasize against the expression theory that the feelings experienced by both the artist and the artist's audience are always circumscribed within a contemplative delight in the phenomenon of picturing.

No doubt, the emotional experience of the artist can itself be the object of imitation, as is the case in much lyric poetry and popular music, and it is always at least indirectly involved whenever an artist pictures something. The mimetic universal that Jane Austen attempted to capture through the character of Mrs. Philips is the fruit of how Jane Austen saw and felt about the characters of human beings. Note well, however, that within the Aristotelian-Thomistic tradition of the mimetic arts, an artist's emotional expression is always a reaction to a horizon of significance extrinsic to the artist's psychological state. Without this crucial qualification, emotional expression collapses into the muted cries and exhalations of the buffered self. But with that qualification in mind, it is fair to say that the language of mimesis and the language of emotional expression are not necessarily opposed.[25]

25. Stephen Halliwell confirms this point in his historical overview of the mimetic tradition in music, chapter 8 of *Aesthetics of Mimesis*.

7

Mimetic Art as Knowing Delight

And if we, as readers, keep our religious and moral convictions in one compartment, and take out reading merely for entertainment, or on a higher plane, for aesthetic pleasure, I would point out that the author, whatever his conscious intentions in writing, in practice recognizes no such distinctions. The author of a work of imagination is trying to affect us wholly, as human beings, whether he knows it or not; and we are affected by it, as human beings, whether we intend to be or not.
 T.S. Eliot, "Religion and Literature"

What we love we shall grow to resemble.
 St. Bernard of Clairvaux

In the previous chapter, we explored the cognitive delight we take in the mimetic arts with an emphasis upon what is known or cognized. This involved us in a discussion of compositional form and the three requirements of beauty. In this chapter, I want to emphasize the "delight" side of the experience: what is happening in us when a work of art delights. As I said earlier, it is both impossible and undesirable to separate the two aspects of the one experience of cognitive delight. In chapter 6, in talking about an artwork's compositional form, I therefore could not avoid bringing in the spectator and the spectator's contemplation and enjoyment. And indeed, the very notion of *claritas*, clarity or radiance, refers to the irradiation of the perfection and harmony of an artwork's compositional form upon the senses and intelligence of a spectator. Yet the subjective aspect of the experience of mimetic

art, the way in which it is received by us, is in need of greater development, and that is our aim here in chapter 7.

"Beautiful things are said to be that which, being seen, please."[1] So says St. Thomas Aquinas in another famous text related to beauty. Here Aquinas puts emphasis not upon the requirements of beauty that we look for in an artwork's compositional form, but in the way in which that form causes pleasure in the spectator. The beautiful necessarily produces a reaction in us when we see it: *it pleases us*. But the text quoted above is only the second half of a sentence in which Aquinas says:

> Beauty however has to do with the cognoscitive power: for beautiful things are said to be that which, being seen, please. Whence beauty consists in due proportion: because our senses delight in things of due proportion, as being similar to themselves; for sense is a certain proportion [*ratio*] like all knowing powers. And because cognition is accomplished through assimilation, and similitude regards form, beauty properly pertains to the notion of a formal cause.

By the strange phrase "cognoscitive power," Aquinas simply means "knowing power," our ability to grasp the realities of the world either through our senses or through our intellect. Beauty, he is saying, has to do with *knowing*. The knowing of the beautiful is a sight that pleases. Though Aquinas seems to restrict the experience of beauty to sense knowing, and to the sense of sight in particular, this is only because sense knowing is the first thing engaged when we encounter beauty in a work of art. Elsewhere, Aquinas makes plain that our cognoscitive power includes both our senses and our intellect.[2]

The entire passage just quoted from Aquinas nicely captures

1. *Summa theologiae* 1.5.4 ad 1. This translation and the longer one just below that sets it in context are my own.

2. *Summa theologiae* 1-2.27.1 ad 3: "But to the nature of beauty pertains that which by a glance or by intellectual cognition quiets the appetite. Whence those senses principally regard

the objective side of cognitive delight, the due proportion in the compositional form of the work, and the subjective side, the fact that the compositional form, on both the sensible and intellectual levels, is assimilated or, we might even say, pictured.[3] In brief, when we enjoy a work of art, the compositional form of the work is re-presented in our senses and intellect, and our affections—our sense appetites, as well as the will—are moved by the re-presentation.

This chapter will be something of a commentary on that last sentence, beginning with our sensible delight in a work of art's compositional form.

SENSIBLE DELIGHT

Aristotle famously says, "All human beings by nature desire to know," and that a sign of this is the delight we take in our senses. Aristotle's point is that sense delight is a sign that we human beings are naturally inclined to know the world. Coffee aficionados, for example, delight in distinguishing, purely on the sensory level, between the aroma of a particular brand of (ground) coffee bean *before* hot water is added and *after*.[4] Such fine sensory discrimination is a kind of knowing, and, as Aristotle says, we delight in this sensory knowing. To delight in something means that one of our appetites or desires has been activated. Our appetites are, by definition, movements of our soul either *toward* something perceived to be good or *away from* something perceived to be evil. On the

beauty which are maximally cognitive, namely sight and hearing when ministering to reason." Translation my own.

3. In cognition, either sensible or intelligible, forms are re-presented in a different medium, namely, our senses or our intellect. Thus, cognition is a kind of picturing of the real.

4. The delight in making such discriminations is palpable in a discussion such as the following: "What Creates Coffee Aroma? Understanding the Chemistry," *Perfect Daily Grind*, August 30, 2019, https://perfectdailygrind.com/2019/08/what-creates-coffee-aroma-understanding-the-chemistry/. This piece makes plain, however, a point we will discuss in the next section: that sense delight is usually bound up with the mind's efforts to articulate *in words* the compositional form of the sense object being enjoyed.

sensible level, we are moved by a kind of sense appetite we usually call *emotion*, and specifically the emotion of pleasure or delight.

Imagine that you are standing in the Art Institute of Chicago, gazing at Georges Seurat's pointillist masterpiece, *A Sunday Afternoon on the Island of La Grande Jatte*. Say that in gazing upon the painting, you are moved by it. What is happening? It is a complex experience. First, your sense of sight is engaged by the compelling colors of the painting: the various hues of green on the lawn of the park and in the leaves on the trees; the different hues of blue in the river; the red of the woman's waistcoat and umbrella that draws your eye to the very center of the painting.

But it is not just color that you delight in when you take in this picture. The expansion of color into line and length and shape and volume (the bustle of the woman's dress in the foreground, the curve of the river, the arcs of the many umbrellas) are also available to be sensed and enjoyed. For Aquinas, these sensations do not properly belong to sight, whose object is simply color. These subtler discriminations belong to what Aquinas terms an inner sense power, the *common sense*, which picks up on various aspects of the quantitative nature of Seurat's compositional form.[5]

In all this sensation, you are not merely registering these colors and shapes in some detached, quasi-intellectual mode; you are also *feeling* pleasure or delight. But it is a delight in knowing, a cognitive delight. Your sense appetite delights in the workings of your sense of sight and of your common sense as they grasp the sensible forms made available to them by Seurat's painting.

As you contemplate *La Grande Jatte*, your sensible delight may well prompt you to do what many lovers of the painting do when they see it in person: *move in close* to see Seurat's pointillist technique at work. It is delightful to see the purely sensible aspects of the painting's compositional form from several feet away. But the delight is enhanced upon seeing that the colors and shapes are composed of thousands of tiny colored dots, and that it is our

5. See *Summa theologiae* 1.78.3 obj. 2 and ad 2.

perceptual apparatus that connects and blends them. Our visual memory is now able to make a distinction between the painting up close and the painting from several feet away. We experience a pleasurable sameness-within-difference.

Sense delight is also, though minimally, involved in reading a novel like *The Great Gatsby*. Our five external senses are not really exercised in direct fashion by the mimesis itself. Though we may admire the famous artwork of the cover or the typography of our edition or even the very look of the words Fitzgerald chooses in their material form, these delights properly belong to the appreciation of the illustrator's or book designer's or typographer's craft, not the novelist's. All the same, our internal senses of memory and imagination are vigorously exercised as we imagine and recall the rich sensible world Fitzgerald conjures on the Long Island and Manhattan of his story.

Another important internal sense in play when we enjoy a novel like *The Great Gatsby* is a sense Aquinas calls the *cogitative sense*.[6] Recall that the cogitative sense, which Aquinas also calls the "particular reason," is an extremely sophisticated internal sense power by which we make discriminations about particular sense objects within the context of things to be done.[7] As we reason practically about something to be done (e.g., to flee a bear that has appeared on the scene of our picnic), we have a universal consideration ("Bears can be dangerous and should be avoided") that we connect to a particular consideration ("Here is a bear, one that looks very eager to make our picnic his own") and so draw

6. I owe to a conversation with my colleague Mark Wunsch much of my thinking about the role of the cogitative sense in the enjoyment of works of fiction.

7. *Summa theologiae* 1.78.4 and 1.81.3. At 1.78.4, Aquinas describes the equivalent of the cogitative sense in lower animals (which has its own name: the *estimative sense*) as being concerned with the animal's need to seek or to avoid certain things, not because they are pleasing or displeasing to the external senses but because of other advantages or disadvantages to the animal. He then gives an example of a sheep fleeing a wolf because by its estimative sense the sheep senses that the wolf is a predator. Though Aquinas in the cited articles does not give an example of the use of the cogitative sense in human beings, it seems fair to say that the cogitative sense is similarly on the alert to what is advantageous and disadvantageous to the overall good of the human person.

a conclusion ("This bear is dangerous and we need to flee"). The particular considerations in that chain of reasoning are supplied by the cogitative sense.[8]

In the reading of a novel, of course, the cogitative sense is not making discriminations about things in the real world but of imaginary particulars. When we read, for example, the episode where Tom Buchanan takes Nick Carraway to see his mistress, a chain of reasoning instantaneously arises in our minds: "No man who cheats on his wife can be trusted; Tom Buchanan is a man who cheats on his wife; therefore, Tom Buchanan cannot be trusted." The two particular considerations about Tom Buchanan in this chain of reasoning, that he is a man who cheats on his wife and that he cannot be trusted, are supplied by the cogitative sense. Clearly, the cogitative sense plays a huge role in our following the events of a novel. We might even say that it is by the cogitative sense that we are grounded in the imaginary world of the novel and not just floating above it in the abstract and universal considerations of our intellect.[9]

Further, it is by the cogitative sense's particular discriminations that emotion is activated. As soon as we sense that a bear

8. At *Summa theologiae* 1.81.3, Aquinas underscores that a particular determination by the cogitative sense is moved and directed by universal reason and makes possible the drawing of a particular conclusion about what is to be done, as in my example of the bear intruding upon the picnic.

9. The episode where Tom takes Nick to see his mistress, Myrtle Wilson, occurs in chapter 2 of *The Great Gatsby* (New York: Simon & Schuster, 1995). It begins when Tom suddenly swerves off the road to New York and says to Nick: "We're getting off. . . . I want you to meet my girl" (28). Interestingly, from that point on, Nick's first-person narration makes no comment on the morally awkward situation Tom has put him in. But as I have indicated, I believe the attentive reader of the novel *does* make a negative moral judgment about Tom's behavior. I believe the attentive reader, with the aid of the cogitative sense, reasons about the situation in the way I have described in the text, concluding that there is something untrustworthy, and therefore disadvantageous, about Tom Buchanan, while also reasoning that Nick's withholding of moral judgment is something defective about him (Nick's withholding of moral judgment is one of the key themes of the novel—see its famous opening pages). It is indeed striking that Nick makes no moral comment throughout the entire afternoon he spends with Tom and Myrtle (and others) in New York, except to say, toward the end of it, "I was within and without, simultaneously enchanted and repelled by the inexhaustible variety of life" (40). Even when a drunken Tom strikes Myrtle and breaks her nose, Nick, though also quite drunk, makes no comment. The reader's critical moral judgment is thus placed at an ironic distance from the sensibilities of both Tom and Nick.

has appeared on the scene, our reasoning instantaneously moves through its chain of reasoning by which our universal consideration about bears is connected to our particular consideration about *this* bear, leading to the conclusion that *this* bear *should be avoided*, and then emotions are elicited, principally fear.[10] Similarly, when we read about Tom Buchanan taking Nick Carraway to visit his mistress, we reason that Tom Buchanan cannot be trusted and feel revulsion at his lack of fidelity.

INTELLIGIBLE DELIGHT

As intellectual creatures, we have a hard time keeping our minds off something that is delightful to our senses. As we gaze in wonder at the way in which the multifariously colored dots in Seurat's painting appear to combine and blend into a single color, our mind is busy thinking about how the pointillist technique works upon our perceptual apparatus. It is also thinking about the effectiveness of the interplay of light and shadow in the painting; about the different characters standing, sitting, or reclining upon the lawn; about the well-dressed man and woman on the right of the scene; and what it means for the woman to be leading a monkey on a leash. In brief, in the presence of a picture, the mind searches for the intelligibility of the picture's compositional form as well as the intelligibility of what is pictured and how the picturing itself helps convey that intelligibility. About the intelligibility of pictures Robert Sokolowski writes:

> Pictures are made to be works of intelligence by their compositional form, which also enables them to convey a "content," just as the grammatical form of speech signals intelligence and allows an intelligibility to be distinguished and thus made

10. See *Summa theologiae* 1.81.3. But we human beings do not *act* on the fearful emotion, Aquinas clarifies in this article, unless and until the will, the rational appetite, gives its command.

manifest. Pictures have to be structurally composed by their
makers and syntactically "read" by their viewers.[11]

The compositional form of a picture, in other words, that which
makes it to be a work of intelligence, is analogous to the compo-
sitional form, the syntax, of speech. And the two usually come
together when we appreciate a work of art, as we often "break
into speech" in front of an artwork such as a painting. Either to a
friend or to ourselves, we use language to express our understand-
ing of the work's compositional form, perhaps in wondering what
Seurat's painting is "saying" about late nineteenth-century Paris-
ian leisure.

But let us return to F. Scott Fitzgerald's *The Great Gatsby* and
think about how a reader might experience this story's intelligible
delights. Imagine that you have just finished reading the novel
for the first time. You are struck by its ironic Controlling Idea—
namely, (spoiler warning) that Gatsby's "romantic readiness" is
both the reason why he is morally superior to Daisy and Tom
Buchanan and all the other insipid souls who enjoy the syba-
ritic luxuries of Gatsby's outrageous parties *and* the reason why
he takes on a life of crime and puts himself into the circumstances
that lead to his demise. Of course, you don't close the book with
the Controlling Idea all worked out. Upon closing the book, you
are still in thrall to the lingering power of Fitzgerald's literary im-
ages and to the emotional impact of the story's violent ending.
Presumably, too, you are feeling something about this Jay Gatsby.
A mixture of feelings, most likely. Pity that, from all the hundreds
who attended Gatsby's luxurious parties, only Nick Carraway, the
narrator, and one other single strange figure, Owl Eyes, bothered
to show up at his funeral. Pity that a young man of such tal-
ent and ambition would wind up shot dead, by mistake, in his
swimming pool. And pity, too, combined with abhorrence, that
Gatsby couldn't give up his past with Daisy Buchanan and that

11. Sokolowski, *Phenomenology of the Human Person*, 139.

he would aspire to attract her again by becoming prodigiously wealthy through bootlegging. You probably feel some justified anger, too, at Daisy and Tom Buchanan for the way in which they successfully slip away from the wreckage they helped cause.

To feel the feelings just described is to hold certain beliefs, and such beliefs are the work of the intellect. Your feeling pity for the sad attendance at Gatsby's funeral, for example, is informed by the belief that it is a great pity for one's funeral not to be attended by one's family and friends, though it is also informed by the cogitative sense's particular determination that Gatsby's funeral was not attended by family and friends.

The intellect is involved, too, in the "reading" of Fitzgerald's imagery. When you finish the novel, you may not have a firm idea of the meaning of the green light at the end of Daisy's dock or just what Fitzgerald is saying about America in those gorgeous closing paragraphs, but you are hopefully beginning to articulate for yourself what those images are all about.

The intellect's principal task, of course, is to grasp the Controlling Idea or mimetic universal, the very essence of the work and the most important focus of our experience of an artwork's beauty. But again, you probably do not close the cover of *The Great Gatsby* with such a notion fully worked out. Happily, the experience of beauty does not require that you grasp the mimetic universal, much less the other, subordinate meanings of the work (such as the meaning of the green light at the end of Daisy's dock), with scholarly precision. Scholarly study of the novel may come later, but it is not necessary in order to enjoy an initial experience of the work's beauty.

But exactly how much of the mimetic universal needs to be grasped in order for a reader to delight in the beauty of *Gatsby*? A certain reader may not grasp anything of the mimetic universal and yet still be impressed by the mastery of Fitzgerald's musical, Keatsian language. Another reader, however, may discern that there is something attractive, even morally attractive, about

Gatsby's romantic eros, perhaps recalling Nick Carraway saying, in the famous opening of the novel, that Gatsby "was worth the whole damn bunch [of them] put together," but also find Gatsby's bootlegging activities and romantic self-mythification morally repugnant. Such a reader would experience a complex, even a confusion, of thoughts. The best that might be said by such a reader is that Gatsby is a mixed bag morally, coupled perhaps with the lingering sense that his being a mixed bag is important, and that finding out *why* his romantic readiness is both his glory and his degradation would be worth the effort. And all this would be an exercise of intelligence in regard to reading Fitzgerald's novel, of the kind we talked about back in chapter 5.

But there is no guarantee that a reader of *Gatsby* will even get this far in appreciating its beauty. A very different and much more impressionable reader may come away too much taken with Gatsby's riches, his pink suit, his chest of drawers full of shirts, his amazing automobile, his stupendous house, his raucous parties. Such a reader may be entranced by the torch Gatsby carries for Daisy, cheer when they reunite, and be somewhat puzzled and disappointed when they don't get together in the end. Such a reader will miss the point of Fitzgerald's novel. The beauty this impressionable reader finds in the novel, however, will not be wholly mistaken. Gatsby's poise and wealth and romantic readiness, especially as they are pictured by Fitzgerald's consummate artistry, do have a legitimate attractiveness about them. Yet it is an attractiveness in need of critical examination by an attentive reader. Our impressionable reader, sadly, makes no effort to do that. This reader is content with thinking Gatsby a romantic figure and his attempt to reunite with Daisy thrilling, if ultimately disappointing, all of which underscores the necessity of good moral and critical habits in the appreciation of works of mimetic art. As I mentioned in the last chapter, the beauty of even a great

work of art can be completely misunderstood, or even rejected, by an audience unprepared for its riches.[12]

A CASE OF SIMULATED PRACTICAL REASONING

The experience of our impressionable reader of *The Great Gatsby* is a good reminder that the greatness and beauty of a work of mimetic art does not guarantee the appropriate response in just anyone who engages with it. And this is not even to mention works of art that depict a mimetic universal at odds with genuine human flourishing but whose sensible and intelligible delights are sufficient to attract and mislead many uncritical admirers.

But let us take a further moment to consider the ideal case. For the present, assume that Fitzgerald's *The Great Gatsby* pictures something true about human fulfillment. Assume, also, an attentive reader of the novel who intellectually grasps its mimetic universal. In grasping that universal, the reader grasps a moral judgment. But unlike the judgment to flee the bear that has intruded upon the picnic, this moral judgment is not one that drives the reader to action in the real world. This judgment concerns an imaginary world, a picture, and so the moral judgment is, we might say, *simulated*. It is a judgment made within a world of virtual reality.[13] But the reader's response is not exclusively in-

12. The practical judgment of the artist in making a work of art does not rely on the rectitude of appetite relative to the good life for human beings but only on the rectitude of appetite relative to the end of the work to be done. This is a distinction that the Salieri of Milos Forman's film *Amadeus* does not get. He assumes any great artist will possess rectitude of appetite relative to the good life for human beings—that is, moral virtue—as well as rectitude of appetite relative to the end of the work to be done (i.e., a commitment to craftsmanship), and he is frustrated by the fact that Mozart has the latter but is wanting in the former. From the standpoint of the audience of a work of mimetic art, by contrast, the right practical judgment as to what the work is all about has everything to do with the rectitude of appetite relative to the good life for human beings. This wisdom was well known to Plato and Aristotle. For discussions of this distinction, see Ralph McInerny's "Apropos of Art and Connaturality" and "Maritain and Poetic Knowledge" in *Being and Predication* (Washington, DC: The Catholic University of America Press, 1986).

13. About the "practical judgment that is the conclusion in poetic argumentation," Rover claims that it is "a judgment in the moral order communicated through an imitative artifact; a judgment about human action, passion, character, etc., and a judgment, moreover, that is aimed at a practical-moral effect" (Rover, *Poetics of Maritain*, 128). See also 129 of this same text: "Everything [in the poetic argument] points to the generation of *practical* knowledge in the

tellectual. For the reader does not grasp the mimetic universal in abstraction from the events of the novel. Being immersed in those events, the reader's appetites are also involved, especially emotions. And directing these emotional responses is a simulated act of the will, one that, in turn, is directed by the intellect's moral judgment.

This simulation in practical reasoning is highly pleasurable to the reader, and a big part of the pleasure is what occurs at the climax and resolution of the novel, when the reader experiences *catharsis*, relief, from the emotional excitement. I will have more to say about catharsis in a moment, but here I will simply say that while catharsis is an emotional experience, it is also a contemplative one. For in catharsis, the reader's emotions are projected and put on display so that the reader might better understand the right ordering of those emotions to reason.

The result of all this intellectual, emotional, and sensible experience is that, within the world of the simulation, the reader assents to Fitzgerald's literary argument. The moral judgment on the part of the intellect, the conclusion of the novel's argument, induces an appetitive response, on the level of both sense and rational appetite, that inclines the reader to accept the imaginative argument of the novel. This is what we mean when we say that a reader is "moved" by the novel. Recall, however, that the assent involved is one Aquinas describes as a *sola existimatio*, a mere "fancy" or "conjecture." In poetry—and we can extrapolate and say all mimetic art—assent is not given because of the absolute logical necessity of the argument but because of the pleasing probability of the picturing.

The fact, however, that the reader is pleased in large part by a *moral* judgment may appear to confuse the ethical and the beautiful. How are the two distinguished in the reading of a novel like

contemplator: the characteristic objects of the poetic art; its close connection with experiential knowledge; its use of sense-pleasing devices of ornamentation, composition, music, language, etc.; its persistent and connatural effort to move the emotions or the will."

The Great Gatsby? This is a fascinating question, one that calls for some careful distinctions. On the one hand, the *good*, with which ethics is concerned, is distinguished from the beautiful. They are founded upon the same thing, *form*, but they relate to this form in different respects. Goodness has to do with the form of something considered as the end or object of desire—that is, as final cause. Thus, I can regard the form of *The Great Gatsby*, its perfectly realized plot, as "good" because I see its form as the perfect realization of Fitzgerald's effort to produce a masterful work, or because I see its form as supplying the literary satisfaction I was desiring when I picked up the book. The *beauty* of Fitzgerald's novel has to do with the very same form, but now not as final cause but as formal cause. When we delight in the beauty of form, our will is not delighting in an end to be achieved through action but in an intelligibility that has been grasped by the mind. In delighting in beauty, the will's delight is not in pursuing its own end, the good, but in the intellect's having achieved *its* end: intelligibility and truth. And this delight in the intellect's grasp of mimetic compositional form is exactly what Aristotle speaks of in the *Poetics* when he observes that human beings naturally delight in imitations because imitations help satisfy our natural desire to know.

On the other hand, in the simulated world of Fitzgerald's novel, as we have seen, the argument of the plot has everything to do with ethical considerations. This is because a novelistic plot is a simulation of human beings willing ends or goods—that is, human beings endeavoring to achieve fulfillment.

This leads to the question, however, whether assenting to a novel's conclusion in a simulated act of practical reasoning leaves any kind of real moral effect upon the reader. *Do works of mimetic art have the power to change us?* Do we finish the novel, the movie, the new album, *a different person* than we were before, or have we simply experienced a pleasant "ride" that does not leave any deep

and lasting impression? And if we are changed in a significant way, in what sense are we changed?

MIMETIC ART AND MORAL TRANSFORMATION

I want to approach these questions by way of the most mysterious of classic texts relating to the moral impact of mimetic art: Aristotle's famous definition of tragedy from the *Poetics*.

> Tragedy, then, is a representation of an action that is serious, complete, and of a certain magnitude—in language which is garnished in various forms in its different parts—in the mode of dramatic enactment, not narrative, and through the arousal of pity and fear effecting the *katharsis* of such emotions.[14]

For centuries scholars have hotly debated what Aristotle means by catharsis in this sentence. Aristotle himself provides no comment on his single use of this word in the surviving text of the *Poetics* ("The most striking instance of an aesthetic concept whose history has proved utterly disproportionate to its origins . . . one word in the *Poetics* has been transformed into a protean concept of popular aesthetic psychology."[15]). In Greek, *katharsis* literally means "cleansing" or "cleaning" or "clearing up." So apparently the mimesis of tragic action upon the stage is meant to arouse pity and fear in a way that "cleanses" or "clears up" these emotions in the audience. Though the interpretation of catharsis in the *Poetics* is a ticklish business, it seems quite plausible that Aristotle understands tragedy's cathartic effect as a certain kind of moral

14. *Poetics* 6 (1449b24–28).

15. Stephen Halliwell, "Catharsis," in *A Companion to Aesthetics*, 2nd ed. (Malden, MA: Wiley-Blackwell, 2009), 182–83.

transformation in the audience, a transformation that involves the emotions of pity and fear.[16]

Pity and fear, as Aristotle understands them, are an intertwined pair of emotions. He defines pity as an emotion provoked by the perception of someone's undeserved misfortune, which in turn provokes the fear that such misfortune could also happen to ourselves or someone close to us.[17] The plot of a well-made tragedy is a mechanism that triggers this intertwining of pity and fear in the audience and, in so doing, accomplishes, as Aristotle says in his definition, the catharsis of these emotions. In other words, it is the audience's grasp of the tragedy's mimetic universal, a universal that includes the key element of the protagonist's undeserved misfortune, that causes the audience to experience the pity and fear that "cleanses" or "clears up" and that also, we must not forget, provides a distinctive kind of contemplative delight.

But what exactly is "cleansed" or "cleared up"? The way in which we should feel pity and fear according to reason. "When functioning properly, emotions such as pity and fear are consistent with reason and are a reflex of its judgments," writes Stephen Halliwell.[18] But we cannot assume that each member of a tragedy's audience will feel pity and fear in the right way—that is, as the virtuous person would feel these emotions. And indeed, as Martha Nussbaum emphasizes, even the virtuous need reminders of what it means to respond well to undeserved misfortune.[19] The function of tragedy is, therefore, to help bring pity and fear in line with reason, "clearing up" the way in which these important emotions should serve as a reflex of prudent discernment. The process, as Halliwell describes it, is homeopathic in its structure,

16. In my approach to the tragic emotions and catharsis, I am following Halliwell's careful and persuasive account in chapter 6 of his book *Aristotle's Poetics*, as well as Martha Nussbaum's complementary discussion in her essay "Tragedy and Self-Sufficiency: Plato and Aristotle on Fear and Pity," in *Essays on Aristotle's Poetics*, ed. Amélie Oksenberg Rorty (Princeton, NJ: Princeton University Press, 1992), 261–90.

17. See *Poetics* 13 (1453a2–7). See also *Rhetoric* 1385b13–15.

18. Halliwell, *Aristotle's Poetics*, 196.

19. Nussbaum, "Tragedy and Self-Sufficiency," 282–83.

in that "the arousal of pity and fear . . . effects a *katharsis* of these same emotions (which therefore ought in some degree to be changed)."[20] There is both "expenditure of emotion" and "amelioration of the underlying emotional disposition."[21] As a result of this catharsis, the emotions "become better attuned to the perception of reality, and, consequently, as Aristotle believes, better disposed towards virtue."[22]

An example will help. In Sophocles's tragedy *Philoctetes*, set against the backdrop of the Trojan War, crafty Odysseus and the young and noble-minded Neoptolemus arrive at the desert island of Lemnos in order to retrieve their erstwhile comrade Philoctetes, whom years before, on their way to Troy, Odysseus had abandoned on Lemnos. Why? Because an injury to Philoctetes's foot had made him useless for battle. But now the Greeks need Philoctetes. He has a magical bow gifted him by the god Heracles, and a prophet has foretold that the Greeks will never defeat the Trojans without Philoctetes and his bow. Odysseus convinces Neoptolemus to play a trick on Philoctetes in order to get him to return with them. But when Neoptolemus sees Philoctetes suffering from the wound in his foot, Neoptolemus is moved to pity and fear and abandons his role in Odysseus's scheme. Neoptolemus, therefore, stands in for us, the tragic audience, who also experience pity and fear at the sight of Philoctetes's undeserved misfortune along with the consequent catharsis or right alignment of these emotions. As Nussbaum explains:

> The sight of Philoctetes' pain removes [from Neoptolemus] an impediment (ignorance in this case, rather than forgetfulness or denial), making him clearer about what another's suffering means, about what his good character requires in this situation, about his own possibilities as a human being. The audience, in

20. Halliwell, *Aristotle's Poetics*, 199.
21. Halliwell, 198–99.
22. Halliwell, 197.

the midst of wartime, is recalled to awareness of the meaning of bodily pain for another, for themselves [at the time of the first performance of *Philoctetes*, Athens was fighting the Peloponnesian Wars with Sparta]. Even good people do need to be reminded—especially in time of war, when military passions run high and awareness of the enemy's similar humanity is easily lost from view in the desire to inflict a punishment.[23]

Nussbaum's comment helps us to see that the good effects of tragic catharsis are not merely for the sake of an individual's moral improvement but are for the sake of the entire political community, a point that has also been developed by Stephen Salkever. Salkever offers an intriguing interpretation of catharsis by observing how the term is used in Plato. He notices that in Plato, catharsis is used, among other ways, to describe the effect on souls of the Socratic *elenchus*, his method of refutation through questioning and answering. In this sense, catharsis is more transformation than purgative cleansing in that it introduces order "into otherwise disorderly or incoherent souls . . . with the result that involuntary ignorance and tyrannical dreams are removed and the educated person becomes better. The process here is not one of removal, but of giving the soul its proper form and order."[24]

Tragic catharsis, on this view, is analogous to philosophical dialogue; it is a mode of charming *persuasion* intended to bring just order into the soul.[25] Of what truths does tragedy seek to persuade us? From the extant tragedies, Salkever culls three overarching themes, all with a clear political resonance: "First, that serious mistakes are possible, and one must therefore act with caution;

23. Nussbaum, "Tragedy and Self-Sufficiency," 282.

24. Stephen Salkever, "Tragedy and the Education of the *Dēmos*: Aristotle's Response to Plato," in *Greek Tragedy and Political Theory*, ed. J. Peter Euben (Berkeley, CA: University of California Press, 1986), 274–303.

25. Poetic *paideia*, observes Salkever, "like Socratic *elenchos*, operates indirectly; it neither admonishes nor implants moral rules, but prepares its auditors to use their leisure well, to act virtuously and thoughtfully rather than under the influence of *pleonexia*" ("Tragedy and the Education of the *Dēmos*," 290). I will turn to the theme of *pleonexia*, "graspingness," in chapter 14.

second, that wealth, social prestige, and the power to do whatever we want do not necessarily bring happiness, and one must therefore resist the tendency to identify freedom and happiness with power; third, that the familial order is as fragile as it is precious, and so requires the support of institutions such as the laws if it is to be maintained."[26] These are the truths by which tragedy hopes to introduce order into the souls of democratic citizens, a set of truths, certainly, that testify to the enduring relevance of tragedy to democratic government.

While it is too much to say that tragedy accomplishes, on its own, that reordering of the soul, it does prepare the ground for it by *simulating* it—that is, it gives the spectator, in Salkever's phrase, a new "focusing of concern."[27] The word "concern" is well chosen, as it captures both the contemplative and the affective elements of the experience of tragedy. In a suggestive comparison, Salkever likens the new focus of concern produced by tragedy to the wonder that begins philosophy. Indeed, for many, in the ancient world as in ours, works of mimetic art are the most compelling occasions of that wonder.

Mortimer Adler makes a similar point when he argues that our emotions themselves are part of what we contemplate when we, the audience, contemplate a work of mimetic art. "Because art is imitation, the emotions which it creates in the spectator become part of the spectacle and are thus understood rather than expended in impulse and activity."[28]

What does this excursus into the Aristotelian notion of catharsis teach us about the mimetic arts and moral transformation? What I would like to suggest is that Aristotle's account of tragic catharsis provides a general model for how moral transformation works in the enjoyment of mimetic art. Not all works of mimetic

26. Salkever, "Tragedy and the Education of the *Dēmos*," 300.

27. Salkever, 300.

28. Adler, *Art and Prudence*, 46. Adler's discussion of catharsis (45–48), though leaning overmuch on the sense of catharsis as "purgation," is perceptive and illuminating.

art are tragedies, of course, and therefore not all works of mimetic art effect a catharsis of pity and fear. But all works of mimetic art arouse emotions of some kind, and all audiences, to one degree or another, need better attune to reason the emotions aroused by the works they enjoy and thus better dispose themselves to virtuous action.[29] Because this attunement of our emotions is inherently pleasurable, we return to the exercise again and again and, in so doing, form our passionate responses, our likes and dislikes, in certain definite ways.[30] To take just one example of a mimetic art other than tragedy, Gene Fendt has argued for a kind of catharsis related to the emotions provoked by comedy. Fendt concludes his discussion by saying:

> Comedy "teaches the things that are best" by taking our de-siring passions through a set of movements that leaves them less constricted—as they undoubtedly are by the world, less fixated, less bound to inadequate objects and partial truths. Such recreations also make us more capable of joy by giving us joy in something like our proper loves and sympathies, as tragedy allowed an uninhibited run through the appropriate fearful and pitying passions.[31]

We will have occasion later on, in part 3, to delve more deeply into comic catharsis when I offer a reading of Jane Austen's comic novel *Northanger Abbey*. We will also, in part 3, consider how this clarifying of our emotional disposition works in mimetic arts that do not seem to involve narrative, such as painting and music.

29. For the evidence that Aristotle himself extended the notion of catharsis to include epic and comic poetry, see Halliwell, *Aristotle's Poetics*, 200, esp. note 43, and 274–75n33.

30. Even to feel pity and fear at a tragedy is a pleasurable experience, as Aristotle empha-sizes at *Poetics* 14 (1453b11–14). On this text, see especially Halliwell, *Aesthetics of Mimesis*, 186.

31. Gene Fendt, *Love Song for the Life of the Mind: An Essay on the Purpose of Comedy* (Washington, DC: The Catholic University of America Press, 2007), 174.

Meanwhile, I would like to close this chapter by addressing an objection regarding the suggestion I just made.

One might argue that substantial moral transformation in the audience of a work of mimetic art—even one of the acknowledged masterpieces of mimetic art, in whatever genre—is an exceedingly rare phenomenon. How often, for example, do we go home after the tragedy, or turn off the television, or close the book, and feel that our lives will never be the same again? Granted, after enjoying a work of mimetic art, we might experience a certain change in the way we think or feel about the world. Our souls might be stirred to some small extent. But only very rarely, it seems, do we witness what we might call the Neoptolemus Effect, where all at once a work of art effects deep moral change in its audience. There may be widespread substantial *enjoyment* of the work, but not deep and widespread *moral transformation* inspired by the work. This seems especially to be the case when we consider that an audience makes no real-world (non-simulated) moral choice in enjoying a work of mimetic art besides that of buying the ticket, picking up the book, or sitting down in front of the TV, and these choices alone do not make for significant moral change (unless circumstances, such as the work's being gravely compromised morally, make the choice to enjoy it morally significant). In brief, the kind of moral realignment that Aristotle's idea of catharsis seems to suggest would be common in enjoying great works of mimetic art simply does not meet the facts.

Let us first notice what this objection gets right. As we enjoy a work of mimetic art, we do not engage directly in moral choice. What the mimetic arts do, as Fendt has aptly put it, is allow for the arousal of passion "without existential import"; in other words, they arouse our passions outside the arena of real-world practical

reasoning.[32] The mimetic arts take us into a contemplative space where we enjoy a simulation of moral decision-making.

Within the simulation, the passions or emotions of the audience get, as it were, a workout. They practice becoming a surer reflex of prudent discernment. The result is what the objection misses: real transformation of the audience's emotional dispositions, as directed by simulated acts of the will, under the guidance of the beliefs that inform the audience's emotional responses.

Why, then, isn't deep moral transformation more common-place among the audiences of works of mimetic art? The answer is that it *is* commonplace, but that we do not always notice it because it is not typically all-at-once and dramatic but gradual and subtle. The enjoyment of one particular song or movie may not deeply change us. We may not notice anything special about our enjoyment of it except the enjoyment itself. But a steady diet of a certain kind or quality of mimetic art will tend to create deep patterns in the way we think and feel about the world—for bet-ter or for worse, depending on the quality of the art. I say "tend to," because no result is necessary when we speak about human beings, who are always free to surprise us with their responses to anything. But the truth that our objector has to acknowledge is that to a large degree, our moral perceptions and habits are a function of our habits of artistic enjoyment. This was a truth already well known to Plato and Aristotle, and it is a truth well known to parents reflecting on what books and shows and video games are appropriate for their child.

32. Fendt, *Love Song for the Life of the Mind*, 174.

Interlude

Sunday Afternoon in the Town Museum

A Conversation on Art, Beauty, and Transcendence

> He was the sort of painter who can paint leaves better than trees. He used to spend a long time on a single leaf, trying to catch its shape and its sheen and the glistening of dewdrops on its edges. Yet he wanted to paint a whole tree, with all of its leaves in the same style and all of them different.[1]

This is Niggle, the not terribly successful painter from J.R.R. Tolkien's short story "Leaf by Niggle." One day, Niggle is at work on a painting of a leaf when he finds himself painting the whole Tree he has always imagined. Over time the Tree grows large, "sending out innumerable branches and thrusting out the most fantastic roots." And behind the Tree, there appears a broad country, with "glimpses of a forest marching over the land, and of mountains tipped with snow." Niggle loses interest in all his other pictures or else tacks them onto the edges of his great picture.

But Niggle has trouble finishing his painting. He can be idle, you see. And his kind heart keeps drawing him into helping his neighbor. He also has a long journey to prepare for, a journey he does not want to make but that he cannot get out of.

Niggle has yet to finish his Tree when the day for his journey arrives. He is taken on an adventure, and not a pleasant one. At least not until the day when, bicycling in the country, he comes upon something that makes him fall off his bicycle:

> Before him stood the Tree, his Tree, finished. If you could say that of a Tree that was alive, its leaves opening, its branches

1. J.R.R. Tolkien, "Leaf by Niggle," in *Tree and Leaf* (London: HarperCollins, 2001), 93–108. All quotations in this recapitulation of the story are taken from this edition.

growing and bending in the wind that Niggle had so often felt or guessed and had so often failed to catch. He gazed at the Tree, and slowly he lifted his arms and opened them wide.

"It's a gift!" he said. He was referring to his art and also to the result, but he was using the word quite literally.

Beyond the Tree, Niggle can also see the forest he had imagined and the snow-tipped mountains in the distance. It turns out that the unnamed land where Niggle's journey has taken him, and particularly its Tree and forest and snow-tipped mountains, is the living exemplar of the painting he had once painted.

I am simplifying the story. I haven't said anything about Niggle's neighbor, Parish, the same one who always needed Niggle's help and who eventually joins Niggle in the land of Niggle's Tree, or the land that a shepherd they meet calls "Niggle's Picture." Parish cannot believe that this Tree and this country is the reality of what Niggle was painting in his great picture, a picture that Parish had always disdained, along with the rest of Niggle's paintings. "But it did not look like this then, not *real*," exclaims Parish to the shepherd. To which the shepherd replies, "No, it was only a glimpse then."

The shepherd has arrived to guide Niggle to his ultimate destination: the Mountains. Niggle shakes hands with Parish and goes off with the shepherd. And that is the last we hear of Niggle the painter.

But later on, back in the town where Niggle lived, the locals remember Niggle as "a silly little man." Save for one, a schoolmaster named Atkins, who seems to understand that there is something of value in Niggle's work. The paintings Niggle left behind have been made "use of." The great picture of the Tree has been used to patch the roof of Parish's old house. Most of it, anyway. A corner of it depicting "one beautiful leaf," Atkins preserves. He has it framed and later leaves it to the Town Museum, where "for a long while 'Leaf: by Niggle' hung there in a recess and was

noticed by a few eyes. But eventually, the Museum was burnt down, and the leaf, and Niggle, were entirely forgotten in his old country."

So ends Niggle's story as told by Tolkien. But imagine if the story of Niggle and his painting didn't end there. Imagine Niggle's painting, in the years when it still hung in the Town Museum, inspiring conversations between the people who came to enjoy it—conversations about the painting and its beauty but also about art and its relation to the realities that transcend art. Below, I imagine one of those conversations.

SUNDAY AFTERNOON IN THE TOWN MUSEUM

The following conversation took place in the Town Museum, before its destruction, at a time when "Leaf: by Niggle" still hung there in a recess. Atkins often came alone on a Sunday afternoon to admire the painting. On this day, however, he happened to bump into his lovely colleague Miss Parish, the granddaughter of Niggle's neighbor. They sat together on a little cushioned bench gazing at Niggle's painting. Atkins was rather fond of Miss Parish. He liked to think they shared a poetic soul.

DIVINE AND CREATED BEAUTY

After a long silence, Atkins clears his throat . . .

ATKINS. You know, Miss Parish, when I look at Niggle's painting, I feel I am seeing the face of God!

MISS PARISH. How extraordinary. You believe the face of God is rectangular?

ATKINS. I beg your pardon?

MISS PARISH. The painting is framed, Mr. Atkins.

ATKINS. Ah! I see. No, what I mean is, when I look at the *leaf* that Niggle painted, I feel I have been transported into the divine presence.

MISS PARISH, *looking askance at him*. Do you *worship* leaves, Mr. Atkins?

ATKINS. No, Miss Parish!

MISS PARISH. Then whatever do you mean?

ATKINS, *fumbling*. I mean . . . What I'm trying to say is . . . It's just so *beautiful*, isn't it? That kind of beauty, it's as though it doesn't belong to this world. It's as though it's a glimpse of God's own beauty, if you see what I mean.

MISS PARISH. Perhaps I do.

ATKINS. You do?

MISS PARISH. But I'm not sure.

ATKINS. Oh.

MISS PARISH. One thing I am sure of, however: it's a beautiful painting.

ATKINS. It is, isn't it? I've always thought so.

MISS PARISH. And God is beautiful.

ATKINS. I've always thought that too.

MISS PARISH. And I suppose every beautiful thing in this world, whether it is Niggle's leaf or (*she happens to catch Atkins watching her intently*) . . . or my dog, must somehow owe its beauty to God's beauty. But what I'm not sure of is what you mean by saying that you look at that beautiful painting by Niggle and see the face, or the beauty, of God. How does that work? Are you having a mystical experience right here in the Town Museum?

ATKINS. Oh, no! That would be rude.

MISS PARISH. Then what do you mean by describing Niggle's painting

as a kind of *portal* to God? I am more inclined to say that it is simply excellent craftsmanship.

ATKINS. You make Niggle's art sound so quaint and *artisanal,* Miss Parish. As if it were *carpentry.*

MISS PARISH. Isn't painting a bit like carpentry?

ATKINS. Doubtless some such analogy holds between the useful arts and the fine arts. The useful arts make things; the fine arts make things. Fair enough.[2] But then a chasm opens up between them! The useful arts, while they may *accidentally* produce a beautiful bookshelf or bridge or asparagus bed, are not essentially ordered to the making of beautiful things but to some human *need.*[3] The fine arts are free of all that. They are all about the beautiful. I should thus call them the "free arts."[4]

MISS PARISH. I have no problem with thinking of the arts as free from need. But what frees them from need is their desire to imitate, and thus to contemplate, human beings in their quest for wholeness. That's why I prefer the term "mimetic arts."

ATKINS. You assume the point of the free arts is to imitate?

MISS PARISH. You choose to part ways with Aristotle?

ATKINS. Obviously, not entirely. Aristotle has much to teach us about

2. Maritain, *Creative Intuition in Art and Poetry,* 34–36. At p. 48, Maritain details the way in which the conceptual, discursive, logical reason proper to the useful arts plays an essential, albeit secondary, role in the fine arts.

3. "The division between the useful arts and the fine arts must not be understood in too absolute a manner. In the humblest work of the craftsman, if art is there, there is a concern for beauty, through a kind of indirect repercussion that the requirements of the creativity of the spirit exercise upon the production of an object to serve human needs" (Maritain, *Creative Intuition in Art and Poetry,* 46). Yet Maritain goes on, then, to emphasize that whatever beauty is achieved by the useful arts is incidental. He speaks of the beauty of the Brooklyn Bridge and waxes poetical on the "chaos of bridges and skyways, desolated chimneys, gloomy factories, queer industrial masts and spars, infernal and stinking machinery which surrounds New York" as "one of the most moving—and most beautiful—spectacles in the world," only to conclude: "For the kind of beauty I just described exists indeed: but as an accidental occurrence, a quite peculiar case in the whole universe of art, and I even wonder whether the delight we find in it does not flatter, perhaps, some perverse instinct of our too civilized eyes" (46).

4. "First, the fine arts, because of their immediate relation to beauty and to the pure creativity of the spirit, are free—with the very freedom of the spirit" (Maritain, *Creative Intuition in Art and Poetry,* 47).

the free arts. But he also tends to be very . . . *workmanlike*. He never puts his finger on what is truly distinctive about the free arts. I've taught his *Poetics*, you know, and in that book, he mentions "beauty," in some form of the Greek word *kalon*, at least ten times.[5] And in every case but one, he's talking about plot construction. He never touches upon the real spirit of the free arts. Not a word about the nature of inspiration and what allows a piece like Niggle's painting to connect us to Divine Beauty.

MISS PARISH. What I would prefer to say is that Niggle's painting is an *image* or a *likeness* of Divine Beauty. You might even say that, in being beautiful, it *pictures* Divine Beauty. Do you read St. Thomas Aquinas, Mr. Atkins?

ATKINS, *pop-eyed and open-mouthed, like a hooked fish*. Not as much as is ideal.

MISS PARISH. Well, St. Thomas Aquinas says that the beautiful creature—whether it be a tree, a landscape—

ATKINS, *gazing at Miss Parish*.—or a face!

MISS PARISH, *ignoring him*.—or Niggle's painting—*participates* in the Beauty of the first cause, which of course is God.[6]

ATKINS. Participates? Does that mean it *shares* in the Beauty of God?

MISS PARISH. Exactly.

ATKINS. Well, that's what *I* mean, then! We look at Niggle's painting and see God because the painting shares in the Beauty of God.

MISS PARISH. It all comes down to what you mean by "and see God," Mr. Atkins. You don't mean you look upon God's face *directly* as though you were enjoying the beatific vision?

ATKINS. Something a little less than that, I suppose.

5. *Poetics* 1 (1447a10); 4 (1448b25); 6 (1450b1); 7 (1450b34, b37, 1451a11); 9 (1452a11); 11 (1452a35); 13 (1453a23); 15 (1454b12).

6. Drawn from St. Thomas's *Exposition of Dionysius on the Divine Names*, in *The Pocket Aquinas*, trans. and ed. Vernon J. Bourke (New York: Washington Square, 1960), chap. 4, lect. 5–6, p. 269.

MISS PARISH. Yet I agree with you: if the painting participates in God, there must be *some sense* in which I detect God, catch a glimpse of God, when I look at the painting.

ATKINS. How about this? When God makes something, anything, he must leave his mark upon it. His signature, so to speak. Niggle didn't literally sign that painting on the wall there, but his "signature" is everywhere on the canvas. All those brushstrokes, lines, and colors are *Niggle's* brushstrokes, lines, and colors. Don't you think it's the same with every beautiful creature, including the artifacts of creatures, that they bear the signature of God's creative activity?

MISS PARISH. I do, indeed, Mr. Atkins. And I'll tell you in what God's signature consists. St. Thomas says it is in the beautiful thing's integrity, proportion, and brilliance. Every beautiful created form participates, according to its limits, in God's Integrity, Proportion, and Brilliance.

ATKINS. I think *you* are brilliant, Miss Parish.

MISS PARISH. Concentrate, Mr. Atkins! St. Thomas says that every created form is, for example, brilliant principally because it shares in, participates in, the actuality and intelligibility of God. Sensible things, like Niggle's painting, have also a *sensible* brilliance, mainly in the colors they radiate. But even sensible things are brilliant or radiant primarily because of their substantial form by which they achieve actuality and intelligibility.

ATKINS. Niggle certainly had a gift for painting sensible brilliance. Don't you just love his use of color? Look at that amber and the way he's made it look translucent!

MISS PARISH. Let me ask you, Mr. Atkins. Would you like Niggle's use of color so much if he had just splattered it about the canvas?

ATKINS. Not at all.

MISS PARISH. Do you think Niggle achieves that translucent effect simply by chance?

ATKINS. Not at all. Niggle was a true artist.

MISS PARISH. And what is a true artist but someone who is able to put order into materials? That translucent amber pleases you because Niggle put that translucent design, or effect, into paint.

ATKINS. I see. So, the design that makes the amber translucent is the substantial or compositional form of the painting?

MISS PARISH. Well, I think there is a compositional form that makes the amber translucent, but I wouldn't call it the *painting's* substantial form. The substantial form of the painting refers to the design, the "argument," one might say, of the *entire* painting. But there are subordinate forms that support the overall design, and that's what I think we find actualizing that amber there to make it look translucent.

ATKINS. So, it's the compositional form or design of Niggle's painting that primarily makes it brilliant, though his use of color makes it brilliant too?

MISS PARISH. Exactly.

ATKINS. And when I call Niggle's painting beautiful, I am primarily reacting to its compositional form—that is, its substantial form and all the other subordinate forms?

MISS PARISH. Yes. Tell me, Mr. Atkins, have you ever heard St. Thomas's definition of beautiful things as *those things which please upon being seen*?[7]

ATKINS. I'm sure I have. Somewhere.

MISS PARISH. Well, when the brilliantly arranged colors of Niggle's painting please your sense of sight, you are having an experience of the beautiful on the level of your senses. And that is a wonderful experience! But when you understand the compositional form of Niggle's painting of this leaf—meaning the *intelligible* brilliance of its substantial form and any or all of its subordinate forms—you

7. *Summa theologiae* 1.5.4 ad 1.

are having a deeper experience of the painting's beauty on the level of your intellect. And that's even more wonderful!

ATKINS. I think I understand. But we seem to have come very far from God.

MISS PARISH. Not at all. All of this brilliance we're talking about is what God shares with creation—including the works that we human beings produce—out of his own brilliance. He pours his brilliance out upon creation *through form*. And our human intellects, which themselves participate in the light of the divine intellect, are made to cognize form. We are made to understand and delight in God's brilliance in the brilliant forms all around us, just as we are doing right now with Niggle's painting.[8]

ATKINS. But didn't we say that God's Beauty consists of brilliance along with integrity and proportion? Where do we find integrity and proportion in created beauty?

MISS PARISH. We find integrity or wholeness in the way in which created things achieve their ends. And we find proportion or harmony in two ways. First, in the wonderful ordering of the parts of the universe to one another; and second, in the wonderful ordering of all those parts to their end, God himself. All throughout creation, there is a marvelous arrangement. Each thing, according to its substantial form, holds a place in the great hierarchy of being according to the perfection of its form. And each level of the hierarchy is connected to the levels above and below it.[9] Consider the oyster.

ATKINS. Do *you* like oysters, Miss Parish? Because I know a little place—

MISS PARISH. The oyster is a sea animal, though it barely surpasses the life of a plant. It cannot move itself, for instance. The one

8. On this point, see Alice M. Ramos, *Dynamic Transcendentals: Truth, Goodness, and Beauty from a Thomistic Perspective* (Washington, DC: The Catholic University of America Press, 2012), chap. 4, esp. 73. In this part of the dialogue, I am greatly indebted to Ramos's discussion in chapter 4 of this work.

9. Ramos notes that, in his *Exposition of Dionysius on the Divine Names*, Aquinas only discusses two features of the beautiful: harmony, or due proportion, and brilliance, or radiance. See *Dynamic Transcendentals*, 72.

power the oyster has that plants don't have is the sense of touch. Thus, the oyster is connected to the plants below it through its ability to nourish itself, grow, and reproduce, and it belongs to the animal kingdom because it has the sense of touch.

ATKINS. And we human beings, while being animals, surpass the life of animals because of our intellectual soul.

MISS PARISH. Yes, Mr. Atkins. And the human intellect, in turn, places man lower in the hierarchy of intellectual beings because our intellect, unlike that of the angels or God, needs the body and its senses in order to know things.[10]

ATKINS. So, one kind of harmony or proportion is the ordering of parts to one another in the hierarchy of being, but the other kind of harmony—

MISS PARISH. —is the ordering of all these parts to their end, God. God is not only the efficient or moving cause of things, bringing them into existence. He is also the final cause or end of all things: the goal that they seek to attain by imitating him as far as their natures allow. As their goal, God calls all things to himself. The word "beauty" in ancient Greek, *kalon*, is derived from a verb meaning "to call." And in calling all created things to himself as their end, God makes them beautiful.

ATKINS. What you say, Miss Parish, puzzles me. The flower doesn't consciously respond to God's call. Nor does Niggle's painting.

MISS PARISH. A very astute observation. In response, I would say this: Everything achieves the end God has in mind for it when it reaches its perfection, when it becomes all God designed it to be. When the rose flourishes as the rose is meant to flourish, it radiates integrity, proportion, and brilliance in its being fully actualized by its substantial form. It's not a matter of the rose being *conscious* of aiming for this end. But Niggle's painting presents a different case altogether.

10. For this discussion of the hierarchy of being and the example of the oyster in particular, I am depending on Ramos, *Dynamic Transcendentals*, 75n21, which refers to Aquinas's *Summa contra Gentiles* 2.68.

ATKINS. How so?

MISS PARISH. Because, unlike the rose, it is a product of human art.
It was produced by an intelligence consciously aiming to achieve
an end. And here's what is especially interesting. Niggle's paint-
ing is Niggle's way of responding to God's call. It is Niggle's way
of becoming beautifully integral, proportional, and harmonious,
because in using his intelligence to produce a perfect work of art,
he was achieving part of his own perfection as a rational being. A
moment ago, I said that all things seek to attain God by imitating
God as far as their natures allow. Niggle imitated God's Beauty by
painting this leaf that God had first created out of nothing! . . .
Why are you smiling?

ATKINS. I was just thinking. Given all that we're saying, there's a cu-
rious pattern to God's creative activity. First, God's creative act
pours out of himself, out of his own Integrity, Proportion, and
Brilliance, into the forms of created things. Then, all created things
are called back to God according to their natures by imitating his
Integrity, Proportion, and Brilliance. Now I can make sense out of
my initial statement. When I look at Niggle's painting, I really am
seeing the face of God because I am seeing in it God's signature
Integrity, Proportion, and Brilliance.

MISS PARISH. I wouldn't put it just like that, Mr. Atkins.

ATKINS. Why not? Doesn't that follow, given all we've said?

THE BEAUTY OF MIMETIC FORM: METAPHYSICAL OR INTENTIONAL?

MISS PARISH. The relationship of mimetic art to the realm of the
transcendent where God dwells is a thorny business, Mr. Atkins.

ATKINS. I thought we had just worked it all out!

MISS PARISH. We have just been doing what the philosophers call
metaphysics. Metaphysics allows us to take, as it were, the point

of view of the universe. We look at the whole panoply of reality, created and uncreated, and try to work out the ultimate foundations of things. But think about Niggle niggling away in that tall shed in his garden where he worked on this painting. That wasn't metaphysics he was doing in there; that was him just trying to paint a leaf.

ATKINS. But I think it *was* metaphysics. We just said that his painting was part of Niggle's way of imitating God's Beauty. Well, how could Niggle imitate God's Beauty if he hadn't some insight, some *intuition*, into it? You'll forgive me, Miss Parish, but on this question, I believe you are quite mistaken. I have insider's knowledge, you see. I am something of an artist myself.

MISS PARISH. You paint, Mr. Atkins?

ATKINS. Poetry is more my line, Miss Parish. I don't make any claims to greatness, but I think one or two of my sonnets are not altogether embarrassing.

MISS PARISH. Sonnets indeed! You astonish me, Mr. Atkins. What do you write sonnets about?

ATKINS, *blushing*. Oh, I write whatever the Muse instructs me to write. The thing is, I believe, in the absence of Niggle, that I can speak for him and for all artists in saying that art is most definitely a portal to the transcendent. I've experienced it myself. Now, I understand what you're saying, Miss Parish. Niggle in his shed was just painting a leaf. It was all just canvas and oil paint and brushes and whatnot. But I say, when he saw the *beauty* that he wanted to manifest in that painting on the wall there—and we agree that he *did* manifest beauty in it—he was transported *beyond the physical world*. He entered the realm of the spirit. He transcended the finitude of matter and wandered, like a great explorer, in the infinitude of being![11]

11. Atkins would agree with Maritain: "The work which involves the labor of the Fine Arts is ordered to beauty: insofar as it is beautiful it is an end, an absolute, self-sufficient; and if, as work to be done, it is material and enclosed in a kind, as beautiful it belongs to the realm of the spirit and dives deep into the transcendence and the infinity of being" (Maritain, *Art and Scholasticism*, 34–35). A reading of Aristotle and Aquinas on the mimetic arts, however,

MISS PARISH. Oh my. And this experience has happened to you?

ATKINS. Many times, Miss Parish. Many times. Put it this way: the fine arts have a certain material component. In the case of painting, it is paint applied to some kind of surface. But what makes the fine arts "fine" is that they also have a *soul*.

MISS PARISH. And what is this "soul"?

ATKINS. The ability to make contact with the transcendent! Just as man transcends the genus "animal" because he has an intellectual soul, so the fine arts transcend the genus "art" because they have a spiritual soul that can reach beyond the material world.[12]

MISS PARISH. Your claim that the mimetic arts have a soul is very interesting. Aristotle, as you may know, talks about tragedy as having a "soul," by which he means its form, which is to say its *plot*. He doesn't talk about a tragedy's plot making contact with a transcendent realm of beauty, though. He simply means that the tragic plot—the ordered sequence of events with a beginning, middle, and end—actualizes the matter of the work, which is its language, and, in a Greek tragedy, music and dance. The "soul" of a tragedy, as Aristotle seems to understand it, is very *this-worldly*. It is simply the design, the substantial form of the work. And I think we can say the same for the other mimetic arts. The "soul" of a painting or of a sculpture or of a piece of music is the substantial form that actualizes the matter of that particular art.

ATKINS. If it is permissible to strongly disagree with a lady, I must strongly disagree with you, Miss Parish. I believe you are overemphasizing the craft dimension of the fine arts, the fact that they must always work with some matter. My point, however, is that there is another dimension to fine art, call it the *poetic* dimension—not understanding "poetry" as having exclusively to do

would better conclude that the specific object of mimetic art is not beauty as such, much less beauty as a transcendental property of being, but, as Rover puts it, "*a manifest imitation of the probable or possible in human action*" (*Poetics of Maritain*, 78; italics in original). For a critique of Maritain's *Art and Scholasticism* on the same general lines as that of Rover, see Belgion, "Art and Mr. Maritain."

12. In regard to Atkins's last two comments, see Maritain, *Art and Scholasticism*, 35.

with the writing of verse, but rather with the mysterious workings of the artist's creative intuition into transcendent beauty.

MISS PARISH. If you will allow me to strongly disagree with *you*, Mr. Atkins, it seems to me that you are turning art into metaphysics. For me, the mimetic form is *intentional*, in that it intends or brings into view the human action being imitated. But for you, the mimetic form is primarily metaphysical, insofar as it "makes contact," as you say, with transcendent being, or transcendent beauty (you keep switching between these terms). I'm not sure Niggle himself would understand what you say about art.

ATKINS. He may not have been able to put his creative intuition into words, I grant you. But that's just the nature of creative intuition; it is incommunicable. But when I consider the beauty of that painting there, Miss Parish, I have no doubt that Niggle was seeing something not available to many eyes. It is as though he were looking into another country, another land, where his leaf really existed, hanging upon a real Tree. I don't mind calling that kind of seeing metaphysical. Why not? Like the metaphysician who looks into the infinity of being, so Niggle looked into the infinity of Beauty.[13]

MISS PARISH. My reading of Aristotle and St. Thomas leads me to think of mimetic art as a humbler activity, Mr. Atkins. Eminently worthy and glorious at its own level, to be sure, but as compared to the work of the metaphysician or the theologian, quite humble indeed. St. Thomas calls poetry the *infima doctrina*, the *least* of doctrines, characterized by the *existimatio*, the "conjecture" of the poetic judgment, resulting in a *defectus veritatis*, a *defect* of truth.[14] This is to regard poetry, and by extrapolation the other mimetic

13. Maritain, 35.

14. Aquinas refers to poetry as the *infima doctrina* at *Summa theologiae* 1.1.9 obj. 1. The *sola existimatio* of the poetic judgment comes from his description of poetry in the prologue to *In Posteriorum analyticorum*. He says that poetry has a *defectus veritatis* at *Scriptum super libros Sententiarum* 1.1.5 ad 3 and *Summa theologiae* 1-2.101.2 ad 2.

arts, as rather humble in their aspirations.[15] But you want to make of mimetic art a kind of companion, if not rival, to metaphysics.

ATKINS. The free arts have both a poverty and a grandeur, I agree. But in their grandeur, they move beyond the world of things into the world of the spirit. Tell me, when you look at Niggle's beautiful painting there, do you not experience yourself entering a realm that is more than simply words or paint?

MISS PARISH. I do.

ATKINS. Wait. *You do?*

MISS PARISH. I do. But in a different sense than you understand it.

ATKINS. Please explain.

MISS PARISH. When I contemplate Niggle's painting, I experience a particular kind of delight, a cognitive delight, a delight in knowing. And what do I know? After all, I knew what a leaf was before I ever saw Niggle's painting. *At least I thought I did.* When I look at Niggle's painting, I begin to really see and understand what a leaf is for the first time. Not in the purely biological sense. Niggle's leaf doesn't increase my understanding of photosynthesis in the least.

ATKINS. So what do you really see and understand when you look at Niggle's leaf?

MISS PARISH. I see what it means to be a leaf—a small, beautiful, brittle thing—in the concrete circumstances of the natural world. See how Niggle has made the leaf look like it has been caught in the wind?[16] How it is lifted up by the wind in a way that allows the slanted sunlight on an autumn day to strike and pass through it, thus making the leaf translucent in the way we have been talking about? How the leaf is plaintive in its overwhelmingly beautiful

15. Rover's assessment of the difference between the Aristotelian-Thomistic approach to poetry and Maritain's approach is summed up as follows: "For the *infima doctrina* and the inventive knowledge of probables the lightly weighted *pondus* of the poetic judgment is required and is sufficient; for a grasp of 'the infinite ocean of Being' through an artifact radiating transcendental beauty some higher form of knowledge is evidently called for" (*Poetics of Maritain*, 192).

16. Tolkien, "Leaf by Niggle," 94.

amber, because this color is its swan song? Niggle's leaf is dying. And so, it stands in for all those other natural beings, like you and me, Mr. Atkins, who are fragile creatures born to die.

ATKINS. What a beautiful meditation, Miss Parish!

MISS PARISH. What I learn from Niggle's painting is something true about leaves and about all natural beings—that they are small, beautiful beings that are most glorious and, yes, *noble* when they are most vulnerable. And here's my point, Mr. Atkins. Insofar as I have grasped these truths, my spirit—my intellect and my will—has risen above the level of sense particulars.

ATKINS. Exactly! The transcendental realm!

MISS PARISH. Well, it depends on what you mean by "transcenden-tal." Yes, when I experience cognitive delight in the universal truths I have mentioned, I rise above, even while I continue to enjoy, sensory delight. But that is a far cry from saying I am experiencing or making contact with transcendental being or beauty *as such*. The latter is an achievement peculiar to the science of metaphysics. It goes well beyond mimetic art's humble aspiration to manifest truths about human action and the natural world that is its environment.

ATKINS. But how is it possible for you to experience universal truths via the beauty of Niggle's painting without somehow touching upon truth and beauty as transcendental properties of being?[17]

MISS PARISH. I agree that without the transcendental properties of being—the Truth, Goodness, and Beauty woven into the very fabric of created being itself—we human creatures could not

17. Atkins's question echoes Maritain's observation in *Art and Scholasticism*, 34:

It is remarkable that the only real means of communication between human crea-tures is through being or some one of the properties of being. This is their only means of escape from the individuality in which they are enclosed by matter. If they remain on the plane of their sensible needs and their sentimental selves, they tell their stories to one another in vain; they cannot understand each other. They watch each other and cannot see, each infinitely alone, however closely work or the pleasure of love may bind them together. But once touch the good and Love, like the Saints, or the true, like an Aristotle, or the beautiful, like a Dante, a Bach or a Giotto, then contact is established and souls communicate.

communicate with one another. They are the ultimate metaphysical backdrop of our theo-drama. So, in a certain sense, yes, we "make contact" with the properties of being whenever we successfully communicate. But that "contact" does not mean that those communicating with one another are *focused directly* on that ultimate metaphysical backdrop. Rather, they are focused on discovering a particular truth or enacting a particular good or making or enjoying a particular work of mimetic art.

ATKINS. I'm not sure I understand you, Miss Parish.

MISS PARISH. Then let's not talk about beautiful works of art for a moment. Let's talk about a good or virtuous action. When I perform a virtuous action, do I in my action commune with Goodness as a transcendental property of being? In a sense, yes, insofar as transcendental being is the fabric of, well, *everything*. But from *my* point of view, as I act generously or patiently, I am simply focused upon my act of generosity or patience: bringing some flowers to a sick friend or listening patiently to someone who is upset and needs to be listened to.

ATKINS. Actions very typical of you, I know, Miss Parish.

MISS PARISH. Not always, Mr. Atkins, I assure you. Sometimes I give in to my weariness or selfishness and do not bring flowers to my sick friend or listen to that person who is upset. But at other times I do overcome my limitations and do my best to embody the good—understood generally as service to others—in action. And when I do so, I grant you, I achieve a kind of transcendence, a transcendence of my selfish ego and my physical limitations. But that is not the transcendence that typifies metaphysical or theological thought. Now, the point of all this is to say that something analogous happens in the case of the mimetic arts. A mimetic universal, something true about human beings in their quest for happiness or wholeness—true according to the logic of what Aristotle calls "the probable or necessary"—is embodied in sensible particulars. An audience's grasp of that universal involves a transcendence of the egoism and differences in belief that keep human

beings closed off from one another and so enables real communication between artist and audience. But the mimetic universal is not itself a *metaphysical* truth. It is a necessary or probable truth about *human action*, one known through pleasing picturing.

ATKINS. But wait a minute. Let's go back to what I was saying earlier about works of free art having a "soul." In the study of human nature, when we discern that the soul is an immaterial form of the body that also enjoys its own subsistence, we pass from natural philosophy into metaphysics. Why can't we say something similar about the free arts? Why can't we say that when we discern the "soul" of a work of art, we've passed from the realm of art, understood on the natural level as an artifact, into metaphysics, the domain of poetry and transcendental beauty?

MISS PARISH. We cannot do it because the "soul" of a work of mimetic art, which I follow Aristotle in calling its "plot," is not an immaterial nature as is the human soul. It is a construction, a *humanly made thing*. To be sure, with our minds we can abstract from the work the mimetic universal that serves as the conclusion of the work's argument. And, given that whatever is received is received according to the mode of the receiver, our immaterial minds receive that form immaterially and universally. But again, what is received immaterially is a truth according to the "probable or necessary," and such truths are in no way metaphysical truths, which are absolute and necessary without qualification.

ATKINS. I think I understand you, Miss Parish. Yet your argument leaves me unsatisfied. You seem to be tying the magic of poetry down to merely human construction. I can see how this would apply to useful arts, like carpentry or candle making. But the *poetry* of the free arts is not tied down to its materials. Poetry is not tied down to anything. It roams free, radically free, of any consideration of making.[18]

18. Maritain argues that a work of *art* as a *made thing* is circumscribed within a specific genus—poem, novel, tragedy, symphony, etc.—and thus has an object. "All the activity of art is specified and formed by the rules intended for the object to be made to exist. Here again the object is master." But *poetry*, in Maritain's special sense, being synonymous with creative intuition, has no object: "There is nothing to which the creativity of the spirit tends so as to be *specified*

MISS PARISH. And where, then, does poetry roam if not among the materials of a given mimetic art?

ATKINS. It roams in that other country I mentioned earlier. Call it the land of transcendental Beauty. Or the land of Niggle's Tree as it really exists.[19]

MISS PARISH. So, what about making things? Isn't that what mimetic art is all about? If Niggle had roamed radically free in this other land you're talking about, he never would have painted the painting we have been enjoying this afternoon.

ATKINS. Yes, I agree. At some point, Niggle was constrained to return from that transcendental realm and live the life of a drudge among pots of paint.[20]

MISS PARISH. Why do you describe the life of an artist in that way? Why this talk of mimetic making being drudgery? Your language is downright Platonic, not to say Manichaean. I know artists themselves sometimes talk this way, but usually because they are exhausted or in some Romantic stupor—or, as I hear Niggle was sometimes, too idle.[21] But the greatest artists don't speak like this. Dante didn't. I'll bet Shakespeare didn't either. Can you imagine Jane Austen or Dickens or P.G. Wodehouse talking about the drudgery of their artistic vocations? Surely, they sweated out the hard work of maintaining a daily habit of writing, often against

and *formed*, nothing which originally plays with regard to this creativity a specifying or formally determining part; nothing, then, which may exercise command or mastery over it" (Maritain, *Creative Intuition in Art and Poetry*, 130).

19. For Maritain, however, not even beauty ties down poetry as its object. Poetry has no object. Beauty, rather than being the object of creative intuition, is more like its correlate. Beauty is poetry's "native climate and the air it naturally breathes in." It is an "*end beyond any end* of poetry" (Maritain, 131).

20. Maritain says in *Art and Scholasticism*, 36, that art—he won't until *Creative Intuition in Art and Poetry* make the distinction between "art" and "poetry" in his special sense—"remains always essentially in the sphere of Making and it is by drudgery upon some matter that it aims at rejoicing the spirit. Hence for the artist a strange and pathetic condition, the very image of man's condition in the world, where he is condemned to wear himself out among bodies and live with minds."

21. Tolkien, "Leaf by Niggle," 93.

deadline, but they also couldn't wait to get to their writing desks each day![22]

ATKINS. So, when all the dust clears, the transcendence of the free arts, the way of beauty, is, for you, nothing more than the light conjecturing of the humble *infima doctrina*. As you understand things, when we contemplate a beautiful work of art like Niggle's painting, no veil is lifted, the infinite ocean of being is not sighted, the voice of God is not heard. Poor Edgar Allan Poe! He thought our love for beauty was "the desire of the moth for the star," a "wild effort to reach the Beauty above." And poor Baudelaire; he must have been, to your mind, similarly mistaken when he, in a passage from *L'Art romantique* inspired by Poe, wrote:

> It is that immortal instinct for the beautiful which makes us consider the world and its pageants as a glimpse of, a *correspondence* with, Heaven. The insatiable thirst for everything beyond, which life reveals, is the liveliest proof of our immortality. It is at once by poetry and *through* poetry, by music and *through* music that the soul perceives what splendors shine behind the tomb; and when an ex-quisite poem brings tears to the eyes, such tears do not argue an excess of enjoyment but rather attest an irrita-tion of melancholy, some peremptory need of the nerves, a nature exiled in the imperfect which would fain possess immediately, even on this earth, a paradise revealed.[23]

22. Apropos of drudgery, Maritain quotes Aristotle at *Art and Scholasticism*, 36: "Although he reproaches the old poets for making the Divinity jealous, Aristotle admits that they were right in saying that to the Divinity alone is reserved the possession of wisdom as his true property: 'The possession of it is beyond human power, *for human nature in many ways is in bondage*'" (emphasis added). The Aristotelian text is *Metaphysics* 1.2 (982b28ff). But Miss Parish would likely retort that "Aristotle is only saying that because human life is servile compared to the life of God, we might think that the science of metaphysics, which alone exists for itself and is free, would be beyond human reach. But it is a bit of a stretch to use this text as support for the claim that mimetic art looks down on the 'servile misery' (36) of having to muck about with matter."

23. The texts from Poe and Baudelaire are taken, respectively, from *Art and Scholasticism*, 185–86n70, and 33–34. In note 70, Maritain explains how Baudelaire's text is almost a transla-tion of a passage from Poe's essay "The Poetic Principle."

But your reply, I imagine, is that Poe and Baudelaire were deluded by an overly Romantic vision of the arts![24]

MISS PARISH. I have upset you, Mr. Atkins.

ATKINS. No, no! I am not angry. Only a little sad and shaken that your view of art makes no room at all for the yearning of our souls for paradise.

THE INTENTIONAL FORM OF MIMETIC ART AND TRANSCENDENCE

MISS PARISH. My view of mimetic art does make room for the yearning you speak of, Mr. Atkins. Would you allow me to explain?

ATKINS. It would be churlish of me not to allow you, Miss Parish. Please, I am all ears.

MISS PARISH. Thank you, Mr. Atkins. What I would like to add to what I have said is simply this. When a painting or a poem or a story pictures human beings in action toward happiness—or at least the environment of that adventure (as with Niggle's painting of this leaf)—it pictures human agents experiencing the longing for paradise described by Baudelaire.[25] Recall my meditation on

24. Rover persuasively argues that Maritain's departure from a true understanding of the Aristotelian-Thomistic approach to mimetic art is motivated in part by an overweening appreciation of Romanticism. Because of this he ascribes to Maritain what Allen Tate would call an angelic imagination:

> It becomes increasingly clear that Maritain is not simply constructing a neo-Thomistic aesthetics out of the virtualities inherent in certain unexplored, undeveloped Thomistic principles, e.g., in the areas of art and beauty. Rather, he has been struck by the "angelism" of contemporary art, by its "radical spirituality," its bursting of limits—the limits of sensible appearances, of natural form, of language, even of logical meaning—and its straining for the infinite." (*Poetics of Maritain*, 190)

25. And as well by C.S. Lewis in the following passage from his sermon "The Weight of Glory," where Lewis cautions us against mistaking beauty in art for the ultimate fulfillment for which we long: "The books or the music in which we thought the beauty was located will betray us if we trust to them; it was not *in* them, it only came *through* them, and what came through them was longing. These things—the beauty, the memory of our own past—are good images of what we really desire; but if they are mistaken for the thing itself, they turn into dumb idols, breaking the hearts of their worshippers." *The Weight of Glory and Other Addresses*, ed. Walter Hooper (New York: Macmillan, 1980), 7.

Niggle's leaf, the one you were so good as to find moving. Remember how I said that the leaf is plaintive in its overwhelmingly beautiful amber because this color is its swan song. And that I also said that Niggle's leaf stands in for all those other natural beings, like you and me, who are fragile creatures born to die. What was I noticing so richly embodied in Niggle's tiny leaf, Mr. Atkins? I was noticing that "irritation of melancholy," to use Baudelaire's words, of "a nature exiled in the imperfect which would fain possess immediately, even on this earth, a paradise revealed."

ATKINS. Oh, Miss Parish!

MISS PARISH. A beautiful work of mimetic art does give us a glimpse of paradise, Mr. Atkins, just not quite in the way you think. It gives us a *picture* of the human longing for perfection and completion and total satisfaction, a picture that can reflux back upon our lives so that we recognize our own longing for perfection and completion and total satisfaction.[26] From there, hopefully, we will be inspired to follow up on that longing, to see where it leads, or to explore it more deeply. We might be led into a formal ethical inquiry into the nature of human happiness, and from there— who knows?—into a study of metaphysics and theology. But these possibilities go beyond the immediate and humble end of the work of mimetic art, which is to deliver cognitive delight in its picturing of humanity's place in the theo-drama. The picturing itself does not give us direct access to, or indisputable evidence of, the immaterial, much less of the transcendental or of God himself.

ATKINS. I see, Miss Parish. You've given me a lot to ponder. Just one more thing: What about all that we were talking about at the beginning about God's Integrity, Proportion, and Brilliance shining forth through the form of the work of art? How does that fit into what you are saying?

26. Sokolowski speaks of the "reflux" of pictures back upon life in chapter 9 of *Phenomenology of the Human Person*, 138ff. Sokolowski attributes the use of the term "reflux" in regard to picturing to Thomas Prufer's "Providence and Imitation in Sophocles's *Oedipus Rex* and Aristotle's *Poetics*," which is collected in Prufer's *Recapitulations: Essays in Philosophy* (Washington, DC: The Catholic University of America Press, 1993), esp. 18–19.

SUNDAY AFTERNOON IN THE TOWN MUSEUM

MISS PARISH. Very good question. I would venture to say this: mimetic art's picturing of the human longing for perfection and completion and total satisfaction, if it is truly beautiful, will evince the Integrity, Proportion, and Brilliance that are the signature of God's action in this world. And if we are alive to the work's beauty, we will keenly sense God's Beauty as it is embodied in the actions and conflicts of a fictional protagonist, or in the trembling movement of a leaf being lifted by the wind.

ATKINS. So then, we *will* be seeing God in the work after all?

MISS PARISH. We will be seeing something that *participates* in God's beauty, yes. On that, if nothing else, Mr. Atkins, we are firmly agreed. And as the integrity, proportion, and brilliance of the beautiful work refluxes upon our own souls, we might well be inspired to inquire into the cause of such beauty. Then we might find ourselves imitating that seeker after beauty described by the character Diotima in Plato's dialogue *Symposium*.[27]

ATKINS. I'm sorry, but I haven't read that dialogue in some time, Miss Parish.

MISS PARISH. The seeker after beauty is one who begins by being entranced by the physical beauty of a single person, but who then realizes that what he is really after is the beauty that belongs to all physical bodies, and so afterward, seeks that common form. Yet the seeker after beauty doesn't stop there.

ATKINS. He doesn't?

MISS PARISH. No. From the beauty of physical bodies, he will ascend to the enchantments of beautiful souls. He will learn that the soul's ability to craft customs and laws, and to attain all varieties of knowledge, is far more beautiful than the beauty of any physical body. To combine the thought of Plato with that of Aristotle and St. Thomas, I submit that one of the branches of knowledge the lover of beauty will admire is the poetic knowledge gained in the

27. In what follows, I paraphrase the speech of Diotima from 208e to 212b, using the translation of the *Symposium* by Alexander Nehamas and Paul Woodruff (Indianapolis, IN: Hackett, 1989).

experience of mimetic art. This knowledge, however, will be the least of doctrines compared to all the other kinds of knowledge he can acquire, and especially the knowledge of—

ATKINS. Of what, Miss Parish?

MISS PARISH. There remains one more step for our lover of beauty to take, Mr. Atkins. From a love of the various kinds of knowledge, all so beautiful in their various ways, he will ascend, finally, to the knowledge and love of Beauty itself, that form of Beauty that makes all the other things he has admired beautiful. This is the Beauty that neither comes to be nor passes away, that is not beautiful in one respect but not in another, but that is beautiful in every respect.

ATKINS. Yes, Miss Parish! That is the Beauty we are looking for! That is the Beauty Niggle was longing for when he painted his leaf.

MISS PARISH. It was, Mr. Atkins. But Niggle's painting of the leaf was only one step on what Plato describes as the staircase to Divine Beauty itself. If our aim is to attain knowledge of a Beauty that it is always one and never changes, then we must climb. The Way of Divine Beauty is a laborious ascent. There is no shortcut to the highest stair. We must first learn the beauty of the physical world, including the beauty of men in action, men pursuing wholeness, before we can ascend to the Beauty that utterly transcends the realm of human action. That is how we become protagonists in pursuit of Niggle's Country. And that, Mr. Atkins, is the real adventure.

Part III
A Guided Tour of Some
Mimetic Arts

A Word before We Begin the Tour

I have set forth, in chapters 1–7, the basic principles of the Aristotelian-Thomistic approach to mimetic art, as well as discussed, in the interlude, the sense in which the mimetic arts are related to transcendence. I am now ready, in part 3 of my argument, to undertake a guided tour of some specific mimetic arts. My point in doing so is twofold: first, to give the reader a sense of how the principles we have examined are applicable across an array of particular works; and second, to make good on my claim that all the mimetic arts, in analogous ways, are storytelling arts. By this latter claim, I mean that all the mimetic arts, according to their different media and modes of imitation, imitate human beings in action, human beings living out the quest for happiness. Music, as we shall see, uses the medium of structured sound to picture, in a mysterious mode of enactive mimesis, the interior experience of the singer, or of the "virtual person" in a piece of wordless music, striving to realize the human end. Analogously, painting, in media such as oils, tempera, or watercolors, endeavors, in the mode of literal picturing, to capture a certain "essay at beatitude," or at least a habitat suitable, or not suitable, to such an essay. The other mimetic arts we will consider—poetry, cinema, the novel, and drama—are more obviously narrative, yet it is valuable to understand how each pictures the human story in media and in modes of imitation that allow us to contemplate that story in a delightful variety of expressions. The final chapter of part 3 takes up not any particular mimetic art but rather the serious significance, indeed the political significance, of what we typically refer to as entertainment.

8

The Soundtrack of the Theo-Drama

On BBC Radio 4, there is a long-running show called *Desert Island Discs*. The idea is for a celebrity to come on the show with a list of the eight favorite songs the celebrity would want if he or she were ever to wash up on a desert island. The eight songs are played, and in between tracks, the host asks the celebrity to talk about why these particular songs made the celebrity's list, which serves as a jumping-off point for a discussion of the celebrity's life and career.

It's interesting. No one has ever thought to produce a show called *Desert Island Sculptures*. And presumably, this is not just because sculpture makes for bad radio or because it's rather unwieldy to travel over faraway seas with eight sculptures in tow. No, a show like *Desert Island Discs* makes sense because most people value music more than they do sculpture and more than they value most, if not all, other arts. Not that a denizen of a desert island would reject a collection of sculptures and books and movies if offered. But if forced to choose, many people would choose to have their music with them. *Their* music. A big part of what we value in music is the way it speaks so intimately to us, the way that we identify with it and become possessive about it—the way that, according to the premise of *Desert Island Discs*, it provides a kind of "soundtrack to our lives."

This image of being a castaway with a small music collection is an intriguing one. The novelist Walker Percy compares the

predicament of modern, secular, technological human beings to that of a castaway, as we all exist exiled from our true homeland.[1] This true homeland is our home with God, in the most perfect sense. But it is also what we might make of our home here on earth if we understood ourselves as what we really are: wayfarers searching for the truth, goodness, and beauty for which we are made and for which we are, perhaps unknowingly, homesick. In significant ways, we live in an unbeautiful world—which is to say (as we have learned), a dis-integrated world, a world of fragments. The arts, along with everything else, have suffered from this dis-integration. Music, as Aristotle understood it, was an integral part of the ethical-political-cultural life of the most perfect human community, the *polis*. It served as entertainment, no doubt, but it also played an important role in childhood education and in the continued moral formation of adults, not to mention in that leisured contemplation that, for Aristotle, was the summit of human happiness. Music for us, however, exists as the ruin of this once intact tradition. It remains a source of intense personal enjoyment, or the intense enjoyment of *ad hoc* tribes of fans, but this enjoyment, apart from the odd charity concert, has no link to our lives in political community or to moral formation. In education, the learning of music and the playing of musical instruments has some role in certain schools, though because there is no shared vision in our culture of the nature and purpose of education, there is little shared coherent understanding of music's place in a school curriculum.

Music serves as the soundtrack to our lives; our favorite playlists give expression to our longings for fullness. The intense personal enjoyment and sense of identity and community that we find in music speaks to its deep and mysterious relevance to our lives. But at the same time, this intense personal enjoyment, this

1. See Walker Percy, "The Message in the Bottle," in *The Message in the Bottle* (New York: Farrar, Straus and Giroux, 1975), as well as "Another Message in the Bottle," in *Signposts in a Strange Land*, ed. Patrick Samway (New York: Farrar, Straus and Giroux, 1991).

sense of identity and community, is too often disconnected from the true sources of music's relevance. Lost is the sense of the beauty of music as a *calling*, as a way of becoming attracted to and *maturing* in the good, as a privileged acoustical space for contemplating how it feels to live in *genuine fullness*. What would music "sound like" if it were reintegrated into the Aristotelian-Thomistic understanding of mimetic art I developed in the first part of this book? In this chapter, I would like to sketch in broad strokes an answer to this question.

THE WORDLESS SOUND OF OUR INNER LIFE

Human beings are made for goodness and for complete goodness. Our natures are ordered to an ultimate end that measures our choices and that we must conform to at the risk of leaving our natures unfulfilled.

This is a nice pat statement of the human quest for fulfillment from the "outside," as it were, *sub specie aeternitatis*, from the point of view of the universe. But we *live* this quest from the "inside," amidst the swirl of pinging thoughts, blustery emotions, and alternatively supine or truculent wills. We may have a philosophical sense of ourselves as "teleologically ordered to the life of virtue," but this says nothing about what it *feels* like to live such ordering on any given day and at any given moment. A person of middling virtue might wake up one winter's morning and, pulling up the shade to yet another low-ceilinged sky of grey perma-cloud, experience a sinking feeling: "Will the sun never shine again?" In the backwash of this slightly depressed emotion, the day laid out in this pretty good person's planner, with all its deeds of service and self-sacrifice, will seem, perhaps, a little more daunting, a little drearier. A pep talk while shaving might rally him. A moment of prayer in the shower. Or he might remain at disequilibrium a little longer, until that first cup of coffee, or until he plunges into that first task of the day and his duties take

him out of himself. Or maybe he won't find his equilibrium at all. Maybe he will simply try to escape from the low mood with the help of the endless distractions provided by his smartphone.

This is life, is it not? This is a representative peek into how, on an ordinary day, the quest for happiness is experienced from the inside.

Josef Pieper, in "Thoughts about Music," a piece originally delivered as a talk during the intermission of a Bach concert, emphasizes this dynamic experience of the human journey toward fulfillment:

> Man's being is always dynamic; man is never just "there." Man "is" insofar as he "becomes"—not only in his physical reality, in growing, maturing, and eventually diminishing toward the end. In his spiritual reality, too, man is constantly moving on—he is existentially "becoming"; he is "on the way." For man, to "be" means to "be on the way"—he cannot be in any other form; man is intrinsically a pilgrim, "not yet arrived," regardless of whether he is aware of this or not, whether he accepts it or not.[2]

To be "on the way," "not yet arrived," is for every power of one's soul to be, in either a physical or metaphysical sense, *in motion*. It is to experience a countless variety of thoughts, feelings, memories, imaginings, and possible avenues of deliberation, each variety with its own spectrum of subtly differing, and not always terribly well integrated, shades of emphasis and intensity. Our interior lives are, to put it mildly, complex and not seldom chaotic. And here's the really strange thing, as Pieper contends: "To articulate such intimate realities, the dynamism of human existence itself, the spoken word proves utterly inadequate. Such realities, by their very nature (and also because of the spirit's nature), exist

2. Josef Pieper, "Thoughts about Music," in *Only the Lover Sings: Art and Contemplation*, trans. Lothar Krauth (San Francisco: Ignatius, 1990), 42.

before as well as beyond all speech."[3] This is an enigmatic claim, yet one that strikes us as very much true. The intimate, dynamic realities we experience from the inside cannot be put into words, or at least not wholly into words. As Pieper says, they exist "before as well as beyond all speech." What does this mean?

One aspect of our interior lives that can exist "before all speech" is our emotional lives. If I am insulted by someone, for example, my anger has a clear source. But imagine that I do not say anything to the person who has offended me. I sublimate my anger. I do not express it. Why not? Things are complicated. I may not have a good habit of fortitude that inclines me to stand up for myself. I may not even understand that I lack this habit. My passive habit of being nonconfrontational is so much a part of who I am that I don't question whether nonconfrontation is the best response. Even more, my feelings toward the person who insulted me are conflicting. I may really admire this person in some ways, but in other ways find the person obnoxious. It could be, too, that I want to impress this person for reasons that I have never explored and that are tucked deep into my automatic, subconscious reactions to life. So I am feeling anger about the insult, but the feeling is largely an unexplored labyrinth. It would take much self-examination to discover and come to terms with the Minotaur at the middle of it.

Notice, however, that in the above description of emotional turmoil, the intellect is very much at work forming the beliefs that help characterize the emotions. I feel anger after an insult because I *believe* the insult is unjust. Our emotional life is not an area of our animal existence cordoned off from the intellect and its efforts to achieve acts of intelligence. But, as we saw in chapter 5, even when we achieve a certain level of intelligence, our conceptual grasp of the sensible reality concerned can remain vague and obscure. And how much more vague and obscure is our intellectual grasp of some sensible reality, and our emotional

3. Pieper, 44.

response to it, when we are still straining after insight? This, I believe, is the best gloss on Pieper's notion that the dynamism of our interior life exists "before and beyond" all speech. Our experience of sensible reality remains vague and obscure, "before and beyond" all speech, because it is, at bottom, of *sensible* reality, and so, as we saw in our discussion of story as moral argument back in chapter 3, it always eludes the attempt to articulate it in abstract concepts alone.

Memory is another aspect of our interior lives that is not easily articulated by us and so exists, in a way, "before and beyond" all speech. Memory is simply higher-level sensation and, as such, does not come prepackaged in words and sentences and paragraphs. It needs to be articulated in speech. And when a memory is infused with strong emotion, there is yet another source of possible inarticulateness. Consider the love that a wife feels for a husband who has been her sturdy shelter and best friend for over half a century, through the joys and hardships of raising a family and of growing old together. This is not an experience easily put into words. A bare statement of the fact that they've been married so long, like my bare statement about human nature's desire for fulfillment, hardly does justice to the reality involved. Their love is too rich, too full of *life* to be so easily articulated. Which is why, on the occasions when we do want to articulate that which is not easily, and never wholly able to be, articulated, we turn to poetry (if only the mawkish Hallmark variety) or to music.

Certain other intimate, dynamic realities of our interior life can exist, in another sense, "beyond" all speech. The highest realities of human existence are so marvelous, so nuanced, so *lovably intelligible*, that our poor minds cannot get around them. As we saw in our discussion of the Catholic imagination in chapter 4, God is the best example of such a reality. We cannot know in this life all there is to know about God, or even what it means to long for him. Our minds run out of language to describe a being who, to take just one of his glories, has existed forever outside of time.

The logical incoherence of the last part of that sentence—"has existed forever outside of time"—testifies to our inability to articulate a reality that so exceeds our intellectual competence.

This is the task of music: to articulate, in the "language" of *structured sound*, the dynamism of our interior life, and especially our emotional life, as we strain after, and perhaps even achieve, acts of intelligence. But because its subject matter is that which is "before and beyond" all speech, music's structured sound maintains an ineliminable connection not only to inarticulateness but to silence. Pieper stresses this point, quoting from Paul Claudel: "Music opens a path into the realm of silence. Music reveals the human in stark 'nakedness,' as it were, without the customary linguistic draperies, 'which usually get entangled in ever present thorns.'"[4]

All the same, much music, including the most popular music of any era, does not attempt to chart a course into the realm of silence without the assistance of words. It makes use of poetry and of the human voice to utter the unutterable in *song*. Let us turn now to consider the importance of song to the reintegration of music into an Aristotelian-Thomistic understanding of the good life.

POP MUSIC

When philosophers speak about music, they usually make a beeline for what is often termed "absolute" or "pure" music—that is, instrumental music with no lyrics or narrative attached. This is not my approach for two reasons. First, it obscures the fact that music has, from its origin, been a vocal form of mimesis just as much as an instrumental one, and that, arguably, even instrumental music should be regarded as an extension of the human voice and thus as a storytelling art. Second, giving exclusive attention to instrumental music obstructs understanding the way in

4. Pieper, 44.

which today's youth culture, characterized above all by its songs, is the biggest contemporary rival to the Catholic musical imagination. Pop music is our most popular poetry and thus deserves special attention.

The medium of musical mimesis is threefold: rhythm, harmony, and melody as realized in tones. These elements, John Oesterle argues,

> are realized originally in the human voice, a point some composers seem to have ignored. The fact is, of course, that music first began with song, and while music has developed in many respects from early vocal music, its point of origin in the human voice can never be ignored. This is also why melody is the most formal and most important means of imitation in music even though rhythm, in one respect, is a more basic element. In the growth of music as an art form, musical instruments were employed as substitutes for the human voice and by way of increasing the means of musical representation and expression.[5]

It is probably impossible to judge definitively whether Oesterle is correct in saying that the appearance of song was temporally prior to that of instrumental music, though it is possible and even plausible that the development of instruments was both preceded and inspired by the exercise of the human voice in song. In any event, voice and instrumental music grew up together. In ancient Greece, for example, the lyre and kithara "were played alone and to accompany the singing or recitation of epic poems."[6] This is important insofar as it shows that music has, from its earliest origins, whether in the context of a religious ritual or in the singing of a Homeric epic, been associated with the narrative aspects of

5. John A. Oesterle, "Toward an Evaluation of Music," *The Thomist* 14, no. 3 (July 1951): 323–34, at 326.
6. Donald Jay Grout and Claude Palisca, *A History of Western Music*, 5th ed. (New York: W.W. Norton, 1996), 2–3.

song. Human beings now, just as much as in ancient times, use song in order to tell the tale of their tribe.

How that tale *feels* in the dynamic interiority of individual human lives may greatly vary as we wind our way down the paths we have chosen in our quest for fullness. The choices we make relative to our different talents and opportunities, our different challenges and satisfactions, will result in differences in moral character, intellectual development, and other aspects of the interior life—differences that distinguish us not only from other people but also from past versions of ourselves. For this reason, the music that pictures and appeals to one person's inner life can differ dramatically from the music that pictures and appeals to another person's inner life. Pieper reflects on the negative consequences of this reality:

> Thus the musical articulation may include a shallow contentment with the facile availability of the cheapest "goods," the rejection of any ordered structure, the despairing denial that man's existential becoming has a goal at all or that such a goal could be reached. There can also be, as in Thomas Mann's *Doctor Faustus*, the music of nihilism, which lives on parody and comes about through the "devil's help and hellish fire under the cauldron."[7]

Because of the dangers of music affirming and helping in the malformation of individuals, particularly of youth, Plato and Aristotle in their political works, the *Republic* and *Politics* respectively, took pains to distinguish and recommend the music that was best for education in virtue. Yet sadly, we do not live in a culture that seeks to educate in virtue. Our culture is predominantly a youth culture, a culture defined by the attitudes and excesses of young people "emancipated" from the traditional institutions once taken to be essential to their development into

7. Pieper, "Thoughts about Music," 46.

flourishing adults. This culture takes to music as a toy, as a personal or fan-group obsession, above all as a means of identity formation and self-expression. Popular music in our culture is, on balance, the soundtrack to a drama of progressive expansion of desire, above all sexual desire.

It is worth noting a qualitative difference between the youth culture and music of the 1950s and '60s and the youth culture and music of today—the difference between the culture of Sinatra, Elvis, and the Beatles, on the one hand, and the culture of Ariana Grande, Justin Bieber, and Taylor Swift, on the other. Compared to today's youth culture, the kind of alienation, disaffection, and rebellion against social mores typified in the 1950s and '60s by a James Dean, Marlon Brando, or Mick Jagger seems positively quaint. This is because, for today's pop star, there is not much left of traditional culture to rebel *against*, given that the ambient culture is now more or less identical with youth culture.[8] Apart from sheer age difference, in mainstream culture today, distinctions between youth and adults are harder and harder to make. The young, in fact, more than the old are taken to be repositories of (progressive) wisdom. All of this explains why a talented young singer like Billie Eilish is so playfully at ease with her 24/7, always-on-camera celebrity, as there is nothing in her surrounding culture to conflict with her expressiveness. Even her goth fashion choices are made for comfort, which indicates that they should not be taken as tokens of her alienation but simply as the standard uniform citizens wear in the Republic of Expressiveness. It is interesting, too, that Eilish, though admittedly only twenty, still proudly lives with her brother and her parents. If Mick Jagger had still been living with his parents at twenty, it is doubtful that he would have advertised it. At twenty, Bob Dylan had already ditched Minnesota for Greenwich Village. But what would be the point of Billie Eilish rebelling against her parents,

8. Which helps explain why pop elder statesmen like Bob Dylan, Paul McCartney, and Mick Jagger are now lionized as heroes for their early rebellions.

given that her parents have, from the start, whole-heartedly supported her singing career and share all her progressive views?

It is, in fact, in some rap music today that we find the strong sense of alienation, and even social and religious conscience, that at times characterized earlier versions of the pop music head table.[9] A trust in God, for example, is manifest amid the turbulent musings of Kendrick Lamar in the hit song "Alright." And in his music generally, Lamar addresses, according to the words of one reviewer, "such difficult topics as black male identity, social stigma, historical racism, and personal responsibility, setting witty, complex lyrics to a broad musical palette embracing funk, soul, jazz, and electro in a challenging fusion of sound."[10] Like Bob Dylan before him, Lamar is now hailed as the voice of his generation. But as refreshing as it is to find an artist haunted by the Christian theo-drama and interested in asking questions that go beyond the typical erotic longings of most pop songs, Lamar's musical imagination is also disturbingly violent, sexually predatory, megalomaniacal, and, like that of Mann's *Doctor Faustus*, apparently aided by "the devil's help and hellish fire under the cauldron." Lamar opened a recent show at the Glastonbury music festival by appearing "as a bleeding Christ figure in a silver crown of thorns, enveloped by dancers, repeatedly chanting 'God speed for women's rights' in reference to the US abortion controversy."[11] The *Roe* and *Casey* decisions had been overturned by the United States Supreme Court three days earlier.

What we have in much of today's popular music is the latest instantiation of the angelic imagination, the imagination that eschews the way of transcendence via the demands of finite reality so as to embrace a "selfie-made" cosmos of personal expression.

9. I include in this thought the music from Lin-Manuel Miranda's wildly popular 2015 Broadway musical, *Hamilton*.

10. Neil McCormick, "Kendrick Lamar, Glastonbury Review: Baffling, Dazzling, and Brilliant Closing Pyramid Show," *The Telegraph*, June 27, 2022, telegraph.co.uk. Accessed June 29, 2022.

11. McCormick, "Kendrick Lamar, Glastonbury Review."

Whatever fragments of the Catholic imagination that might still appear, distorted, in the music of today's most popular singers bob like so much flotsam on the ever-expanding sea of expressivity. And although pop music plays no official role in moral and political formation, it exerts a most powerful unofficial influence upon morality and politics and the mainstream culture that it helped form and that it serves as its most definitive voice. But the pressure of sustaining the angelic imagination often leads to it showing its demonic face and, in certain instances, capitulating to the temptations to meaninglessness that characterize the homeless imagination. Only by a return to the Catholic imagination and to the idea of music as mimetic can such dead ends be avoided.

For the better part of Western history, music has been considered a mimetic art. In his magisterial study of the history of the concept of mimetic art throughout Western culture, Stephen Halliwell observes:

> Strange though it now seems to many, the concept of mimesis has played a fundamental and tenacious part in shaping the history of Western philosophies of music. Until the major shift of attitudes constituted by the romantic movement, mimesis had long been central to attempts to resolve the enigma of music. That music is, in some sense, a mimetic art, alongside poetry, painting, sculpture, and dance, was the prevailing, though not unquestioned orthodoxy of the ancient tradition from at least the time of Plato onward.[12]

Thus, up to the Romantic era, roughly 1830–1900, music was broadly understood to be a mimetic art. But in the work of Romantic composers such as Tchaikovsky, Brahms, Liszt, Chopin, Berlioz, Wagner, and Mahler, music was reconceived as a mode of *expression*. One of the two chief reasons Halliwell gives for

12. Halliwell, *Aesthetics of Mimesis*, 235–36.

the rise of Romanticism in music, apart from the new interest in self-expression and creativity, is that mimesis was regarded as "too closely bound up with vocal music—and accordingly with the traditional theory of music as intimately related to the natural expressiveness of the human voice—to be able to survive in an era in which instrumental, and especially orchestral, music had acquired such importance for both composers and audiences."[13]

But let us try to identify more precisely the difference between the Catholic imagination and the angelic or expressivist imagination when it comes to music. Listen to any popular song, and the distinction might well seem to blur. There is Taylor Swift, singing about a romantic break-up, about her hurt or indignant feelings. Isn't this mimesis? Isn't she giving us a vocal picture of what has happened in her life and her reactions to it?

In a minimalist sense, yes, Swift is providing us with an imitation of human action. And in that imitation, we can detect a rather tortured attempt to achieve fulfillment. But this is not the richness of mimesis as understood by the Catholic imagination. Taylor Swift's songs give us a picture of a modern castaway attempting, above all, to express *her* sense of personal authenticity, her sense of what fulfillment must be *for her*, *her* choices and preferences as the standard by which her actions should be judged. From the Aristotelian-Thomistic point of view, we can listen to Taylor Swift's music and discern how her natural inclinations are longing for a happiness that she does not seem to comprehend. But we do not hear her inviting us to distinguish between human purposes and human ends. Whatever mimesis of her life she offers us is only at the service of the expression of her ego.

13. Halliwell, *Aesthetics of Mimesis*, 257–58. Halliwell notes, at esp. 236–37 but also 258, that explicitly in the neoclassicist conceptions of musical mimesis that flourished from the sixteenth to the eighteenth centuries, and implicitly in ancient Greek traditions of music, the vocabulary of expression and representation is freely mixed. In short, music as expressive and music as mimetic are not necessarily mutually exclusive conceptions. A pop artist singing about a real-life romantic break-up is expressing herself, but also picturing the feelings she is experiencing. A mimetic universal is doubtless achieved, but one deeply grounded in the unique substance of the artist. The real issue is whether the pop artist sets his or her emotional expression within a horizon of significance extrinsic to the self.

This minimalist mimesis that goes on in popular music like Taylor Swift's—or in any modern art, for that matter—is insufficiently robust to be called mimesis as the Catholic imagination and the Aristotelian-Thomistic tradition more broadly uses this word. At the same time, we should acknowledge that the personal expression that undoubtedly occurs in a work of the Catholic imagination, such as in a choral work by Byrd or Palestrina, is not the same as the personal expression that occurs in a work of the angelic or expressivist imagination. For in the work of Byrd or Palestrina, the artist's ego is put in service of his natural and supernatural ends. That is, the artist sees himself and his work as just one part of the great work of the theo-drama.

A retrieval of a mimetic understanding of music within the context of the Catholic imagination would lead us back to the world of small, definite things moving through time and especially of human beings questing for genuine happiness. The songs that sing of this journey would be of a wholly different kind than those sung by leading contemporary pop artists. And the music itself, even apart from song, would imitate that journey. But all this raises a mysterious question: How does instrumental music—music not assisted by lyrics or any other kind of explicit narrative connection—imitate human beings in action? How does music picture the quest for happiness?

MUSIC AS PICTURING

We often ascribe emotional states to music. We say that a minor chord is "sad." We say that Beethoven's "Ode to Joy" is, well, "joyous." What are we doing when we do this? One answer is that we are noticing that sad music "shares the dynamic properties of sad people." It is "slow-moving, drooping, ponderous, and so on," just as noble music is "upstanding, fully presented,

with straightforward gestures and clear, honest cadences."[14] This answer is often understood as an attempt to identify a similarity, a likeness, between the music and the emotional state of a human being.

But a likeness or similarity, as we discussed back in chapter 1, is different from a picture. A picture might well resemble that which it pictures, but it need not. Many pictures are in no way similar to the objects they picture. And sometimes, only when we take something *as* a picture do we find similarities that we would not otherwise have seen. *Being a picture cannot be explained by likeness or similarity alone.* The biggest difference between a likeness and a picture is that in similarity we have two things, or two phenomena, that resemble one another, while in picturing we have *one* individual or phenomenon presented in two different ways.[15] So the "sad" music might be similar to my sad emotion, but that doesn't explain how the music works as a picture. It only says that between these two phenomena, my emotion and the music, there is resemblance.

Music pictures like any other mimetic art pictures: by presenting the form of something in a different medium. So what form does it re-present? Oesterle provides this succinct and perhaps startling response: what music pictures, at its best, is "the subordination of the emotions to reason."[16] An emotion is a sensory response to some sensible good or evil in the world. When we make a decision to act upon an emotion—by choosing not to give in to feelings of jealousy, say, or by choosing to act upon a feeling of righteous anger in the cause of justice—our emotions come under the sway of reason and thereby become a component

14. I am quoting from Roger Scruton's discussion of Peter Kivy's views on music in Scruton's *The Soul of the World* (Princeton, NJ: Princeton University Press, 2013), 160. Scruton refers in particular to Kivy's *The Corded Shell: Reflections on Musical Expression* (Princeton, NJ: Princeton University Press, 1981).

15. In this paragraph I am drawing again upon Sokolowski, "Picturing," 5.

16. Oesterle, "Toward an Evaluation of Music," 333.

of the virtuous actions necessary to achieve happiness—the very actions that are so central to the Catholic imagination.

What music pictures is not so much a person or a thing moving in physical space as an *experience* moving, being *enacted*, in intellectual-emotional space.[17] Though he does not use the language of picturing, Pieper formulates well the attractive immediacy and intimacy of music's enactive mimesis:

> Since music articulates the immediacy of man's existential dynamism in an *immediate* way, the listener as well is addressed and challenged on that profound level where man's self-realization takes place. In this existential depth of the listener, far below the level of expressible judgments, there echoes—in identical immediacy—the same vibration articulated in the audible music.[18]

Sound is not all by itself a picture of the emotions coming under the sway of reason, any more than oil paint and canvas are, by themselves, a portrait of Winston Churchill. There is nothing sad in any of the three notes that make up the A minor chord. The medium of music—the medium of any mimetic art—requires structure, form, intelligibility, composition, if picturing is to be achieved. But when the three notes of the A minor chord are put in harmony, something magical happens: an intellectual-emotional movement is experienced. But how? There does seem to be something to the claim that the dynamic movement of music is *like* the dynamic movement of human emotion and action. But if there is such a likeness, it is a function of

17. Sometimes music will attempt to picture people and things moving in physical space, as Beethoven does in the fourth movement of his Sixth (*Pastoral*) Symphony, in which he mimics a thunderstorm. But this literal mode is only one possible mode of musical mimesis, and, most would agree, not its most important one. For all the literal picturing that goes in Beethoven's Sixth, Beethoven himself wanted it to be more about feeling than "painting." See "Beethoven's Sixth Symphony," Saskatoon Symphony, accessed March 30, 2023, https://saskatoonsymphony.org/beethovens-sixth-symphony/.

18. Pieper, "Thoughts about Music," 47.

picturing, of the re-presentation in notes and beats of the subordination of emotion to reason. Music is by its nature abstract, in the sense that it is not (usually) a very literal mode of picturing. So, analogously to what we do with certain kinds of abstract painting, with music we need first to establish it *as* a picture before we can begin to see similarities between it and our emotional life. Once we understand music as picturing, we realize that, while the subordination of emotion to reason does not always make a sound and certainly never occurs in four or five movements like a symphony, there is a resemblance between the dynamic movement of music and the dynamic movement of our interior lives.

It is an interesting question whether, from our earliest childhood, we intuit the pictorial nature of music in the same way that we intuit the pictorial nature of cartoons or bedtime stories. No one has to teach the child that the cartoon or bedtime story is a re-presentation of human action and emotion (even if animals or mythic beings are the protagonists), and it seems also that no one has to teach the child that music is a re-presentation of the very same things. The nature of the picturing is simply heard, in the sense of being immediately understood, which is not the same as saying that the child can clearly articulate what is heard.

Pianist Jeffrey Chappell gives a good example of music's ability to picture the "character" or the "quality" of a specific emotion as it moves under the sway of reason. In response to a student's question on his website regarding what it means for a musician to control the "character" of a phrase, Chappell explains:

> Character in music is expressed in sound by means of timbre (sound quality), dynamics (loudness), balance (relative simultaneous loudnesses), articulation (amount of connection between successive notes), tempo (speed), beat division (number

of counts per measure), and the amount of rubato (rhythmic flexibility).[19]

Chappell then applies this understanding to the Prelude in C Major from book 1 of *The Well-Tempered Clavier* by Bach, describing how to give this music "a profound, relaxed, serene character":

> Serene timbre would be one that is rounded and light.
>
> Serene dynamics would have no sudden contrasts, no big contrasts, and no strongly accentuated notes, and the level would be generally quiet.
>
> Serene balance would bring out more of the bass notes and less of the treble notes.
>
> Serene articulation would be legato.
>
> Serene tempo would be a slower tempo.
>
> Serene beat division would have fewer beats per measure. In this example, there are sixteen notes in each measure, therefore you could feel sixteen, or eight, or four, or two beats, or one beat per measure. Let's select two beats per measure because that is less agitated than the higher numbers.
>
> Serene rhythm would be flexible but not with a distracting amount of rubato.[20]

What Chappell provides in this prescription for bringing out the mimetic possibilities in Bach's prelude is the way in which the mimetic universal of "a profound, relaxed, serene character" directs the structuring of the piece. Chappell shows how the medium of notes and beats can be manipulated in certain ways (e.g.,

19. Jeffrey Chappell, "What is 'Character' in Music?" accessed July 6, 2022, https://jeffreychappell.com/pianist/q_c07.php.
20. Chappell, "What is 'Character' in Music?"

articulation of notes legato as opposed to staccato) so as to picture serenity.

MUSIC AS DRAMATIC ACTION

I will incline my ear to a proverb;
I will solve my riddle to the
music of the lyre.
 Psalm 49:4

Throughout my argument, I have been advancing the case that mimetic art is essentially narrative, a picturing of the theo-drama. As we listen to a piece of instrumental music such as the Bach prelude, however, we detect no protagonist, no obvious dramatic conflict. So how does it make sense to think of the Bach prelude, and instrumental music in general, as narrative?

Drama requires, first and foremost, a protagonist. Plato in his *Republic* speaks of "keeping company" with another human being as a metaphor for the experience of engaging with a work of mimetic art. On this metaphor, when we listen to music, it is as though we are keeping company with a "virtual person."[21] Who is this person? Not necessarily the composer. It may well be that the composer was attempting to express in the music a private emotional experience, but this need not be the case. Much less is there reason to identify this person with the musician or the ensemble of musicians. Instead, it is best to think of this virtual person as the unnamed protagonist of the music's story. This unnamed protagonist is pursuing a goal, though not one (typically) explicitly identified; he is undergoing an experience being musically enacted right in front of us, or rather *in us*, in identical immediacy

21. I owe to Halliwell, *Aesthetics of Mimesis*, 239, the reference to Plato's metaphor, at, e.g., *Republic* 10 (603b1), as well as the reference to a hearer's imagining a "virtual person" within a piece of music, 238. Halliwell, at 238n9, reports that the idea of a "virtual person" as the imaginary subject of a piece of music has been advanced in experimental psychology by R. Watt & R. Ash, "A Psychological Investigation of Meaning in Music," *Musicae Scientiae* 2, no. 1 (Spring 1998): 33–53.

with our own intellectual-emotional lives.[22] In Kendall Walton's winning metaphor, "music provides the smile without the cat—a smile for the listener to wear."[23]

We have spoken about stories picturing human action using a special brand of mimetic causality that Aristotle calls "the probable or the necessary." Something analogous can be detected in music. "In successful works of music," Roger Scruton reflects, "there is a reason for each note, though not necessarily a reason that could be put into words. Each note is a response to the one preceding it and an invitation to its successor."[24] There is what Scruton terms a "virtual causality" at play in music, an unfolding purpose to the sound, *as though a mind is working something out.* "Real music," observes Scruton, "is not a sequence of mechanical movements but a continuous *action*, to which the 'why?' of interpersonal understanding applies."[25] This is a striking contention. Scruton seems to mean that even in the wordless music of Bach's Brandenburg Concerto no. 3 or Beethoven's Quartet op. 95 there is a picturing of a mind in motion, a *mind acting*, so that it makes perfect sense to ask of the music the same question we would ask of a friend whose action has not yet unfolded its intelligibility: "*Why* are you acting in the way you do?"

Consider the opening of Beethoven's Quartet op. 95. Fred Everett Maus has broken down the first eighteen measures of this extraordinarily demanding piece into three parts. The opening two measures consist of "an abrupt inconclusive outburst." After a beat of silence, measures 3–5 present "a second outburst in response, abrupt and coarse in its attempt to compensate for the first." Finally, in measures 6–18, we hear "a response to the first two actions, calmer and more careful, in many ways more

22. "Listening is in some deep way like being in the presence of, and in communication with, another person, though a person known only through the selfhood that is in some way breathed through the musical line" (Scruton, *Soul of the World*, 166).

23. Kendall Walton, "Listening with Imagination: Is Music Representational?" in *Music and Meaning*, ed. Jenefer Robinson (Ithaca, NY: Cornell University Press, 1997), 80.

24. Scruton, *Music as an Art* (London: Bloomsbury Continuum, 2018), 81.

25. Scruton, 81.

satisfactory."[26] Notice the way in which Maus describes the music in these eighteen measures. We have an *abrupt outburst*, followed by *a second outburst in response*, which in turn is followed by *a calmer and more considered response to all that has come before.* Just as Scruton does in talking about music in general, Maus describes these first eighteen measures of Beethoven's piece in terms of intention and action, in fact several actions, as though we are listening to two (or perhaps three) minds in conflict with one another. And notice: the point of these actions in the first eighteen measures is to bring an outburst of emotion under the sway of reason in the form of "a calmer and more considered response to all that has come before."

About pure or "absolute" music, Scruton touches upon the same point:

> In the case of what was once called "absolute music," there is no way of completing the description of its 'aboutness.' It is about nothing in particular, or everything in general, depending on how you look at it. There is no specific story about human life that is the story of Beethoven's C-sharp Minor Quartet. But in some way all human life is there. The music is not merely an intricate form that is pleasurable to listen to: it contains a soul, and that soul addresses us in the most serious of accents.[27]

What this comment helps us see is that the mimetic, narrative content of instrumental music, such as the Bach prelude or Beethoven's C-sharp Minor Quartet, is *in the composition itself*, not in some extramusical narrative connection. The "soul" or virtual person with whom we look to keep company as we listen to the music is "there" in the notes and beats. There is no *specific* story, as Scruton rightly says, in a piece of "pure" music. We don't know

26. Fred Everett Maus, "Music as Drama," in *Music and Meaning*, ed. Jenefer Robinson (Ithaca, NY: Cornell University Press, 1997), 105–30, 118. Like the authors cited earlier, Maus also invites us to think about music as presenting fictional "musical agents," 119n12.

27. Scruton, *Soul of the World*, 166.

the name of this virtual person with whom we are keeping company; we don't know specifically what he or she wants; we don't know the specific conflicts he or she is facing or has had to face. Yet there *is* a drama unfolding in the music.[28] At one point in T.S. Eliot's poem "The Love Song of J. Alfred Prufrock," the emotionally stammering young man who is Prufrock imagines that a magic lantern has thrown his nerves in patterns on a screen. This is not a bad image for what happens when we listen to music, whether purely instrumental or accompanied by lyrics. It is as though someone's "nerves," some soul's emotional life, has been by a magic lantern thrown, not upon a literal screen, but upon the "screen" of our, the audience's, auditory imagination. What is naturally interior to a person's soul has been turned inside out so that we experience a musical *enactment* of living and moving emotion, one that forges an immediate isomorphic connection to our own emotional life, such that we live and move and are carried along by the music's emotional stream. And while it is a drama about "nothing in particular," as Scruton says, in that no dramatic situation is named, I wouldn't go so far as to say that a piece of "pure" music is about "everything in general." Not at all. There is a specific, though no doubt complex, emotional content in every piece of music, as we see indicated, for example, in Chappell's description of the Bach prelude as profound, relaxed, and serene.

The example of Beethoven's Quartet op. 95 helps underscore the point that music's mimesis, while dramatic, need not aspire to literal picturing or what we might call a "sound painting" of human beings and the natural world in general. Beethoven's Sixth (*Pastoral*) Symphony is an interesting case study in this regard. In obvious ways, the symphony is attempting to present a very

28. And for Scruton, the drama of music takes the form of an argument, as I have claimed is the case with all mimetic art: "The great works of music involve large-scale musical *argument*. They venture forth into difficulties and trials, which put their material to the test, so to speak, and show that melodic, harmonic, and rhythmical elements can be enhanced by trials" (Scruton, 173).

literal form of picturing. The titles of each of the five movements invite us to imagine episodes in a group outing to the country. In the original manuscript of the second movement, you can find Beethoven in his own hand directing the flute to imitate the voice of a nightingale, the oboe a quail, and the two clarinets a cuckoo. To be sure, this latter degree of literalness in sound-painting, the attempt to mimic nature like a voice impressionist, is not something Beethoven or most composers seek to do very often. It is a particular effect, one that contains its own pleasure, but not one that deserves to be counted among the very highest expressions of Beethoven's or any other composer's art. But apart from these birdsongs, Beethoven with the titles of the movements is inviting us to use this extramusical content as an aid in a particular type of mimetic enjoyment, one in which we have the delight of making more literal connections between the musical and extramusical content (cheerful rides, thunderstorms).

Still, in Beethoven's Sixth Symphony, the titles of the movements and other efforts at literal picturing do not do all the mimetic heavy lifting. Just as with any other piece of music, the central act of picturing is done by the music itself. True, without the titles, our understanding of the emotional journey of the piece might not be tied to a pastoral sojourn. But would it then be any less of an experience? Especially if we have given the piece the kind of attention that we see Fred Everett Maus giving to the much more challenging Quartet op. 95? We might not "get" that the cheerful feelings evoked in the first movement are meant to have anything to do with a ride out into the country, but we would still have the experience of "dancing" with the cheerfulness that is the core emotion of the music's drama.

MARKING THE MUSIC

The man that hath no music in himself,
Nor is not moved with concord of sweet sounds,
Is fit for treasons, stratagems and spoils;
The motions of his spirit are dull as night
And his affections dark as Erebus:
Let no such man be trusted. Mark the music.
 Shakespeare, *The Merchant of Venice* 5.1.83–88

I take from Scruton this metaphor of "dancing" when it comes to music. He sees dancing as the best description of our engagement with the "virtual person" that is a piece of music's intentionality.[29] Dancing to music is not always a metaphor, of course. Sometimes we literally dance to it. When we literally dance to music, the dancing itself is an exercise in enactive mimesis. As Scruton observes, dancing "involves the deliberate imitation of intentional activity located elsewhere than one's own body."[30] To be clear, the "intentional activity" imitated by dance is that of the music, not that of a dance partner, if there is one. But even when we are not literally dancing to music, argues Scruton, we still "dance" with it metaphorically insofar as we become sympathetic with its emotional through-line: "The person who listens to music is being led by it in something like the way a dancer is led by the music he or she is dancing to. Listening is in some deep way like being in the presence of, and in communication with, another person, though a person known only through the selfhood that is in some way breathed through the musical line."[31]

Whether our dancing to music is literal or metaphorical, the role of *sympathy* is all-important. About music Aristotle says, "Everyone feels a sympathetic response through the rhythms and melodies themselves, even apart from the words."[32] To engage

29. Scruton, 164–66.
30. Scruton, 164.
31. Scruton, 165–66.
32. This is Halliwell's translation of *Politics* 8.5 (1340a13–14), which is developed out of his analysis of the difficulties of the text. See *Aesthetics of Mimesis*, 244.

with a piece of music is to "feel with" it, to be "one in feeling" with its intentionality. All mimesis is a re-presentation of a single, albeit typically complex, action, and in listening to or literally dancing to music, we re-present the beginning, middle, and end of the music's emotional movement. This is most evident on the literal dance floor, where our bodies imitate the swirling, pumping motion of the waltz in three-quarter time or the more sensual bouncing and twisting of the latest pop hit. Even when we are just listening to music, there is still a mimesis, though not one that is always perceptibly physical (perhaps not even a light tapping of the foot). Nonetheless, as we listen, our emotions feel with, become one with, the emotional through-line of the music.

This sympathetic movement with music is an instance of our participation in that virtual moral action that in chapter 7 I argued makes a significant contribution to moral transformation. As we listen, we sympathize with what is "wanted" by the music, and in this act of sympathy, this *catharsis*, we become more inclined to want the same.[33] One act of listening, one dance, is not enough to change a person's character, for well or for ill. But a habit of listening to certain kinds of music will have an unquantifiable yet very real impact on how a person moves in the world outside the music. Our likes and dislikes, our pleasures and our pains, are directed and formed by that which we find attractive, and the special intimacy that is created by music's powerful enactive form of mimesis makes this subtle influence all the more potent.

We began this chapter by talking about music's power to bring us into intimate relationship with it. As Aristotle points out, there is a power in music denied to the visual arts. The visual arts are limited to conveying our emotional life by means of "signs,"

33. "Music offers us a pure aboutness that we can put to other uses, but which in its pure form has a kind of cleansing effect on the sympathetic listener: it opens us up to sympathy, though with nobody in particular, and speaks to us of another order of being than the one in which our embodied lives are trapped: an order of pure sympathy between subjects, without the encumbrance of an objective world" (Scruton, *Soul of the World*, 166). For myself, I would interpret this "cleansing" effect of music in light of my description of catharsis in chapter 7.

as Aristotle says.[34] I do not think we should take this to mean that the visual arts are merely instrumental signs. As we talked about in chapter 1, a painting or a sculpture is not merely an instrumental sign. Aristotle is indicating here, rather, an important difference in medium and manner of imitation. The inert nature of the medium of the visual arts, to borrow a term from the art of acting, can only "indicate" or "point to" the emotional line of the mimetic universal. It keeps us, the audience, at a certain distance. It cannot make the emotional line live and move inside us, as happens in the enactive mimesis of music. Make no mistake: the visual arts exert tremendous emotional power. But the art of music, along with other forms of enactive mimesis like drama and dance, enjoy an even more intimate isomorphic relationship with, and influence upon, our interior lives.

Which explains why we will probably want our playlist on that desert island and not a collection of sculptures.

34. See *Politics* 8.5 (1340a18–42). Halliwell translates and discusses the passage at *Aesthetics of Mimesis*, 240–49.

9

Poetry's Marvelous Inevitabilities

In a story's climax, a protagonist experiences a recognition and reversal that actualizes self-knowledge. As Aristotle explains this in the context of tragedy, he says a good climax comes about with a *marvelous inevitability*.[1] The dialectic of a story, in other words, arrives at its climax as though there is no other way things might have turned out, yet still in a way, a marvelous way, that the protagonist would never have predicted. The climax is marvelous not only because the protagonist would never have predicted it but also because the protagonist has turned and recognized, with an act of intelligence, a marvel, a truth, largely incommunicable, that uncovers both the protagonist's self and the world.

In canto 28 of the *Paradiso*, Dante experiences, in a recognition and reversal, the moment to which his entire adventure through hell and purgatory has been leading. In depicting it, Dante, now in his role as poet, deploys, not for the first time in the *Paradiso*, the image of a light reflected in a mirror:

> As when a torchlight shimmers from behind
> upon a man who sees it in a glass
> before he grasps it in his sight or mind,
> He turns around to see if it's the case
> and sees the glass has spoken in accord

1. See *Poetics* 9 (1452a1–11).

with what is true, as notes of music pace
With measure—so my memory will record . . .[2]

This is the image: a man turning around to the light he has caught shimmering in a glass. Now for what the image pictures:

I turned to look into her lovely eyes
 where Love once set the snare and drew the cord.
My own were seized then by a wondrous thing,
 by what that scroll of Heaven reveals to sight
 whenever you gaze deep into this ring:
I saw a point that shot out rays of light
 so keen, you have to shut your eyes before
 the searing brilliance of its radiant might.[3]

The woman with the lovely eyes is Beatrice, Dante's earthly beloved and now guide through heaven (at least until St. Bernard of Clairvaux takes over for the home stretch). Beatrice's eyes are the mirror. For an instant, in those lovely eyes, Dante catches a glimpse of a light. He turns toward the light, and then his own eyes are "seized" by "a wondrous thing." He sees a point from which rays of light shoot out so brilliantly that Dante must shut his eyes against their radiance.

This image of a luminous point, indivisible, without extension in space and time, is Dante's picture of God. In turning toward it, Dante finally turns away from the "mirror" that is his human, erotic love for Beatrice, "where Love once set the snare and drew the cord," and faces toward the Love that has now caught him: God himself. And in doing so, Dante has turned away from all those other "mirrors"—lower, created loves—which both foreshadow and distract from the Love that "moves the sun

2. Dante, *Paradise*, canto 28, lines 4–10. All quotations from the *Paradiso* are taken from the Anthony Esolen translation (New York: Random House, 2007).
3. *Paradise* 28.11–18.

and the other stars."[4] This is the reversal in which Dante finally recognizes his end. Significantly, in canto 33 of the *Paradiso*, the final canto of the *Commedia*, Dante's recognition of God and of himself experiences a last and unexpected deepening. As he gazes into "the heart of light" that is God, he suddenly sees three rings, the three persons of the Trinity, and in the second of the three circles, which is a "reflected radiance," as when a rainbow begets another rainbow, appears *la nostra effige*, "our effigy."[5] What Dante sees is the figure of a man. It is the figure of Christ, but Christ as the figure for the "in-God-ing" of human nature. In a way it is his own destiny that Dante sees in this "effigy," sees but does not achieve, for this is only a momentary vision, after which Dante, returned to this quotidian world, must take up his cross and begin his imitation of Christ anew, an imitation that will now include the imitation of his visions in poetry.

For Aristotle, "poetry" is story in a broad sense that includes epic poetry, tragic and comic drama, as well as lyric poetry. Poetry in the tradition of the theo-drama is not some quirky boutique in a corner of the cultural bazaar. It is the "tale of the tribe," the primary way in which a community achieves self-understanding. Here in the twilight of our progressive anti-culture, we have little use for epic heroism, nor for the divine backdrop that makes sense out of tragedy and comedy as classically conceived. By and large, we have reduced the category of "poetry" to those thin volumes of brief, gnomic expressions of individual consciousness that provide nourishment only for a very particular, almost entirely academic, subculture.[6] But Aristotle's understanding of story and Dante's quest for happiness invite us to renew our understanding of poetry, to reconnect it to the call to

4. Allen Tate, in "The Symbolic Imagination," offers a masterful reading of Dante's use of mirror imagery in the *Paradiso*, to which my approach to poetry in this chapter is deeply indebted.

5. *Paradise* 33.131.

6. No culture, in fact, whatever its condition of health, can exist without "poetry" understood in the broad sense of story. Later, in chapter 14, we will consider how, for us, "poetry" in this broad sense has been transmuted into cinema and television.

transform ourselves as players in the theo-drama. And in light of that invitation, a definition of poetry suggests itself. Poetry in the Aristotelian-Thomistic tradition of the theo-drama is the effort of capturing in highly condensed musical language the marvelous inevitability of a protagonist's recognition and reversal, as well as the simultaneous actualization of self-knowledge.[7] Let us explore how this definition works through a close reading of some poetry written by a man very much in tune with the Catholic imagination: the nineteenth-century British poet, Catholic convert, and Jesuit priest Gerard Manley Hopkins.

THE BLIGHT MAN WAS BORN FOR

Dante's journey manifests the paradoxical poetic logic that, as we have seen, drives the Catholic imagination: *the way up is the way down.* The Risen Christ Dante sees in the final moments of his vision is the goal of the human quest. The Risen Christ is also the most beautiful, most paradigmatic, most definitive picturing of the Catholic imagination. For Christ not only pictures but simply *is* the small things of this world taken up into and transformed by the Divine Intelligibility. But to get to Christ, whether in the working out of one's salvation or in the picturing of the human adventure in poetry, is not to ascend straightaway to the empyrean. First, one must go down, down to the small things of this world, the things that come to be and pass away, the things that are doomed to fail and die. Only by this harrowing way will we find, like Dante, a hallowing path upward to the mountain of purgation.

Dante's way down is, in the literal world of the poem, a journey through hell. On this journey, he is an observer of the effects

7. Stephen Fry, in his winsome book on how to write poetry, *The Ode Less Traveled* (New York: Gotham Books, 2006), defines poetry as "the concentration, or compression, of thought, feeling, and language into words with a rhythmic structure" (48). This definition is, while serviceable enough to get started with, still rather anemic insofar as it abstracts from any background account, let alone the theo-dramatic account, of the human story.

of others' sinfulness, of what it means to lose "the good of intellect." But he is not merely a spectator. He wouldn't be journeying through hell if he hadn't first found himself wandering in the dark wood of his own sin. He is in hell to look and learn and to begin his reeducation in Love and Truth. Not every poetic way down, however, will involve a poem's protagonist directly in the wayward choices that make up human sinfulness. On another kind of way downward, the poem's protagonist will simply experience the world, including the natural world, as it works out the consequences of the catastrophe of original sin. This is what we find in one of Gerard Manley Hopkins's most heartbreaking lyrics:

Spring and Fall
to a young child

Márgarét, áre you gríeving
Over Goldengrove unleaving?
Leáves, like the things of man, you
With your fresh thoughts care for, can you?
Ah! ás the heart grows older
It will come to such sights colder
By and by, nor spare a sigh
Though worlds of wanwood leafmeal lie;
And yet you *will* weep and know why.
Now no matter, child, the name:
Sórrow's spríngs áre the same.
Nor mouth had, no nor mind, expressed
What heart heard of, ghost guessed:
It ís the blight man was born for,
It is Margaret you mourn for.

A poet in the writing of a poem follows the Way of Affirmation through Images. But in the poem's protagonist, often though not necessarily the poet him- or herself, the poet often shows

us someone following, consciously or no, voluntarily or no, the Way of Rejection or Negation, in which the small things of this world show themselves incapable of satisfying the desire for perfect goodness.[8] Enter Margaret, the child-protagonist of Hopkins's lyric.

We plunge into her predicament *in medias res*. She is grieving, experiencing the passion associated with the loss of sensible goods. Margaret feels that special brand of melancholy we often feel when confronted by the beauties of autumn. "Goldengrove unleaving" produces in her a plaintive wistfulness for the good green things of this world that, strangely, become most glorious as they pass away. "Spring and Fall" proves how even a short poem can have a plot. Margaret's quest, long underway before the start of the poem, has been to enjoy, with all the innocence of childhood, the good such innocence is made for, a good she identifies, at least in part, with nature. She may be well aware, on an abstract level, that she is not actually living in the earthly paradise. But the fall of leaves has given her "fresh thoughts" a piquant sense of the reality that, even in Arcadia, death exercises a certain lordship.

Yet in these dying leaves, there is a mystery hidden. Is she ready to discover it? The middle way of Margaret's story is for her heart to grow older and to "come to such sights colder." This is the opposing value in her dialectic with her girlhood grieving. It is a kind of "dark wood": not Dante's dark wood of personal sin, necessarily; perhaps only a dark wood of complacency and obliviousness. Maybe Margaret has suffered, in regard to the natural world, an early-stage version of that loss of sovereignty that Walker Percy describes as so typical of our lives in the modern world, in which we sign over our lordship and mastery of creation to experts and their representations of things, the consequence being that we render ourselves unable to *see* reality

8. The Way of Affirmation through Images and the Way of Rejection, first mentioned in chapter 1, are terms taken from Charles Williams's *Figure of Beatrice*.

apart from their representations.[9] In any event, Margaret cannot see the green world anymore. She passes the ensuing autumns of her life and their "worlds of wanwood leafmeal" without sparing a sigh and so without discovering the mystery hidden in grief for the "unleaving." Again, her "dark wood" is not necessarily the wood of personal sin, but it resembles sin in being a form of forgetfulness. Forgetfulness of what? In order to discover that, Margaret's path must turn. Something must happen to take her off the road of complacency in the face of the dying natural world.

At this point in her predicament, Margaret is, in fact, in a far worse state than Dante is in canto 28 of the *Paradiso*. Dante, after all, is still very much able to see in the sense we are talking about. His sight still lingers upon Beatrice, to be sure, but it is precisely in gazing into Beatrice's eyes that he sees reflected the Light that has been drawing him on. He is "alive" to the mysteries hidden in small, created things. Margaret's turn, if she ever makes one, will, first, have to be back toward those small, created things. Only after attending closely to *them* will she make herself ready to see something far more important flicker in their mirrors. The narrator of Margaret's story turns prophet: "And yet you will weep and know why." He predicts that Margaret will turn back and grieve again.

But what will cause her to turn back to the natural world

9. See Walker Percy, "The Loss of the Creature," in *The Message in the Bottle* (New York: Farrar, Straus and Giroux, 1975), esp. 56:

> The same is true of the layman's relation to *natural* objects in a modern technical society. No matter what the object or event is, whether it is a star, a swallow, a Kwakiutl, a "psychological phenomenon," the layman who confronts it does not confront it as a sovereign person, as Crusoe confronts a seashell he finds on the beach. The highest role he can conceive himself as playing is to be able to recognize the title of the object, to return it to the appropriate expert and have it certified as a genuine find. He does not even permit himself to see the thing—as Gerard Hopkins could see a rock or a cloud or a field. If anyone asks him why he doesn't look, he may reply that he didn't take that subject in college (or he hasn't read Faulkner).

For more on the alienating effect of technological expertise and the way in which its representations keep us from seeing reality for ourselves and realizing our full personhood, see Matthew Crawford's most insightful *The World Beyond Your Head: On Becoming an Individual in an Age of Distraction* (New York: Farrar, Straus and Giroux, 2015).

and really see it? The poet only hints at the cause of Margaret's climactic turning point:

> Nor mouth had, no nor mind, expressed
> What heart heard of, ghost guessed.

From these lines we are left to surmise that no one will tell Margaret the nature of the mystery hidden in her childhood grief. What no mouth or mind will express, her heart will hear of; her "ghost," or mental insight, will guess. Margaret will eventually, based on no more, presumably, than further ordinary experience of sorrow, *recognize* the reason why she, as a girl, grieved the fallen leaves in autumn—and other losses as well. "Sórrow's spríngs áre the same." Whether it is the colorful leaves drifting to their demise, or the loss of loved ones, or dreams deferred or even defeated, all of these sorrows have the same root. That is the first part of her recognition. The second part is the root itself:

> It is the blight man was born for,
> It is Margaret you mourn for.

What Margaret ultimately will recognize is that in grieving fallen leaves and other losses, she has actually been grieving her own mortality, a mortality rooted, whether she knows it or not, in original sin, "the blight man was born for." What does it mean to say that man was born *for* this blight? We are born in original sin, but we are not born *for* it as an end. Presumably, the poet means that we are *born into* a state of original sin as a blight, or catastrophe, one that Margaret will recognize again, not as something that has happened "outside" of her and in the past but is still happening "inside" of her. She will recognize that, like Oedipus, she, in a certain sense, *is* the plague.

THE TRAGIC BEAUTY OF "SPRING AND FALL"

The specter of Oedipus reminds us that the genre of Margaret's story, at least the part contained in this poem, is tragedy. Despite how it may seem, this is not out of keeping with the Catholic imagination. For although that imagination is ultimately comic in its trajectory, it does not disdain or pass over the fact that, on the natural level and unaided by grace, human nature cannot realize its highest aspirations. It must end in tragedy. Robert Lynch defines the tragic image as that which "moves down into the most finite moments of the finite: it discovers its most limited points."[10] The images of fallen leaves and of fallen Margaret in Hopkins's lyric probe the most limited point of the human condition: that it cannot overcome finitude by acts of will, and thus that it is doomed to die. True, compared to, say, Oedipus's and Macbeth's tragedies, Margaret's tragedy is very small. Whatever the details of her middle way, it does not seem to be characterized by the level of hubris, the sound and fury, that we find in the great tragic protagonists.[11] Nonetheless, her tragic recognition is, like both Oedipus's and Macbeth's, mournful of human finitude. Perhaps she would not go so far as to say, with Macbeth, that it signifies "nothing." But she does see human nature as blighted, and the poem ends without offering any consolation, without any hope that the blight can be repaired.

And in this is the poem's particular beauty—as well as the source of its austere form of catharsis. Tragedy, when it is really achieved, as Lynch argues, "produces an extraordinary impact of beauty and exaltation in the spectator." This achievement of tragedy, he continues, "has always occurred when the dramatic text has allowed itself to move through human time to the very

10. Lynch, *Christ and Apollo*, 92.
11. See Lynch's fine commentary on *Oedipus* and *Macbeth* and other Greek and Shakespearean tragedies at *Christ and Apollo*, 95–98.

last point of human finitude and helplessness."[12] Such an achievement belongs to Hopkins in "Spring and Fall."

To see how, consider first that the poem's beauty consists in the fact that it is a compositional whole, that it gives us a complete thought in the form of a story with a beginning, middle, and end. It is the story of Margaret's solution to the mystery hidden in her childhood grief over autumn leaves, and its Controlling Idea, which only communicates in a limited way what is largely incommunicable, is that *the spring of all sorrow is found in grief over our own mortality.*

The poem also manifests proportion, the intelligible relationship between parts, in a number of different ways: for example, in its use of rhyming couplets, its play on the multiple senses of "leaves," and in its joining of words into the delightful neologisms *wanwood* and *leafmeal.* Catherine Phillips suggests that *wanwood* might come from "wann," the Old English word for "dark," though she prefers the associations suggested by "wan," pale from fatigue or sorrow. And as for *leafmeal,* Phillips opines that the word is a more specific version, happy indeed, of "piecemeal."[13]

Finally, "Spring and Fall" manifests clarity or radiance, firstly in the way in which its sensible forms shine brightly to the senses (that wonderful image, both visual and auditory, of crushed and decomposing leaves upon the ground: *leafmeal*); and secondly in the way in which its intelligible form "shines forth brightly" to the intellect by manifesting levels of meaning. All four levels of meaning—literal, moral, allegorical, and anagogical—radiate from this poem. On the literal level, a little girl grieves over the

12. Lynch, 94.

13. *Gerard Manley Hopkins: A Critical Edition of The Major Works*, ed. Catherine Phillips (New York: Oxford University Press, 1986), 366. In his *Journals*, Hopkins makes an exercise in close noticing of the fall of autumn leaves: "Wonderful downpour of leaf: when the morning sun began to melt the frost they fell at one touch and in a few minutes a whole tree was flung of them; they lay masking and papering the ground at the foot. Then the tree seems to be looking down at its cast self as blue sky on snow after a long fall, its losing, its doing" (quoted by Phillips in *Hopkins: The Major Works*, 366).

beauties of autumn. On the moral level, Margaret's sense of loss is a symptom of her caring, a virtue that, the poet predicts, will cool as she grows older but then return. Allegorically, Margaret's grieving pictures the tragic consequences of the fall of man. Due to the fall, the season of fall brings grief because it is an intimation of human mortality. And on the anagogical level, in regard to what the poem is saying about eternal life, Margaret's grieving is a type of that grief that is cut off from Christ forever. The moral, allegorical, and anagogical meanings are most radiant at the moment of recognition and reversal: "It is Margaret you mourn for." Here we recognize, with Margaret, the tragic, blinding, marvelously inevitable truth that reverses the trajectory of her complacency to the mystery of human finitude.

SAND AND WELL WATER

"Spring and Fall" shows us the way down but does not show us the way up. Hopkins's greatest poetry, however, is intent on the reversal in which the poem's protagonist recognizes that tragedy does not have the final word. I want to consider as a miniature of this kind of comic climax stanza 4 of Hopkins's magnum opus, "The Wreck of the Deutschland," an ode, as Hopkins calls it, written to "the happy memory of five Franciscan nuns, exiles by the Falk Laws, drowned between midnight and morning of Dec. 7th, 1875."[14] Before turning to that verse, however, let me say a word about "The Wreck of the Deutschland" as a whole.

According to one of Hopkins's most sensitive interpreters, Peter Milward, SJ, "The Wreck of the Deutschland" "was a truly

14. For directing me to the importance of this verse as a kind of synecdoche of Hopkins's poetics, as well as for a perceptive reading of these lines, I am indebted to Seamus Heaney's essay "The Fire i' the Flint: Reflections on the Poetry of Gerard Manley Hopkins," originally the Chatterton Lecture on an English Poet given at the British Academy, December 1974, and reprinted in Heaney's *Preoccupations: Selected Prose 1968–1978* (New York: Farrar, Straus and Giroux, 1980), 79–97. The quoted description of the poem is that included by Hopkins himself. The "Falk Laws," also known as the "May Laws," were penal measures against Catholics that were part of Bismarck's *kulturkampf* with the Catholic Church in the 1870s.

revolutionary poem in the history of English literature," revolutionary in its Controlling Idea, its diction, its play with syntax and grammar, and in its rhythm. The poem was so revolutionary that it baffled the editors of a Jesuit journal, *The Month*, who rejected it. The poem was never published in Hopkins' lifetime. It was published after his death, as was almost all Hopkins's poetry, by the generous agency of Hopkins's close friend and fellow poet Robert Bridges.

On the literal level, "The Wreck of the Deutschland" concerns the death of five Franciscan nuns. But on the moral level, as Milward argues, it concerns a metaphorical shipwreck in Hopkins's own life and thus pictures a man's efforts at detachment from earthly loves:

> This is a poem not just about what it seems to say, the shipwreck of the *Deutschland* with the consequent drowning of the five nuns, but also about the metaphorical shipwreck that had taken place in the poet's own life on the occasion of his conversion to the Catholic Church in 1866 and his subsequent vocation to the Society of Jesus, which he entered in 1868. It was a shipwreck of his human attachments to his family in London, to his Church at Oxford, to his ties with his many Anglican friends, to his intellectual promise and his poetic ambitions. So what he saw in the experience of the drowning nuns . . . he had already undergone in his own experience.[15]

With this description in mind, we can now approach verse 4 of the poem alive to its moral meaning but also on the lookout for allegorical and anagogical meanings:

> I am soft sift
> In an hourglass—at the wall
> Fast, but mined with a motion, a drift,

15. Peter Milward, *A Lifetime with Hopkins* (Naples, FL: Sapientia, 2005), 120.

And it crowds and it combs to the fall;
I steady as a water in a well, to a poise, to a pane,
But roped with, always, all the way down from the tall
Fells or flanks of the voel, a vein
Of the gospel proffer, a pressure, a principle, Christ's gift.

The demanding nature of "The Wreck of the Deutschland" is on full display in this one stanza, so let us take it slowly. The first four lines present the image of an hourglass, a standard image of time's passing and human mortality. Hopkins the protagonist sees himself as the sand in this hourglass, "soft sift," apparently held fast to the glass wall of the hourglass, but in actuality, as is always the case with the Catholic imagination, being "mined with a motion, a drift." His natural destiny, as with Margaret's, is downward; according to sin's gravity, his motion "crowds and combs to a fall."[16] The movement of the sand downward, as Milward comments, "is but the outward manifestation in time of a *fall* that has already taken place in the human spirit. . . . It is because human nature has fallen into sin that it combs to the fall of decay and death in the course of time."[17] "Deutschland" as a whole gives us something more about the beginning and middle of the poet's journey, but these first four lines of stanza 4 are wholly devoted to the "fall," the tragic end of that journey.

But death's dominion, in the deeper supernatural outlook of this poem, is limited. In the last four lines of the stanza, another

16. Peter Milward, whose fine reading of the verse I am also indebted to, sees a secondary image in these first four lines:

> Here, too, is implied a further image of a boat drawn up on a sandy shore and attached by a rope to the sea wall, yet "mined with a motion" as the waves break around it and draw the sand from beneath its keel. Of these two images the former [the hourglass image] is predominant, with the explicit mention of "an hourglass" whereas the latter is implicit in the description following the dash. In either case there is a strong rhythmic emphasis on "the fall," suggestive both of the poet's own sinking feeling at heart and of the further theological associations with the original sin of Adam, or Fall of Man, which prevails over all natural life. (*Landscape and Inscape: Vision and Inspiration in Hopkins's Poetry* [London: Elek, 1975], 22)

17. Peter Milward, *A Commentary on G.M. Hopkins' "The Wreck of the Deutschland"* (Tokyo: Hokuseido, 1968), 32.

image reveals that Hopkins's journey is capable of unexpected fulfillment. This second image is that of Hopkins "steady as a water in a well." Water in the biblical context is often a symbol of death, yet it is also capable, as in the story of Jesus's meeting with the Samaritan woman at the well, of being a symbol of new life. Hopkins describes himself as peacefully poised, comparing the stillness of himself as water to the glass of a windowpane. But how is such peacefulness achieved? On the literal level of the image, the well exists ultimately by virtue of the rain, which falls upon the hills and, from there, flows down upon the lowest reaches of the earth. The water in the well is "roped with," the word "roping" being a word Hopkins often uses in his *Journal* to describe the downward flow of a mountain stream.[18] The hills are the "tall / Fells" and the "flanks of the voel" (a voel being a Welsh word for a small hill).[19] The well exists because water has fallen in the form of gentle rain from heaven, which, after its downward journey, rises up again through the earth as a spring.

This gentle rain droppeth indeed as an image of "the quality of mercy." For Hopkins, it is "a vein / Of the gospel proffer, a pressure, a principle, Christ's gift." Milward explicates Hopkins's use of the word "vein" as follows: "Its primary reference is to the veins of blood which bring life and nourishment to every part of the human body; and thence it is applied to the veins on a leaf, the veins of a rock that is cleft in twain, and the veins of the earth or streams of water. The Gospel is thus compared to a source of everlasting life which irrigates the spirit of man, as veins irrigate the body or streams irrigate the earth."[20] Seamus Heaney notes how Hopkins's use of "proffer" neatly inverts the word's usual function as a verb into that of a noun. For Heaney, in making the

18. Milward, *Landscape and Inscape*, 22: "This equilibrium [of the water in the well], he goes on to emphasize, is not self-sufficient, but derived from the continual supply of water (a traditional image of divine grace) coming down from above, or 'roping'—as Hopkins often describes the downward flow of a mountain stream in his *Journal*."

19. Heaney, "Fire i' the Flint," 89.

20. Milward, *Commentary on G.M. Hopkins' "The Wreck of the Deutschland,"* 34.

Gospel a "proffer," "with its suggestion of urgency and obligation to accept," Hopkins makes the action of the Gospel so much more alive than if he had used "offer."[21] Milward in turn reads "proffer" as emphasizing the Gospel as "a free gift of God, offered to man for his free acceptance."[22] The "gospel proffer" puts downward pressure on the earthen vessel that receives it, while also serving as the principle of its equilibrium. Heaney neatly summarizes how the downward trajectory of the verse's first four lines becomes, in the dialectic of the stanza, the way up in the last four lines:

> It works like this. The streaming of sand is faded into the downpour of streams on the fells or flanks of a hill, and what had been at the bottom a sinking becomes a source, because this downing motion from above sustains, and rises as, a spring. So that suddenly the downing motion of Christ, his dark descending, becomes not something to make the soul sink in a quicksand of terror but to steady and be sustained by descending graces.[23]

Heaney's analysis serves as a fine précis of the beauty contained in just this stanza: the integrity or completeness of its narrative, as tragedy is transformed into comedy; the proportion of its parts, as the image of sand in an hourglass stands in ordered juxtaposition with water in a well; and the clarity or radiance of its images, as the sensible forms of sand and water radiate their moral, allegorical, and anagogical meanings: moral, in that the water in the well images Hopkins's soul as filled with grace; allegorical, in that the water in the well images "Christ's gift," Christ's salvific action for all people; anagogical, in that the water in the well images the grace that "wells up to everlasting life" (John 4:14).

21. Heaney, "Fire i' the Flint," 89.
22. Milward, *Commentary on G.M. Hopkins' "The Wreck of the Deutschland,"* 34.
23. Heaney, "Fire i' the Flint," 89–90.

THE WINDHOVER

For a more extended look at Hopkins's poetic discovery of "the way up" through delight in what he called, borrowing from the medieval theologian Duns Scotus, *haecceitas*, the "this-ness" of the particular, finite being, let us turn to what is perhaps Hopkins's most famous sonnet, and certainly one of his most beautiful and moving achievements, "The Windhover," dedicated "to Christ our Lord."[24]

> I caught this morning morning's minion, king-
> > dom of daylight's dauphin, dapple-dawn-drawn Falcon, in
> > his riding
> > Of the rolling level underneath him steady air, and striding
> High there, how he rung upon the rein of a wimpling wing
> In his ecstasy! then off, off forth on swing,
> > As a skate's heel sweeps smooth on a bow-bend: the hurl
> > and gliding
> > Rebuffed the big wind. My heart in hiding
> Stirred for a bird, – the achieve of, the mastery of the thing!
>
> Brute beauty and valour and act, oh, air, pride, plume, here
> > Buckle! AND the fire that breaks from thee then, a billion
> Times told lovelier, more dangerous, O my chevalier!
>
> > No wonder of it: shéer plód makes plough down sillion
> Shine, and blue-bleak embers, ah my dear,
> > Fall, gall themselves, and gash gold-vermilion.

The sonnet is divided into an octet (the first eight lines) and a sestet (the final six lines). In the octet, we are taken inside the

24. As Peter Milward tells us in his commentary on "The Windhover": "The poem is dated 'St. Beuno's, May 30, 1877.' In a letter to [Robert] Bridges, of June 22, 1879, Hopkins describes it as 'the best thing I ever wrote.'" St. Beuno's College, in North Wales, is where Hopkins studied theology while preparing for ordination. Milward, *A Commentary on the Sonnets of G.M. Hopkins* (Chicago, IL: Loyola, 1969), 35.

experience of Hopkins's delight in the sensible beauty of "morning's minion," a windhover or kestrel (a small falcon) "striding / High there" in the air above his head. The morning is the kingdom of this bird, which is called daylight's "dauphin," a medieval French word for the crown prince—an allusion that suggests, quite apart from the dedication of the poem, that the bird images Christ. Hopkins calls the bird, as Milward observes, "not by the common names of hawk or kestrel, but by the more aristocratic French-derived name of 'falcon,' with a capital F as though to indicate a personal, and even divine, significance."[25] The metaphor of chivalry runs through the poem until the final three lines of the sestet, a metaphor that is read by Marshall McLuhan in the following way: "To a member of a militant religious order [the Jesuits] whose founder was a Spanish soldier or chevalier, the feudal character of the opening imagery is quite natural. 'Minion,' 'dauphin,' 'valour,' 'plume,' and 'buckle' alike evoke the world of dedicated knighthood and shining panoply of armor."[26] Milward adds to this reading that Hopkins "sees the bird as bestriding the air beneath him like a skillful horseman controlling his horse. The air is at once rolling and yet level and steady beneath him, as he rides high and erect in the saddle."[27]

Hopkins's close and rapturous observation of the bird's flight feeds our own senses and allows us easily to understand how Hopkins's heart "Stirred for a bird" when he gasped at "the achieve of, the mastery of the thing!"

The sestet begins with a litany of qualities of the bird: "Brute beauty and valour and act, oh, air, pride, plume." These qualities are then strangely followed by the words "here / Buckle!" What is referred to by "here," and what does it mean to "buckle"?

25. Milward, *Commentary on the Sonnets of G.M. Hopkins*, 35.

26. Marshall McLuhan, "The Analogical Mirrors," in *The Interior Landscape: The Literary Criticism of Marshall McLuhan, 1943–1962* (New York: McGraw-Hill, 1969), 69.

27. Milward, *Commentary on the Sonnets of G.M. Hopkins*, 35. In this same comment, Milward wonders whether Hopkins may be recalling the Dauphin's praise of his horse in Shakespeare's *Henry V* 3.7: "When I bestride him I soar, I am a hawk; he trots the air."

McLuhan guides us to the medieval context: "Buckling is the tra-ditional gesture of the knight preparing his armor for action. A buckler is the bright shield of defense bearing insignia, flashing defiance."[28] And "here," for McLuhan, means "in the obedient and humble heart."[29] So, McLuhan concludes, in the lines "Brute beauty and valour and act, oh, air, pride, plume, here / Buckle!" the poem argues that "the 'brute beauty' of the bird as mirror of God's grandeur is to be transferred or flashed to the 'heart in hiding,' just as [in the last three lines of the poem] the burnished surface of the plow in action is hidden in the earth."[30] In brief, the beauty of the bird prepares the hiding heart for defiant ac-tion—action soon to be associated in the poem with the "cheva-lier," Christ.

Before we come to that association, however, observe that not least in the litany of the bird's beauty is "act." Though not capable of action of the most intelligent kind, lower animals are capable of exercising, as Aquinas argues, a certain kind of intelligent ac-tion piloted by the estimative sense. Like us, the lower animals live out a drama of sorts, pursuing the goods that make up their fulfillment, one of which, as we see in this windhover, is the "ec-stasy" of play, "rung upon the rein of a wimpling wing."

But then, after the capitalized conjunction "AND," Hopkins dialectically reverses the trajectory of his contemplation as he rec-ognizes that the bird is not only a kestrel. The bird is also Hop-kins's "chevalier," his knight, his lord. The windhover is Christ, whose qualities are "a billion / Times told lovelier, more danger-ous" than the beautiful and noble qualities found in the bird. The final three lines of the poem are a curious extension of this recognition. They meditate on the simple, definite actions in this world that radiate the *claritas* of Christ. A ploughman makes a

28. McLuhan, "Analogical Mirrors," 69.
29. McLuhan, 69.
30. McLuhan, 69–70.

"sillion," a strip of arable land, "Shine" precisely because of his plodding, just as dying embers break into "gold-vermilion" only when they "fall, gall themselves." These images picture divine radiance breaking into this world at the point where the humble thingness of things is evident: when the farmer must plod to break the soil, when the almost glasslike fragility of the spent coal breaks into glowing pieces, and when, Hopkins would have us include, a falcon breaks across the air in its morning ride.

SAVORING AND HEARING POETIC ARGUMENT

I would like to close these reflections on poetry in general and Hopkins's poetry in particular with a word about the material form of poetry, by which I mean the tactile and musical character of poetic language. We are not genuinely engaging with Hopkins's poetry, or with any other poetry, if we are not also savoring in our mouths the particular words and concatenations of words used by the poet, as well as listening to the music that the words make. The taste and music of words comprise the medium of the poetic art and can no more be separated from the poem than can the mimetic universal that actualizes the poem as its "soul." They make a substantial unity. In his essay on Matthew Arnold, T.S. Eliot describes what he means by the "auditory imagination": "the feeling for syllable and rhythm, penetrating far below the conscious levels of thought and feeling, invigorating every word."[31] Eliot indicates here that part of what makes for great poetry, and part of what is needed for us to be the appreciators of great poetry, is a sensitivity to the feeling and rhythm of words, a sensitivity that yields meanings that elude the abstractions captured by prose. Tasting and listening to a poem's language and rhythm is not ancillary to appreciating the poem's argument but integral to it.

Eliot affirms this when he writes that poetry "attempts

31. T.S. Eliot, "Matthew Arnold," in *The Use of Poetry and The Use of Criticism* (London: Faber & Faber, 1959), 118–19.

to convey something beyond what can be conveyed in prose rhythms,"[32] and also when he remarks that genuine poetry "communicates before it is understood."[33] What else could such communication consist in but communication by means of the poem's language and music? Yes, but the poem's language and music *formed by* the levels of meaning embodied in the poem's diction and rhythm. Let us conclude our consideration of poetic mimesis by concentrating especially on how music works as part of poetic argument.

The question of how music can communicate meaning is a question that should by now be familiar, as we encountered it in our discussion of the music made, not by words and rhythm alone as poetry's is, but by singing and by instruments. Nonpoetic music pictures the emotional dynamism of our quest for happiness and the finding of it, or the reverse. In a similar way, poetry ventures out onto those "frontiers of consciousness beyond which words fail, though meanings still exist."[34]

In verse 4 of "The Wreck of the Deutschland," Hopkins continues the set rhythm that runs throughout the first part of the poem, a rhythm he explains in a letter to his friend R.W. Dixon: "I had long had haunting my ear the echo of a new rhythm which now I realized on paper. To speak shortly, it consists in scanning by accents or stresses alone, without any account of the number of syllables, so that a foot may be one strong syllable or it may be many light and one strong."[35] In another explanation of the poem's meter, Hopkins advises his reader "strongly to mark the beats of the measure, according to the number belonging to each of the eight lines of the stanza, as the indentation guides the eye, namely two and three and four and three and five and five and four and

32. T.S. Eliot, "The Music of Poetry," in *On Poetry and Poets* (New York: Farrar, Straus and Giroux, 1969), 23.

33. T.S. Eliot, "Dante," in *Selected Essays* (New York: Harcourt, Brace, 1950), 200.

34. Eliot, "Music of Poetry," 23.

35. The letter is quoted in Catherine Phillips's notes to "Deutschland" in *Hopkins: The Major Works*, 334.

six, not disguising the rhythm and rhyme, as some readers do."[36]
In the following presentation of verse 4, I put in boldfaced type
the syllables where the stresses fall according to this scheme:

> I am **soft sift** (2)
>
> **In an hourglass—at the wall (3)**
>
> **Fast,** but **mined** with a **mo**tion, a **drift,** (4)
>
> **And it crowds and it combs to the fall;** (3)
>
> I **stead**y as a **wa**ter in a **well,** to a **poise,** to a **pane,** (5)
>
> But **roped** with, **always, all** the way **down** from the **tall** (5)
>
> **Fells** or **flanks** of the **voel,** a **vein** (4)
>
> Of the **gos**pel **prof**fer, a **pres**sure, a **prin**ciple, **Christ's gift.** (6)

It is easy to imagine hearing this verse for the first time, per-
haps especially without seeing it also on the page but just listening
to it, and not understanding much if anything at all. One would
then be in a good position to test Eliot's claim that genuine po-
etry communicates before it is understood. What does Hopkins's
rhythm communicate? Of course, we don't savor in the sounds or
hear in the stresses themselves sands in an hourglass or still water
in a well. What we hear, first of all, is a declaration of identity in
the melancholy sibilants "soft sift," a susurrus that hints of some-
thing, apparently or lately at rest, beginning to move. Whatever
it is holds on "fast," but the ensuing alliteration of "mined with a
motion" indicates a jostling, a shaking up, a physical movement
apparently downward, indicated by the elegiac swing of the three

36. Quoted by Phillips in *Hopkins: The Major Works*, 335. This is all the further I will ven-
ture into the baroque intricacies of Hopkins's theory of "sprung rhythm." Hopkins endeavors
to make his theory plain in the "Author's Preface" he wrote to an unpublished collection of his
poems, but I can make little of his explanation. See *Hopkins: The Major Works*, 106–9. To my
knowledge, Yvor Winters and Paul Mariani have made the bravest attempts to make Hopkins's
theory clear: see Winters's "The Poetry of Gerard Manley Hopkins," in *On Modern Poets* (New
York: Meridian, 1959) and Mariani's *A Commentary on the Complete Poems of Gerard Manley
Hopkins* (Ithaca, NY: Cornell University Press, 1970), Appendix B. Marshall McLuhan declares
that Hopkins is full of pitfalls for the unwary, one of which is his theory of prosody, which
McLuhan deems "irrelevant" ("Analogical Mirrors," 63). I will simply note that Hopkins's music
is characterized by heavy use of stress and lots of alliteration, such as we find in the Anglo-Saxon
poem *Beowulf*.

anapests in the following line, finally hitting the ground with the final word "fall." Then, a starting again with "I steady," and another kind of holding on, "to a poise, to a pane," until another downward fall "always, all the way down from the tall / Fell or flanks of the voel." Then, in the final line, the strange word "proffer," functioning here, as Heaney notes, as noun rather than as verb and alliterative with "pressure" and "principle" like "three piston-strokes heightening the pressure down the line."[37]

The word that first comes to my mind to describe the music of this verse is *insistence*. The rhythm is not just steady: it is hard and relentless. The rough Anglo-Saxon consonants, the predominance of short lines with four stresses or less, and the heavy use of alliteration add to the overall impression of someone speaking with great energy and emphasis, of someone *needing* to say something. There is also a sense, to use a word often used by critics when discussing the music of poetry, of *incantation*: as though the words are part of an ancient ritual, made to summon a spirit, the sounds themselves being magical.

37. Heaney, "Fire i' the Flint," 89.

10

The Painted Argument

You are standing in the Contarelli Chapel in the church of San Luigi dei Francesi in Rome (St. Louis of the French). All three walls of the chapel feature oil paintings depicting the life of St. Matthew by the Baroque master Caravaggio (1571–1610). On the left wall is the particularly well-known masterpiece *The Calling of St. Matthew*. With a dramatic use of *chiaroscuro*—a technique involving bold contrasts of light and dark—a shaft of light breaks through a darkened room (of a house? of an inn?) and illuminates St. Matthew sitting among his comrades. The figures standing on the right also capture your attention. One is clearly Christ, whose finger points at Matthew in an attitude reminiscent of the finger of God bringing Adam to life in Michelangelo's Sistine Chapel ceiling. But there is an older figure standing next to Christ, his back mostly to the viewer, who with a bit of reading, you will learn to identify as St. Peter.

According to art historian Elizabeth Lev, *The Calling of St. Matthew* is paradigmatic of Catholic Counter-Reformation art. In an age of post-Reformation uncertainty, Caravaggio in effect took up his brush with the question "How to make the first fearful step of following Christ attractive or, better yet, captivating?"[1] His answer, says Lev, was to make conversion "look like love at first sight, the first fear of change immediately replaced

1. Elizabeth Lev, *How Catholic Art Saved the Faith: The Triumph of Beauty and Truth in Counter-Reformation Art* (Manchester, NH: Sophia Institute, 2018), 154.

with the compelling light of truth."[2] Yes. This is how you feel as you look up at the painting. You feel Matthew's surprise at being singled out by Christ but also the excitement that such a calling entails. In this way, the painting works on you, as it has worked on countless others over the centuries, as a mode of persuasion, *as an argument*.

Yet it works as a *painted* argument, which is both a very familiar and a very strange thing. The art of painting, as we first talked about back in chapter 1, is a literal instance of mimetic picturing, where the reality of human agents questing for their good in the theo-drama is re-presented in media such as oils, acrylics, tempera, and watercolors, not to mention charcoal and pastel crayons, as applied on paper, canvas, wood, glass, and other surfaces. We are used to taking paintings as "saying something," sometimes something quite controversial. Just think of the strong historical reactions to Michelangelo's *Last Judgment* from the Sistine Chapel, Picasso's *Guernica*, and Andy Warhol's *Campbell's Soup Cans*.[3] But though we naturally think of such pictures as speaking some truth about the human condition, we rarely pause to reflect on how strange it is that these images "speak" to us at all, much less in the form of arguments. How can something that is simply an image, no more than paint arranged upon a surface, not just speak but make an argument that can attract a viewer to the theo-drama?

"FOLLOW ME"

"Painters are men who have made their choice of a silent medium." So writes Étienne Gilson; and to underscore the point,

2. Lev, 155.

3. In this chapter the focus will be on painting, but almost everything that is said can also be applied to still photography. When it comes to still photography as the making of arguments, think of Neil Armstrong's photo of Buzz Aldrin's Apollo 11 moonwalk (July 20, 1969), and the AP photo of "Tank Man" featuring the brave Chinese citizen standing in front of his own country's tanks on the day after the Tiananmen Square Massacre (June 5, 1989). Which is not to say, however, that there is no difference between painting's mimesis and photography's mimesis.

he goes on to quote a letter that Delacroix wrote to his friend George Sand after some of Delacroix's paintings had been praised by a critic: "If it were not about myself that all this has been said (forgive the modesty), I would tell you that it is just too bad for the kind of painting that makes people see so many things. The beauty of this art consists in the things that the language is not able to explain."[4] What many painters like Delacroix in the nineteenth century began to worry about was the tendency of Renaissance and Baroque art critics to draw too close an analogy between, if not to identify, painting and literature, as if painted images could be readily translated into, if not reduced to, words. One can imagine a painter like Delacroix complaining, "If I wanted to express myself in words, I would have become a poet. I became a painter precisely because painted images can express things that words cannot."

There is truth to this complaint. What, for example, Van Gogh gives us in *The Starry Night* is irreducible to any number of words that might be said about the beauties of the night sky in summer over Saint-Rémy. Van Gogh's painting is in significant ways its own reality, produced out of a medium—oil on canvas— that can never be translated into another medium, such as words, without remainder.

But this respect that we must show for the integrity of the medium of painting and indeed for any artistic medium should not blind us to the fact that for us human beings, picturing and speech always go together.[5] We human beings cannot know anything except through the instrumentality of images. The essentials

4. Gilson, *Painting and Reality*, 208 for the first quotation, 209 for the second. But see more generally chapter 7 of this volume, entitled "Painting and Language."

5. In this paragraph and throughout this chapter, I rely heavily upon Robert Sokolowski's illuminating analysis in "Visual Intelligence in Painting," *The Review of Metaphysics* 59 (December 2005): 333–54. In that essay, Sokolowski argues for a strong analogy between painting and human speech in general, and story-argument in particular. He says that the images of a painting "combine to make a single statement or *narrative*" and that in a painting "all these partial pictures are like so many subordinate clauses in a sentence or so many steps in an *argument*: they are linked by pictorial grammar into one thought, one complex thing being stated" (339, emphases added).

of things become evident to us only as our minds play upon images of them, like hands playing upon the keys of a piano. And when it comes to the production of a mimetic image, the artist is always articulating more or less clearly in speech, if only in his or her thoughts, how the image should be composed. This is as true of painting as it is true of literature and is the reason why it is somewhat misleading to say that painting is a silent medium.

There is, of course, a mode of receptivity that we must place ourselves in before any painting worthy of our attention, and this mode is characteristically silent. We must first of all engage a painting with our vision, and vision, along with all the other sense powers, is essentially passive and so thrives in calm and quiet.[6] Before a painting, we must first "drink" it in with our vision. We must simply receive the visual feast as a gift, without comment. But the point of this passivity on the sensory level is to prepare our intelligence to be active, an activity that consists in making a set of distinctions. What distinctions are those?

The first and most important has to do with the story the painting is telling. In the Aristotelian-Thomistic tradition of mimetic art, the argument of a painting is always a narrative argument. How does a painting construct such an argument? By offering a composition of images picturing human beings in action, images that argue dialectically, as in any story, for a Controlling Idea. Imagine again that you are looking at Caravaggio's *The Calling of St. Matthew*. How would you articulate its Controlling Idea? For Robert McKee, remember, a Controlling Idea takes the form of an equation: Value + Cause. The value of Caravaggio's painting

6. Intelligence consists in a passive power but also an active power, the one St. Thomas calls the *intellectus agens* or "agent intellect." We need this active power to make the distinctions that illuminate what is essential, as opposed to what is accidental, in whatever we are thinking about. The senses, by contrast, are purely passive, as their objects—colors, sounds, textures, etc.—are already actualized, "preprepared," as it were, for our senses. There is no need for an "agent sense" to actualize color, for example. We simply need to open our eyes. See *Summa theologiae* 1.79.3, especially ad 1. On the passivity of sense and of intellect, see Kurt Pritzl, "The Place of Intellect in Aristotle," *Proceedings of the American Catholic Philosophical Association* 80 (2007): 57–75. On the receptivity of sensation, Pritzl on p. 61 quotes the fine remark by Yves Simon: "Unlike movement, sensation is an activity by way of rest. It is the first image of heaven."

seems clearly to be a positive, albeit unsettling, one. In a word, it is "call" or "conversion," a *metanoia* or change of heart initiated by Christ (the Cause). Christ is the true protagonist of the story depicted in this painting. His pointing makes plain that it is his action that initiates the change in Matthew.

The image of Christ's pointing alerts us to the way in which the painting "argues" for its Controlling Idea. As we view the painting, we discern that it is Christ who is initiating the action being pictured and, accordingly, that Christ is protagonist when it comes to our call to faith. This discernment or distinction is not a mere matter of visual perception, though it certainly relies upon it. It is an act of intelligence that we make as our minds play over the images of the painting. The shaft of light breaking through the gloom of the room is another "premise" in this story-argument, a Value in opposition to that represented by St. Matthew and his comrades. As its angle is more or less congruent with the angle of Christ's pointing, we associate the light with the grace of conversion, the grace that we see lighting up Matthew's face as he sits gaping at Christ with a finger pointing to his breast as if to say, "Who, me?" Other elements of the painting serve as premises in its argument, such as the fine clothing of Matthew and his comrades at the table, clothing more customary to Caravaggio's sixteenth-century Italy than to the world of fishermen and itinerant rabbis in first-century Palestine. What is Caravaggio trying to say in making this choice? He is helping his audience to identify with Matthew. This would be easier for Caravaggio's original audience than it is for us. But although stockings and waistcoats and swords are no longer customary for men in our culture, the fact that the clothing of Matthew and his companions is anachronistic helps us grasp the point that the Controlling Idea of this painting is not simply the calling of St. Matthew but the calling of *all of us*.

The Calling of St. Matthew is a piece of Christian sacred art. As such, the landscape of the world it represents, in Sokolowski's words, "is not just a habitation for men but a place in which the

Son of God can dwell and has dwelt. Christian art, therefore, presents and celebrates God's own beatitude, the happiness that is God's own life, which he has presented to us through the Death and Resurrection of Christ." Sokolowski nicely encapsulates the way in which Christian sacred painting works as argument: "Every Christian painting serves to convey the central message of the gospels that is summarized in the line of the *Benedictus*: 'to give knowledge of salvation to his people, *ad dandam scientiam salutis plebe eius.*'"[7] Thus, a piece of Christian sacred art will have not only a literal meaning and a moral meaning (related to the salvation of Matthew's soul) but an allegorical meaning (Matthew's calling is a type of every Christian's calling) and an anagogical meaning (we are called by Christ to live everlastingly in the abode of the Trinity).

But what if a non-Christian is viewing Caravaggio's painting? Or a Christian, but one who doesn't understand the spiritual dynamics of vocation? Does such a viewer "get" the story of the painting, and does such a viewer have a chance of being persuaded by its argument?

The answer must be negative. Such viewers will not understand the painting's argument, at least not completely. But what if a non-Christian viewer stands before the painting with a guidebook containing a brief explanation of *The Calling of St. Matthew*? Such a guide would presumably explain the story of Matthew's calling as told in Matthew 9:9–13 (or Mark 2:13–17 or Luke 5:27–32). A really good guide would then go on to explain the Controlling Idea and the premises of the painting's story-argument as we have done, though probably not in the same terms. But even granting such a guide, a non-Christian would not appreciate the painting's argument fully as long as she or he regarded the painting's argument as a mere collection of religious, historical, and aesthetic *information*. For a real engagement with the painting's argument to occur, the non-Christian viewer would have to grasp that its

7. Sokolowski, "Visual Intelligence in Painting," 351.

Controlling Idea has to do with Christ's call to all of us. That is, the hypothetical non-Christian viewer would have to react to the painting much as Matthew in the painting reacts to Christ: by experiencing the call to conversion. In sum, the painting presents a challenge about *how to live one's life*, and the viewer who appreciates the painting merely for its cultural value, as "a memorable experience in Rome," will have missed Caravaggio's point.

Meanwhile, the Christian viewer of the painting who does not understand the spiritual dynamics of vocation will miss the point for a different reason, perhaps because this viewer misapprehends faith as something that *we* do, as something that we somehow have to manufacture in our souls, rather than as something Christ offers to us as gift.

This discussion touches upon another important issue regarding the mimetic arts, one we discussed in chapter 5: the mimetic arts always have a social context and a tradition in which they are presented to their audiences. Caravaggio was commissioned to paint *The Calling of St. Matthew* for the church of San Luigi dei Francesi, in particular for a side chapel, where it still hangs to this day. This tells us that much of the force of the argument of the painting consists in the liturgical environment in which it hangs. The fact that the painting is situated within a house of worship, and right near the altar of sacrifice, reinforces the Controlling Idea that Christ's call is made to all of us. It also helps deepen our understanding of the value of Christ's call, for the painting, combined with its setting, intimates that Christ's call is a call to imitate him all the way to the cross, the altar of sacrifice. This point is plain when we keep in mind that there are three paintings by Caravaggio in the Contarelli Chapel: *The Calling of St. Matthew* on the wall to the left of the altar, *The Inspiration of St. Matthew* serving as the altarpiece, and, on the wall to the right of the altar, *The Martyrdom of St. Matthew*. Reading Matthew's Christian calling from left to right, the context argues that the call of Christ leads to total sacrifice, if not martyrdom.

Imagine that you are viewing *The Calling of St. Matthew* in a museum, bereft of its liturgical context as well as of its companion paintings. How would its argument work upon you in this very different social setting? Is a call, or a deeper call, to conversion possible in a museum environment? It is certainly possible. But apart from considerations of what God's grace can work, it seems more likely that in a museum, *The Calling of St. Matthew* would be regarded more as a cultural artifact, an interesting piece of European art history, indeed even a masterpiece—yet not as the summons "Follow me."

RHETORIC AND RHYTHM IN PAINTING

There are those who would argue that a religious reaction to Caravaggio's painting has nothing to do with the painting as a painting—that is, as a *work of art*. So imagine another scenario: a viewer of *The Calling of St. Matthew* who experiences a conversion as profound as that which Matthew himself experienced, yet who fails to appreciate any of what is often referred to as the "aesthetic" content of the painting. Hasn't such a person failed to engage with Caravaggio's painting as a work of art?

One reason I prefer not to use the term "aesthetic" in my analysis of the mimetic arts is that it involves this kind of distinction between "religious" and "aesthetic" responses to a painting like *The Calling of St. Matthew*. When it comes to the art of painting, those concerned with the "aesthetic" see it as a privileged space of encounter between the viewer and the compositional elements of a picture, a space set apart from religious, moral, political, and familial concerns. This view arose in Europe during the eighteenth century as part of the "fine arts system," and we have every reason to abandon it. For what it does is compartmentalize the various concerns of human life and so works against the very integrity of the human quest for the good. Many visual artists working today have gladly abandoned the view, but only by going to the other

extreme of taking their art as pure political statement. What we need to think about is how a painting can speak to us in a way that integrates, not compartmentalizes, the various goods that we human beings pursue—religious, moral, familial, artistic—while still respecting the intrinsic value and dignity of each.

And we can begin by once again appreciating what is right about the so-called "aesthetic" or "formalist" viewpoint. Those who adopt this viewpoint are correct to remind us of a truth we have noted more than once along our way already: that a painting is not an instrumental sign. It is not a mere pointer, like a street sign, directing us to some other reality. A painting needs to be engaged with in its own right *as a painting*, as a re-presentation of a given reality in another medium. Pictures, keep in mind, bring the reality they picture *into themselves*, and what a painter like Caravaggio asks us to do is to engage with that reality, not as it exists in the world outside the painting, but in the painting itself.[8] If all Caravaggio had been interested in was the making of religious signs, he might simply have painted the words "Follow Christ!" on the wall of the Contarelli Chapel and been done with it. But he didn't do that. He made a mimetic world for us to enter and delight in, and it is in *that* world that he asks us to engage with Christ's call.

But here's the rub: to engage with a painting *as a painting* does not mean that one should, in the case of a painting such as *The Calling of St. Matthew*, divorce "aesthetic" considerations from "religious" ones. The religious considerations are right there on Caravaggio's canvas. Not only Caravaggio's choice of subject but also his choice of how to re-present that subject in forms upon his canvas together comprise the religious argument he is making about call and conversion. These religious elements can

8. In this sentence, I am making particular use of Sokolowski, "Visual Intelligence in Painting," 342n20: "An important contrast between speech and painting lies in the fact that speech moves us away from the words to the thing, while pictures bring the thing into themselves. There is, therefore, an interesting 'spatial' difference between the two modes of presentation."

no more be separated from the compositional form of the piece than can Caravaggio's use of line or color, about which I would like to say something now.

Line and color might seem to be more "aesthetic" in nature than Caravaggio's choice of an overall "religious" subject matter. But we fail to understand a painter's use of them unless we understand how they also contribute to the overall story-argument of the work. I would suggest that line and color constitute the "rhetoric" of a painting's argument. They are the way in which, the style in which, the painter "pitches" his argument to us.[9]

Consider an analogy from literature. Back in chapter 3, we considered a famous autobiographical article Evelyn Waugh wrote for *Life* magazine in 1946, in the wake of his novel *Brideshead Revisited* becoming a best seller in the United States. In that article, Waugh wrote:

> So in my future books there will be two things to make them unpopular: a preoccupation with style and the attempt to present man more fully, which, to me, means only one thing, man in his relation to God.[10]

Here, Waugh distinguishes two characteristics of his future novels: a religious Controlling Idea or mimetic universal (put generally, "man in his relation to God") and the "preoccupation with style" with which he will attempt to make his Controlling Idea persuasive. Style or rhetoric is just that: persuasive speech, speech intended to persuade by use of its own alluring diction and

9. In his development of the analogy between painting and speech, Sokolowski compares color to vowels and line to consonants: "Vowels are the fundamental, spontaneous, and emotive component in words, while consonants are more rational and need to be learned. Analogously, color is chthonic and affective, while line, *disegno*, is more rational and determinative. Lines clip, cut, and trim colors just as consonants define vowels" ("Visual Intelligence in Painting," 339). This is an illuminating comparison, but given that the compositional form of a painting is analogous to speech primarily in the way it functions as argument, I prefer to compare color and line, so integral to a painting's argument, to something more linguistically complex than vowels and consonants.

10. Evelyn Waugh, "Fan-Fare," 302.

devices. Style or rhetoric in literature has to do with the sweetness and suavity of language. The romantic lushness of Waugh's style in *Brideshead Revisited* is part of the argument of the narrative; the lushness of the prose is the rhetorical analogue to the depicted charm of the Flyte family that is the forerunner of grace.[11] Grace, by contrast, is never depicted in the novel lushly or romantically but, in keeping with the Catholic imagination, with a spare diction meant to indicate its lack of charm, its indirection, its smallness.

This kind of distinction between mimetic argument, on the one hand, and the rhetoric of that argument, on the other, is found in poetry (Hopkins's updating of Anglo-Saxon alliterative verse is a rhetorical choice), music (a contemporary singer's use of electropop is rhetoric), and indeed all the mimetic arts. When it comes to painting, it is the painter's choices in regard to line and color that make up a painting's rhetoric or style. In Sandro Botticelli's *The Birth of Venus*, for example, we see Botticelli's emphasis upon the outline of his figures, an outline so decisive that it is reminiscent of a certain sort of cartoon drawing, such as the *ligne claire* that Hergé popularized in his Tintin books. This comparison is not meant to disparage Botticelli's line work in the least. Such clarity of line, which gives the figures a rather flat two-dimensionality against their background, has a distinct rhetorical purpose: as used by both Botticelli and Hergé, it is meant to persuade us that the reality being pictured exists in mythological rather than naturalistic space. The boldness of the line, along with its easy, graceful dynamism, lifts the figures out of the natural world. As E.H. Gombrich explains, the Italians of the Renaissance, in their zeal to recapture the former glory of Rome, became convinced of the wisdom contained in classical mythology. The member of the Medici family who commissioned this painting for his villa, or one of his learned friends, would have known, and likely would have explained to Botticelli, that

11. On this theme, see again Thomas Prufer's essay on *Brideshead*, "Death of Charm."

the story of Venus's birth "was the symbol of mystery through which the divine message of beauty came into the world."[12] The bright, sharply contrasting colors of the painting—the luminous pale skin of Venus as she floats ethereally toward the viewer; her golden locks set against the blue sky; the green and blue garments of the flying wind-gods as they blow her landward; and the dazzling pinkish-purplish cloak that one of the Hours or Nymphs readies to wrap around the naked Venus's shoulders—these are all also reminiscent of cartoon coloring and contribute to the rhetoric that places the painting in mythological space.

The Birth of Venus has another quality that Sokolowski identifies as an integral part of what allows a painting to "speak," and that is its rhythm. Just as music and well-wrought language contain a rhythmic movement, so too does a painting. The rhythm of a painting is discernible, however, only when the painting is taken as a whole. Stand thirty feet away from Van Gogh's The Starry Night, and the kinetic, swirling rhythm of the painting remains unmistakable. "The rhythm of a picture lies not only in the balance of colors," writes Sokolowski, "in which, for example, this red patch on the one side picks up something red on the other; it is also the cadence of the images as they make up the whole; it is the visual rhapsody of meanings, colors, and lines."[13] In The Birth of Venus, there is a strong rhythmic movement to the scene: the push of the waves as they help propel Venus's half-shell toward the shore; the thrust of air out of the mouths of the winged wind-gods, in itself made visible by Botticelli, but also discernible in its waving effect upon Venus's hair; the shower of roses floating on the breeze; and then, as a counteracting force, the garment held out for Venus by the Hour or Nymph, which billows in the face of the gusts made by the wind-gods. As a good example of rhythm in painting, Sokolowski points to the example of Piet

12. E.H. Gombrich, The Story of Art (New York: Phaidon, 1989), 199. Throughout this paragraph, I rely on Gombrich's study of Botticelli's painting—though I cannot place on his shoulders the comparison to Hergé.

13. Sokolowski, "Visual Intelligence in Painting," 341.

Mondrian's *Broadway Boogie-Woogie*, which, perhaps with particular effectiveness because it is an abstract painting, "captures not only the beat of the music but the tempo of New York City, as would be obvious to anyone who has spent some time there and has experienced what it is like to dodge pedestrians while walking on the streets of Manhattan."[14]

The paintings we have been considering generate rhythm mainly out of the mimesis of physical movement (though what Van Gogh is trying to capture of the night sky in *The Starry Night* certainly goes beyond any literal mimesis of movement in the sky). It is more of a challenge to discern the rhythm of a painting that is much "quieter" in its conception. Cézanne's *Mountains in Provence* is just such a painting. It depicts what looks to be a warm summer day in southern France. Not a trace of a breeze disturbs the branches of the trees. No human figure or animal intrudes upon the scene. Part of what is so attractive about the painting is its stillness, its *serenity*. Yet this serenity is the product not of an inert assembly of forms, lines, and colors but of an intense activity—not of human beings and other things in physical motion but of forms, lines, and colors placed in dynamic relationship to one another. In the rocks in the foreground of the painting, we see anything but dull slabs of matter. Cézanne has discovered great energy in this rock formation, an energy brought out in part by the bulkiness and jaggedness of the forms, in part by the judicious use of heavy outlining, but most of all by the juxtaposition of colors and shade in small, clear, vigorous brushstrokes. What is fascinating is that all this energy is present within a rock formation that is completely still. The overall impression is of a balance of forces, of rough-hewn proportion, of the sublime order of inorganic nature. Beyond the rock formation is a line of trees and a low hill covered by rectangles of farmland. A gentle dialectic exists between the rock formation in the foreground and this hillside. It is like a trochaic foot of poetry in that there is a stress (the

14. Sokolowski, 342.

rock formation) succeeded by something unstressed (the hillside). And the gentle counterpoint of lively greens and golden browns used to depict the rectangles of farmland on the hillside creates its own measured, tranquil cadence, one perfectly in tune with the sempiternal rhythms of the seasons and of the earth.

ESSAYS AT BEATITUDE

The painted argument, like all other mimetic arts, imitates "the action that actualizes or destroys our beatitude."[15] Painting, as understood in the Aristotelian-Thomistic tradition of the mimetic arts, is a narrative argument about human happiness. Its way of arguing is not linguistic but is analogous to language, first in that it presents, in the arrangement of its forms, a dialectical exchange between images resulting in the illumination of the Controlling Idea. But the argument of painting is also analogous to linguistic argumentation in that it involves rhetoric or style as well as a rhythm to its "language." In the Aristotelian-Thomistic tradition, to be persuaded by a painted argument is to be intellectually and appetitively inclined by the painting's arrangement of its forms, rhetoric, and rhythm to the truth of "something virtuous."

The beauty of a painting is found in the way its form actualizes the medium that serves as its matter. The form of a painting is principally its "plot," the story it has to tell about human happiness, a story that comes to completion and wholeness in the illumination of its Controlling Idea. A variety of forms, of images, help make up the painting's argument, and insofar as these images exhibit order among themselves, order ultimately directed to the Controlling Idea of the painting's argument, then the painting will manifest proportion or consonance. The radiance of a painting consists in the brilliance with which the forms, colors, lines, and rhythms strike the eye, but also in the way the painting reveals to the intellect layers of meaning, starting with

15. From an unpublished lecture by Francis Slade, quoted in Sokolowski, 344.

its literal meaning but radiating out into moral, allegorical, and anagogical meaning.

However many of the fourfold layers of meaning a particular painting contains, they will be latent within it until an observer comes along and takes the time necessary to really attend to the painting and learn what it is trying to say. "After all," Sokolowski notes, "it takes time to be able to 'read' a painting; one has to learn to see a painting as one learns to sing a song. We appreciate a painting properly only when we have lingered over it, when we have seen it many times and have looked at it at different times of day and during different moods of our own."[16] But after taking the time to really learn how to read a painting, we will, with an act of intelligence, grasp its argument, as that argument is presented in the painting's compositional form, with its particular use of painterly rhetoric and painterly rhythm. As an elaborate, very deliberately constructed phantasm, the painting allows for the moment of insight in which we simply see, with our eyes but also with our minds, what the painting is arguing regarding the human good.[17]

We need to be careful to make a distinction here. When we grasp a painting as a whole, when we understand what it is that the painting argues about human happiness, our sense of sight and our intellectual capacity are not themselves busy making arguments. They are simply "drinking in" the intelligibility of the painting. They are enjoying, as I said a moment ago, intelligence or insight. As we saw in chapter 5, intelligence is not intellectual "work." It is, rather, intellectual *rest* in a complex reality having been made perspicuous to the mind. Much work may be needed to prepare the way for insight. If you have never seen Marc Chagall's *White Crucifixion*, you will likely be somewhat confused by the dazzling array of images, which at first sight lack narrative order and proportion. But after some study of the painting, it

16. Sokolowski, 342.
17. Sokolowski compares a painting to a phantasm at 347.

is possible that you will "get," with an act of intelligence, what Chagall is saying in this painting.[18] Yet whether or not you do "get" Chagall's painting, the argument is always there on the canvas, waiting to be understood.

Sokolowski contends that a portrait is the clearest instance of a visual imitation that pictures human happiness. In thinking about portraiture, we once again come upon the crucial difference between a likeness and a mimesis or picture. A picture of someone might present a good likeness or similarity to the person depicted but not achieve what it means to be a *portrait* of that person. A portrait is always more than a likeness. In Sokolowski's fine articulation, a portrait "is a depiction of an essay at beatitude. It presents, poetically, someone's shot at happiness and self-identity. It presents what Aristotle would call a 'first substance,' an individual entity, an instance of the species man, but it does not present that substance as a mere compound; it presents that entity as an essence, with a necessity and a definition."[19] Alasdair MacIntyre makes the same point. After quoting George Orwell's thesis that "at fifty everyone has the face he deserves," MacIntyre adds: "What painters from Giotto to Rembrandt learnt to show was how the face at any age may be revealed as the face that the subject of a portrait deserves."[20] By "deserves," I take Orwell and MacIntyre to mean the face that the subject of the portrait deserves as an estimate of that person's degree of success in achieving beatitude.[21]

In another context, MacIntyre tells the story of Graham Sutherland's infamous 1954 portrait of Winston Churchill. Sutherland was commissioned by Parliament to paint a full-length portrait

18. On this theme, see Sokolowski, 347–48.

19. Sokolowski, 344.

20. MacIntyre, *After Virtue*, 189.

21. MacIntyre in this same discussion goes on to make the intriguing point that in medieval paintings, the face of the saint is the face of an icon; and in fifteenth-century Flemish and German painting, naturalism in portraiture is established as the antithesis to iconography; but with Rembrandt "there is, so to speak, synthesis: the naturalistic portrait is now rendered as an icon, but an icon of a new and hitherto inconceivable kind" (MacIntyre, 189).

of Churchill, then in his second term as the United Kingdom's prime minister, to celebrate Churchill's eightieth birthday and to thank him for his long and very distinguished career in service to his country. Sutherland, however, did not produce the portrait that anyone had in mind, especially Churchill. As MacIntyre describes it: "What was unveiled at the presentation [in Westminster Abbey] was a shockingly truthful portrait of Churchill as the victim of fatigue and old age, a face whose lines and planes communicated the imminent dissolution of a personality. Those who cared most for Churchill found it difficult to look at the painting. His wife first hid it and then destroyed it."[22] On MacIntyre's view, Sutherland's portrait of Churchill "was a great and truthful achievement as a work of art."[23] Sutherland, then, if MacIntyre is right, faithfully represents Churchill's "shot" at happiness and identity as it appeared to Sutherland during Churchill's sittings for the portrait in 1954. Lord Moran, Churchill's personal physician, later wrote in his biography of Churchill that

> Sutherland's intentions, at any rate, seem to have been unexceptionable. The trouble was not that he admired the PM too little, but rather that he worshipped him too blindly. Graham Sutherland was thinking of the Churchill who had stopped the enemy and saved England, and the manner in which, without a word of guidance, Mr. Churchill took up a pose on the dais convinced the painter that he was on the right tack. "I wanted," he said, "to paint him with a kind of four-square look, to picture Churchill as a rock."[24]

22. MacIntyre, *Ethics in the Conflicts of Modernity*, 144.

23. MacIntyre, 144.

24. This passage from Lord Moran's *Churchill: The Struggle for Survival* (Boston: Houghton Mifflin, 1966) is quoted in "The 1954 Sutherland Portrait," International Churchill Society website, accessed July 4, 2022, https://winstonchurchill.org/publications/finest-hour/finest-hour-148/the-1954-sutherland-portrait/.

If Sutherland's argument in the portrait was to re-present Churchill as the "rock" who had stopped the enemy and saved England, he also seemed to argue, perhaps unwittingly, that being that rock had taken a tremendous toll upon Churchill emotionally and physically, and that Churchill's degree of beatitude, while having a certain haggard nobility, was nonetheless not one characterized by joy.

While taking a portrait as an essay at beatitude might seem reasonable enough, given that we are used to regarding the face and eyes of a person as a window to the soul, it may be more difficult to understand how other sorts of paintings—street scenes, seascapes, and landscapes—can be taken as essays at beatitude. Sokolowski, drawing upon some observations of Francis Slade, argues that landscapes, seascapes, and street scenes can be taken as narrative arguments about human happiness insofar as they "are presented as backgrounds for the possibility of human choices."[25] Cézanne's *Mountains in Provence* is a landscape devoid of human action in any explicit sense, but the evidence of human choices is implied throughout. The good-sized farmhouse in the middle ground and the smaller ones in the distance indicate that this landscape is not barren but rather a place where human beings have chosen to dwell. Further, the fields themselves indicate that human culture has taken hold of the land. The painting's Controlling Idea, in fact, is not about the natural beauty of Provence *per se*, but about that beauty as transformed by, made habitable by, yet still respected by, the ingenuity of human beings questing for happiness. To be sure, paintings sometimes depict wild and barren landscapes, but even these show us a landscape precisely as it is not, or at least not commonly, a setting for human beings to dwell in and cultivate.

What Sokolowski reports of a conversation between Francis Slade and himself while attending an exhibition of paintings by John Singer Sargent is an instructive way of ending our

25. Sokolowski, "Visual Intelligence in Painting," 346.

meditation on how the Aristotelian-Thomistic tradition regards paintings such as street scenes, seascapes, and landscapes:

> Some of the pictures in the show represented people in various settings: on the bank of a river, in a restaurant, on a street, in a room. Slade observed that in Sargent's paintings the settings were always such that people could be at home in them. I replied that Sargent was very different from Edward Hopper in that respect; in Hopper's paintings, nobody is at home [think of Hopper's most famous painting, *Nighthawks*]. Slade responded: "It's more than that. They aren't at home—*and they know it*."[26]

ABSTRACTION

A final word concerning abstract painting.

It has hopefully been clear since chapter 1 that mimetic art is not just about copying the contours of the physical world. Much mimetic art, in fact, pictures a reality fairly well abstracted from its natural embodiment. David Jones's axiom, already mentioned, is worth mentioning again: *All art is abstract, and all art re-presents.*

But is there a line beyond which abstraction undermines mimesis? What Sokolowski says about Jackson Pollock and Mark Rothko, two of the most highly regarded abstract expressionist painters of the twentieth century, is of relevance here:

> Even Jackson Pollock and Mark Rothko express a context for human being. They present a particular setting, or even, by implication, the universe as such, as a place that is or is not habitable, a place where beatitude can or cannot be sought. In extreme instances, they may present a place where it would be laughable to seek happiness, but even then they cannot

26. Sokolowski, 346.

extinguish our search for it. Eliminating any context in which beatitude can be sought, while still keeping the search for it alive, is precisely what nihilism is. Among contemporary artists, Francis Bacon may be the most vivid example of this combination.[27]

Sokolowski claims that the work of Pollock and Rothko presents a setting in which beatitude can or cannot be sought. The setting they present, however, is not the natural or supernatural order in which beatitude is sought but rather an emotional state, a mood. The abstract expressionism of Pollock, in particular his action painting, is interested in showing the formlessness of the subconscious and of emotional impulsiveness. It is not interested in discovering how the internal life of the human person can be guided and inspired by reason's grasp of a good outside itself. A work such as *Autumn Rhythm (Number 30)* might be read on an analogy to musical improvisation, as a painted version of one person's emotional response to the season and, therefore, as mimetic painting in some minimalist sense. But the "all over," unstructured nature of the paint on the canvas indicates nothing of argument, nothing of rhetoric save that of line and color wholly unhinged from form, and a zany, pointless, mindlessly repetitive rhythm. Other of Pollock's action paintings, which he chose to name only with numbers rather than with descriptive titles, are similarly banal: emotional spume without any interest in the world outside the artist's psychological state. To distance oneself in this way from horizons of significance outside the artist, whatever lingering yearning for fulfillment may still be evident in the work, is to reject the Catholic imagination. It is to paint by an angelic or expressivist imagination tilting toward the homelessness characteristic of nihilism.[28]

27. Sokolowski, 346.
28. As Sokolowski notes, the pioneers of nonrepresentational painting at the beginning of the twentieth century had a different kind of angelic imagination. Kandinsky, Malevich, and to a lesser degree Mondrian, were theosophists. "They thought that art could express ultimate,

Mark Rothko's work is far more agreeable to the eye than that of Pollock. His play with rectangles and subtle gradations of color invites contemplation of the beauty of even the simplest sensible form. Yet Rothko was not merely interested in color and other formal relationships. He once said: "I'm interested only in expressing basic human emotions—tragedy, ecstasy, doom, and so on. . . . And the fact that a lot of people break down and cry when confronted with my pictures shows that I can communicate those basic human emotions. . . . If you . . . are moved only by their color relationships, then you miss the point."[29] So Rothko declares his interest in communicating human emotion, and thus his work, like Pollock's, can be considered mimetic in a minimalist sense. It attempts to picture human emotional experience, yet without picturing the horizons of significance that make sense out of that experience. There is no explicit picturing, for example, of supersensible or sacred reality. Religious and moral sentiment in regard to Rothko's work is often *invoked* by external commentary. And the sense of peace induced by the contemplation of his painting has led collectors, rather unfortunately, to name the rooms in which they exhibit his work "chapels." But apart from such external commentary, Rothko's painting communicates nothing beyond a mood. His is also an angelic imagination.

In regard to Sokolowski's comment about the work of Francis Bacon, I am not sure what he means by saying that it eliminates any context in which beatitude can be sought while still keeping the search for it alive. In any event, if it is clear that an artist still yearns for a beatitude that might still seem impossible to attain, it is plausible to argue that a germ of the Catholic imagination abides. But if an artist declares the quest for beatitude

quasi-divine powers of the universe. To reach these forces the artists *bypassed individual things*" ("Visual Intelligence in Painting," 349; emphasis added).

29. The Museum of Modern Art, *MoMA Highlights* (New York: Museum of Modern Art, revised 2004, originally published 1999), 196, as quoted in the article on Rothko by Karen Kedmey on the MoMA website, moma.org/artists/5047. Accessed May 29, 2023.

definitively to be impossible, whatever yearning for it might remain, then one's imagination is a homeless one.

I submit that abstract painting is perfectly acceptable and a source of keen enjoyment for a Catholic imagination as long as the abstraction from a specific embodiment in nature makes intelligible a mimetic universal substantially and positively and delightfully related to the theo-drama.

Cubism, for example, typified by the work of Picasso and Georges Braque, still maintains some mimetic connection to reality. But by disrupting our expectations about how things should be represented on a canvas, it heightens our awareness of how even the simplest objects provide a rich feast for our perceptions. Picasso's *Violin and Grapes* is a good example. Gombrich reconstructs the reasoning behind Picasso's approach to this canvas: "If we think of an object, let us say a violin, it does not appear before the eye of our mind as we would see it with our bodily eyes. We can, and in fact do, think of its various aspects at the same time. Some of them stand out so clearly that we feel that we can touch and handle them; others are somehow blurred. And yet this strange medley of images represents more of the 'real' violin than any single snapshot or meticulous painting could ever attain."[30] On this reading, *Violin and Grapes*, and Cubism in general, is an effort at picturing reality. Call it a more phenomenological approach, an approach through how things *appear* to consciousness.

"Of course," as Gombrich observes,

> there is one drawback in this method of building up the image of an object of which the originators of Cubism were very well aware. It can be done only with more or less familiar forms. Those who look at the picture must know what a violin looks like to be able to relate the various fragments in the picture to each other. That is the reason why the Cubist painters

30. Gombrich, *Story of Art*, 456.

usually chose familiar motifs—guitars, bottles, fruit-bowls, or occasionally a human figure—where we can easily pick our way through the paintings and understand the relationship of the various parts.[31]

I would not call Cubism's reliance upon familiar forms a "drawback" but simply a limitation. It is the limitation imposed by the natural mimetic impulse to show, as Aristotle says, that "this image is of so-and-so—or such-and-such."

In sum, while Cubism, and other forms of abstract painting, may not enjoy a substantial connection to the Catholic imagination, they do contribute to that imagination's continual need to freshen perception; in Josef Pieper's phrase, "to learn how to see again."[32]

31. Gombrich, 458.

32. I recommend to lovers of painting and all mimetic art Pieper's essay "Learning How to See Again," in *Only the Lover Sings*. A celebrated contemporary and Christian painter whose work aspires to be mimetic while still employing techniques of abstract expressionism is Makoto Fujimura, a Boston-born Japanese artist. See the discussion of his work in Thomas S. Hibbs, *Rouault-Fujimura: Soliloquies* (Baltimore, MD: Square Halo Books, 2009), and in Peter Frank, "Makoto Fujimura: An Immanent Abstraction," available at Fujimura's website, makotofujimura.com, accessed May 29, 2023, https://makotofujimura.com/assets/pdf/An_Immanent_Abstraction.pdf.

11

Capturing Beauty in Motion Pictures

Black screen.
Water slaps hollow metal, metal knocks creaking wood . . .
Super title:

DUNKIRK

Fade in:
Paper. Falling like snow. Six young, filthy Tommys raise their
heads along a deserted street, checking rubbish bins, windows . . .
One crouches to check a coiled garden hose. He tries the tap—
nothing . . .

Title 1:

THE ENEMY HAVE DRIVEN THE BRITISH AND FRENCH ARMIES TO THE SEA

One Tommy plucks paper from the air . . . Propaganda leaflets
showing their position . . . "YOU ARE SURROUNDED" . . .

Title 2:

TRAPPED AT DUNKIRK, THEY AWAIT THEIR FATE

He wads the leaflets up, crouches, drops his trousers . . . The Tommy
with the hose carefully lifts each side . . .

Title 3:

HOPING FOR DELIVERANCE

He gets a tiny dribble of water which he licks from the nozzle—

Title 4:

FOR A MIRACLE

BLAM BLAM BLAM! Tommy jolts, grabs his trousers. All six race away from us. . . . One by one, five are shot down. . . .

Tommy spins around, fires blind until empty, scrambles out the back. He races down narrow Dunkirk streets. Breathing. Kit jangling . . . Building after building . . . He rounds a corner—

BLAM! Bullets hit dirt and bricks near him. The street ahead is barricaded, manned by French troops.

TOMMY

ANGLAIS! ANGLAIS!

The French stop firing and wave him through.

He scrambles over their sandbag barricade, taking in their dirty, frightened faces as he passes . . .

A French Soldier grabs him—

FRENCH SOLDIER

Allez, Anglais.

Tommy's mouth opens at the man's bitterness.

FRENCH SOLDIER
(contempt)

Bon voyage.

He shoves Tommy down the street behind their protection.

Gunfire behind. Tommy takes off again, hurtling down the dark street, heading towards the blazing lights of—

EXT. BEACH AT MALO LES BAINS – CONTINUOUS

The longest, widest beach he's ever seen, sunlight dazzling off the water, endless dark fences snaking across the sand and out into the water. Tommy squints—not fences, lines of men, hundreds of thousands of men . . . [1]

In Christopher Nolan's 2017 film *Dunkirk*, there is, compared to most popular films, a paucity of dialogue. Nolan's vision was to make a war film that didn't explain itself but simply showed events on film. As he details in an interview with his brother and sometime collaborator, Jonathan: "I remember saying to Emma [Emma Thomas, Nolan's wife and producing partner] and Nathan [Nathan Crowley], our production designer . . . I said I don't want a script. Because I just want to show it, it's almost like I want to just stage it. And film it. And Emma looked at me like I was a bit crazy and was like, okay, that's not really going to work."[2] So Nolan did eventually produce a script, but because of the emphasis upon action, it came to only seventy-six pages, some fifteen to twenty pages shorter than your average script for a feature film. There is barely any dialogue in the first twenty pages of the script, as Jonathan Nolan observes in the interview, to which

1. Christopher Nolan, *Dunkirk: The Complete Screenplay* (London: Faber & Faber, 2017), 3–5.
2. "Allowing Fate to be Arbitrary: A Conversation between Christopher Nolan and Jonathan Nolan," included in Nolan, *Dunkirk*, ix–xxxvii, at xviii.

Christopher responds: "That's something I really wanted to do. I just wanted to push away from the kind of filmmaking I've been doing where everybody's always explaining things in dialogue."[3]

The first page or two of Nolan's script for *Dunkirk*, reproduced above, is typical of the script in that there is almost no dialogue. But even if you are not used to reading screenplay format, the action is easy enough to follow. Six young British soldiers—Tommys—appear on a street. They take notice of some Nazi propaganda. Try to find a drink of water. Attempt to relieve themselves. Then they are ambushed by German soldiers. We focus on one Tommy, who fires all his rounds at the enemy. Then he runs for safety. Seems to find a haven behind a French barricade, but they only push him away from them.

That's all there is on screen: human beings in action. But that's also *all* we need, as Nolan intuited when he planned the film. We don't need dialogue—human speech, language—in order to imitate human action and present a story on film. In the interview with his brother, Nolan praises films of the silent era, which had to use images alone to communicate story:

> What I wanted to do was go back to the silent films that I love, where they just find a way to use large images and the mass movement of people within the frame to make you feel something or imagine something. That's why *All Quiet on the Western Front* [the 1930 adaptation] is a fascinating film because it's got the silent-era mechanics with a little bit of sound. It's right on that transitional phase, and there's a very real sense in which sound ruined movies for a while—probably for ten or fifteen years. Really set them back, because of the technology.[4]

Now of course, the written word, even apart from the few lines of dialogue, is used in these opening pages of *Dunkirk*,

3. Nolan, xix.
4. Nolan, xix–xx.

and in more than one way. There are five titles, superimposed on screen, that situate us on the north coast of France and tell us, in barest outline, the basic situation of the story: the British and French are trapped by the Germans in Dunkirk, hoping for a miracle that will allow them to escape. Leaflets of propaganda, falling like snow from the sky, also help communicate the situation. In the film itself, Nolan uses the technique of an insert to show us one of the leaflets as it is read by one of the Tommys.

The written words in the titles and in the leaflets of propaganda do significantly contribute to communicating story in these opening pages. It is interesting to imagine, however, these opening pages without the titles and without the leaflets, or at least without the insert of one of the leaflets in the finished film. That is, it is interesting to imagine what it would be like to try to follow the story without any spoken or written language whatsoever, with just the action. From the title of the film and the image on the one-sheet (poster), we would have a decent sense of a World War II setting, even if we were ignorant of what happened at Dunkirk from May 26 to June 4, 1940. In watching the opening, we would probably guess that we were watching Allied soldiers, if not British soldiers, and once the shooting started, we would, no doubt, have a strong sense that it was an attack by the Germans. We would have protagonists in desperate search of a goal: *survival*. And, frankly, that's enough story to be going on with, at least for a good while.

A film can communicate without speech. We are able to "read" a film and appreciate its beauty just by the way the cinematic images are presented to us—a fascinating phenomenon. In this way film is akin to music and even more so to painting, in that by pictorial images alone it is able to imitate human beings taking the actions that will either achieve or destroy their beatitude. In this chapter, we are going to explore in more detail how cinema, with a focus on popular, fictional cinema, constructs its arguments, its dramatized dialectical debates, about human

happiness. By getting into the details of how a film puts its images together to make an argument, we will see how the three qualities of beauty are realized specifically in the medium of a feature film. My procedure will be the same as that followed in our discussion of painting. First, we will look at how film builds up images into arguments; next, we will consider the rhetorical elements that are particular to film; and finally, we will contemplate how the rhythm of a cinematic argument contributes to its persuasiveness.

THE ARGUMENT OF CINEMA: THE SHOT

Before we do anything else, let us first situate ourselves with an understanding of cinema as a mimetic art by identifying the object, medium, and manner of its mimesis.

An Aristotelian Understanding of Cinematic Mimesis (inspired by *Poetics* 1–3)	
Object of imitation	Human beings in action pursuing happiness
Medium of imitation	The threefold medium of cinematography, editing, and projection resulting in a story being told by way of "cuts"
Manner of imitation	Action "living and moving before us" presented in the wide variety of cinematic styles (e.g., the conventional Hollywood film, the French New Wave, the Dogme 95 movement)

Notice a few things about this chart. First, cinema is one of the rare arts whose medium is really a collection of arts. Cinema makes use of cinematography, editing, and projection, which work together to imitate human beings in action. Other arts, not absolutely necessary to the imitation, are often employed as well:

the art of production design, scene design, sound design, makeup, and many others, not to mention the art of acting.[5] Second, while sound (ambient, in dialogue, in special effects, and in a musical soundtrack) is almost always employed in contemporary feature films and contributes significantly to the cinematic argument of these films, it nonetheless is not necessary to the medium of cinematic imitation. Third, notice that the manner of imitation in film, like that of the drama, is human action "living and moving before us." What is distinctive about film is not *narrated* action such as we find in a novel, though sometimes the device of narration is used (think of the grandpa's bedtime-story narration in *The Princess Bride*). What is distinctive about film is *enacted mimesis*, the showing, captured in photography, of human beings doing things: walking, drinking, running, shooting, etc. The enacted nature of cinematic mimesis is what Christopher Nolan is referring to when he says to his brother about the action of *Dunkirk*: "Because I just want to show it, it's almost like I want to just stage it. And film it."

Films tell their stories, dramatize their debates, by a series of "cuts." In other words, photographed images are edited into varying lengths and juxtaposed with one another. Borrowing from Sergei Eisenstein's theory of *montage*, playwright, screenwriter, and director David Mamet describes cinematography as "a succession of images juxtaposed so that the contrast between these images moves the story forward in the mind of the audience." He adds that the juxtaposed images, or cuts, should ideally be "uninflected."[6] By this I take Mamet to mean that the contrasting cuts should move the story forward in the mind of the audience

5. Stage drama, opera, and ballet are other mimetic arts whose mimesis requires more than one art, a phenomenon that typically characterizes mimetic arts whose manner is that of enacted mimesis. Mimetic arts that do not use the manner of human agents living and moving in front of us can be executed by a single artist, though often the work of other artisans is used (the maker of paints to assist the painter, for example, and the book binder to assist the novelist).

6. David Mamet, *On Directing Film* (New York: Penguin, 1992), 2. Mamet's definition of cinematography is emphasized in his original text.

without comment—that is, without explicit narration.[7] As we have seen, not even speech itself is essential to cinematic storytelling, since even in silence a film can "speak" to us through the contrasts found in its juxtaposed images.

The most basic building block of cinematic argument is the shot. The shot is the smallest compositional or intelligible whole in cinematic language. A single frame might make for a nice still photograph—some people even like to collect and frame still shots from films—but in the context of film itself, a single still frame is not a compositional whole. It is, rather, a part of the compositional whole that is the shot. Before we get into the reason why a shot makes a compositional whole, let us first preview all the parts of cinematic language, from the shortest to the longest:

- the shot
- the scene
- the sequence
- the act

A series of shots make up a scene; a series of scenes make up a sequence; a series of sequences make up an act; and a series of acts make up a completed story. Almost all popular feature films have three acts. A film story builds its argument not with premises in the literal sense but with shots, scenes, sequences, and acts.

Returning now to the shot: a shot is defined as a photographed moving image that is a compositional or intelligible whole because (1) the camera position or the object photographed remains virtually unchanged, and (2) the image advances one small step one of the positions in dialectical debate within the wider scene. This definition captures both the material and formal elements of

7. Certain modern literature has a cinematic quality because the action is portrayed without explicit narration and often without any, or much, internal monologue on the part of the characters. See, for example, the early comic novels of Evelyn Waugh or just about anything of Ernest Hemingway, and contrast these with the explicit, not to say intrusive, narration found in Anthony Trollope.

the compositional whole that is the shot, as the position of the camera or of the object photographed refers to the matter of the shot, and the one small step in the cinematic debate refers to the form of the shot.[8]

In the opening scene of *Dunkirk*, one of the young British soldiers walking down the street stops beside a house that has a garden hose attached to the wall. The soldier turns the spigot and then tries to drink out of the end of the hose without even bothering to uncoil it. That's the entire shot. As it reads in the script: *One crouches to check a coiled garden hose. He tries the tap— nothing* . . . As filmed, the camera tilts downward a bit as the soldier kneels to pick up the coiled hose and then tilts upward slightly to catch the soldier drinking from the open end. But the camera's position and the object photographed remain virtually unchanged. On the formal level, the shot advances one small step the soldiers' position in the film's dramatized dialectical debate: even apart from the other shots in the scene, it shows us that these soldiers are in a tough spot. They are at least out of basic provisions, such that they must check the local garden hoses for water. The fact that there's no running water in the hose further underscores the trouble they are in. And the further fact that the soldier tries to drink whatever water might be trapped in the hose since its last use underscores the trouble even more emphatically. We read the argument of this shot—*The British are in trouble*—by articulating to ourselves, in a simple act of intelligence, what is happening in this image of a young man living and moving in front of us.

No matter how short a shot is, it is a compositional whole: there is a beginning, middle, and end governed by a Controlling Idea. In the above example from *Dunkirk*, the Controlling Idea, in McKee's equation of Value + Cause, would be *The British are*

8. Though my discussion of cinematic language is indebted to that of Mortimer Adler in his book *Art and Prudence*, my analysis differs from his in emphasizing how dramatized dialectical debate is the formal element in every image of a film.

in trouble because their enemies are apparently getting the best of them. Because each shot has a beginning, middle, and end, we can speak of each shot as manifesting one of the characteristics of beauty: wholeness or integrity. If Nolan had cut the shot right at the point where the young man's hand touches the spigot, the scene would not have achieved wholeness and intelligibility. We would have wondered *why* Nolan had shown us the young man reaching for the spigot and nothing more. *Did the soldier get a drink, or did he not get a drink? Did he want to use the water for something else?* We would not know. The "plot" of the young man and the garden hose would be incomplete and unintelligible.

We can also talk about the proportion of the shot insofar as we can talk about how the parts of the soldier's action—turning on the spigot, kneeling down to drink without even bothering to uncoil the hose—are ordered to one another in making up the single action *trying to get a drink from the hose,* and thus make up the compositional whole of the shot. We can also detect radiance in this simple short shot. On the sensible level, the shot is admittedly not the most radiant in the film, though there is something in the open end of the hose with its lack of a nozzle that strikes one as *impoverished,* and something *desperate* about the soldier drinking in this way. On the intelligible level, the shot radiates two levels of meaning: on the literal level, that the soldier needs water and is not going to get much from this hose; on the moral level, as we've said, that *the British are in trouble because their enemies are apparently getting the best of them.*

Notice how much meaning, how much intelligibility, is in each shot of a film, no matter how mundane. Consider that in writing the script, shooting the film, and later editing the film, Christopher Nolan made and remade the decision to show, if only for a few seconds, one of the soldiers trying to get a drink of water from a garden hose. For Nolan, this little act meant something. He thought it worth writing, rehearsing, shooting, and keeping in the edited film. In conceiving this shot, Nolan well understood

that compositional wholeness and intelligibility do not come to light only when a film is over but at each step—each shot—of a film's argument.

There are many different kinds of shots. For example, there are establishing shots (wide-angled shots that establish the location for a scene or for an entire film), master shots (which typically give us a look at all the partners in a particular conversation), over-the-shoulder shots (used most often as we switch back and forth between two or more people in conversation), close-ups (of various degrees of proximity), and tracking shots (in which the camera is pushed down a track in order to capture the movement of one or more persons).[9] The different kinds of shots make up the elemental "grammar" of cinematic argument. More precisely, each shot is its own argument, its own very short story.

THE ARGUMENT OF CINEMA: SCENE, SEQUENCE, AND ACT

How does a scene differ from a shot? How is it *more* of a compositional or intelligible whole than a shot is? On the material level, a scene is a series of shots with an identity of locale. On the formal level, a scene involves a movement from one value charge to another.

Robert McKee captures both the material and the formal levels in his definition of a scene as "an action through conflict in more or less continuous time and space that turns the value-charged condition of a character's life . . . with a degree of perceptible significance."[10] It only needs to be kept in mind that the "action through conflict" photographed "in more or less continuous time and space" involves two or more shots cut or juxtaposed together in order to advance the story.

9. Although a tracking shot does not maintain one position, there remains one overall "condition" of the camera (angle, height) as it follows the action.

10. McKee, *Story*, 35.

The opening scene of *Dunkirk*—the portion of the script re-produced above, from our first look at the group of young British soldiers walking down the street, to the point where "Tommy," the unnamed British soldier who emerges as the film's protag-onist, finds himself on the beach at Malo-les-Bains, where he discovers hundreds of thousands of soldiers waiting for rescue—consists of thirty-one shots.[11] Each one of these thirty-one shots tells a story, but an even more complete story is told by the scene. What is the scene's beginning, middle, and end? The beginning of the scene, its Inciting Incident, is when the British are fired upon by unseen German forces. What we see before this, includ-ing the shot of the soldier drinking from the garden hose, tells us that these soldiers are in trouble, that they are experiencing conflict. But in the world of the story, this much was true earlier that day, and the day before, and probably the day before that. In the world of the story, this level of conflict is the *status quo ante*, a (relative) calm before the storm. The story of the film is what will happen to these soldiers—we don't know yet that one of them will emerge as a single protagonist—from *this* moment. The Ger-mans firing upon them is what happens to them in this moment, and it launches Tommy onto a new path, the scene's "middle." Initially, that path is running away down the street as fast as he can and jumping a fence at the end of it. Then his path involves cocking his rifle and firing back at the Germans who continue to fire upon him. Then it is entering a new street and coming upon a group of French soldiers behind a barricade of sandbags. Once they identify Tommy as English, they allow Tommy to scramble over their barricade, only to push him away out the back. This leads Tommy down an alley that opens out onto the beach, where he realizes, at the "end" of the scene, that he is only one of a myr-iad of soldiers in need of rescue.

11. You can study the scene, 3:06 of screen time, here: "Dunkirk (2017), Opening Scene, HD," YouTube video, accessed July 11, 2022, https://www.youtube.com/watch?v=c7DH-baY54YQ.

So here we have a wider wholeness, comprised, like the shot, of both matter and form. Materially, this scene is a series of thirty-one juxtaposed shots sharing an identity of locale (a couple of streets in Dunkirk). Formally, this scene presents a turn or change in the "value-charged condition of a character's life . . . with a degree of perceptible significance." What is that turn or change? Certainly not a deeply dramatic turn from Tommy's being in trouble to Tommy's being rescued. It is a subtler though still dramatic turn from Tommy's being in trouble to Tommy's being in much deeper trouble. The presence of the tens of thousands of men stranded on the beach intimates that Tommy faces major obstacles to the achievement of his goal: survival. And this is what keeps us, the audience, wanting to see more. The change in Tommy's circumstances from bad to worse raises the question in our minds: *Is he going to make it out of this situation alive? Is he in fact going to survive?* Because we are curious to know the answers to these questions, we keep munching our popcorn and watching.

The "I am your father" scene from *Star Wars: Episode V—The Empire Strikes Back* also and very famously fulfills the definition of a scene. Materially, the scene is a series of juxtaposed shots (I'll leave you to count them[12]) in one locale—a catwalk somewhere in the bowels of Cloud City. Formally, the scene presents a turn in Luke Skywalker's fortunes, from very bad (being in a lightsaber death match with Darth Vader, the archvillain of the universe, who has just cut off Luke's hand and is pressuring him to join the dark side of the Force) to even worse (finding out that the archvillain of the universe is his dad).

Now we turn from the scene to the sequence. A sequence, sometimes called a montage, is an even larger compositional

12. "Star Wars: Episode V—"I am your Father," YouTube video, accessed July 12, 2022, https://www.youtube.com/watch?v=_lOT2p_FCvA.

whole than the scene. On the material level, it can be composed either of

1. scenes; or
2. different shots, reflecting different locations, that are not organized into scenes; or
3. *both* shots reflecting different locations *and* different scenes.

On the formal level, a sequence stands for a larger argument, a more significant turn or reversal of the value-charged condition of the protagonist. Robert McKee defines a sequence as "a series of scenes—generally two to five—that culminates with greater impact than any previous scene."[13]

A fine example of a sequence can be found at the end of Nolan's *Dunkirk*. Materially, it is a sequence in the third sense listed above, in that it involves different scenes juxtaposed as well as some shots. The sequence is linked thematically by Tommy's reading aloud a newspaper account of Winston Churchill's speech in the House of Commons addressing the Dunkirk evacuation. Tommy by this point (spoiler warning) has achieved his goal. He is back in England, safe and on a train with one of the other British soldiers with whom he has shared many harrowing adventures. As Tommy reads Churchill's speech to the other soldier, the film intercuts between (a) this scene in the train; (b) a scene of one of the small boat owners showing the obituary of his son, who was accidentally killed on the boat during the evacuation, to his other son; and (c) a scene of Farrier, a British Spitfire pilot, whose plane is out of fuel, landing at the beach of La Panne near Dunkirk and being captured by German soldiers. Interspersed with these scenes are shots of Dunkirk's harbor that show dead bodies floating in the water and discarded helmets on the beach.

Formally, a sequence pictures a more significant turn or reversal of the value-charged condition of the protagonist. This

13. McKee, *Story*, 38.

sequence from *Dunkirk*, however, because it occurs after Tommy and the major supporting characters have achieved, or failed to achieve, their goals (Farrier, the Spitfire pilot, has not yet been captured when the sequence begins, but it is clear that he is going to be), does not so much picture a turn or reversal as much as it reveals the *consequences* of the climactic turns that Tommy and the major supporting characters have just gone through. These consequences manifest the theme—that is, the Controlling Idea—of each one of the scenes and shots in the sequence. So Tommy and his comrade discover, as crowds of civilians cheer the train from a station platform, that their rescuing will lead not to revulsion by the British people ("They'll be spitting at us in the streets," fears Tommy's comrade Alex) but to their being treated as heroes. The Controlling Idea driving this scene is that *One is a hero if only because one has survived, because survival means that one has risked all.* The Controlling Idea of the scene of the father and son reading the other son's obituary is that *One is a hero even if one dies accidentally in fighting for a good cause.* And the Controlling Idea of Farrier's scene is that *One is a hero by sacrificing his very life for a good cause* (Farrier chose to continue providing air cover for others rather than return home due to low fuel). Finally, the Controlling Idea of the shots of dead bodies in the water and helmets on the beach is *War is a terrible thing because its cost is the lives of many young men.* The Controlling Idea for the sequence as a whole is that *Heroism or courage is greatly to be honored because it costs not less than everything.*[14]

The act is the largest compositional whole of a feature film that still functions as a part of a film. McKee defines an act as "a series of sequences that peaks in a climactic scene which causes a major reversal of value, more powerful in its impact than any

14. A good introduction to Christopher Nolan's use of the sequence or montage can be found at StudioBinder, "How Christopher Nolan Elevates the Movie Montage," YouTube video, accessed July 12, 2022, https://www.youtube.com/watch?v=29xvA9Ly7IQ&t=330s. This sequence from *Dunkirk* is discussed beginning at 4:17.

previous sequence or scene."[15] An effective turning point of an act, according to screenwriting teacher Linda Seger, typically requires a major new decision on the part of the protagonist(s), a decision that raises the stakes of the protagonist's pursuit of the goal, turns the story in a whole new direction, and pushes the story into the next act.[16] A popular feature film almost always has three acts, meaning that the story will have three major turning points: at the end of the first act, at the end of the second act, and the final climax and turning point at the end of the third act. In Ron Howard's film *Apollo 13*, the turning point at the end of the first act is the unexpected explosion that compromises the spacecraft and turns a routine mission into a struggle for the astronauts' survival; the turning point at the end of the second act is the discovery of a new idea that everyone hopes will save the lives of the astronauts; and the third, climactic turning point is the success of the new idea and the safe splashdown of the astronauts in the ocean.[17]

THE RHETORIC OF CINEMA

If a film story builds its argument not with premises in the literal sense but with shots, scenes, sequences, and acts, then the *way* in which these elements are used constitutes the rhetoric, or style, of the film. Cinematographer and director Blain Brown argues for the need for cinematographic rhetoric, or what he calls "composition," as the means for enabling an image to "speak" forcefully and persuasively *on its own*:

> If all we did was simply photograph what is there in exactly the
> same way everyone else sees it, the job could be done by a ro-
> bot camera; there would be no need for a cinematographer or

15. McKee, *Story*, 41.

16. Linda Seger, *Making a Good Script Great*, 3rd ed. (Los Angeles, CA: Silman-James, 2010), 32.

17. For a full analysis of the structure of this film, see Seger, *Making a Good Script Great*, 41–42.



editor. An image should convey meaning, mode, tone, atmos-
phere, and subtext on its own—without regard to voice-over,
dialogue, audio, or other explanation. This was in its purest
essence in silent film, but the principle still applies: the images
must stand on their own."[18]

Bruce Block, the holder of the Sergei Eisenstein Endowed
Chair in Cinematic Design at the University of Southern Cali-
fornia, distinguishes seven basic visual components of film: space,
line, shape, tone, color, movement, and rhythm.[19] Blain Brown
also mentions unity, balance, visual tension, proportion, contrast,
texture, and directionality. Such rhetorical components all have to
do with the composition, or the compositional form, of what is
placed within the frame. In their various ways, these elements sup-
port the film's dramatized dialectical debate. As Block contends,
"A visual component communicates moods, emotions, ideas, and
most importantly, gives visual structure to the pictures."[20]

The rhetorical elements of space, line, and shape all pertain
to the arrangement of visual components in the camera frame
that directs the attention and emotional reaction of the audience.[21]
Space refers to the physical space in front of the camera, which
might be tightly enclosed by characters in a close-up, or which
might include an entire landscape in a wide shot.[22] As an example
of the latter use of space, consider the way in which Hitchcock, in
the famous crop duster scene from *North by Northwest*, uses wide

18. Blain Brown, *Cinematography: Theory and Practice*, 3rd ed. (New York: Routledge, 2016), 14.

19. Bruce Block, *The Visual Story: Creating the Visual Structure of Film, TV, and Digital Media*, 3rd ed. (New York: Routledge, 2020).

20. Block, 2.

21. See the discussion of film blocking and its use of the elements of space, line, and shape in the video tutorial at "Filmmaking Techniques: Blocking for Directors," StudioBinder, accessed July 12, 2022, https://www.studiobinder.com/filmmaking-techniques-film-blocking/. I owe the example from *The Godfather Part II* to this source.

22. See Block, *Visual Story*, 2. For more on the element of "space" and how camera choices manage audience attention, see Noël Carroll, *The Philosophy of Motion Pictures* (Malden, MA: Wiley-Blackwell, 2007), chap. 5.

shots of Cary Grant's character in a barren, isolated landscape in order to emphasize his vulnerability, especially when a plane that looks like an ordinary crop duster comes to hunt him down. But accomplished film directors also arrange the visual components in the camera frame into definite shapes—circles, squares, or triangles—to communicate ideas and emotion to the audience. Circles typically suggest safety and inclusivity. Squares limit space, boxing characters in. The sharpness of triangles indicates energy and power, especially in relation to the character positioned at the apex of the triangle. Lines also create powerful dynamics between characters, as in the scene toward the end of Francis Ford Coppola's *The Godfather Part II* when the vertical line created by Michael Corleone as he stands by a window creates tension with the nearly horizontal line created by his brother Fredo, reclining in a nearly supine position next to him in a chair. The vertical line created by Michael suggests power over the nearly horizontal line created by Fredo, which is appropriate given that the point of the scene is Michael's condemnation of his brother for his treachery. These ways of arranging or "blocking" actors and other visual components work to externalize the conflict that typically is being played out in the film's dialogue.

What should be clear is that in a film, there is no such thing as the merely or purely pictorial. A wide shot of Cary Grant emphasizes his vulnerability as a hunted man. A character's vertical positioning indicates power. The visual elements of a film are never detachable from the intentions of the characters involved and the themes that arise from those intentions; visual elements always function as ingredients in, or enhancements of, the dialectical argument that makes up the story.

Use of the color palette can also move us to react emotionally to one or other of the intentions in conflict.[23] The director David

23. Lighting is related to color in that it is what allows color to be perceived. See Roger Deakins on StudioBinder, "Learning to Light—Cinematography Techniques Ep. 1," YouTube video, accessed July 12, 2022, https://www.youtube.com/watch?v=K9w8I_YD29E.

Fincher is well known for color-grading his locations to a uniform shade, and for making particular and repeated use of the color yellow. His use of yellow is so consistent that when he introduces a different color into a scene predominated by yellow tones, it stands out and suggests a certain meaning to the audience. In Fincher's adaptation of the novel *Gone Girl*, for example, there is a scene in which the husband of a woman who has mysteriously disappeared appears before the press, along with his wife's parents, in order to plead to the public for information about his wife's whereabouts. Everything about the scene is in yellow or earth tones, including the clothing of the husband's in-laws, but the husband himself wears a blue shirt, a fact that strikes our eye as discordant and draws our attention to him. Fincher's use of the color blue in this scene triggers suspicion in the audience; it gives them a sense that the husband does not form a unit with his in-laws, that he does not stand with them and that perhaps he himself is the cause of his wife's disappearance.[24]

Let us conclude this discussion of cinematic rhetoric by giving special attention, as we did with painting, to rhythm as an element in a film's visual persuasiveness. In his discussion of painting, Sokolowski speaks of the rhythm or prosody of a painting's "speech." When it comes to expressing rhythm, motion pictures have an obvious advantage over still images because the visual elements in the film frame are most of the time quite literally in motion. Rhythm is thus easier for a movie audience to discern and to engage with emotionally. It can be established in more than one way. For example, the *pacing* of cuts in a scene—as in the quick cuts often employed in thrillers when two drivers are involved in a chase scene—creates a definite pulsating rhythm, a rhythm usually accentuated by the rhythm of the accompanying soundtrack. Rhythm can also be established between entire scenes

24. StudioBinder, "Why is David Fincher a Genius?—Directing Styles Explained," YouTube video, accessed August 30, 2023, https://youtu.be/F3ZSX3D1dUI?si=y7JUPvB5Q6igdA2p.

and sequences, as when a fast-paced chase scene is followed by a slower, quieter scene in which, for example, the protagonist, having escaped in the chase, begins anew to extricate himself from his predicament. While it is the chief aim of a film to take the audience on an emotional journey, no audience can be held at a pitch of excitement for the two hours of the film. There must be a varied rhythm to the film's emotional experience.

Rhythm in film can also be achieved by the motion of the actors and the music of the dialogue within a single shot or scene. David Mamet's dialogue, both in his stage plays and his films, is often described as having a staccato rhythm.[25] But a good example of both rhythmic movement of the actors and rhythmic dialogue occurs in a scene from Greta Gerwig's 2019 adaptation of *Little Women*, a scene where several characters engage one another in the library of Mr. Laurence's stately home. The scene begins with three characters in the room: Laurie, Amy March, and Mr. Brooke, Laurie's tutor. Amy has just been punished at school and has an injured hand, though her spirits are far from dampened as she playfully shows Laurie a picture she likes in one of the books on a table. At this point, two of Amy's sisters, Jo and Meg, enter the library—the first time they have ever been in the house. Their entrance creates a swirling motion as everyone reacts both physically and emotionally to their entrance. The shots begin to cut quickly, and the excited dialogue overlaps. Each short shot, however, gives us insight into one of the characters and reveals emotional dynamics between them. Jo reveals her bookish nature when, upon seeing all the books, tells Laurie that he "must be the happiest boy in the world." A quick shot is then inserted of Mr. Brooke, who, because of his feelings for Meg, moves with romantic interest toward the sofa upon which Meg and Amy have sat in order to examine Amy's

25. In his course on dramatic writing on the MasterClass platform, Mamet himself teaches that all good dialogue is rhythmic. (https://www.masterclass.com/classes/david-mamet-teaches-dramatic-writing). See also the excellent discussion of screenwriter and playwright Aaron Sorkin's rhythmic dialogue at Insider, "How Aaron Sorkin Creates Musical Dialogue in *The Social Network* | 10 Minutes of Perfection," YouTube video, accessed July 12, 2022, https://www.youtube.com/watch?v=SExMi2E4fRI.

injured hand. Laurie, meanwhile, responds to Jo's comment about the books by saying, pointedly, "A fellow can't live on books alone," to which Jo retorts, "I could," even as she moves to the sofa to ask Amy, accusingly, what she did to her hand.[26] Amy then launches into a not-too-accurate defense of her innocence at school, during which a shot is inserted of Laurie looking longingly at Jo, further revealing his feelings for her. And the scene goes on. But already, in just under twenty seconds of screen time, the swirling motion of the characters, combined with the quick tempo of the cuts and the overlapping dialogue, creates a rhythmic energy appropriate to the youthful energy of these characters.[27]

THE BEAUTY OF FARRIER'S LANDING

From shots, scenes, sequences, and acts, with each subsequent part encompassing the lesser wholes of which it is composed, the dramatized dialectical debate of a three-act feature film is constructed. The climactic turning point at the end of the third act, including whatever wrap-up or denouement is necessary (such as the final sequence of *Dunkirk*), is the moment of maximum wholeness and intelligibility, where the marvelous inevitability of the protagonist's essay at beatitude is finally revealed and the delightfulness of the story-argument either persuades or fails to persuade. The climactic turn of the Farrier storyline from *Dunkirk* is especially marvelous and achieves a poignant beauty. The goal of Farrier's adventure is to provide air cover for the small boats sailing to Dunkirk to evacuate the soldiers on the beaches. He is extremely successful shooting down enemy planes, but at the cost

26. The actions, emotions, and dialogue captured in the shots of Laurie and Mr. Brooke in this scene can be thought of as making up the "premises" in the romantic arguments that each young man contributes to the film's dialectic.

27. Though she doesn't use the word itself, in an interview regarding *Little Women* Greta Gerwig clearly is speaking about rhythm when she explains why she is so proud of the blocking in this scene (Vanity Fair, "Saoirse Ronan, Timothée Chalamet, Laura Dern & Greta Gerwig Break Down a Scene from 'Little Women,'" YouTube video, December 17, 2019, esp. 2:34 to 3:20, https://www.youtube.com/watch?v=Li9ff4rQlck).

of using up all his fuel, which means that he will not survive the fight uncaptured. The turning point itself occurs in Farrier's decision to continue fighting despite his low fuel. That decision is the marvelously inevitable result of his commitment to his duty. But it is the scenes of Farrier out of fuel and gliding over the beaches of Dunkirk, looking for a place to land—scenes where the consequences of his heroic decision are most fully felt by the audience—that most beautifully disclose the *wholeness* of his storyline as it achieves its end, the triumphant-yet-melancholic *proportion* of the film's parts as the scenes of Tommy and Alex being celebrated contrast ironically with Farrier's capture, and the *radiance* of Farrier's landing on the beach that puts on display the glorious moral truth that *There is no greater good than to sacrifice one's life for one's friends.*

EXT. BEACH AT LA PANNE – CONTINUOUS

Farrier kneels, hands on head, as dark shapes of German soldiers (seen only from behind) surround him . . .[28]

28. Nolan, *Dunkirk*, 94.

12

Staging the Theo-Drama

Celebrated playwright and screenwriter Tom Stoppard likes to tell of an open-air production of *The Tempest* he attended in the late 1950s staged by a lake in the gardens of an Oxford college. Stoppard recounts one of the closing moments of the play:

> When it became time for Ariel to leave the action of the play he turned and he ran up the stage, away from the audience. Now the stage was a lawn, and the lawn backed onto a lake. He ran across the grass and got to the edge of the lake, and he just kept running, because the director had had the foresight to put a plank walkway just underneath the surface of the water. So you have to imagine: it's become dusk, and quite a lot of the artificial lighting has come on, and back there in the gloom is this lake. And Ariel says his last words and he turns and he runs and gets to the water and he runs and he goes splish splash, splish splash, right across the lake and into the enfolding dark, until one can only hear his little figure disappeared from view. And at that moment, from the further shore, a firework rocket was ignited and just went whoosh into the sky and burst into lots of sparks. All the sparks went out one by one and Ariel had gone. Here's the thing: you can't write anything as good as that. When you look it up, it says "Exit Ariel."[1]

1. This story concludes Hermione Lee's biography of Stoppard, *Tom Stoppard: A Life* (New York: Alfred A. Knopf, 2021), 754. As Lee indicates in the accompanying note, this

Imagine being at that production of *The Tempest* when Ariel ran across the water and the firework exploded. How enthralling it would have been! Those are the kinds of moments we look for in the theater, indeed with the experience of any mimetic art: moments of *contemplative presence*, when the performance overwhelms us with its beauty and with its truth.

In this chapter of our survey of various mimetic arts, I would like to explore some of the ways in which theater achieves these moments of contemplative presence. Certain things I say will pertain to acting in general, and thus include film and television and voice acting, but my primary focus will be on acting for the stage, which, for reasons I touched on in the last chapter, is the most significant expression of the most distinctive kind of mimesis: enactive mimesis. One or two things I say in this chapter will also have implications for the art of dance.

It may seem strange that I am leaving out the most essential element of stage drama: the play itself. But in our discussions of the relationship between mimesis and story, storytelling as a form of moral argument, and the Catholic imagination, we have already explored many of the issues that arise when considering the play as a narrative, as a *literary* work. So here I will leave the analysis of particular dramatic narratives to one side, except insofar as they help us understand the staging and acting of plays and how the art of dramatic performance pictures the theo-drama. In terms of the chart I introduced in chapter 11, we will be concentrating on the medium and manner of imitation involved with dramatic performance.

is a story Stoppard also tells in his lecture "The Event and the Text," which can be found in *Tom Stoppard in Conversation*, ed. Paul Delaney (Ann Arbor, MI: University of Michigan Press, 1994), 199–211. The epigraph to this chapter is taken from "The Event and the Text," 201. In her note, Lee adds that Stoppard revised the story when he told it to her in conversation on November 1, 2019.

The Art of Acting	
Object of imitation	Human beings in action
Medium of imitation	The human body and often, though not necessarily, speech
Manner of imitation	Action "living and moving before us" presented live upon some sort of stage.

ARIEL'S EXIT

But theater is a curious equation in which language is merely one of the components.

Tom Stoppard, "The Event and the Text"

"The playwright's work is *potentially* drama: it only becomes *actual* through the actor."[2] So insists Hans Urs von Balthasar, thus seeming to contradict Aristotle. In the *Poetics*, Aristotle asserts of any tragedy worth its salt that "even without seeing a performance, anyone who hears the events which occur [in it] will experience terror and pity as a result of the outcome."[3] Aristotle seems to be saying that what the playwright manufactures—a plot—is all that is necessary to actualize drama and move an audience to pity and fear. All one need do is read the story. No performance required.

Mortimer Adler agrees with Aristotle and explicitly extends the point to all drama: "The drama as a piece of literature exists independently in writing, whether or not it is produced; the verbal composition is an adequate imitation of human action."[4]

Gilson, however, agrees with Balthasar:

To say that a play is a written work before being spoken is a confirmation of this obvious fact. But from this it does

2. Balthasar, *Theo-Drama: Theological Dramatic Theory*, vol. 1, *Prolegomena*, 1:281.
3. *Poetics* 14 (1453b3–6).
4. Adler, *Art and Prudence*, 472.

not follow that a play is at one and the same time a written work by virtue of its essence and its destination. . . . A play is first of all written with a view to being heard and it is not well-written unless the text grips the imagination of the public when it is spoken on the stage by actors.[5]

Gilson and Balthasar, to my mind, have the better of this argument. A play, a screenplay, a libretto for an opera, no matter how enjoyable in its own right, is not a work of literature in the way that a novel or poem is. Rather, such works are elaborate blueprints for live performance. Speaking as someone who has both taught Shakespeare in a high school English classroom and taught Shakespearean acting to, and adapted and directed Shakespearean plays with, high school actors, I can say that mistaking even Shakespeare's plays as primarily literature is the reason why they so often fail in the classroom. But put the plays of Shakespeare "on their feet," even with teenagers, and magic happens. The language, hitherto impenetrable, becomes much more easily understood because now it is attached to action and character "living and moving in front of us." Perhaps the fact that not even Shakespeare regarded his dramatic writing primarily as literature helps explain why he apparently, in retirement in Stratford, did not keep his collected works upon his shelf.

It is not that Aristotle and Adler are wholly wrong. In the text from the *Poetics* cited above, Aristotle is chiefly observing that while it is possible for a performance of a tragedy to produce pity and fear in an audience through stage effects—what Aristotle calls *opsis* or "spectacle"—it is the tragic playwright's task to ensure that the audience experiences the tragic effect not on account of stage pyrotechnics but on account of the events set forth in the plot. That someone can sit down and read *Oedipus the King* and experience *something* of pity and fear is undeniable.

5. Étienne Gilson, *Forms and Substances in the Arts*, trans. Salvator Attanasio (Dallas, TX: Dalkey Archive, 2001), 275.

I have witnessed the shocked reactions of young teenage students when, in reading Sophocles's play for the first time and having never seen a production of it, they recognize with Oedipus that he is the one who killed his father and married his own mother.

Yet it is also undeniable that Sophocles did not intend his writing for a classroom literary exercise. He meant the play to be enacted, and I am quite sure that if my students had encountered *Oedipus the King* for the first time in live performance, they would have been moved much more profoundly than when they were reading the play silently to themselves as homework.

What is it that makes live performance so moving? What is this capability of the actor to bring a text to life and make us think and feel so profoundly? Even apart from the gifts of the playwright—which of course contribute to the movement of the audience—what power does the actor have to help the audience transcend the surface of things and grasp the mysterious truth of the human quest for the good?

The specific difference of the actor's art is potentially two-fold. The medium of the actor's mimesis is the actor's body and, sometimes, the use of speech. When the actor only uses his or her body on stage, as in a pantomime, the only difference between acting and dance, in this instance, is that dance involves greater continuity and fluidity of movement. But if the dramatic performance involves speech, as in a performance of *Oedipus the King* or *Hamlet*, the medium of the actor's mimesis is specifically different than that of dance.

But acting is always specifically different from other mimetic arts in its manner of mimesis: the picturing of human beings living and moving in front of us. It's true that a live performance can be recorded for film or television and retain much of its power. Indeed, the recorded performance has its own advantages, in that it can be shared with an audience with a degree of intimacy—for example, in an extreme close-up—denied live performance. But there is an intimacy to live performance that no recording, or

even digital livestream, can quite capture. Sit in a theater before a performance that you are much anticipating, and even before the lights go down, you will feel an electricity in the room associated with the fact that, in a moment, characters will be living and moving in front of you. Here again, we notice the intoxicating delight we human beings take in enactive mimesis, the kind of picturing that breathes and moves and can look us in the eye. In performance, the mimetic universal is not just embodied in some material; it is embodied in material that closely mirrors the look and abilities of the audience. The distance between the picture and the pictured is reduced closer to zero than in any other mimetic art.[6] And so, in attending a live dramatic performance, it is much easier and more delightful for us, the audience, to recognize that "this image is of so-and-so"—that is, of *us*—and thereby to contemplate the picture of ourselves on stage.

About dance, Gilson says the following:

> The dance is pre-eminently the domain of the union of body and mind, or as traditional philosophy—ever so close to reality—expressed it: their "substantial union." The born dancer thinks with his body the way he dances with his mind. No other art is so completely and integrally an art of man, understanding thereby the human being in the organic unity of all his constitutive material and spiritual elements.[7]

This is well said. But I would contest Gilson's claim that no other art is so completely and integrally an art of man as dance. I believe that when the medium of the actor's art is connected to speech of the highest order, such as we find in Sophocles and Shakespeare,

6. I don't say the distance is reduced absolutely to zero simply because the two-hours' traffic of a live dramatic performance remains an artifice that in no way copies real life.

7. Gilson, *Forms and Substances in the Arts*, 191.

there is no other mimetic art that so maximally exercises the material and spiritual powers of human nature.

David Mamet, interestingly, grounds the elemental nature of theater in the predatory instincts of the communal hunt:

> In the hunt story, the audience is placed in the same position as the protagonist: The viewer is told what the goal is and, like the hero, works to determine what is the best thing to do next. How may he determine what is the best course toward the goal? Through observation. He, the viewer, watches the behavior of the hero and his antagonists, and guesses what will happen next. . . . In this prognostication we engage the same portion of the brain that we use when we hunt: the ability to spontaneously process and act upon information without subjecting the process to verbal (conscious) review.[8]

Mamet is onto something here. A protagonist's—and by imaginative extension an audience's—desire to do all that is necessary to achieve an important goal, in circumstances that are typically rather desperate, does summon basic instincts to do whatever is necessary to attain the goal, whether the goal be survival or some other critical aspect of well-being. But note well that the dramatic protagonist's hunt is not of course for game but for *well-being*, for the good that will bring completion and meaning not only to the protagonist's life but to the lives of those he or she loves. This desire for completion, communal just as the hunt for game is, is as instinctual in rational animals as the desire for food and survival. It has to do with the survival of the spirit.

This helps explain why theater in the West has its origins in religious ritual and myth, for these are the elemental ways in which we human beings seek the (ultimately divine) source of well-being that makes sense out of our lives. Francis Fergusson, in

8. David Mamet, *Theatre* (New York: Farrar, Straus and Giroux, 2010), 17–18.

an illuminating discussion of Sophocles's *Oedipus the King*, characterizes Sophocles's audience as having a *ritual expectancy*:

> Sophocles' audience must have been prepared . . . to consider the playing, the make-believe it was about to see—the choral invocations, with dancing and chanting; the reasoned discourses and the terrible combat of the protagonists; the mourning, the rejoicing, and the contemplation of the final stage-picture or epiphany—as imitating and celebrating the mystery of human nature and destiny. And this mystery was at once that of individual growth and development, and that of the precarious life of the human City.[9]

Fergusson highlights here the original link between imitation and ritual. Religious ritual and the myths that inform it picture and celebrate "the mystery of human nature and destiny." Greek tragedy was an outgrowth of the ancient Athenian community's desire to find and celebrate ultimate meaning through imitation. Oedipus is shown by Sophocles, Fergusson writes, "seeking his own true being; but at the same time and by the same token, the welfare of the City. When one considers the ritual form of the whole play, it becomes evident that it presents the tragic but perennial, even normal, quest of the whole City for its well-being."[10] It is worth noting that the area of stone benches on which Athenians sat to watch plays was known as the *theatron*, literally the "seeing place," the place of contemplation (the word Aristotle uses for philosophical contemplation is the related word *theōria*). Our very word "theater" is thus linked to intellectual-appetitive gazing at the mystery of human life.

Theater as the community's contemplative space is a thought applicable not only to ancient Greek tragedy but to all drama.

9. Fergusson, *The Idea of a Theater* (Princeton, NJ: Princeton University Press, 1949), 40–41.
10. Fergusson, 41.

Drama feels so elemental to us because of its link to the original mythic-ritualistic mimesis of the community's hunt for fulfillment and meaning. In terms of the Aristotelian-Thomistic tradition, dramatic performance is the political community's enacted contemplation and celebration of its shared destiny in the theo-drama. Though mainstream contemporary theater is culturally very far away from the situation of ancient Greek drama, the mythic-ritualistic origins of theater in the West are so charged with primal energy that we cannot help but feel the depth of their power even in our theater's largely secularized form—if only as the sensation of a phantom limb.

A PLATFORM AND A PASSION OR TWO

Thornton Wilder's *Our Town* earns my vote for the best play ever written by an American.[11] Many know it as the play with a minimal set and no props in which the characters pantomime all their actions. In one of his writings, Wilder explains why he chose to stage the play in this unusual fashion:

> Every action that has ever taken place—every thought, every emotion—has taken place only once, at one moment in time and place. "I love you," "I rejoice," "I suffer," have been said and felt many billions of times, and never twice the same. Every person who has ever lived has lived an unbroken succession of unique occasions. Yet the more one is aware of this individuality in experience (innumerable! innumerable!) the more one becomes attentive to what those disparate moments have in common, to repetitive patterns. As an artist (or listener or beholder) which "truth" do you prefer—that of the isolated

11. I therefore agree with Mamet. See his chapter "Great American Plays and Great American Poetry," in *Theatre*, 70–74.

occasion, or that which includes and resumes the innumera-
ble? Which truth is more worth telling?[12]

Wilder is wrestling here with the tension between personal ex-
perience ("I love," "I suffer") and the understanding of what is
essential and universal to human beings *as such* (the nature of
love, the nature of suffering). Each of these ways, Wilder attests,
is a way of truth. My personal experience of love has a truth for
me that cannot simply be absorbed in the "common experience
of love." At the same time, there is a truth in what is essential to
human loving that may or may not be reflected in my personal
experience of loving. Wilder asks us: Which way of truth do you
prefer? Which truth is more worth telling?

William Lynch, recall, advocates an imagination that goes
"up" to the transcendent and universal, and ultimately to God,
only by first going "down" into all the particularities of time and
place and individual experience. One doesn't really have to choose
between the way of personal experience and the way of under-
standing the essentials of things. *The way up is the way down.*
Wilder came to the same realization and thought the theater was
the ideal place to picture this trajectory:

> The theater is admirably fitted to tell both truths. It has one
> foot planted firmly in the particular, since each actor before us
> (even when he wears a mask!) is indubitably a living, breathing
> "one"; yet it tends and strains to exhibit a general truth since
> its relation to a specific "realistic" truth is confused and un-
> dermined by the fact that it is an accumulation of untruths,
> pretenses, and fiction.

Theater for Wilder gives us the one small individual (Oedipus;
Hamlet, prince of Denmark; Emily in *Our Town*) in a magnetic

12. Thornton Wilder, "Preface to Three Plays," in *Collected Plays & Writings on Theater* (New York: Library of America, 2007), 684–85.

333

picturing that breathes and moves and looks us in the eye, even while it presents us with that which "includes and resumes the innumerable" particulars—that is, the "general truth." The exhibiting of this "general truth," however, can be a strain. The source of this strain, as Wilder sees it, was the dramaturgy of the nineteenth century, geared as it was toward a rising middle class that liked its theater soothing in the form of naturalistic melodramas, sentimental dramas, and easily digestible comedies. These audiences liked to keep the power of theater at arm's length, and so they settled it comfortably in a box, under a proscenium arch, coverable with a curtain. They "emphasized and enhanced everything that thus removed, cut off, and boxed the action; they increasingly shut the play up into a museum showcase."[13]

But it wasn't just the box set that kept the action removed and cut off from the nineteenth-century middle class audience's encounter with the "general truth" that might touch their hearts. It was also the naturalistic staging. To imitate the individual on stage in a realistic or naturalistic mode means depicting that individual with all the *accoutrement* such an individual requires in real life. Time and space will need to be pictured with exactness. We will need bookshelves upstage with real period books in them.

> They loaded the stage with specific objects, because every concrete object on stage fixes and narrows the action to one moment in time and place. . . . So it was by a jugglery with time that the middle classes devitalized the theater. When you emphasize *place* in the theater, you drag down and limit and harness time to it. You thrust the action back into past time, whereas it is precisely the glory of the stage that it is always "now" there. Under such production methods the characters are all dead before the action starts. You don't have to pay deeply from your heart's participation.[14]

13. Wilder, 684.
14. Wilder, 685.

Wilder is not saying that the theater should try to free itself from place and time and individual experience. What he is after, rather, is a dramaturgy that pictures place and time and individual experience without committing to realism, because realism, he thinks, obstructs the imagination as it attempts to move *through* the particular *to* the universal. Realistic staging gives us too much particularity and, consequently, too much of what will be, if not today then tomorrow, thrust back into past time. But when we are confronted by a showing that is so obviously in past time, it is more difficult to experience the always "now" of the "general truth." It would be better, Wilder thinks, to do away with naturalistic staging. After all, we all know that stagecraft is "an accumulation of untruths, pretenses, and fiction." We know that the door stage right does not lead onto a street. We know that the prop master had to collect those period books and arrange them on the bookshelf. We do not need reality to be "copied" so exactly. We just need enough of a mimetic connection to real life such that we can see how the "general truth" of the play is related to the particularities of our personal experience.

Thus, Wilder in *Our Town* did away with all but a few tables and chairs to stand in for a house and a ladder to serve as a staircase. In the third act, when Emily, now deceased, returns to earth to relive her twelfth birthday, even the chairs and tables are gone. This more stripped-down dramaturgy allows the character of Emily more starkly to stand out as both an individual and as a representative of all humanity. She is more easily regarded as occupying a place, not in New Hampshire at the turn of the twentieth century, but in mythic space—an echo of theater's once decidedly religious space—where we can contemplate her as both one of the innumerable human beings who have walked this earth but also as a type who can help us see and learn about ourselves. Wilder's central thesis sums up beautifully the attraction of theatrical mimesis: "It is through the theater's power to raise the

exhibited individual action into the realm of idea and type and universal that it is able to evoke our belief."[15]

I am suspicious, however, of a tendency in Wilder's thinking toward a Romantic expressivism. He talks about drama's ability to communicate "general truth," but then he also says this: "Emily's joys and griefs, her algebra lessons and her birthday presents—what are they when we consider all the billions of girls who have lived, who are living, and who will live? Each individual's assertion to an absolute reality can only be inner, very inner."[16] This understanding of absolute reality as nothing more than an expression of inner self-assertion justifies, for Wilder, the minimalist staging: "Our claim, our hope, our despair are in the mind—not in things, not in 'scenery.'"[17] In such comments, Wilder undermines his reasonable justification for the minimalist staging (so that the way up will not get obstructed by the way down) by claiming that the meaning our spirits crave is not to be found in the reality outside the mind that naturalistic staging was at (unnecessary) pains to copy. But this is to put us back into the problems we have already touched upon regarding the angelic and homeless imaginations. It is to place us on an unfruitful path that leads from the tables and chairs and ladders of *Our Town* to the single tree by the side of the road in *Waiting for Godot*.

Still, the truth of Wilder's central thesis about theater should not be dismissed. Theater's power to evoke our belief, to persuade us to incline to one side of a contradiction, as Aquinas would say, lies in its ability "to raise the exhibited individual action into the realm of idea and type and universal." For this work, staging that deemphasizes realism and puts the audience in a more mythic space seems to be more conducive. Wilder makes the compelling observation: Why do we never see anyone

15. Wilder, 685.
16. Wilder, 686.
17. Wilder, 686.

sit down in Shakespeare's plays, except occasionally a ruler? It is an indication that the Elizabethan theater did not think chairs and other realistic props necessary to communicating the truth of the story. And what theater has had a greater impact on audiences than Shakespeare and the Elizabethan theater? Wilder quotes a fine remark of Molière, who said that "for the theater all he needed was a platform and a passion or two." The climax of *Our Town* needs similarly "only five square feet of boarding and the passion to know what life means to us."[18]

It is an interesting question whether a deemphasis on realism is more necessary in the theater than it is in film and television and in the novel and short story as well. Minute fidelity to the instruments of war and uniforms worn by the soldiers is part of what makes a war film like *Dunkirk* believable and compelling to its audience. This may have to do with the way in which film is more of a virtual reality experience than a play. Not that this virtual reality experience is impossible in the theater—far from it. But the theater is meant to be more of a contemplative, rather than immersive, experience. This may in fact indicate a potential weakness in cinematic and television mimesis: the excitement produced by the immersive experience, which relies on naturalistic staging and costuming, may be so strong as to get in the way of contemplation of the mimetic universal. Contemplation requires some critical distance from emotional reaction, and film and television need to work harder to achieve that distance.

PRESENCE

(I and mine do not convince by arguments, similes, rhymes,
We convince by our presence.)
 Walt Whitman, "Song of the Open Road"

18. Wilder, 686. But that "to us" at the end of this sentence gives me pause.

But how exactly does a performance unlock the mystery of truth? Why are some actors able to achieve this truthfulness in performance and others not?

Patsy Rodenburg is one of the world's leading voice teachers and has worked with many acclaimed actors such as Ralph Fiennes, Daniel Craig, Helen Mirren, and Hugh Jackman. When Rodenburg began teaching actors in the late 1970s, she noticed how more experienced teachers would assess students summarily by saying something like "That student's got it" or "That student just doesn't have it." Rodenburg's sense of justice was provoked. She thought the judgments of her colleagues unfair and refused to accept a fundamental inequality of the human ability to create a *presence* onstage. What's more, as she worked with students, she found that some actually developed presence and were able to retain it. Rodenburg began to suspect that whatever the mysterious, charismatic quality of presence was, it was something that could be taught—or better, rediscovered. For Rodenburg, all human beings are born with natural presence and only later lose it. Look at newborn babies and you will experience presence most vividly. Engage with the child and you will find that the child is simply "there" with you, happy to accept your love and attention and happy to return it, uninhibited by worries about the past or future. Presence thrives, says Rodenburg, amid unconditional love and joy, but because in this vale of tears such an environment is often lacking, our natural condition of being present is hammered out of us. We develop opposing habits that choke off presence. We live in the past or in the future, full of ourselves, full of anxiety, inattentive to the richness of what is happening right in front of us—fundamentally *un-present*.[19]

As her teaching and thinking developed, Rodenburg began to identify three basic movements of human energy. By "energy,"

19. This story of Patsy Rodenburg's insight into the power of presence is told in the introduction to her book *The Second Circle: Using Positive Energy for Success in Every Situation* (New York: W.W. Norton, 2017).

do not think of some New Age force but rather of the common-place energy we all exude as embodied spirits. It is the cumulative energy generated by our body, breath, and voice, as well as by how we listen, think, and feel. It is an energy we experience in ourselves and others experience about us, and it is plainly perceptible.[20]

When a teacher enters a classroom and finds the students slouched in their seats, bored expressions on their faces, the teacher immediately picks up on a certain low level of dull, introverted energy. When a big personality arrives at a party, full of his own jokes and anecdotes, eager to command attention, a different kind of energy is emitted. The energy of the bored students emanates from what Rodenburg calls the First Circle:

> Here [in First Circle], your whole focus is inward. The energy you generate falls back into you. First Circle absorbs other people's energy and draws all outward stimulus inward. When you are in First Circle, you are not very observant or perceptive about people or objects outside yourself. They interest you only as a means to clarify yourself, not the world around you.[21]

The big personality at the party, by contrast, operates in what Rodenburg calls the Third Circle:

> In the Third Circle, all of your energy is outward-moving and non-specific, and is untargeted. It is as if you are spraying your energy out to the world with an aerosol can. Your attention is outside yourself, yet unfocused, lacking precision and detail. You get a loose connection to any situation, but miss the nuances. The world is a dimly lit audience for whom you are performing.[22]

20. Rodenburg, *Second Circle*, 15.
21. Rodenburg, 16.
22. Rodenburg, 17.

The First and Third Circles have their uses, but they also, in their different ways, disconnect us from the people and situations that surround us. A life lived habitually in the First Circle tends to be a life characterized by self-consciousness and blunted enthusiasm, while a life lived habitually in the Third Circle tends to be lived behind a shield of apparent invulnerability, and the engagements with others that Third Circle energy is capable of quickly establishing are superficial and lacking in intimacy.

The energy that genuinely connects us to the world is found in the Second Circle. In the Second Circle,

> your energy is focused. It moves out toward the object of your attention, touches it, and then receives energy back from it. . . . You are in the moment—in the so-called "zone"—and moment to moment you give and take.[23]

The Second Circle is where real intimacy (not necessarily romantic) occurs. There is no imposition of one's will upon another but a genuine "give and take" between persons. There is listening, close noticing, openness to the new, generosity. In a word, there is *presence*.

The "zone" of presence is a contemplative space. It is where, in Josef Pieper's evocative phrase, we "learn how to see again." When we are present, we open ourselves up in loving attention to the world, curious to learn and to share what we've learned.

The mimetic arts, both in their creation and in their reception, in their giving and in their receiving, thrive in presence. Pieper relates the contemplative space of the Second Circle to artistic creation in the following way:

> Long before a creation is completed, the artist has gained for himself another and more intimate achievement: a deeper and more receptive vision, a more intense awareness, a sharper and

23. Rodenburg, 19–20.

more discerning understanding, a more patient openness for all things quiet and inconspicuous, an eye for things previously overlooked.[24]

The artist must be present if moments of inspiration are not to be missed. One morning, the poet Gerard Manley Hopkins was present enough not to miss the flight of a windhover:

> I caught this morning morning's minion, king-
> dom of daylight's dauphin, dappled-dáwn-drawn Falcon,
> in his riding . . .[25]

And when we contemplate Hopkins's poem, we too are invited into that presence where that windhover rides again. The mimetic *re-presencing* of reality that characterizes the mimetic arts is one of the chief ways we human beings experience presence.

The adventure of a stage or screen protagonist, as is the case with any protagonist, moves from appearance to reality. We might say: from some seeming presence to the achievement of genuine presence. This is why plays typically end with an image of the genuine presence achieved, as we find in the closing moments of *Hamlet*. By act 5, Hamlet has come to a recognition that providence is still guiding his life, that the divine order has not been abolished despite his failure, so far, to adhere to it:

> There's a divinity that shapes our ends,
> Rough-hew them how we will.[26]

24. Pieper, "Learning How to See Again," 35–36.
25. For more on Hopkins's poem "The Windhover: To Christ Our Lord," see chapter 9. Hopkins's journals are a vivid exercise of contemplative presence not yet congealed into poetry.
26. *Hamlet* 5.2.11–12.

Far too late, Hamlet comes to a recognition of his duty (see especially 5.2.71–80).[27] Though in recognizing at last the demands of his duty and the risk of his life that it will now entail, Hamlet achieves a measure of peace in his resolution to act according to his duties as a prince. His words echo Matthew 10:31:

> Not a whit. We defy augury. There is special providence in the fall of a sparrow. If it be, 'tis not to come. If it be not to come, it will be now. If it be not now, yet it will come. The readiness is all, since no man of aught he leaves knows what is't to leave betimes. Let be.[28]

Let be. There is the note of Second Circle presence achieved by resignation to the divine will—an example that makes clear that "genuine presence" is not synonymous with the "happy ending" in the superficial sense.

The art of acting is the art of re-presencing the truth of the human quest for happiness through the medium of a human being "living and moving in front of us." Again, the identity of picture and pictured in the art of the actor is closer than in that of any other mimetic art. Great acting creates such an intimate sense of presence because near identity is achieved with the reality being imitated. The distinction between picture and pictured seems utterly to disappear. There is only presence. The picture has come to life.

This means that acting excellence comes out of the energy of the Second Circle. Even when the character being portrayed operates out of the First or Third Circle, the actor's performative picturing is itself a Second Circle achievement. The contemplative presence of the actor is necessary to re-presence whatever human action is being pictured.

27. Again, I follow the interpretation of *Hamlet* offered by Sister Miriam Joseph, CSC, in "*Hamlet*, A Christian Tragedy," similarly argued by Fr. David Beauregard, OMV, in chap. 4 of his *Virtue's Own Feature* and chap. 5 of his *Catholic Theology in Shakespeare's Plays*.

28. *Hamlet* 5.2.197–202.

THE KIDS AND THE BOX

The point of an actor developing presence is, accordingly, not to conjure an inner emotional state but to bring the imitation of the action called for by the script vividly to life for the audience. Beauty in dramatic performance is found in the imitated action, not in what the actor may or may not be feeling. Again, wholeness, proportion, and radiance are features of an imitated external act that mirrors depths of meaning in the soul of the person imitated.

The dominant school of acting in our own day, the so-called Method, tends to work against the Aristotelian approach. The Method has its origins in the early decades of the twentieth century, when Konstantin Stanislavski's ideas were imported into the American theater by several of the Russian's American devotees, principally Lee Strasberg. The Method urges the actor to use personal memory to locate a real emotion that can be grafted onto the action and dialogue called for by the script, thus creating (according to the theory) an absolutely authentic, "real" performance. What the actor does in rehearsal is plumb the actor's own psyche, searching for the personal ingredients that will make the character come alive on stage and thus communicate emotional truth.

But what the Method does not sufficiently appreciate is the way in which character and emotion are revealed through action. At its worst, it subordinates action to the creation of character and emotion. The result is a very different, more modern understanding of character itself, one founded upon the "dominant post-Romantic belief in the centrality of psychological characterization both to drama and to other forms of literature (above all, the novel)."[29]

<hr>

29. Halliwell, *Aristotle's Poetics*, 139. Halliwell argues that this post-Romantic belief in the centrality of psychological characterization is what prevents many contemporary readers of Aristotle from understanding what Aristotle is up to in the *Poetics*. I am indebted to Halliwell's analysis of Aristotle's subordination of character to action found in chapter 5 of this book.

Francis Fergusson compares getting to know a play with getting to know a person, a comparison that can help us see how mimetic truthfulness and beauty are achieved in acting: "We seek to grasp the quality of a man's life, by an imaginative effort, through his appearances, his words, and his deeds."[30] Fergusson then finds the philosophical principle undergirding this process in canto 18 of Dante's *Purgatory*:

Every substantial form—
distinct from matter, yet united with it—
contains within itself its proper power,
Which, till it's moved, remains unfelt, unseen,
demonstrable only in its effect—
as a plant's life is manifest in green.[31]

The soul, the substantial form, is revealed by its effects—which, for the actor, means by *action*. If an actor attempts to reveal a character's inner life principally through gesture or through facial and vocal expression not clearly and plausibly tied to an action intended by the character, then the result will typically be self-indulgent and tedious acting that takes the audience out of the story. Mamet's criticism of the Method is that it produces a self-consciousness in the actor that detracts from the priority of mimetic action:

My philosophical bent and thirty years' experience inform me that nothing in the world is less interesting than an actor on the stage involved in his or her emotions. The very act of striving to create an emotional state in oneself takes one out of the play. It is the ultimate self-consciousness, and though it may

30. Fergusson, *Idea of a Theater*, 24.
31. Dante, *Purgatory* 18.49–54, trans. Anthony Esolen (New York: Modern Library, 2004). Fergusson only quotes lines 52–54, but the preceding tercet is needed to capture Dante's full meaning and to relate it to the task of the actor.

be self-consciousness in the service of an ideal, it is no less boring for that.[32]

Consider then, in this light, the kids and the box.

The family has just moved to a new house, and among the detritus of the move is a large box for hanging clothes. The kids seize upon it. This box will be their spaceship. In moments, they have thrown themselves into the game of a space adventure, utterly lost in the play, utterly convinced by the story they are enacting.

The secret to truthful and beautiful dramatic performance is all right there. Notice there is no preparation for the play except perhaps the laying down of a few ground rules ("*I'll* be the captain . . . *You* be Matt Damon stranded on Mars . . ."). There is no delving into emotional memory. No rooting around in the subconscious. What, then, is there? First and foremost, *action*. Imagined human agents in pursuit of concrete goals. Whatever character or emotion may be on display is a concomitant effect of fighting aliens, quashing a mutiny, landing the ship on Mars.

In his *Poetics*, Aristotle speaks of happiness as an activity as opposed to a quality of character:

> Tragedy is a representation not of people as such but of actions and life, and both happiness and unhappiness rest on action. The goal is a certain activity, not a qualitative state; and while men do have certain qualities by virtue of their character, it is in their actions that they achieve, or fail to achieve, happiness. It is not, therefore, the function of the agents' actions to allow the portrayal of their characters; it is, rather, for the sake of their actions that characterization is included. So, the events and the plot-structure are the goal of tragedy, and the goal is what matters most of all.[33]

32. David Mamet, *True and False: Heresy and Common Sense for the Actor* (New York: Vintage Books, 1999), 10–11.
33. Aristotle, *Poetics* 6 (1450a16–23).

Because, given Aristotle's definition of happiness, qualities of character are subordinate to activity, the mimesis of the human quest for happiness must also prioritize the mimesis of action, not character. *Character portrayal is included only for the sake of the actions.* In the next lines, Aristotle goes on to underscore the subordination of character to action by saying that "without action you would not have a tragedy, but one without character would be feasible."[34] In declaring that a tragedy, or any narrative, is possible without characterization, Aristotle provides the justification for many an "action movie," where just enough characterization is employed to introduce the illusion of depth and to relieve the monotony of chase and fight scenes.

So here is Aristotle's lesson: Happiness is the end of human life, and because happiness is achieved, or lost, through action, our primary concern as human beings should be with the quality of the actions that we take. Our character, the settled disposition of our rational and sensitive appetites, is revealed whenever we take action because it is our character that inclines us to the ends we choose. These are home truths of the ethical life. But they are also truths of that mimesis of the ethical life that is the art of acting.

Anthony Hopkins, speaking about his performance in *The Father*, a film for which he won the Oscar for Best Actor, had this to say:

> People ask me, how do I prepare? Well, I just learn the lines and show up. It sounds trite, but what else can I do? The clue is in the script. I say to young students and actors, it's all there in the text. You don't need to rewrite. It's there. It's there for you to do. It's the roadmap.[35]

34. *Poetics* 6 (1450a23–25).

35. American Film Institute, "*The Father* Conversation with Olivia Colman & Anthony Hopkins," YouTube video, October 21, 2020, esp. 10:30 to 12:00, https://www.youtube.com/watch?v=7ESaYiMtCos&t=750s. Elsewhere, Hopkins emphatically states that he is not a Method actor.

Hopkins's point should not be taken as trite in the least. The screenwriter or playwright has already constructed a contemplative way station, and so the foundational ingredients of the actor's performance are already there in the events of the story.

When it comes to "creating a part," it can never be forgotten that the creation is foremost the job of the playwright or screenwriter. In fact, "character" in the sense of a human being with a history is an illusion produced by the juxtaposition of lines of dialogue with a concrete objective pursued by an imagined human agent. "Underneath" that juxtaposition, there is no character. Macbeth's tough relationship with his father as a teen never existed, and an actor's meditation upon it in the rehearsal process is unlikely to help him play the dagger soliloquy. Mamet makes this point about character by way of an analogy to Eisenstein's theory of montage. Just like shot A of a teakettle whistling juxtaposed with shot B of a young woman raising her head from her desk conjures in the mind of the viewer the idea "rising to renewed labors," so dialogue juxtaposed with action conjures in the mind of a viewer the idea that a human being with a history really exists.[36]

Aristotle himself gives the actor direction as to how to proceed. The direction is in fact given to poets, but its application to actors is clear:

> A poet ought to imagine his material to the fullest possible extent while composing his plot-structures and elaborating them in language. By seeing them as vividly as possible in this way—as if present at the very occurrence of the events—he is likely to discover what is appropriate, and least likely to miss contradictions.[37]

What Aristotle is suggesting here for both poet and actor is an elaborate game of "as if," in which the actor employs the

36. Mamet, *True and False*, 9.
37. *Poetics* 17 (1455a22–26).

contemplative imagination in order to make him- or herself "present at the very occurrence of the events." The word "presence" here connects us back to the Second Circle energy of the actor, a presence, Aristotle teaches, that allows for the actions and dialogue of the scene to unfold as if newly minted.

Aristotle goes on to advise the poet, in composition, to be present to the action by working it out "with gestures": "For the most convincing effect comes from those who actually put themselves in the emotions; and the truest expression of distress or anger is given by the person who experiences these feelings."[38] This advice would seem to be an endorsement of the Method, as it seems to encourage the poet, and by extension the actor, to produce a "convincing effect" by conjuring in himself or herself the same emotions the character is feeling in the scene being written or enacted. But this would be an anachronistic way of reading the passage. Aristotle is not suggesting that the poet or actor tap into his or her own personal emotions; rather, he is suggesting that they experience the emotions of the imagined character by acting them out. Action remains prior to character and feeling.[39]

Instead of the striving to create an interior emotional state, Mamet would have the actor turn his or her energy outward to the actions, including the responses to other actors' actions, required by the scene. The mimetic depiction of action is itself mesmerizing for an audience:

> In "real life" the mother begging for her child's life, the criminal begging for a pardon, the atoning lover pleading for one last chance—these people give no attention whatever to their own state, and all attention to the state of that person from whom they require their object. This outward-directedness brings the

38. *Poetics* 17 (1455a30–32).
39. See Halliwell's entire commentary on *Poetics* 17 in *Poetics of Aristotle*.

actor in "real life" to a state of magnificent responsiveness and makes his progress thrilling to watch.[40]

40. Mamet, *True and False*, 12–13. But what, then, are we to make of all those memorable Method performances? Brando in *A Streetcar Named Desire*. Pacino in *The Godfather*. De Niro in *Raging Bull*. Streep in *Sophie's Choice*. Heath Ledger in *The Dark Knight*. How do we explain their success if not by their study of the Method? Mamet's reply: "Through the gifts which God gave them, through experience, and in spite of their studies—to quote Fielding, 'Education being proved useless save in those cases where it is almost superfluous'" (*True and False*, 14). I would only add, as an addendum to Mamet's reference to experience, that what the Method actor draws upon is the experience of losing oneself in the imagination game of the play or the film.

13

A Reading of Jane Austen's
Northanger Abbey

Northanger Abbey is not Jane Austen's best novel and, indeed, must occupy the last place, or better said, the "least best" place, in any ranking of the six novels Austen completed in her maturity. Its narrative voice, which Austen's biographer Park Honan calls "its freshest and most innovative feature," is also "a lithe and slithery eel of great energy which is less than fully controlled" as it jerks uneasily at times between the burlesque of eighteenth-century novelistic tropes and a more naturalistic manner.[1] Added to this, Honan maintains, there is a "sharp break in tone, tempo, and manner between the Bath and abbey sections, which her heroine's development required but which still seems aesthetically dissatisfying."[2] And, perhaps most importantly of all, there is a decided lack of complexity in Austen's character and plot development as compared to her other five novels. On this score, Marilyn Butler notes Austen's reluctance in *Northanger Abbey* to commit herself entirely to her heroine's consciousness, such that the heroine's mental processes are summarily dealt with, even in the scene of that heroine's greatest emotional distress.[3] Likewise, Sarah Emsley, though exaggerating somewhat, puts her finger on the real problem of the thinness of the heroine's conflict: "She

1. Park Honan, *Jane Austen: Her Life* (New York: St. Martin's, 1987), 141.
2. Honan, 143.
3. Marilyn Butler, *Jane Austen and the War of Ideas* (Oxford: Clarendon, 1976), 177.

agonizes (sometimes), but she is never shown to be seriously in error, only a little silly and easily led by her imagination. Later Austen heroines will have to think more, struggle more, and suffer for more than ten minutes or one dark night in a scary room."[4]

Yet Jane Austen's artistry sets a very high bar, and the "least best" of her mature efforts is of a quality much higher than the common run of novels. As we continue our tour of particular mimetic arts with the art of the novel, *Northanger Abbey* is of special relevance, not only because it is a work of the Catholic imagination, according to the first precision made in chapter 4, but also because one of its central themes is how the art of the novel itself works as a "way of beauty"—that is, as a way of insight and moral transformation both for Austen's protagonist and for us, Austen's readers.

But to be a source of insight and moral transformation, a novel must have a positive connection to the emotional life of the reader. Literature, however, is not always regarded in this way. In "Men without Chests," the first lecture in his book *The Abolition of Man*, C.S. Lewis takes to task the authors of an English literature textbook for high school students, the title of which Lewis politely hides under the pseudonym *The Green Book*. Lewis criticizes *The Green Book* for trying to teach students that literature that appeals to the emotions is bad literature. The emotions are irrational forces, say *The Green Book*'s authors, and one of the aims of a literary education is to help the student distinguish between that literature which only appeals to irrational emotion and that which appeals to reason.

For Lewis, the authors of *The Green Book* have misconceived not only literature but also literature's role in promoting the life of virtue. Lewis's idea of virtue is founded upon classical philosophy and Christian theology, the philosophy and theology that inform the Catholic imagination. He quotes approvingly St.

4. Sarah Emsley, *Jane Austen's Philosophy of the Virtues* (New York: Palgrave Macmillan, 2005), 55.

Augustine's definition of virtue as the *ordo amoris*, the "order of love," the order of appetite shaped by reason—and for the believer, grace. Our loves—that is, our sensible appetites and our rational appetite, the will—naturally reach out for goodness, but without reason to guide them, they cannot make any distinction between *what seems good here and now* and *what is best overall*. The whole point of education is to habituate our appetites to this distinction by teaching us how to hunger only for those goods that genuinely perfect us as human beings. Literature plays a vital role in education by offering us stories and poetry whose beauty delights us and, by so delighting, helps us think and feel and will in the ways we ought.

Reason's guidance of appetite is conceived by Lewis along the lines of the tripartite division of city and soul defended by Plato's Socrates in the *Republic*. On that schema, as Lewis puts it, "The head rules the belly through the chest."[5] Just as in the ideally just city the philosopher-king governs the mass of his people by using his "loyal dogs," his auxiliaries or soldiers, so too in the individual soul, reason (the "head") governs the lower concupiscible appetites (the "belly") by means of the spirited element (the "chest"), what Aquinas calls the irascible appetite.

Lewis associates the spirited element in human beings, or the "chest," with the heart, the seat of the virtue of magnanimity or "greatness of soul": "The Chest-Magnanimity-Sentiment—these are the indispensable liaison officers between cerebral man and visceral man. It may even be said that it is by this middle element that man is man: for by his intellect he is mere spirit and by his appetite mere animal."[6]

The problem with *The Green Book* is that it aspires, by belittling the emotions, to produce "men without chests," without heart, without greatness of soul—we might say, without *heroism*.

5. C.S. Lewis, *The Abolition of Man* (New York: HarperOne, 2021), 24. This edition of Lewis's book is the one sold in tandem with Michael Ward's commentary, *After Humanity: A Guide to C.S. Lewis's The Abolition of Man* (Park Ridge, IL: Word on Fire Academic, 2021).

6. Lewis, *Abolition of Man*, 25.

But literature, according to Lewis, is about forming the concupiscible appetites principally by educating the chest / heart / spirited element so that it becomes a "loyal dog" in defense of reason. Jane Austen's *Northanger Abbey* is an excellent example of a novel fulfilling this role by ironically depicting a protagonist who must learn the dangers of indulging in literature that fails to fulfill this role. When we meet Catherine Morland at the age of seventeen, she is "in training for a heroine,"[7] dreamily poised to experience the kind of adventure that heroines experience in the novels she has read. But the adventure she is about to experience is not the one her overstimulated appetites are longing for, though it is the one that will help her achieve, and help us achieve in the reading, a measure of real heroism.

CATHERINE MORLAND AND THE "REFLUX" OF THE GOTHIC NOVEL

In speaking about picturing, Sokolowski points to the interplay of presence and absence. Christ is present in a new way in Caravaggio's *The Calling of St. Matthew*, though he is physically absent from us when we stand in the Contarelli Chapel and enjoy the painting. The presence of Christ in the painting, however, can also, hopefully, make itself felt in our lives after we leave the chapel. Caravaggio's striking picturing of Christ might linger in our memory and give us a stronger sense of our own calling by Christ, a deeper sense of our own evangelical mission. The way in which a piece of mimetic art works its magic on us in this way is a kind of "reflux" or "flowing back" of the meaning of the work upon our lives. "What is gained in the absence associated with pictures blends back into the presences given in direct experience. It can flow back into experience in this way because we have, all

7. Jane Austen, *Northanger Abbey* (New York: Penguin, 2003), 17.

along, been dealing with one and the same thing in its presence and absence: things are identities in presence and absence."[8]

The reflux of art upon our lives, however, is not always salutary. "Pictures can enrich life, but they can also mislead. We might begin to live in mere picturing, in movies or novels, for example, or in television. . . . The reflux of art into life may submerge life for a while, until the real thing's insistence finally breaks through."[9] This is the situation of Catherine Morland. The grip of Gothic novels upon her imagination and her sense appetites has submerged important elements of life, and without perception of that submerged reality, Catherine is left blind, unable to exercise the prudence necessary to "read" the new experiences into which she enters by going with her friends the Allens on a visit to the resort city of Bath.

Northanger Abbey, then, is a novel about reading, and especially the reading of novels. Throughout the eighteenth century, the novel was commonly regarded as the lowest of literary forms:

> Loose in structure, quotidian in its settings and references, epistolary and journalistic in its origins and compositional impetus, female in its readership and (often) authorship. Writing novels was simply supposed to be easier than other types of literary endeavor, while reading them was not thought conducive to moral welfare, particularly if the reader was fanciful and female.[10]

But in the famous ending of *Northanger Abbey* book 1, chapter 5, Austen's outspoken narrator vigorously defends the novel, and in particular female readers of the novel, against those who think the genre facile and morally frivolous. The peroration of the defense

8. Sokolowski, *Phenomenology of the Human Person*, 138–39.

9. Sokolowski, 139.

10. Fiona Robertson, "Novels," in *An Oxford Companion to the Romantic Age*, ed. Iain McCalman et al. (Oxford: Oxford University Press, 2009), 286–95.

imagines an embarrassed young lady admitting to an inquirer what she has been reading:

> "Oh! it is only a novel!" replies the young lady; while she lays down her book with affected indifference, or momentary shame.—"It is only Cecilia, or Camilla, or Belinda;" or, in short, only some work in which the greatest powers of the mind are displayed, in which the most thorough knowledge of human nature, the happiest delineation of its varieties, the liveliest effusions of wit and humor are conveyed to the world in the best chosen language.[11]

"Cecilia, or Camilla, or Belinda" refers to two novels by Frances Burney (*Cecilia, or Memoirs of an Heiress* and *Camilla, or a Picture of Youth*) and one by Maria Edgeworth (*Belinda, A Moral Tale*). All three of these novels, as Marilyn Butler describes them, feature "the dangerous entry into the adult world of an inexperienced, vulnerable heroine,"[12] a statement that also exactly describes the situation of Catherine Morland in *Northanger Abbey*. Butler neatly shows, in particular, the parallels between Burney's *Camilla* and *Northanger Abbey*: like Camilla, Catherine Morland is the eldest daughter of a clergyman who is entrusted to the care of close friends (an uncle in Camilla's case) who turn out to be foolishly inattentive. And, just as Camilla was to have been her uncle's heir, so too Catherine is rumored to have expectations from the Allens, expectations that drive the machinations of the Thorpe siblings and General Tilney in *Northanger Abbey*.[13]

Austen's construction of the Bath episodes in volume 1 of *Northanger Abbey* is especially indebted to Burney and more firmly establishes the story in the genre of romance. The conventions of the genre are closely adhered to: Catherine, the naïve

11. Austen, *Northanger Abbey*, 36–37.
12. Marilyn Butler, introduction to *Northanger Abbey*, xix.
13. Butler, xviii.

young woman, enters the wider adult world at the fashionable watering hole and becomes attracted to an eligible young gentleman, Henry Tilney, even as she becomes vulnerable to the predations of another young gentleman, the oafish John Thorpe, and his attractive, flirtatious, and mercenary sister, Isabella (another type learned from *Camilla*).

Catherine's burgeoning friendship with Isabella Thorpe helps define one side of *Northanger Abbey*'s dramatized dialectical debate. Though Catherine has apparently been a reader of romance novels since the age of fourteen or so, it is Isabella who introduces her to the Gothic novel, a high-octane variant of the romance novel, one with more mystery, terror, sexual titillation, and also, at times, supernatural elements. The Gothic novel is defined as

> a story of terror and suspense, usually set in a gloomy old castle or monastery (hence "Gothic," a term applied to medieval architecture and thus associated in the eighteenth century with superstition). Following the appearance of Horace Walpole's *The Castle of Otranto* (1764), the Gothic novel flourished in Britain from the 1790s to the 1820s, dominated by Ann Radcliffe, whose *Mysteries of Udolpho* (1794) had many imitators. She was careful to explain away the apparently supernatural occurrences in her stories, but other writers, like M.G. Lewis in *The Monk* (1796), made free use of ghosts and demons along with scenes of cruelty and horror.[14]

The Gothic is a genre still very much alive today in fiction for young adults as well as films and television aimed at a wider public. The name of the genre, as the definition indicates, implies a certain prejudice against the Catholicism of the European Middle

14. *Oxford Dictionary of Literary Terms*, 4th ed., ed. Chris Baldick (Oxford: Oxford University Press, 2008), s.v. "Gothic novel."

Ages but also, to be sure, a certain fascination with, and perhaps even nostalgia for, the richness of that lost cultural world.[15]

One of the amusements Catherine and Isabella share is to squirrel away together to read Gothic novels. When Catherine arrives late to one of their meetings, Isabella asks Catherine what she has been doing with herself all morning. "Have you gone on with [Ann Radcliffe's] Udolpho?"

> "Yes, I have been reading it ever since I woke; and I am got to the black veil."
>
> "Are you, indeed? How delightful! Oh! I would not tell you what is behind the black veil for the world! Are not you wild to know?"
>
> "Oh! yes, quite; what can it be?—But do not tell me—I would not be told on any account. I know it must be a skeleton, I am sure it is Laurentina's skeleton. Oh! I am delighted with the book! I should like to spend my whole life reading it.

15. For a fascinating discussion of how *Northanger Abbey* signals Austen's lament for the loss of the abbey and that the Tilneys are "unworthy owners of land once consecrated to God," see Roger E. Moore, "Northanger before the Tilneys: Austen's Abbey and the Religious Past," *Persuasions: The Jane Austen Journal* 41 (2019): 119ff. G.K. Chesterton, by contrast, does not find Austen lamenting anything about the dissolution of the abbey:

> Negatively, of course, the historic lesson from Jane Austen is enormous. She is perhaps most typical of her time in being supremely irreligious. Her very virtues glitter with the cold sunlight of the great secular epoch between medieval and modern mysticism. In that small masterpiece, *Northanger Abbey*, her unconsciousness of history is itself a piece of history. For Catherine Morland was right, as young and romantic people often are. A real crime *had* been committed in Northanger Abbey. It is implied in the very name of Northanger Abbey. It was the crucial crime of the sixteenth century, when all the institutions of the poor were savagely seized to be the private possessions of the rich. It is strange that the name remains; it is stranger still that it remains unrealized. We should think it odd to go to tea at a man's house and find it was still called a church. We should be surprised if a gentleman's shooting box at Claybury were referred to as Claybury Cathedral. But the irony of the eighteenth century is that Catherine was healthily interested in crimes and yet never found the real crime; and that she never really thought of it as an abbey, even when she thought of it most as an antiquity. ("The Evolution of Emma," in *The Uses of Diversity: A Book of Essays* [London: Methuen, 1920], 87)

I believe Moore's closer reading of the novel allows him to get the better of Chesterton in this argument. I also emphatically disagree with Chesterton's assertion that Austen was "supremely irreligious," either in life or in her fiction.

I assure you, if it had not been to meet you, I would not have come away from it for all the world."

"Dear creature! how much I am obliged to you; and when you have finished Udolpho, we will read the Italian together; and I have made out a list of ten or twelve more of the same kind for you. . . . I will read you their names directly; here they are, in my pocketbook. Castle of Wolfenbach, Clermont, Mysterious Warnings, Necromancer of the Black Forest, Midnight Bell, Orphan of the Rhine, and Horrid Mysteries.[16] Those will last us some time."

"Yes, pretty well; but are they all horrid, are you sure they are all horrid?"[17]

Catherine has become enraptured with the "horrid," the spine-tingling tale of intrigue, murder, and damsels in peril, with a soupçon of sex, and Isabella, though herself more interested in scouting men than reading, is happy to service her appetite.

What Austen gives us in Catherine Morland is a basically sensible and good-natured, naïve and poorly educated girl who is allowed to indulge a taste in fiction that, to borrow Plato's phrase, seeks to water her baser desires. C.S. Lewis again, in his examination of different types of reading in his book *An Experiment in Criticism*, distinguishes one kind of reading, characteristic of the unliterary, "which enables them to enjoy love or wealth or distinction vicariously through the characters."[18] If this is what it means to be an unliterary reader, then it would seem we are all unliterary readers. For who doesn't put himself or herself into the place of an even moderately sympathetic protagonist? But presumably what Lewis means is that those who read *only* for the thrill of living vicariously the adventure of the protagonist

16. All of these titles are actual novels.

17. Austen, *Northanger Abbey*, 38–39.

18. C.S. Lewis, *An Experiment in Criticism* (Cambridge: Cambridge University Press, 2008), 53.

are unliterary readers. Lewis calls this kind of reading "guided or conducted egoistic castle-building."[19] It is a particularly apt description of Catherine Morland's reading, given that so much of it is set in sinister castles. Catherine reads as one who badly wants to *be* "Emily St. Aubert" and escape imprisonment in Castle Udolpho with the aid of a secret admirer. Lewis further remarks that those readers devoted to egoistic castle-building cannot abide marvelous or fantastical elements, as the daydream being enjoyed must be, in principle, realizable.[20] From her reading, Catherine wants nothing other than the marvelous or fantastical, yet not in a way that pops the daydream. She half-believes that the sort of thing she reads about in *Udolpho* could happen to her.

Which is why Catherine's reading provides an unsalutary reflux of the Gothic novel upon her life. The fantastic, melodramatic picturing with which her imagination is absorbed submerges the reality around her in just the way that Plato's Socrates fears when he suggests banishing Homer and all the most popular poets from the ideally just city. What she sees is what she thinks the heroine of a Gothic novel would see, which means that she is blind to the real predatory forces gathering around her.

DRAMATIZED DIALECTICAL DEBATE: GOTHIC HEROINE VERSUS ARCH GENTLEMAN

Alasdair MacIntyre has observed that it is her "uniting of Christian and Aristotelian themes in a determinate social context that makes Jane Austen the last great effective imaginative voice of the tradition of thought about, and practice of, the virtues which I have tried to identify."[21] Though MacIntyre does not use the term, I take him to be situating Jane Austen within the Catholic imagination. In a union of Christian and Aristotelian themes,

19. Lewis, 53.
20. Lewis, 54–56.
21. MacIntyre, *After Virtue*, 240.

the protagonists of Austen's novels all see themselves, though of course not in these precise Aristotelian-Thomistic terms, as ordered to an ultimate end, supernatural beatitude in the Christian sense, though realized partially in this life by playing a specific social role that allows for the acquisition and practice of an array of moral, intellectual, and theological virtues.

Against this theo-dramatic backdrop, Catherine Morland's real adventure in *Northanger Abbey* is a dramatized dialectical debate, the conclusion of which illuminates more fully the good she is seeking. Like any protagonist engaged in such debate, she begins with a set of received opinions, including the dangerously influential ones she has taken from her reading of Gothic novels, and is then challenged by her circumstances to test those opinions against rival opinions that seem to hold equal if not more weight.[22]

The character who holds those rival opinions is Catherine's love-interest in the novel, Henry Tilney. When Catherine meets him for the first time in the Pump Room in Bath, he "seemed to be about four or five and twenty, was rather tall, had a pleasing countenance, a very intelligent and lively eye, and, if not quite handsome, was very near it. . . . He talked with fluency and spirit—and there was an archness and pleasantry in his manner which interested, though it was hardly understood by her."[23]

22. Marilyn Butler, in *Jane Austen and the War of Ideas*, characterizes *Northanger Abbey* in terms of eighteenth-century literary discourse as an anti-Jacobin novel, that is, a novel that attacks the "cult of self in politics, psychology, and ethics" (88). The members of this "cult" were "revolutionary novelists" who showed a "strong moral preference for the private and individual" (57). About *Northanger Abbey* in particular, Butler writes:

> Ideologically it is a very clear statement of the anti-jacobin position; though compared with other anti-jacobin novels, it is distinctive for the virtuosity with which it handles familiar clichés of the type. . . . Most anti-jacobin novels include characters who profess the new ideology, and are never tired of canvassing it in conversation. In *Northanger Abbey* there is no overtly partisan talk at all. . . . But in *Northanger Abbey* Jane Austen develops . . . her version of the revolutionary character, the man or woman who by acting on a system of selfishness, threatens friends or more orthodox principles; and ultimately, through cold-blooded cynicism in relation to the key social institution of marriage, threatens human happiness at a very fundamental level. Isabella Thorpe, worldly, opportunist, bent on self-gratification, is one of a series of dangerous women created by Jane Austen. (180)

23. Austen, *Northanger Abbey*, 25.

Catherine indeed cannot quite keep up with Henry's archness and pleasantry. He is clearly her superior in sense, education, and social knowledge, and, with his equally sensible sister, Eleanor, as his ally, represents the value of prudent discernment in dialectical opposition to Catherine's dreamy espousal, inspired by her reading, of the excitements of the concupiscible and irascible passions.

This last statement must be understood in context. Catherine is by no means the adventuress that her friend Isabella Thorpe is. She is socially inexperienced but tolerably well-formed in virtue. And for his part, Henry Tilney is not someone who looks askance at the reading of novels, including the more high-octane Gothic ones. In the walk to Beechen Hill, outside Bath, that Catherine enjoys with Henry and Eleanor, Henry enthuses about his love of novels, not least of the notorious *Mysteries of Udolpho*. "The person," he says, "be it gentleman or lady, who has not pleasure in a good novel, must be intolerably stupid. I have read all Mrs. Radcliffe's works, and most of them with great pleasure. The Mysteries of Udolpho, when I had once begun it, I could not lay down again; I remember finishing it in two days—my hair standing on end the whole time."[24] Catherine is quite surprised by this admission. She had doubted that Henry read novels at all: "I am very glad to hear it indeed, and now I shall never be ashamed of liking Udolpho myself. But I really thought before, young men despised novels amazingly."[25] Just like the imaginary reader Austen's narrator depicts as caught by someone (no doubt a man) reading a novel, Catherine admits to feelings of shame for doing so. Henry's passion for novels ("I myself have read hundreds and hundreds"[26]), and Gothic novels in particular, endorses Catherine's own literary passions and relieves her of the shame she had felt in reading them. Interestingly, before Henry's admission, Catherine had felt shame for liking *Udolpho*, meaning that she

24. Austen, 102–3.
25. Austen, 103.
26. Austen, 103.

had some inkling that there was something shameful in reading it. Her feelings of shame in relation especially to Henry's good opinion of her, as we will see, become particularly important at the climax of their dialectical debate.

But the conversation on Beechen Hill does not end there. Catherine and Eleanor get onto a discussion about the reading of history, which Eleanor loves and Catherine struggles with (for Eleanor, *Udolpho* is damned with faint praise; she calls it "a most interesting work" and pointedly wants to know whether Catherine is "fond of that kind of reading"[27]). Eleanor and her brother then veer off into a discussion of drawing, of which Catherine, feeling more shame, knows nothing. Henry then treats Catherine to a lecture on the picturesque, which Catherine happily drinks in, which in turn inspires him to air his views on environmental issues, which eventually leads him to the subject of politics, "and from politics, it was an easy step to silence."[28] There is silence for a moment, at least, until Catherine brings the conversation full circle by announcing news of the upcoming publication of a new Gothic novel, which, so she has heard, is to be "more horrible than any thing we have met with yet."[29]

The conflict between Catherine's opinions, character, and knowledge of the world and those of Henry and Eleanor Tilney is evident throughout this episode on Beechen Hill. But their conversation also foreshadows the ultimate resolution of their conflict. Henry's and Eleanor's introduction of books and ideas unknown to Catherine begins to open up for her a world beyond the current state of her moral and intellectual development. She has her first vague realization that there is much more for her to read and more positive "reflux" from that reading onto her life yet to experience. Henry in particular shows Catherine on Beechen Hill that a deeper reading of life's genres is possible through

27. Austen, 104.
28. Austen, 107.
29. Austen, 107.

deeper reading and discussion of different kinds of books, a point captured well by Marilyn Butler:

> Catherine finds not one world but many worlds opening to her through books. Henry [on Beechen Hill] develops and brings to a close the main theme of his courtship to date, which is to explore the world through play. Understanding comes from seeing how many different games there are. Genres are for adults what games are for children (and adults too), special systems which provisionally reduce reality to order, and make conclusions possible. Henry shows Catherine, who at this point only half hears him, that the mind orders the world through genres, lives in them, and plays between them.[30]

The challenge for Catherine in the second book of the novel is to discover and scrutinize what genres she has been living in, and for that, the scene must shift to Northanger Abbey itself.

In leaving Bath for Northanger Abbey, Catherine extricates herself from the manipulative John and Isabella Thorpe, who have been endeavoring to get Catherine to accept a marriage proposal from John Thorpe, whose interest in Catherine hinges upon the fortune he (mistakenly) expects her to inherit. General Tilney's invitation to Catherine to join his family for a time at Northanger Abbey moves the action onto the scene of the novel's final crisis and climax, and with the new setting comes a new set of literary tropes for Austen to draw on. The tamer romantic tropes typified by Burney are replaced by the more lurid Gothic tropes typified by Ann Radcliffe. On the ride to Northanger in Henry's curricle, a ride Catherine and Henry share alone on the insistence of General Tilney, Henry plays upon themes from three Radcliffe novels in depicting the "horrors" that await Catherine at the abbey[31]: "And are you prepared to encounter all the horrors that

30. Butler, introduction to *Northanger Abbey*, xvii.

31. A point made by Butler, introduction to *Northanger Abbey*, xix–xx.

a building such as 'what one reads about' may produce?—Have you a stout heart?—Nerves fit for sliding panels and tapestry?"[32] As Catherine joins his play, it becomes a most humorous and charming scene, and the reflux upon her life generated by her reading of Gothic novels is handled by her with a certain ironic distance. But once she gets to the abbey, the pressure from that reflux proves too much for her to bear. On a stormy night in her chamber, she imagines mysterious things that might be hidden in an old black cabinet and chest at the foot of her bed, only in the morning to find in them, respectively, an old laundry bill and a pile of folded linen. Worse, however, is when she begins to imagine a Gothic backstory explaining the untimely death of Henry and Eleanor's mother, a mystery that implicates in the crime of the woman's death her own husband, General Tilney.

As the reflux from Catherine's imagination becomes ever more distorted, she loses sight of the key reality in front of her: the maneuvers of General Tilney, who, having been misinformed in Bath by John Thorpe that Catherine was a young lady with expectations from the Allens, wants Catherine to marry Henry. The dialectical conflict between Catherine's distorted reflux and Henry and Eleanor's more sensible reflux from better education and broader reading intensifies until it comes to a head on the day Catherine cannot restrain her curiosity any longer and pays a visit to the wing of the abbey she has been forbidden to visit. For it is in that part of the house that Mrs. Tilney's suite of rooms has been kept inviolate since her death.

DEFEAT OF THE DISTORTED REFLUX

When one evening Catherine bids her host goodnight, General Tilney declares that he himself will remain awake for some hours, as there are some political pamphlets that he needs to read. Catherine finds the need to read some "stupid pamphlets" a not very

32. Austen, *Northanger Abbey*, 149.

likely reason for his being up into the small hours and wonders what sort of mischief he is up to. A ghastly new possibility forms in her feverish imagination: "the probability that Mrs. Tilney yet lived, shut up for causes unknown, and receiving from the pitiless hands of her husband a nightly supply of coarse food, was the conclusion which necessarily followed."[33] Catherine then prepares to visit the forbidden gallery in which lay Mrs. Tilney's apartments.

The next day is Sunday, and in church she is struck to find a monument to his wife the General has erected there. But Catherine is not fooled. She does not believe that Mrs. Tilney is really dead: "Were she even to descend into the family vault where her ashes were supposed to slumber, were she to behold the coffin in which they were said to be enclosed—what could it avail in such a case? Catherine had read too much not to be perfectly aware of the ease with which a waxen figure might be introduced, and a suppositious funeral carried on."[34] Catherine therefore resolves to make an attempt on Mrs. Tilney's forbidden door alone. It is a fearful, though not terribly dangerous, resolution, given the surly General's restrictions on his wife's apartments, but Catherine has hope of accomplishing it undetected, and she seizes her opportunity one late afternoon when Henry is away and Eleanor otherwise occupied. As she hurries surreptitiously toward Mrs. Tilney's apartment, her "courage" is described as "high."[35]

Notice Catherine's emotional state at this point. Given that she is faced with a challenge, her irascible passions are very much inspiring her "courageous" action. The passions of both *hope* and *daring* help move her toward her resolution to attempt the sortie into Mrs. Tilney's apartments: hope that she will achieve her desired goal, daring that she will overcome the obstacle of being detected, a possibility that she *fears*, with a third irascible passion,

33. Austen, 177.
34. Austen, 180.
35. Austen, 182.

but not so much as to stop her from executing her plan. A fourth irascible passion is also involved, that species of fear that is *shame*, the fear of disgrace, of one's worth being lowered in someone's eyes. Catherine would be ashamed if detected by any of the Tilneys, but most of all, of course, given her feelings for him, by Henry. It is significant that "she wished to get it over before Henry's return, who was expected on the morrow," as it indicates that, at some level, she knows she is doing something she should not, as she does not want to be found out by him whose judgment she most respects.[36]

The spirited or irascible passions, Aquinas tells us, always have their origin and terminus in the concupiscible passions. Accordingly, we have to think of the irascible passions that Catherine is feeling as having been inspired by some more basic sensible good that she wants or wants to avoid. Catherine's curiosity to see Mrs. Tilney's apartments is driven by a kind of concupiscible love for Gothic thrills and intrigue, as well as hoped-for joy in finding out the solution to the mystery of Mrs. Tilney. We misunderstand horror if we think only irascible feelings of fear and dreadful anticipation are involved with it. A real pleasure in being terrified lies behind the irascible reactions. When Catherine, after she sees Mrs. Tilney's apartment, tells herself that she "had expected to have her feelings worked, and worked they were,"[37] what she means is that she expected to have the pleasure of having her irascible passions "worked up." Later, Catherine will chastise her mind's "craving" to be frightened, by which she means her concupiscible love for thrills and intrigue.[38]

These emotional reactions are fed by Catherine's overheated imagination. What does she really expect to find in Mrs. Tilney's room? She imagines finding "those proofs of the General's cruelty, which however they might yet have escaped discovery, she felt

36. Austen, 182.
37. Austen, 182.
38. Austen, 188.

confident of somewhere drawing forth, in the shape of some fragmented journal, continued to the last gasp."[39] But what she actually finds could not be more anticlimactic: a pleasant, tidy room, "on which the warm beams of a western sun gaily poured through two sash windows!"[40] Her immediate reactions to the upset of her expectations are astonishment and doubt, and then: "a shortly succeeding ray of common sense added some bitter emotions of shame."[41] The sunlight streaming through the two sash windows is a metaphor for the light of common sense streaming into Catherine's mind, telling her how silly she has been to think a scene of Gothic horror had been awaiting her visit to this room. Her bitter emotions of shame indicate that her worth has fallen in her own estimation—an excellent sign, it seems, that the dialectical defeat of her distorted Gothic reflux has commenced with the return of her own common sense.

Yet how far toward wisdom has Catherine actually progressed? She is ashamed for having assumed that the General would have left clues to the mystery of his wife's absence simply lying about. No, she tells herself, "whatever might have been the General's crimes, he had certainly too much wit to let them sue for detection."[42] But is Catherine ashamed for having indulged, in the first place, in wild Gothic fantasies? Apparently not. The defeat of her distorted reflux will require a more decisive weapon. And it arrives in what immediately follows. Catherine, sick of exploring, decides to return to her own room, but before she can quit Mrs. Tilney's apartment, she hears footsteps on the stairs. In a moment, Henry appears before her. He has returned a day early. The climax of their dramatized dialectical debate has arrived.

Even before the truth comes out of why she is in that part of the abbey, Catherine is flooded with a shame very different than

39. Austen, 181–82.
40. Austen, 182.
41. Austen, 182.
42. Austen, 182.

the one she had been feeling a moment earlier. The shame she feels now is the one she most dreaded in formulating her plan, the shame of being discovered by Henry.[43] Catherine is forced to address his questions about what she is doing there. Henry's "quick eye" upon her discomfort, and just as quick reading between the lines of her responses to his account of his mother's death, lead him to guess what Catherine has been imagining: "If I understand you rightly, you had formed a surmise of such horror as I have hardly words to—Dear Miss Morland, consider the dreadful nature of the suspicions you have entertained."[44] Henry then scolds her with a speech that encapsulates the prudent judgment he has represented from the beginning. We should take this speech as the ultimate correction of her distorted Gothic reflux, an articulation of the intelligence Catherine has so badly lacked:

What have you been judging from? Remember the country and the age in which we live. Remember that we are English, that we are Christians. Consult your own understanding, your own sense of the probable, your own observation of what is passing around you—Does our education prepare us for such atrocities? Do our laws connive at them? Could they be perpetrated without being known, in a country like this, where social and literary intercourse is on such a footing, where every man is surrounded by a neighborhood of voluntary spies, and where roads and newspapers lay everything open? Dearest Miss Morland, what ideas have you been admitting?[45]

The speech is an appeal to Catherine's common sense, her own sense of the probable, that already has just begun to reawaken in her. The atrocities she has been imagining, Henry argues, could

43. On the sense of shame and its relationship to virtue, especially the virtues of humility and magnanimity, I am indebted to the discussion of Heribertus Dwi Kristanto, "Aquinas on Shame, Virtue, and the Virtuous Person," *The Thomist* 84, no. 2 (April 2020): 263–91.

44. Austen, *Northanger Abbey*, 185–86.

45. Austen, 186.

hardly be successfully pulled off in a country like England, with its education, its laws, its neighborhoods, even its roads and newspapers. He reminds Catherine, in effect, that she lives in a nation founded upon a Christian understanding of virtue, moral and intellectual habits that, by reason and grace, shape often wayward and distorted thoughts, volitions, and passions in the way of goodness.

Catherine's being caught, coupled with Henry's discovery of her hidden motivations and his correcting speech, constitutes a marvelously inevitable climax, not of the plot as a whole but of the ethical debate at its core, in which Catherine achieves insight into her own defects. Austen's novels are often about the heroine's growth in self-knowledge. Compare Catherine's moment of recognition to Elizabeth Bennet's moment of recognition and self-knowledge after she reads Mr. Darcy's letter.[46] The chapter that immediately follows Henry's speech begins with the solemn words, "The visions of romance were over. Catherine was completely awakened."[47] She admits to herself that her behavior has been the result of "a voluntary, self-created illusion" born of "an imagination resolved on alarm."[48] She even makes a specific reassessment of the moral value of the works of Ann Radcliffe: "Charming as were all Mrs. Radcliffe's works, and charming even as were the works of all her imitators, it was not in them perhaps that human nature, at least in the midland counties of England, was to be looked for."[49] In Italy, Switzerland, and the south of France—the typical settings of Gothic novels—there are, if the novelists are right, only angels and fiends. But in England, Catherine has learned, with special reference to General Tilney, "there was a general though unequal mixture of good and bad."[50]

46. For a parallel discussion of Elizabeth Bennet and Fitzwilliam Darcy's dramatized dialectical debate in *Pride and Prejudice*, see chapter 6 of my book *The Difficult Good*.

47. Austen, *Northanger Abbey*, 187.

48. Austen, 188.

49. Austen, 188.

50. Austen, 188.

After the tears of shame and self-reproach, after Henry's un-stated forgiveness of her folly, Catherine makes a renewed com-mitment to judge and act with prudence: "Her mind made up on these several points, and her resolution formed, of always judg-ing and acting in future with the greatest good sense, she had nothing to do but to forgive herself and be happier than ever."[51] Compare this degree of prudent self-knowledge to what is said of Catherine much earlier in the story: "Little as Catherine was in the habit of judging for herself . . ."[52] Now with prudence rather than her Gothic imaginings in charge, her will is in position to direct her concupiscible and irascible passions in virtuous action. Her irascible passions, Lewis's "chest," are poised to become the "loyal dogs" of her prudent judgment. We see this in Catherine's commitment to the virtue of humility: "Most grievously was she humbled. Most bitterly did she cry."[53] Humility is a virtue that perfects the feelings we have of our sense of self-worth, feelings found in the irascible passion of hope that yearns for the difficult good of "greatness." As fueled by Gothic novels, Catherine's fiery imagination had stirred the hope that maybe *she* could achieve the apparent greatness of the Gothic heroine who overcame all the difficulties of a nightmarish plot to win romance in the end. But now, with better judgment, Catherine seeks to restrain this overweening desire for a distorted greatness. She looks to make herself "smaller," in keeping with the ways of the Catholic imag-ination. Humility, however, does not preclude a different, more reasonable vision of greatness, a real magnanimity or "greatness of soul." It does not even preclude winning romance, indeed marriage, in the end. But it does call for greater self-knowledge, prudential judgment, and emotional disposition. It also calls for some better books, books like Jane Austen's *Northanger Abbey*.

What sort of moral "reflux" does *Northanger Abbey* provide

51. Austen, 188–89.
52. Austen, 65.
53. Austen, 187.

for us as readers? Does it educate or does it submerge reality? Are we, as readers, really morally transformed in the reading of this novel? Or is it simply a pleasurable experience?

I suggest that *Northanger Abbey*, in showing us the distorted reflux of Catherine Morland's imagination, provides for us, the reading audience, a picture, a showing, of the role of the imagination in our own moral formation. We are encouraged to take care with the "showings" we enjoy so that our head might rule our belly through the chest in the delightful, contemplative experience of reading great novels.

14

What's Entertainment?

The clown
With his pants falling down,
Or the dance
That's a dream of romance,
Or the scene
Where the villain is mean;
That's entertainment!
 "That's Entertainment!" from the 1953 musical film *The Band Wagon*

What is hard and necessary and unavoidable in human fate is the
subject-matter of great art.
 Iris Murdoch

Both the making and the enjoyment of mimetic art are so-
cial activities. No artist, no matter how apparently solitary,
revolutionary, or misanthropic, works without some sense of
communal practice and tradition, if only the practice and tra-
dition the artist is busy rebelling against. And no appreciator
of art, no matter how apparently alone with a book in a coffee
shop, a painting in an art museum, or a streaming series on
a smartphone enjoys that art without the benefit of the com-
munal practices and traditions of the publishing world, of art
galleries and museums, and of large-scale digital media enter-
tainment. Though my inquiry throughout this book has been
firmly placed within the Aristotelian-Thomistic tradition, it
has nonetheless abstracted overmuch from the specific practices
and traditions, and histories and debates with rival traditions,
that conditioned the making of the works I have discussed. I

have only just touched on, for example, Gerard Manley Hopkins's place in the tradition of lyric poetry, the social backdrop to Thornton Wilder's critique of realistic staging in the theater, Jane Austen's novels as a response to Romanticism, and the relationship of Christopher Nolan's *Dunkirk* to the tradition of silent film. I have for the most part abstracted from these matters because my chief purpose has been to reinvigorate the *philosophical* understanding of mimetic art, to consider what is essential to it as a kind of picturing, as distinct from the conditions of its making and enjoyment taken either generally or specifically. But I have also largely abstracted from these social structures simply because to get into them would have made this work far too long, indeed impossibly so.

But in this chapter, I want to say more about the social structures surrounding the Aristotelian-Thomistic tradition of mimetic art. We cannot understand this tradition without understanding it as just that, a *tradition*. No artist can achieve excellence without entering into the communal practice of his or her art, whether it be by enrolling in some formal course of study, taking on an apprenticeship, or by learning from books, YouTube videos, and similar resources. And no practice of mimetic art can flourish except within a tradition of practice, the socially embodied argument, extending through the generations, about what it means for the art in question to be excellent, to develop, and to respond successfully to conflicts with rival traditions. At the same time, a tradition of mimetic art is always embedded within wider social traditions. For the Catholic imagination offered to us by the Aristotelian-Thomistic tradition, mimetic art is not a mere matter of private enjoyment or consumption. It is a matter of insight and moral transformation, as we have discussed. But it is also a political matter, understood in the broad, ancient, and sane sense of having a role to play in the flourishing of the *polis*, the political community. Mimetic art is meant to serve the entire political community as a common

good. This places great importance on the popularity of at least certain works of mimetic art, on the need for these works to reach and attract the majority, if not all, of the populace. From a political point of view, as Mortimer Adler affirms, "only popular poetry is important."[1] While it will surely be the concern of a well-ordered political community to ensure a wide liberty for the pursuit of artistic enjoyment, it is only those works favored by all or by the majority, those that have the widest and deepest impact upon common life, that are of chief political concern. Let the few who gather to read and discuss James Joyce's *Finnegans Wake* enjoy themselves. It is the popular stories enjoyed by the many that we must focus on.

So from the point of view of the political community's well-being, popular art, what we today typically refer to as *entertainment*, is of serious significance. Without it, the political community simply cannot know and understand itself.

In this chapter, I want particularly to explore the nature of this service of mimetic art to the political community. I want to outline the difficulties the Catholic imagination faces in our contemporary culture, whose politics is not marked by a commitment to the common good, whose moral sense is governed by an expressivist conception of the self, whose technology is built to keep our minds and hearts from contemplating the reality outside our heads, and whose commercial entertainment is governed more by market forces than by any concern for the polity's growth in virtue.

THE ENTERTAINMENTS OF ANTI-CULTURE

We had fed the heart on fantasies,
The heart's grown brutal from the fare . . .
 W.B. Yeats, *Meditations in Time of Civil War, Part 6: The Stare's Nest by My Window*

1. Adler, *Art and Prudence*, 35.

The tragic drama of ancient Athens was not for the Athenians "an evening at the theater," and not just because the plays were staged beginning at the crack of dawn. When we think of going to see a play, we think of it as a "night out," a bit of entertainment, one of many forms of amusement available to us in modern culture. Greek tragedy was certainly amusement for the Athenians, but not solely that. It was a particular form of amusement, one ultimately grounded in the religious practices of the Athenian people—drama in ancient Athens was always staged within the context of a festival honoring the god Dionysus—and one having serious moral purpose. Ancient tragedy was a form both of worship and of *paideia*, of moral and intellectual formation. It was thus closer to what we would think of as a liturgy than to a hot ticket on Broadway. And because of its connections to religious worship and *paideia*, tragedy was an important concern for the entire political community.[2] A brief look at Aristotle's understanding of tragedy's role within the ancient Athenian *polis* will help us see how alien tragedy is to our contemporary, secularized, expressivist approach to art, and thereby give us a certain leverage as we work toward a new, more enriching conception of popular entertainment.

Tragedy for Aristotle is not only a political institution but a specifically democratic one. The greatest threat to a democratic life, on a view Aristotle inherits from Plato, is *pleonexia*. *Pleonexia* is built upon the belief that "the most desirable life is the life of unlimited power for pursuing whatever our hearts desire."[3] To translate the Greek into a single English word, *pleonexia* is "graspingness." It is the desire for "evermore," principally evermore money and honor and recognition. It is the "shapeless tyrannic

2. As Paul Cartledge has written, tragedy "served further as a device for defining Athenian civic identity . . . exploring and confirming but also questioning what it was to be a citizen of a democracy." Cartledge, "'Deep Plays': Theater as Process in Greek Civic Life," in *The Cambridge Companion to Greek Tragedy* (Cambridge: Cambridge University Press, 1997), 6.

3. Salkever, "Tragedy and the Education of the *Dēmos*," 282. Just as in the discussion of catharsis in chapter 7, for this account of Greek tragedy I am deeply indebted to Salkever's essay.

dream" where everything happens according to the dictates of one's own will.[4]

The antidote to *pleonexia* is *paideia*, formation, and one of the most effective forms of *paideia* is tragedy. For Aristotle, when the many in a democratic *polis* come together to enjoy a tragic performance, they become educable by story. Their tendencies toward *pleonexia* become checked by what is seen on the stage. Tragedy allows the many to practice that popular form of philosophy that we talked about when first discussing mimesis or picturing. Sitting in the audience or discussing and mulling over the play afterward, the tragic audience does not practice philosophy with the utmost rigor, but it does make some advance in clarifying its opinions about the human good.

This philosophical response to tragedy, as we talked about in chapter 7, is both contemplative and cathartic—contemplative insofar as it is cathartic. The catharsis is of the emotions of pity and fear. Drawing upon Aristotle's discussion of the passions of pity and fear in the *Rhetoric*, Salkever contends that because pity and fear are a kind of pain felt upon seeing something evil happen to one who does not deserve it, such as might happen to oneself or one of one's own, pity and fear can inspire us to more careful deliberation.[5] Not everyone, however, will be equally open to this salutary effect. The very young or very wealthy, those of very noble birth or possessed of great power, as well as those who are full of improper pride, will not be as inclined to pity and fear, as they will tend to see themselves as impervious to the misfortunes that provoke it. At the same time, those who have enjoyed too little good fortune will tend to cultivate a cynical frame of mind

4. Salkever, 285.

5. Salkever draws our attention to *Rhetoric* 1385b: "Pity is a kind of pain upon seeing the deadly or painful happening to one who does not deserve it, such as one might expect to come upon himself or one of his own." Salkever then adds: "Fear and pity are thus not separate or separable emotions, since both arise from the solicitude we feel for ourselves and those closest to us" ("Tragedy and the Education of the *Dēmos*," 294). He also makes an illuminating connection between what Aristotle says in the *Rhetoric* about the best way a speaker can arouse fear and the way fear is aroused when a tragic protagonist undergoes a *peripeteia* in his or her fortunes (295).

that prevents them from having any sympathy with undeserved suffering. But between these extremes are those of middling fortune, the very group, argues Salkever, that makes up the major part of the middle class of a democracy. "Such people are neither solitaries nor perpetually busy in the assembly and marketplace, and it is among them, on those intermittent occasions when they leave their homes and families to meet in assembly, that the tragic emotions can take hold."[6]

The challenge for us today is to replicate something like Aristotle's vision in a progressive culture, or rather anti-culture, deeply inimical to it. How can the mimetic arts play for us a role in kindling the life of virtue?

Before answering that question, we first need to take a cold-eyed look at our surroundings. I owe to Patrick Deneen the idea that our progressive culture today is best deemed an *anti-culture*. For Deneen, the project of liberal modernity has failed precisely because it has succeeded, and in its dubious "success," it has wreaked havoc on what older traditions took to be foundational for any flourishing culture.[7]

On the premodern view, culture was the communal effort to cultivate nature's potentialities so as better to enable the members of the community to flourish as their natures demanded. Culture was a human artifact, but it could not be understood apart from a deep appreciation of nature, and above all human nature, as a source of development, excellence, and renewal. These efforts by the community to cultivate nature required rootedness in place and time. A culture was understood as an entity located in a particular place. Even the Jews who wandered forty years in the desert saw themselves as a community looking for a promised land.

6. Salkever, "Tragedy and the Education of the *Dēmos*," 296. Poetic *paideia*, observes Salkever, "like Socratic *elenchos*, operates indirectly; it neither admonishes nor implants moral rules, but prepares its auditors to use their leisure well, to act virtuously and thoughtfully rather than under the influence of *pleonexia*, even when circumstances (such as war or the fear of punishment) do not compel them to do so" (290).

7. Patrick Deneen, *Why Liberalism Failed* (New Haven, CT: Yale University Press, 2018), esp. chap. 3.

Moreover, premodern cultures understood themselves as bound by time, as connected both to generations past and to generations future, because the project of cultivating nature was not something that could be completed in a single generation and was meant to benefit the community for generations to come.

Liberalism, as Deneen explains it, is designed to undermine this threefold foundation of culture: nature, place, and time. Instead of cultivating nature, liberal anti-culture seeks to master and possess it. It seeks not to develop nature's potentialities but to use them as raw material for personal transformation, as the individual is now regarded as prior in importance to any community. Liberal anti-culture also seeks to uproot this individual from connection to a particular locality and from claims made by generations past and future. The default condition of the liberal individual, according to Deneen, is homelessness, a condition, in Walker Percy's phrase, of being "lost in the cosmos."[8]

The strange person who has emerged from this cultural devolution, emancipated from nature, space, and time, is the person described by Charles Taylor as the expressive individual.[9] What makes for an authentic life has nothing to do with being measured by some standard extrinsic to the self, be it God or nature, but by *creating*, out of one's deepest passions, the standard by which alone that individual (and no other) is to be judged. This does not mean that the authentic life is always crudely individualistic. For most people, the authentic life will include horizons of significance: some version of family life, friendships, and participation in a variety of social organizations. To a certain degree, these social involvements will define the authentic life. Yet they

8. Deneen, 78. Concern with the prospect of ecological disaster is one area where the expressive individual shows concern for future generations. In my mind, this paradox speaks to the impossibility of human beings living without some ultimate concern or horizon against which all other concerns are measured. The feared ecological demise of the planet serves as the apocalypse of the progressive testament, a testament that holds for no everlasting life, and so must regard continued progression on this planet as the best humanity can hope for.

9. See Taylor, *Sources of the Self*, esp. chap. 21, and *Secular Age*, 475; and Trueman, *Rise and Triumph of the Modern Self*.

always remain dispensable or open to revision by the expressive individual. The individual's sense of what is "best for *me*" trumps all. It is impossible to understand contemporary Western mass entertainment without understanding this notion of authenticity. It is, explicitly or implicitly, the positive value in the Controlling Idea of pretty much every popular story we tell ourselves.[10]

But notice—this ideal of authenticity is nothing less than a new instantiation of that shapeless tyrannic dream that Plato and Aristotle saw as the chief enemy of human flourishing in a democratic community. In one sense, our political situation has not changed from theirs. In another sense, however, our situation is far worse because, for the most part, our popular entertainment, unlike Greek tragedy, is not designed to wake up the populace from this dream but to ensure that we remain blissfully enraptured by it. How did this new understanding of entertainment come about?

It all started in the middle of the nineteenth century, as Neil Postman argues, with an electronic "big bang" in the form of the invention of the telegraph and photography.[11] Taken together, these two discoveries made an assault upon print culture, replacing its invitations to conceptual formulation and abstract argument, pursued within the context of leisure and reflection, with the more immediate and sensually alluring pleasures of sensationalist information and vivid photographic reproduction. In their different ways, the telegraph and the photograph helped prosecute the conquering of nature, space, and time by wrenching the flow of information out of its immediate, local context and by allowing for the presentation of vivid photographic recordings of life disengaged from place and time. With these inventions, the seeds were planted for both the internet's vast glut

10. For more on the theme of authenticity and its ultimate failure to acknowledge a standard of value outside the self, see my essay "Fortitude and the Conflict of Frameworks," in *Virtues and Their Vices*, ed. Kevin Timpe and Craig A. Boyd (Oxford: Oxford University Press, 2014).

11. Neil Postman, *Amusing Ourselves to Death* (New York: Viking, 1985), 79.

of decontextualized information and social media's addiction to self-fashioning through photography.

Neil Gabler, however, turns Postman's analysis on its head by arguing that it was not so much the new technologies that introduced a new cultural way of being but a new cultural way of being, a new human environment, that created the new technologies.[12] What new environment? A growing democratic populace with an ever-increasing appetite for entertainment. And what whetted this appetite? For Gabler, it was the fact that in America, in contrast to Europe, there was less effective control by religious authorities and cultural elites over popular entertainment. Gabler, in fact, sees the prodigious rise of popular entertainment in the mid-nineteenth century as "a deliberate, self-conscious expression of cultural hostility—a willful attempt to raze the elitists' high culture and destroy their authority by creating a culture the elitists would detest."[13]

The result was nothing less than what Gabler calls the Entertainment Revolution:

> The desire for entertainment—as an instinct, as a rebellion, as a form of empowerment, as a way of filling increased leisure time or simply as a means of enjoying pure pleasure—was already so insatiable in the nineteenth century that Americans rapidly began devising new methods to satisfy it. Naturally, they gravitated toward those forms most congenial to providing mindless fun: forms that were outside the control of the elites as images generally were, forms that appealed to the senses, forms that challenged the hegemony of typography and with it the typographic modes of thinking that Postman had celebrated.[14]

12. Neal Gabler, *Life the Movie: How Entertainment Conquered Reality* (New York: Vintage Books, 2000), 55–56. I am indebted to Gabler for bringing to my attention the lines from Yeats used as an epigraph for this section. See *Life the Movie*, 9.

13. Gabler, 29.

14. Gabler, 56.

This description of the rise of the Entertainment Revolution reveals its motivation in that shapeless tyrannic dream of the expressive individual. Entertainment represented "instinct" or, one might say, the impulse of emotion; it was a form of "rebellion" and "empowerment"; it was an easy, hyperpalatable "pleasure," a treat for the senses for which the American appetite quickly became "insatiable."

And the ultimate weapon in this cultural revolution, Gabler contends, was the movies. "No other entertainment," he writes, "could provide the same immediacy, the same vast scale, the same phenomenological impact as the movies. In a society that loved sensationalism, they were sensationalism's apotheosis."[15] Mortimer Adler, writing in 1937, called the motion-picture theater "the theater of democracy" and the motion picture "its most popular poetry."[16] Of course, as the twentieth century progressed, film's supremacy was greatly challenged, and in some sense defeated, by television. Writing in 1985, Postman deemed television the "command center" of our entertainment culture, as it gave "the epistemological biases of the telegraph and the photograph their most potent expression, raising the interplay of image and instancy to an exquisite and dangerous perfection. And it brought them into the home."[17]

For us in the twenty-first century, however, neither the movies nor television can claim to be the command center of our entertainment culture. Digital technology has replaced both celluloid and airwaves as the meta-medium of our age. Indeed, digital technology helps undercut the very distinction between movies and television, as in our home-entertainment theaters and on other devices, with a couple presses of our thumbs and the help of a streaming service, we can bring an enormous catalogue

15. Gabler, 49–50.
16. Adler, *Art and Prudence*, 118.
17. Postman, *Amusing Ourselves to Death*, 78.

of movies and television shows right into our home—or into the palm of our hand.

And what do we watch on these devices? Most often, we watch images of the expressive individual's desire for authenticity. All the current offerings from Disney and Pixar, all contemporary romantic comedies, the entirety of the Marvel Cinematic Universe, the fare aimed at young and perpetually young adults, not to mention the vast majority of other comedies and dramas, show us pictures of someone struggling to be who that person is truly, authentically, meant to be in the modern, expressive sense.

In these examples, authenticity, whether it is actually achieved by the protagonist or not, is pictured as a source of positive meaning. As a source of meaning, of course, authenticity is not transcendent in any metaphysical sense. It is not, like the premodern ideas of nature and supernature, a principle extrinsic to the psychological states of individuals. Authenticity, rather, is an immanent source of meaning, found in one's deepest passions. But being the source of meaning creates enormous pressure on the expressive individual, and so it is all too tempting to seek the easiest and most available gratifications.[18] For many contemporary storytellers, authenticity takes the form of a sometimes brash, though often very dull, hypnotic, and conventional hedonism. The desire for sex and other sensual comforts, even for simple thrills and chills, becomes paramount. Individuals seeking authenticity at this level are like Nietzsche's "last men," who, as Thomas Hibbs has described them, are "adept at satisfying nearly all desires for pleasure" yet completely devoid of "the will to excel, to prove oneself superior to others, and thereby to win recognition and admiration."[19]

18. For an interesting discussion of how modern individualism generates a loss of purpose, see Taylor, *Ethics of Authenticity*, esp. chap. 2–4.

19. Thomas S. Hibbs, *Shows about Nothing: Nihilism in Popular Culture from "The Exorcist" to "Seinfeld"* (Dallas, TX: Spence, 1999), 12. Meditating later in the book on Tocqueville's prescient thoughts on liberalism's inherent weaknesses, Hibbs notes how Tocqueville saw that one of the possible manifestations of liberalism's decline is a "state of perpetual childhood," a result not only of the "encroaching of secularizing power, but also from the absence of any clear

Other, less sanguine types of storytellers, more philosophically attuned to living in an age without a transcendent purpose, adopt an attitude of what Hibbs calls "jaded amusement." These storytellers have no interest in celebrating authenticity as the secret to life's meaning and instead take a position of irony or mockery at the meaninglessness of existence (e.g., the films of Woody Allen and the hit '90s sitcom *Seinfeld*).[20]

And there are still other storytellers who seek to explore Nietzsche's own path out of the wilderness of nihilism. Their stories disturbingly depict the Nietzschean "overman," the strong individual who rejects the existence of the "last men" and bravely exerts, even while staring into the abyss of meaninglessness, the will to power and creativity.[21] The fact that this "overman" is typically defeated by the end of these stories should not distract us from the way in which he also enjoys a certain exaltation. In a world without clear definitions of good and evil, we become fascinated with the "overman's" ability to create—creations that typically turn out to be quite evil and violent (e.g., *The Dark Knight*, *Joker*). For in a world drained of meaning, violence is one of the only ways left to maintain connection to something real, if only pain and sorrow.[22] The depiction of evil, however, as Hibbs points out, is subject to the law of diminishing returns. Evil ceases to terrify and turns banal, even funny. "If rebellion fails to produce some alternative standard, it becomes pointless and frivolous. All

notion of what it means to be a mature human being" (41). This state of perpetual childhood belongs to the "last men" of our culture. It can be seen in the way parents are often portrayed as perennial adolescents, and it can be heard in the puerile hits of every popular music genre, including today's country music. Country music is often regarded as a stout champion of populist democratic values, but it is interesting, and not unconnected from its populist mystique, that its lyrics rarely rise above an adolescent pursuit of sex within a rather cartoon, pseudo-cowboy saloon culture.

20. Hibbs, 22.

21. See Hibbs, chap. 2.

22. For a fascinating account of our anti-culture's obsession with sex and violence as a double-headed hydra, see Percy, *Lost in the Cosmos*, question 18. For a companion discussion of our modern isolation and loneliness and its connection with explicit sexual behavior in novels and films, see Percy's essay "Diagnosing the Modern Malaise," in *Signposts in a Strange Land*, ed. Patrick Samway (New York: Farrar, Straus and Giroux, 1991), esp. 214ff.

that is left is the aesthetics of evil, whose techniques are increasingly explicit and incredible. As the audience becomes conscious of the artifice, it gains distance from the effects of evil, which is transformed into pure entertainment"[23] (e.g., *Natural Born Killers, Trainspotting, Pulp Fiction, Kill Bill 1* and *2*).

Are there exceptions to the patterns I have outlined? Of course. Hibbs discusses the way in which film noir, both classic and neo-, portrays a morally ambiguous, compromised, and indeed tragic world, but one that still recognizes the value of a longing for intelligibility, meaning, and love.[24] There are other films, too, that can be seen as more compatible with the Catholic imagination simply because they deal with themes more basic than the desires of the expressive individual, such as the treatment of old age and senility in *The Father*, starring Anthony Hopkins, or the treatment of the struggle for bare survival in films such as *Gravity* and *Dunkirk*. And then there are the films that take us to another time, culture, or world entirely, such as the Coen brothers' magnificent *True Grit*, to my mind the best Western ever filmed, or the films based on Tolkien's *Lord of the Rings*. Yet the depiction of older cultures is not immune to being co-opted by the ideal of authenticity, as we see in recent adaptations of Jane Austen's works (the television series *Sanditon* and Netflix's 2022 adaptation of *Persuasion*).

Postman argues that television and the new entertainment media introduce new epistemologies; they serve as metaphors insofar as they are transformative of how we see the world and what we take to be the truth. What the new digital entertainment media do, Postman would say, is persuade us that everything, from starting a business to getting married, from running for office to being trapped for sixty days in a mine in Chile, is a form of entertainment. Life itself, in Gabler's words, has become the movie.

23. Hibbs, *Shows about Nothing*, 52.
24. Hibbs, 29–33. Hibbs develops the theme in his *Arts of Darkness: American Noir and the Quest for Redemption* (Dallas, TX: Spence, 2008).

But if Gabler is right that entertainment is no longer just one sector of our anti-culture but the defining characteristic of it and indeed its "cosmology,"[25] then it is a cosmology of a most singular sort. For our contemporary entertainment cosmos is not one in which the expressive individual is *placed*, as human beings are placed in premodern cosmic understandings, but one in which the cosmos itself is placed within the psyche of the expressive individual.[26] It is a psychic cosmos. And to borrow a term from a trenchant analysis by Matthew Crawford, it is a cosmos composed of "representations."[27] By "representations," Crawford does not mean the kind of picturing or mirroring of the world characteristic of the Aristotelian-Thomistic theory of knowledge. To the contrary, he refers to a peculiarly modern stance to reality, initiated by Descartes, in which the mind, skeptical of what it can know of the world outside itself, takes its own ideas or "representations" as its starting point for a "method" that will help us express ourselves within the world. Crawford gives an arresting example of how the new entertainment cosmos works by comparing the original Mickey Mouse cartoons with the more recent offerings from Disney Junior's *Mickey Mouse Clubhouse*.[28] In the older Mickey cartoons, comedy is generated from Mickey having to come to grips with a world most recalcitrant to his purposes. But in the newer show, there is never a real conflict between will and world. Technology, in the form of the Handy Dandy machine (a computer), arrives on the scene to effortlessly solve whatever practical problem is at hand—a *deus ex machina* that, Crawford observes, not only makes the newer shows spectacularly unfunny, but also serves up the fantasy of technology, the ultimate "method" and the engine of contemporary entertainment,

25. Gabler, *Life the Movie*, 56.

26. On modernity as the displacement of the individual in the cosmos, see Romano Guardini, *The End of the Modern World* (Wilmington, DE: ISI Books, 1998).

27. Crawford, *World Beyond Your Head*. See especially the section "A Brief History of Freedom," 115–23, which should be read in conjunction with the critiques of liberalism found in Deneen and Hibbs.

28. Crawford, *World Beyond Your Head*, 70–73.

mastering and controlling nature, space, and time with consummate ease.[29]

What our anti-culture so desperately requires, then, but what is also a necessary aim of any practice of mimetic art, are works that can dissipate the fantasies generated by so much contemporary entertainment. The cosmos of "representations" in the psyche of the expressive individual, whether that cosmos be cheerfully optimistic about the prospects for living an authentic life or savagely violent in its attempt to create a new standard of values, needs to be dismantled by works that attract to the beautiful goodness of the real.

No one has written more eloquently of this need than the philosopher and novelist Iris Murdoch:

> Art with its secret claim to supreme power blurs the distinction
> between the presence and the absence of reality, and tries to
> cover up with charming imagery the harsh but inspiring truth
> of the distance between man and God.[30]

Much insight is packed into this single line. First, Murdoch identifies a certain kind of art that makes a "secret claim to supreme power," an art, we might say, that indulges the dream of *pleonexia*. Who makes this kind of art? In the previous sentences in this same passage, Murdoch identifies its maker as the "consoling

29. For a consideration of the connections between the modern understanding of "applied science" (i.e., technology) and magic, see Lewis, *Abolition of Man*, 76–77. And for a consideration of how the psyche of the expressive individual is not always in full control of the technology used to create its entertainment cosmos—specifically, how contemporary technologized entertainment, in the form of "social media," is designed to cannibalize the attention of its "users" (note the term, often associated with drug addiction)—see the Netflix documentary *The Social Dilemma*, directed by Jeff Orlowski (2020).

30. Iris Murdoch, *The Fire and the Sun: Why Plato Banished the Artists* (Oxford: Clarendon, 1977), 69.

image-making ego in the guise of the artist," though adding, significantly, "whom every one of us to some extent is."[31]

Second, Murdoch indicates what the philosophical problem is with this consoling, ego-obsessive art: it blurs what we have had occasion to pinpoint as the defining distinction of mimetic picturing, namely the distinction between appearance and reality, or what Murdoch calls the distinction between the presence and absence of reality.[32] Without this distinction between appearance and reality, there is no way out of the maze of appearances. The mind can only know its own "representations." All is only what it seems.

Finally, Murdoch identifies the truth that this kind of art obscures and that good art presumably uncovers: "the harsh but inspiring truth of the distance between man and God." What does Murdoch mean by this? Simply this: that it is no easy journey from where we begin as human protagonists to the ultimate aim of our journey, the Good. Like the prisoners being hauled out of Plato's cave by the philosophers who have already found their way out, we must experience the rough, steep road out of the cave of ignorance and moral confusion. We must learn how hard it is to make and to live the distinction between appearance and reality, how hard it is to become used to the harshness of the light, and how hard it is to resist stumbling backward to the comforting life of a prisoner at the cave's bottom. For Murdoch, great art is the fruit of great discipline. It is "the reward of the sober truthful mind which, as it reflects and searches, constantly says no and no and no to the prompt easy visions of self-protective, self-promoting fantasy."[33]

Murdoch would agree that the cleansing power of tragedy is

31. Murdoch, 69. In another passage, Murdoch avers that "the artist's worst enemy is his eternal companion, the cozy dreaming ego, the dweller in the vaults of *eikasia* [image-thinking]" (79). For a discussion of the roots in Romantic poetry of this art of the "obsessive ego" (Murdoch, 79), see Trueman, *Rise and Triumph of the Modern Self*, chap. 4.

32. In a related passage, Murdoch writes: "Art is about the pilgrimage from appearance to reality (the subject of every good play and novel) and exemplifies in spite of Plato what his philosophy teaches concerning the therapy of the soul" (Murdoch, *Fire and the Sun*, 80). Recall in our discussion of Aristotelian dialectic in chapter 3 that appearances rarely witness to an absence of reality. Most often, they witness to reality grasped only partially and obscurely.

33. Murdoch, *Fire and the Sun*, 79.

one of the best ways we have of helping us traverse this difficult path and resisting the easy visions of fantasy. But tragedy is not the only mimetic art with this power. "What is hard and necessary and unavoidable in human fate is the subject-matter of great art," says Murdoch,[34] but what is hard and necessary and unavoidable in human fate can be pictured by any mimetic art.

Murdoch also, in a way that recalls Salkever's argument, compares great art to philosophical dialogue, or what Murdoch calls, following Plato's usage, dialectic: "The imagination fuses, but in order to do so it must tease apart in thought what is apart in reality, resisting the facile merging tendencies of the obsessive ego. The prescription for art is then the same as for dialectic: overcome personal fantasy and egoistic anxiety and self-indulgent daydream. Order and separate and distinguish the world justly."[35]

And yet—here is the truth in the fantasizing works of our entertainment anti-culture. *They do not forget that great art must also entertain.* If mimetic art is going to attract and help transform the many, it must not neglect the need to delight not just the mind but the senses as well. In his autobiography, Anthony Trollope addresses the issue of what he calls sensationalism in literature. Trollope was considered by many to be an anti-sensational, or realistic, novelist; his friend Wilkie Collins, on the other hand, author of *The Woman in White* and *The Moonstone*, was considered a sensational one. But here is how Trollope himself views the matter:

> The readers who prefer . . . [realistic novels] are supposed to take delight in the elucidation of character. Those who hold by the other [i.e., sensational novels] are charmed by the continuation and gradual development of a plot. All this is, I think, a mistake—which mistake arises from the inability of the imperfect artist to be at the same time realistic and sensational. A

34. Murdoch, 79.
35. Murdoch, 79.

good novel should be both, and both in the highest degree. If a
novel fail in either, there is a failure in art. . . . Let an author so
tell his tale as to touch his reader's heart and draw his tears, and
he has, so far, done his work well. Truth let there be,—truth
of description, truth of character, human truth as to men and
women. If there be such truth, I do not know that a novel can
be too sensational.[36]

In this Trollope is absolutely right. A certain sensationalism is
essential to literature, and the perfect artist is at once realistic
and sensational. This is a point with which T.S. Eliot—for many,
quite wrongly, a high priest of high culture exclusively—heart-
ily agrees:

Those who have lived before such terms as "high-brow fic-
tion," "thrillers" and "detective fiction" were invented realize
that melodrama is perennial and that the craving for it is per-
ennial and must be satisfied. If we cannot get this satisfaction
out of what the publishers present as "literature," then we will
read—with less and less pretense of concealment—what we
call "thrillers." But in the golden age of melodramatic fiction
there was no such distinction. The best novels *were* thrilling;
the distinction of genre between such-and-such a profound
"psychological" novel of today and such-and-such a masterly
"detective" novel of today is greater than the distinction of
genre between *Wuthering Heights*, or even *The Mill and the
Floss*, and *East Lynne*, the last of which "achieved an enor-
mous and instantaneous success, and was translated into every
known language, including Parsee and Hindustani."[37]

36. Anthony Trollope, *Autobiography* (Berkeley, CA: University of California Press, 1978),
189–91. This autobiography was first published posthumously in 1883.
37. T.S. Eliot, "Wilkie Collins and Dickens," in *Selected Essays* (New York: Harcourt,
Brace, 1950), 409–10.

Eliot's thesis, as he puts it later in the same essay, is that you cannot define drama and melodrama so that they are reciprocally exclusive. For Eliot, "great drama has something melodramatic in it, and the best melodrama partakes of the greatness of drama."[38]

How should we understand these terms "melodrama" and what I take to be its equivalent, Trollope's "sensationalism"? David Mamet's definition of melodrama is useful here. It is made in relation to film but is applicable generally: "Film is *essentially* a melodramatic medium—it appeals to and involves the emotions with depictions of the emotional. Great melodrama, as Stanislavski told us, is just tragedy *slightly* manqué. It flutters at the intersection of the *exploration of circumstance* and the *exploration of the human condition*."[39]

In the insistence that in the greatest literature drama and melodrama unite, Trollope and Eliot are joined by G.K. Chesterton, who famously said in one of his greatest essays that "Literature is a luxury; fiction is a necessity."[40] By "literature," Chesterton has in mind those "high-brow" works that task the intellect at the expense of the emotions; by "fiction," Chesterton means those popular works of art that do not despise the melodramatic. Whether they are what Chesterton calls "trash," or whether they are of much higher literary quality, in a sense does not matter. What matters most is that we human beings need exciting, melodramatic, sensational stories. We do not all need to work through every line of Joyce's *Finnegans Wake*—very few have seen the point of doing so—but we all need stories, and paintings, and music, and mimetic art generally, that excite, amuse, and stir the mind but also the senses, the imagination, and the blood.

But *why* do we need them? Without making any allusion

38. Eliot, 418.

39. David Mamet, preface to *The Spanish Prisoner and The Winslow Boy: Two Screenplays* (New York: Vintage Books, 1998).

40. G.K. Chesterton, "A Defense of Penny Dreadfuls," in *The Defendant* (London: J.M. Dent & Sons, 1902), 21. See also the thematically linked essays "A Defense of Detective Stories" and "A Defense of Farce" in this same volume.

to Aristotle, Chesterton's reasoning is eminently Aristotelian in spirit. Works of "fiction," he argues, draw us to those moral truths we cannot live without:

> The vast mass of humanity, with their vast mass of idle books and idle words, have never doubted and never will doubt that courage is splendid, that fidelity is noble, that distressed ladies should be rescued, and vanquished enemies spared. . . . The average man or boy writes daily in these great gaudy diaries of his soul, which we call Penny Dreadfuls, a plainer and better gospel than any of those iridescent ethical paradoxes that the fashionable change as often as their bonnets.[41]

In another of his essays, and in a comment that must keep an Aristotelian defender of the moral purpose of mimetic art on his toes, Chesterton says about drama:

> A play may be as bitter as death, or as sweet as sugar-candy, it matters nothing—but a play must be a treat. It must be something which a mob of Greek savages, a thousand years ago, might, in some ruder form, have uttered passionately in praise of the passionate god of wine. The moment we talk about a theatre or a theatrical entertainment as "dissecting life," as a "moral analysis," as an "application of the scalpel"; the moment, in short, that we talk of it as if it were a lecture, that moment we lose our hold on the thin thread of its essential nature.[42]

The drama, like any story, like any work of mimetic art, must, as Chesterton says, be a "treat," his word and ours for an experience

41. Chesterton, "Defense of Penny Dreadfuls," 26.
42. Chesterton, "The Meaning of the Theatre," in *Lunacy and Letters*, ed. Dorothy Collins (New York: Sheed & Ward, 1958), 43.

that is unforgettable on account of its excitement.[43] For Chesterton, the word "treat" is simply the more common word for "festival."[44] That is what mimetic art must be at its best: *festivity*, an experience Josef Pieper has described as a piercing of the dome of the workaday world, the world of our everyday errands, professional duties, and unpaid bills, and an emergence into the light and goodness of reality. To be festive means "to live out, for some special occasion and in an uncommon manner, the universal assent to the world as a whole."[45]

Would Iris Murdoch join Trollope, Eliot, and Chesterton in proclaiming the value of melodramatic entertainment as a way out of the cave? She would certainly caution us of its abuses, and in this she would be doing right. But I also suspect that she would acknowledge that in the greatest writers, in Homer and Dante and Shakespeare and Austen and Dickens and on and on, we find rollicking good tales with plots, as Eliot observes, akin to what we find in the most popular genre fiction, and with characters we are delighted to identify with or to loathe.

In the well-known song "That's Entertainment!" from *The Band Wagon*, the lyrics cite both Sophocles's *Oedipus Rex* and Shakespeare's *Hamlet* as instances of great entertainment. Iris Murdoch speaks of the "shock of joy" in response to good art.[46] The two quotations I placed at the head of this chapter need not be taken as representing opposed viewpoints on art. The clown with his pants falling down (whether it is Mr. Bean or Estragon in *Waiting for Godot*) shows us what is hilariously funny but also what is hard and necessary and unavoidable in human fate.

I will close this chapter with the statement of a definition. A great work of mimetic art, one that plays its proper part in

43. Aristotle disparages tragedies that rely overmuch on spectacle, but he never discounts the value of spectacle altogether. See *Poetics* 6.
44. Chesterton, "Meaning of the Theatre," 40.
45. Josef Pieper, *In Tune with the World: A Theory of Festivity*, 30. In chapter 4 of this work, Pieper argues that the "home" of the mimetic arts is the festival.
46. Murdoch, *Fire and the Sun*, 78.

the *paideia* of a political community, must, yes, help us to resist the cozy dream life of the expressive individual's obsessive ego. It must teach us to make the hard distinction between appearance and reality. But it must do these things in a way that appeals broadly to the hearts and minds of a wide audience. It cannot attract us to moral truth while disdaining the high concept and the romance of risk. It cannot introduce us to the austere demands of the Good without taking us there by way of the festival. What the Catholic imagination must strive for is art that is, paradoxically, both unconsoling and a treat.

That's entertainment.

Exeunt

In our beginning is our end. When, at the end of his quest, Dante finally beholds the beauty of the face of God, he sings:

> Here ceased the powers of my high fantasy.
>> Already were all my will and my desires
>> turned—as a wheel in equal balance—by
> The Love that moves the sun and the other stars.[1]

In this moment of marvelous inevitability, Dante contemplates the beauty his heart longed for, unwittingly, when he wandered in the dark wood. In this moment, his inquiry complete, he achieves the ultimate intelligence, fulfillment, authenticity. He now realizes who he was always meant to be: a child of his Father God, playing under his gaze, luxuriating in the knowledge that he is intimately and infinitely and unconditionally loved. The catharsis Dante enjoys in this comic climax mirrors the divine beauty. His appetites—"all my will and my desires"—are finally clarified in their right ordering to Truth, and so they turn in perfect harmony or proportion—"as a wheel in equal balance"—moved by the Love that draws everything, in beauty, to itself.

When he wanders in the dark wood, Dante suffers from a malaise no different than the one that characterizes our

1. Dante, *Paradise* 33.142–45.

contemporary anti-culture. That malaise is the shapeless tyrannic dream of *pleonexia*, the desire to be divinity, the playwright of one's own drama.

In the pit beneath the world, at the beginning of his rescuing, Dante is shown images of false and self-defeating ways of escaping his malaise. First, the false authenticity of the angelic imagination, where a legitimate desire to express the heart's passion devolves into a shallow narcissism in which meaning is apparently bestowed upon reality by the magic in the pronoun "my."[2] Such is the story of the illicit lovers Paolo and Francesca, murdered by Francesca's husband and sent to hell unshriven, a story that makes Dante, still tempted by this angelic imagination, swoon. Such is the meaning of Ulysses's gripping tale of his final voyage, where his heroic self-assertion is finally and disastrously forced to recognize the limits laid down by divine order.

Second, Dante is shown the false authenticity of the homeless imagination, which takes itself to have grown up to the thought that all so-called horizons of significance are only expressions of human power. Who one is truly meant to be, on this understanding of authenticity, is someone who knows the world is drained of real meaning. Such is the significance of the Satan we discover at the bottom of the pit, buried up to his torso in ice and, not unlike Samuel Beckett's two clowns, unable to move.

These false and self-defeating ways of escaping the modern malaise are at bottom only one way: the refusal to recognize a reality irreducible to one's own concerns and desires; the refusal, in fine, to be a creature.

This refusal often takes the form of art. Whether we acknowledge it or not, art beckons to us because it is connatural to our nature as embodied spirits. It offers delight to our bodily dimension through our senses and emotions, and it offers delight to

2. I borrow this last phrase from the title of Alasdair MacIntyre's review of Bernard Williams's book of philosophical essays *Moral Luck*, a review entitled "The Magic in the Pronoun 'My,'" published in *Ethics* 94 (October 1983): 113–25.

our spiritual dimension through our intellects and our wills. But rather than seeing art as a picturing of the theo-drama in which we are cast as small, limited creatures struggling to achieve fulfillment, modern imaginations tend to use art either to gratify narcissistic tendencies or to express a sense of meaninglessness. Part of the refusal to be a creature is the refusal to see art as *imitation*—for what is the point of "copying" when one can create?

But Dante chooses to picture himself on the move. As a student of Aristotle, he knows that everything a human being does, from writing a poem to doing the dishes, is for the sake of some good. And he knows that this desire for goodness is insatiable until it discovers the Love that is Goodness itself. To be on the move, therefore, even for the most mundane item, is to be on a quest. It is to see our purposes as measured by our natural and supernatural ends. It is to be a character in God's drama.

Mimetic art, powered by the Catholic imagination, is powered by natural and supernatural order. It is powered by realities extrinsic to, transcendent of, the powers of the human soul and subjective psychological states. It is powered by realities that are publicly available to all rational inquirers.

We live in a world that has largely rejected this understanding of art. Consequently, proponents of the Catholic imagination may feel that they no longer have a voice, that they no longer have the power to persuade. But unlike so much contemporary art, where anything goes, where narcissism and nihilism dully repeat the same wearisome exercises, mimetic art is always capable of renewed freshness. This is because art in the Catholic tradition is in thrall to Being, a Source inexhaustible. Whatever flowering of this tradition there might have been in the Renaissance, that is still only one episode in its history. Who can tell what new stories, what new technical discoveries, what new masterpieces, await us from the hands of future artists working in this tradition? Who can say what future audiences, realizing, finally, that

modern imaginations cannot honor their promise to free them from malaise, might be persuaded by our arguments?

I give the last picture to Shakespeare.

In Shakespeare's Globe Theatre—a replica of which stands on the South Bank of the Thames in London—the ceiling over the stage was painted to represent the heavens. It was the night sky as a picture of heaven. The place underneath the stage was meant to represent the pit of hell—or sometimes purgatory, as presumably the ghost of Hamlet's father, a denizen of purgatory, arrived via the trapdoor on the stage. The play, the action on the boards, was meant to be mimesis of our earthly passage. At the end of Shakespeare's plays, when the characters depart—according to Shakespeare's customary final stage direction, *Exeunt*—they bring to completion that mimesis whose delightful intelligibility allows us to contemplate our own place in God's drama and to be transformed by that contemplation. This is what the best mimetic art does. This is where the way of beauty leads us. With a wholeness, harmony, and clarity that owe their light to God's own being, it shows us that all the world's a stage and all the men and women merely players, playing a game adequate, or inadequate, to the thought of heaven.

Bibliography

Abrams, M.H. *The Mirror and the Lamp: Romantic Theory and the Critical Tradition.* New York: Oxford University Press, 1971.

Adams, Jane. *Remarkably Jane: Notable Quotations on Jane Austen.* Kaysville, UT: Gibbs Smith, 2009.

Adler, Mortimer. *Art and Prudence: A Study in Practical Philosophy.* New York: Longmans, Green, 1937.

Alvis, John. "Shakespeare's *Hamlet* and Machiavelli: How Not to Kill a Despot." In *Shakespeare as Political Thinker*, edited by John Alvis and Thomas G. West, 289–313. Wilmington, DE: ISI Books, 2000.

Aristotle. *Aristotle: On Poetics.* Translated by Seth Benardete and Michael Davis. South Bend, IN: St. Augustine's, 2002.

———. *Aristotle: Poetics.* Introduction, Commentary and Appendixes by D.W. Lucas. Oxford: Clarendon, 1986.

———. *De Arte Poetica.* Edited by I. Bywater. Oxford: Clarendon, 1949.

———. *Nicomachean Ethics.* Translation and notes by Terence Irwin. 2nd ed. Indianapolis, IN: Hackett, 1999.

———. *On Human Nature.* Edited by Thomas S. Hibbs. Indianapolis, IN: Hackett, 1999.

———. *The Poetics of Aristotle: Translation and Commentary.* Translated and edited by Stephen Halliwell. Chapel Hill, NC: University of North Carolina Press, 1987.

Austen, Jane. *Northanger Abbey.* New York: Penguin, 2003.

———. *Pride and Prejudice.* New York: Penguin, 2014.

Baldick, Chris, ed. *Oxford Dictionary of Literary Terms.* 4th ed. Oxford: Oxford University Press, 2008.

Balthasar, Hans Urs von. *Theo-Drama: Theological Dramatic Theory.* Vol. 1, *Prolegomena.* Translated by Graham Harrison. San Francisco: Ignatius, 1983.

Beauregard, David. *Catholic Theology in Shakespeare's Plays.* Newark, DE: University of Delaware Press, 2007.

———. *Virtue's Own Feature: Shakespeare and the Virtue Ethics Tradition.* Newark, DE: University of Delaware Press, 1995.

Beckett, Samuel. *Waiting for Godot: A Tragicomedy in Two Acts.* Translated from the original French by the author. New York: Grove, 1982.

Belgion, Montgomery. "Art and Mr. Maritain." In *The Human Parrot and Other Essays,* 54–73. Freeport, NY: Books for Libraries, 1967. First published by Oxford University Press, 1931.

Bell, Clive. *Art.* London: Dodo, 2007.

Benedict XVI. "Meeting with Artists, Address of His Holiness Benedict XVI." November 21, 2009, vatican.va.

Block, Bruce. *The Visual Story: Creating the Visual Structure of Film, TV, and Digital Media.* 3rd ed. New York: Routledge, 2020.

Booth, Wayne C. *The Company We Keep.* Berkeley, CA: University of California Press, 1988.

Bowra, C.M. *The Romantic Imagination.* Oxford: Oxford University Press, 1969.

Branagh, Kenneth. *Beginning.* New York: St. Martin's, 1989.

Brown, Blain. *Cinematography: Theory and Practice.* 3rd ed. New York: Routledge, 2016.

Butler, Marilyn. Introduction to *Northanger Abbey* by Jane Austen, vii–xliii. New York: Penguin, 2003.

———. *Jane Austen and the War of Ideas.* Oxford: Clarendon, 1976.

Carroll, Noël. *Philosophy of Art: A Contemporary Introduction.* New York: Routledge, 2007.

Carroll, Noël. *The Philosophy of Motion Pictures*. Malden, MA: Wiley-Blackwell, 2007.

Cartledge, Paul. "'Deep Plays': Theater as Process in Greek Civic Life." In *The Cambridge Companion to Greek Tragedy*, edited by P. E. Easterling, 3–35. Cambridge: Cambridge University Press, 1997.

Chappell, Jeffrey. "What is "Character" in Music?" website of Jeffrey Chappell, July 6, 2011, https://jeffreychappell.com/pianist/q_c07.php.

Chesterton, G.K. *The Defendant*. London: J.M. Dent & Sons, 1902.

———. "The Evolution of Emma." In *The Uses of Diversity: A Book of Essays*, 127–36. London: Methuen, 1921.

———. *Lunacy and Letters*. Edited by Dorothy Collins. New York: Sheed & Ward, 1958.

Collingwood, R.G. *Principles of Art*. New York: Oxford University Press, 1958.

Crawford, Matthew. *The World Beyond Your Head: On Becoming an Individual in an Age of Distraction*. New York: Farrar, Straus and Giroux, 2015.

Dante. *Inferno*. Translated, edited, with an introduction by Anthony Esolen. New York: Modern Library, 2005.

———. *Paradise*. Translated, edited, with an introduction by Anthony Esolen. New York: Modern Library, 2007.

———. *Purgatory*. Translated, edited, with an introduction by Anthony Esolen. New York: Modern Library, 2004.

Deferrari, Roy J. *A Latin-English Dictionary of St. Thomas Aquinas*. Boston: St. Paul Editions, 1986.

De Haan, Daniel D. "Perception and the *Vis Cogitativa*: A Thomistic Analysis of Aspectual, Actional, and Affectional Percepts." *American Catholic Philosophical Quarterly* 88, no. 3 (July 2014): 397–437.

Deneen, Patrick. *Why Liberalism Failed*. New Haven, CT: Yale University Press, 2018.

Dickens, Charles. *Hard Times*. Everyman's Library ed. New York: Alfred A. Knopf, 1992.

Dostoevsky, Fyodor. *The Brothers Karamazov*. Translated by Richard Pevear and Larissa Volokhonsky. New York: Farrar, Straus and Giroux, 1990.

———. *The Idiot*. Translated by Constance Garnett. New York: Dover, 2003.

Eco, Umberto. *The Aesthetics of Thomas Aquinas*. Translated by Hugh Bredin. Cambridge, MA: Harvard University Press, 1988.

Eliot, T.S. "The Music of Poetry." In *On Poetry and Poets*, 17–33. New York: Farrar, Straus and Giroux, 1969.

———. *Selected Essays*. New York: Harcourt, Brace, 1950.

———. *The Use of Poetry and The Use of Criticism*. London: Faber & Faber, 1959.

Emsley, Sarah. *Jane Austen's Philosophy of the Virtues*. New York: Palgrave Macmillan, 2005.

Fendt, Gene. *Love Song for the Life of the Mind: An Essay on the Purpose of Comedy*. Washington, DC: The Catholic University of America Press, 2007.

Fergusson, Francis. *The Idea of a Theater*. Princeton, NJ: Princeton University Press, 1949.

Fish, Stanley. *How to Write a Sentence: And How to Read One*. New York: HarperCollins, 2012.

Fitzgerald, F. Scott. *The Great Gatsby*. New York: Simon & Schuster, 1995.

Francis. *Evangelii Gaudium*. Apostolic exhortation, November 24, 2013, vatican.va.

Frank, Joseph. *Dostoevsky: The Mantle of the Prophet, 1871–1881*. Princeton, NJ: Princeton University Press, 2002.

Frank, Peter. "Makoto Fujimura: An Immanent Abstraction." makotofujimura.com.

Freccero, John. *In Dante's Wake: Reading from Medieval to Modern in the Augustinian Tradition*. Edited by Danielle Callegari and Melissa Swain. New York: Fordham University Press, 2015.

Fry, Stephen. *The Ode Less Traveled*. New York: Gotham Books, 2006.

Gabler, Neil. *Life the Movie: How Entertainment Conquered Reality*. New York: Vintage, 2000.

Gilson, Étienne. *The Arts of the Beautiful*. Dallas, TX: Dalkey Archive, 2000.

————. *Forms and Substances in the Arts*. Translated by Salvator Attanasio. Dallas, TX: Dalkey Archive, 2001.

————. *Painting and Reality*. New York: Pantheon: 1957.

Gombrich, E.H. *The Story of Art*. New York: Phaidon, 1989.

Grout, Donald Jay, and Claude Palisca. *A History of Western Music*. 5th ed. New York: W.W. Norton, 1996.

Guardini, Romano. *The End of the Modern World*. Wilmington, DE: ISI Books, 1998.

Halliwell, Stephen. *The Aesthetics of Mimesis: Ancient Texts and Modern Problems*. Princeton, NJ: Princeton University Press, 2002.

————. *Aristotle's Poetics*. Chapel Hill, NC: University of North Carolina Press, 1986.

————. "Catharsis." In *A Companion to Aesthetics*, edited by Stephen Davies, Kathleen Marie Higgins, Robert Hopkins, Robert Stecker, and David E. Cooper, 182–83. 2nd ed. Malden, MA: Wiley-Blackwell, 2009.

Heaney, Seamus. "The Fire i' the Flint: Reflections on the Poetry of Gerard Manley Hopkins." In *Preoccupations: Selected Prose 1968–1978*, 79–97. New York: Farrar, Straus and Giroux, 1980.

Heath, Thomas R. "Review of *Creative Intuition in Art and Poetry*." *The Thomist* 17, no. 4 (October 1954): 583–89.

Hibbs, Thomas S. *Arts of Darkness: American Noir and the Quest for Redemption.* Dallas, TX: Spence, 2008.

———. *Rouault-Fujimura: Soliloquies.* Baltimore, MD: Square Halo Books, 2009.

———. *Shows about Nothing: Nihilism in Popular Culture from "The Exorcist" to "Seinfeld."* Dallas, TX: Spence, 1999.

Honan, Park. *Jane Austen: Her Life.* New York: St. Martin's, 1987.

———. *Shakespeare: A Life.* Oxford: Oxford University Press, 1999.

Hopkins, Gerard Manley. *Gerard Manley Hopkins: A Critical Edition of the Major Works.* Edited by Catherine Phillips. New York: Oxford University Press, 1986.

Hulme, T.E. *Speculations: Essays on Humanism and the Philosophy of Art.* Edited by Herbert Read. London: Routledge & Kegan Paul, 1949.

John Paul II. "Letter to Artists." April 4, 1999, vatican.va.

Jones, David. "Art and Sacrament." In *Epoch and Artist: Selected Writings by David Jones,* edited by Harman Grisewood, 143–85. London: Faber & Faber, 2008.

Jones, David Wyn. *Beethoven: Pastoral Symphony.* Cambridge: Cambridge University Press, 1995.

Joseph, Sister Miriam. "*Hamlet,* A Christian Tragedy." *Studies in Philology* 59, no. 2 (April 1962): 119–40.

Joyce, James. *A Portrait of the Artist as a Young Man.* New York: Penguin Classics, 1992.

Kenner, Hugh. *The Pound Era.* Los Angeles, CA: University of California Press, 1971.

Kermode, Frank. *Shakespeare's Language.* New York: Penguin, 2000.

Kraut, Richard. "How to Justify Ethical Propositions: Aristotle's Method." In *The Blackwell Guide to Aristotle's Nicomachean Ethics,* edited by Richard Kraut, 76–95. New York: Blackwell, 2006.

Kristanto, Heribertus Dwi. "Aquinas on Shame, Virtue, and the Virtuous Person." *The Thomist* 84, no. 2 (April 2020): 263–91.

Lee, Hermione. *Tom Stoppard: A Life*. New York: Alfred A. Knopf, 2021.

Lev, Elizabeth. *How Catholic Art Saved the Faith: The Triumph of Beauty and Truth in Counter-Reformation Art*. Manchester, NH: Sophia Institute, 2018.

Lewis, C.S. *The Abolition of Man*. New York: HarperOne, 2021.

———. *An Experiment in Criticism*. Cambridge: Cambridge University Press, 2008.

———. *The Weight of Glory and Other Addresses*. Edited by Walter Hooper. New York: Macmillan, 1980.

Lucas, D.W. *Aristotle: Poetics*. Oxford: Clarendon, 1986.

Lynch, William F. *Christ and Apollo: The Dimensions of the Literary Imagination*. Wilmington, DE: ISI Books, 2004.

MacIntyre, Alasdair. *After Virtue*. 3rd ed. Notre Dame, IN: University of Notre Dame Press, 2007.

———. *Ethics in the Conflicts of Modernity*. Cambridge: Cambridge University Press, 2017.

———. "The Magic in the Pronoun 'My' [Review of *Moral Luck* by Bernard Williams]." *Ethics* 94 (1983): 113–25.

———. "Poetry as Political Philosophy: Notes on Burke and Yeats." In *Selected Essays*, vol. 2, *Ethics and Politics*, 159–71. Cambridge: Cambridge University Press, 2006.

———. *Three Rival Versions of Moral Enquiry*. Notre Dame, IN: University of Notre Dame Press, 1990.

———. "The Virtues of Practice against the Efficiency of Institutions." The third of MacIntyre's three Agnes Cuming Lectures at University College, Dublin, in 1994, unpublished manuscript.

———. *Whose Justice? Which Rationality?* Notre Dame, IN: University of Notre Dame Press, 1988.

Mamet, David. *On Directing Film*. New York: Penguin, 1992.

———. *The Spanish Prisoner and The Winslow Boy: Two Screenplays*. New York: Vintage, 1998.

———. *Theatre*. New York: Farrar, Straus and Giroux, 2010.

———. *Three Uses of the Knife: On the Nature and Purpose of Drama*. New York: Vintage, 2000.

———. *True and False: Heresy and Common Sense for the Actor*. New York: Vintage, 1999.

Mariani, Paul. *A Commentary on the Complete Poems of Gerard Manley Hopkins*. Ithaca, NY: Cornell University Press, 1970.

———. *The Whole Harmonium: The Life of Wallace Stevens*. New York: Simon & Schuster, 2016.

Maritain, Jacques. *Art and Scholasticism*. Translated by J.F. Scanlan. Providence, RI: Cluny, 2016.

———. *Creative Intuition in Art and Poetry*. New York: Meridian, 1957.

Maus, Fred Everett. "Music as Drama." In *Music and Meaning*, edited by Jenefer Robinson, 105–30. Ithaca, NY: Cornell University Press, 1997.

McCormick, Neil. "Kendrick Lamar, Glastonbury Review: Baffling, Dazzling, and Brilliant Closing Pyramid Show." *The Telegraph*, June 27, 2022, telegraph.co.uk.

McGilchrist, Iain. *The Matter with Things*. London: Perspectiva, 2023.

McInerny, Daniel. "The Catholic Novel About the End of the World: Some Notes for a Sequel." Unpublished manuscript.

———. *The Difficult Good*. New York: Fordham University Press, 2006.

———. "Fortitude and the Conflict of Frameworks." In *Virtues and Their Vices*, edited by Kevin Timpe and Craig A. Boyd, 75–92. Oxford: Oxford University Press, 2014.

———. "Literature as Tradition-Constituted Inquiry." Unpublished manuscript.

McInerny, Ralph. "Apropos of Art and Connaturality." In *Being and Predication: Thomistic Interpretations*, 287–302. Washington, DC: The Catholic University of America Press, 1986.

———. "Maritain and Poetic Knowledge." In *Being and Predication: Thomistic Interpretations*, 303–13. Washington, DC: The Catholic University of America Press, 1986.

———. *Rhyme and Reason: St. Thomas and Modes of Discourse*. Milwaukee, WI: Marquette University Press, 1981.

McKee, Robert. *Story: Substance, Structure, Style, and the Principles of Screenwriting*. New York: ReganBooks, 1997.

McLuhan, Marshall. "The Analogical Mirrors." In *The Interior Landscape: The Literary Criticism of Marshall McLuhan, 1943–1962*. New York: McGraw-Hill, 1969.

Milward, Peter. *A Commentary on G.M. Hopkins' "The Wreck of the Deutschland."* Tokyo: Hokuseido, 1968.

———. *A Commentary on the Sonnets of G.M. Hopkins*. Chicago: Loyola, 1969.

———. *Landscape and Inscape: Vision and Inspiration in Hopkins's Poetry*. London: Elek, 1975.

———. *A Lifetime with Hopkins*. Naples, FL: Sapientia, 2005.

Moore, Roger E. "Northanger before the Tilneys: Austen's Abbey and the Religious Past." *Persuasions: The Jane Austen Journal* 41 (2019): 119ff.

Murdoch, Iris. *Existentialists and Mystics: Writings on Philosophy and Literature*. Edited by Peter Conradi. New York: Penguin, 1998.

———. *The Fire and the Sun: Why Plato Banished the Artists*. Oxford: Clarendon, 1977.

Nelson, E. Charles. "Shakespeare Has Missed the Dandelion." *Shakespeare* 12, no. 2 (2016): 175–84.

Newstok, Scott. *How to Think Like Shakespeare*. Princeton, NJ: Princeton University Press, 2020.

Nolan, Christopher. *Dunkirk: The Complete Screenplay.* London: Faber & Faber, 2017.

Nussbaum, Martha Craven. *Love's Knowledge.* New York: Oxford University Press, 1992.

———. "Tragedy and Self-Sufficiency: Plato and Aristotle on Fear and Pity." In *Essays on Aristotle's Poetics*, edited by Amélie Oksenberg Rorty, 261–90. Princeton, NJ: Princeton University Press, 1992.

O'Connor, Flannery. *The Habit of Being.* Edited by Sally Fitzgerald. New York: Farrar, Straus and Giroux, 1988.

———. *Mystery and Manners: Occasional Prose.* Edited by Sally and Robert Fitzgerald. New York: Farrar, Straus and Giroux, 1997.

Oesterle, John A. "Toward an Evaluation of Music." *The Thomist* 14, no. 3. (July 1951): 323–34.

Ong, Walter. "Imitation and the Object of Art." *The Modern Schoolman* 17, no. 4 (May 1940): 66–69.

Patey, Douglas Lane. *The Life of Evelyn Waugh.* Cambridge, MA: Blackwell, 1998.

———. "The Voices of *Pride and Prejudice*." In the Ignatius Critical Edition of Jane Austen's *Pride and Prejudice*, edited by Joseph Pearce, 405–16. San Francisco: Ignatius, 2008.

Percy, Walker. *Lost in the Cosmos: The Last Self-Help Book.* New York: Farrar, Straus and Giroux, 1983.

———. *The Message in the Bottle.* New York: Farrar, Straus and Giroux, 1975.

———. *Signposts in a Strange Land.* Edited by Patrick Samway. New York: Farrar, Straus and Giroux, 1991.

Pieper, Josef. *In Tune with the World: A Theory of Festivity.* Translated by Richard and Clara Winston. South Bend, IN: St. Augustine's, 1999.

———. "Learning How to See Again." In *Only the Lover Sings: Art and Contemplation*, translated by Lothar Krauth, 31–36. San Francisco: Ignatius, 1990.

Pieper, Josef. *The Philosophical Act*. In *Leisure: The Basis of Culture and The Philosophical Act*, translated by Alexander Dru, 77–143. San Francisco: Ignatius, 2009.

———. "Thoughts about Music." In *Only the Lover Sings: Art and Contemplation*, translated by Lothar Krauth, 39–51. San Francisco: Ignatius, 1990.

Plato. *Republic*. Translated by G.M.A. Grube, revised by C.D.C. Reeve. 2nd ed. Indianapolis, IN: Hackett, 1992.

———. *Symposium*. Translated by Alexander Nehamas and Paul Woodruff. Indianapolis, IN: Hackett, 1989.

Postman, Neil. *Amusing Ourselves to Death*. New York: Viking, 1985.

Pritzl, Kurt. "The Place of Intellect in Aristotle." *Proceedings of the American Catholic Philosophical Association* 80 (2007): 57–75.

———. "Ways of Truth and Ways of Opinion in Aristotle." *Proceedings of the American Catholic Philosophical Association* 67 (1993): 241–52.

Prufer, Thomas. "The Death of Charm and the Advent of Grace: Waugh's *Brideshead Revisited*." In *Recapitulations: Essays in Philosophy*, 91–102. Washington, DC: The Catholic University of America Press, 1993.

———. "Providence and Imitation in Sophocles' *Oedipus Rex* and Aristotle's *Poetics*." In *Recapitulations: Essays in Philosophy*, 12–21. Washington, DC: The Catholic University of America Press, 1993.

Ramos, Alice M. *Dynamic Transcendentals: Truth, Goodness, and Beauty from a Thomistic Perspective*. Washington, DC: The Catholic University of America Press, 2012.

Rieff, Philip. *My Life among the Deathworks*. Charlottesville, VA: University of Virginia Press, 2006.

Robertson, Fiona. "Novels." In *An Oxford Companion to the Romantic Age: British Culture 1776–1832*, edited by Iain McCalman, Jon Mee, Gillian Russell, Clara Tuite, Kate Fullagar, and Patsy Hardy, 286–95. Oxford: Oxford University Press, 2009.

Rodenburg, Patsy. *The Second Circle: Using Positive Energy for Success in Every Situation*. New York: W.W. Norton, 2017.

Rover, Thomas Dominic. *The Poetics of Maritain: A Thomistic Critique*. Washington, DC: Thomist, 1965.

Salkever, Stephen. "Tragedy and the Education of the *Dēmos*: Aristotle's Response to Plato." In *Greek Tragedy and Political Theory*, edited by J. Peter Euben, 274–303. Berkeley, CA: University of California Press, 1986.

Sayers, Dorothy L. *The Comedy of Dante Alighieri: Hell*. New York: Penguin, 1949.

Scruton, Roger. *Music as an Art*. London: Bloomsbury Continuum, 2018.

———. *The Soul of the World*. Princeton, NJ: Princeton University Press, 2013.

Seger, Linda. *Making a Good Script Great*. 3rd ed. Los Angeles, CA: Silman-James, 2010.

Shakespeare, William. *Cymbeline*. In *The Arden Shakespeare Complete Works*, edited by Richard Proudfoot, Ann Thompson, and David Scott Kastan, 255–92. London: Thomson Learning, 2001.

———. *Hamlet*. Edited by Ann Thompson and Neil Taylor. London: Arden Shakespeare, 2006.

———. *Macbeth*. In *The Arden Shakespeare*. Edited by Sandra Clark and Pamela Mason. New York: Bloomsbury, 2020.

Shiner, Larry. *The Invention of Art*. Chicago: University of Chicago Press, 2001.

Slade, Francis. "On the Ontological Priority of Ends and Its Relevance to the Narrative Arts." In *Beauty, Art, and the Polis*, edited by Alice Ramos, 58–69. Washington, DC: American Maritain Association, 2000.

Sokolowski, Robert. "Formal and Material Causality in Science." *Proceedings of the American Catholic Philosophical Association* 69 (1995): 57–67.

———. *Introduction to Phenomenology*. Cambridge: Cambridge University Press, 2000.

———. "Knowing Essentials." *The Review of Metaphysics* 47, no. 4 (June 1994): 691–709.

———. "Knowing Natural Law." In *Pictures, Quotations, and Distinctions: Fourteen Essays in Phenomenology*, 277–91. Notre Dame, IN: University of Notre Dame Press, 1992.

———. *Phenomenology of the Human Person*. Cambridge: Cambridge University Press, 2008.

———. "Picturing." In *Pictures, Quotations, and Distinctions: Fourteen Essays in Phenomenology*, 3–26. Notre Dame, IN: University of Notre Dame Press, 1992.

———. "Visual Intelligence in Painting." *The Review of Metaphysics* 59 (December 2005): 333–54.

Solzhenitsyn, Aleksandr. "Nobel Lecture." Translated by Alexis Klimoff. In *The Solzhenitsyn Reader: New and Essential Writings 1947–2005*, edited by Edward E. Ericson Jr. and Daniel J. Mahoney, 512–26. Washington, DE: ISI Books, 2006.

Stoppard, Tom. *The Coast of Utopia: Voyage, Shipwreck, Salvage*. New York: Grove, 2007.

———. "The Event and the Text." In *Tom Stoppard in Conversation*, edited by Paul Delaney, 199–211. Ann Arbor, MI: University of Michigan Press, 1994.

Tate, Allen. "The Symbolic Imagination." In *Essays of Four Decades*, 424–46. Wilmington, DE: ISI Books, 1999.

Taylor, Charles. *The Ethics of Authenticity.* Cambridge, MA: Harvard University Press, 1992.

———. *A Secular Age.* Cambridge, MA: Belknap, 2007.

———. *Sources of the Self.* Cambridge, MA: Harvard University Press, 1989.

Taylor, James S. *Poetic Knowledge: The Recovery of Education.* Albany, NY: State University of New York Press, 1998.

Thomas Aquinas. *Commentary on the Posterior Analytics of Aristotle.* Translated by F. R. Larcher, with a preface by James A. Weisheipl. Albany, NY: Magi Books, 1970.

———. *Expositio libri Posteriorum Analyticorum,* Corpus Thomisticum website, https://www.corpusthomisticum.org/cpa1.html.

———. *Exposition of Dionysius on the Divine Names.* In *The Pocket Aquinas,* translated and edited by Vernon J. Bourke. New York: Washington Square, 1960.

———. *Scriptum super libros Sententiarum Magistri Petri Lombardi.* Vol. 1. Edited by R.P. Mandonnet. Paris: Lethielleux, 1929.

———. *Summa theologiae.* In *Sancti Thomae de Aquino opera omnia.* Leonine ed. Vols. 4–12. Rome, 1888–1906.

Tierno, Michael. *Aristotle's Poetics for Screenwriters.* New York: Hyperion, 2002.

Tolkien, J.R.R. "Leaf by Niggle." In *Tree and Leaf,* 93–108. London: HarperCollins, 2001.

Tomalin, Clare. *Jane Austen: A Life.* New York: Alfred A. Knopf, 1997.

Trollope, Anthony. *Autobiography.* Berkeley, CA: University of California Press, 1978.

Trueman, Carl R. *The Rise and Triumph of the Modern Self: Cultural Amnesia, Expressive Individualism, and the Road to Sexual Revolution.* Wheaton, IL: Crossway, 2020.

Walton, Kendall. "Listening with Imagination: Is Music Representational?" In *Music and Meaning*, edited by Jenefer Robinson, 57–82. Ithaca, NY: Cornell University Press, 1997.

Ward, Michael. *After Humanity: A Guide to C.S. Lewis's The Abolition of Man*. Park Ridge, IL: Word on Fire Academic, 2021.

Waugh, Evelyn. "Fan-Fare." In *A Little Order: A Selection from His Journalism*, edited by Donat Gallagher, 29–34. Boston: Little, Brown, 1977.

———. *Vile Bodies*. New York: Little, Brown, 1999.

Wilder, Thornton. "Preface to Three Plays." In *Collected Plays & Writings on Theater*, 682–88. New York: Library of America, 2007.

Williams, Charles. *The Figure of Beatrice: A Study in Dante*. New York: Octagon Books, 1983.

Winters, Yvor. "The Poetry of Gerard Manley Hopkins." In *On Modern Poets*, 144–91. New York: Meridian, 1959.

Woods, James. *How Fiction Works*. New York: Farrar, Straus and Giroux, 2008.

Index

Gothic genre, 356–57
grace
 in fiction, 104–6, 112, 116,
 289
 in painting, 283–86

haecceitas, 272
Halliwell, Stephen, 13–14,
 48–49, 196–97, 242
Hamlet (Shakespeare), 20–21,
 34–36, 42, 48, 50–52, 61,
 154–57, 341–42
Handful of Dust, A (Waugh), 119
happiness
 as human end, 54–55, 86, 94,
 345–46
 and music, 243–44
 and painting, 292–96
 and sensible delight, 87–91
 and stories, 92–94
Hard Times (Dickens), 146
Heaney, Seamus, 270–71, 278
Heath, Thomas R., 151–52,
 158–60
Hergé, 289
Hibbs, Thomas, 382–84
Hitchcock, Alfred, 318
Hobbit, The (Tolkien), 60
homeless imagination, 128–29,
 242, 300, 395
Homer, 13–14, 99–100, 359,
 392
Honan, Park, 137, 350
Hopkins, Anthony, 346–47, 384
Hopkins, Gerard Manley, III,
 260–78, 289, 341
 See also individual works by
 name
humility, 65, 370

imagination
 angelic, 122–23, 127, 225n24,
 241–44, 298–99, 395
 homeless, 128–29, 242, 300,
 395
 See also Catholic imagination
imitation
 and acting, 328–29
 art as, 3–13, 98–99, 177, 230
 as copying, 15–23
 as natural, 3–5, 57–58, 194
 and pop music, 242–44
 and ritual, 331
Inferno (Dante), 99–103, 158
infima doctrina, 62, 75, 218, 224
instrumental signs, 11–12, 18,
 256, 287
intellect
 abstracting power of, 24–25
 and emotion, 138, 235–37
 and poetic knowledge, 147–51
intelligible delight, 188–91
isomorphism, 15–16

James, Henry, 110, 153
Jones, David, 21–22, 297
Joseph, Sister Miriam, 52n20

Kenner, Hugh, 171–72

Lamar, Kendrick, 241
Leaf by Niggle (Tolkien), 205–7
Lev, Elizabeth, 279–80
Lewis, C.S., 225n25, 351–53,
 358–59, 370
liberalism, 378, 382n19
Lincoln, Abraham, 26
literature
 and melodrama, 389–90

Stoppard, Tom, 127–28, 132, 160, 324, 326
Strawson, Galen, 57n24
subjectivism, 125
substantial form, 211–14, 217, 344
"Sunday Morning" (Stevens), 126
Sutherland, Graham, 294–96
Swift, Taylor, 243–44
syllogism, 72
 See also poetic syllogism
symbolic imagination, 107
symbols, 115
Symposium (Plato), 227

Tate, Allen, 107, 114, 122–23
Taylor, Charles, 124–25, 127n62, 378
telos (end), 43–44, 52, 54
theo-drama
 and Catholic imagination, 96–104, 118, 120–21, 244
 and Jane Austen, 360
 and Kendrick Lamar, 241
 and nihilism, 127–28, 396
 in painting, 280, 300
 in poetry, 259–60
 and transcendentals, 221
Thomas Aquinas
 on agent intellect, 25, 147
 on beauty, 172–73, 183, 211–12
 on contemplation, 57
 on images, 9–10, 12
 on passions, 366
 on poetry, 62, 75–76, 113, 159, 193, 218, 227
 on sense powers, 3, 144–45, 185–86, 274

Tierno, Michael, 47
Tolkien, J.R.R., 22, 60, 112, 119, 205–7, 384
Tolstoy, Leo, 28
"Tortoise and the Hare, The" (fable), 79, 81
tragedy
 as catharsis, 195–99, 326–27
 and Catholic imagination, 102, 119, 265
 as imitation, 21, 25, 331, 345
 soul of, 217
transcendentals, 220–23
Trollope, Anthony, 388–90

Ulysses (*Commedia*), 99–103, 106–9, 114, 117–19, 127, 395

Van Gogh, Vincent, 281, 290–91
Vasari, Giorgio, 15, 19
Vile Bodies (Waugh), 88–89
Virgil, 97, 99
virtual causality, 250
virtues
 of art, 136
 and education, 65, 76–77, 79, 197, 239, 351, 377
 and human end, 33, 41, 55–56, 61, 81, 91, 106, 137–39, 233, 267
 in Jane Austen, 120, 178–80, 359–61, 369–70
 social context of, 131
Voltaire, 5

Waiting for Godot (Beckett), 128–29, 336, 392
Walton, Kendall, 250